PRINTMAKING TODAY

Jules Heller

York University

second edition

PRINTMAKING
TODAY

A Studio Handbook

Holt, Rinehart and Winston, Inc.

New York Chicago San Francisco Atlanta Dallas
Montreal Toronto London Sydney

To Gloria, Nancy, and Jill

Acknowledgments: *Printmaking Today* owes its very existence to the contributions of ideas and images made by many persons and organizations, and I am pleased to make the full acknowledgment this brief space permits. The publisher and I want to express particular gratitude to the artists who permitted us to reproduce their works and who are extraordinarily generous in responding to our appeals for information and in sharing their views and experience with us. We wish also to thank the collectors, galleries, and museums for their help and cooperation. Garo Z. Antreasian and the Tamarind Lithography Workshop made exceptional efforts that enabled us to complete the series of process illustrations. Ernest de Soto, of the Collectors Press in San Francisco, very kindly let us borrow the etch table that appears on page 57, and Maltby Sykes, professor of art at the University of Alabama, has taught us all we know about the use of trimetal plates in lithography. Brian Perrin, of the Wimbledon School of Art in England, made possible a number of beautifully clear process photographs now reproduced throughout the book. We are in debt to Walter Rogalski, Hershell George, and Michael Gitlin, all of the Pratt Institute, for the illustrations that appear as Figures 65, 104, 105, 155–157, 159–163, 189, and 238–241. June Wayne, director of the Tamarind Lithography Workshop, David F. Driesback, professor of art at Northern Illinois University, John L. Ihle, professor of art at San Francisco State College, Walter Rogalski, head of the Graduate Graphic Arts Workshop at the Pratt Institute, and Andrew Stasik, director of the Pratt Graphics Center in Manhattan, made invaluable contributions in their constructive criticism of the text in its various states. And a final word of quite special thanks to Mary G. McLachlin, film librarian at the Scott Library, York University, for the information she provided for the list of films on printmaking. J.H.

Production: Editor: Dan W. Wheeler; Production editors: Rita Gilbert and Jane Roos; Manuscript editors: Mamie Harmon and Theresa Brakeley; Picture editor: Joan Curtis; Designer: Marlene Rothkin Vine; Associate designer: Ronald Gilbert; Index: Susan Horowitz; U.S. production supervisors: Vic Calderon and John Finnerty; Design and execution of the part and chapter numerals: Hershell George.

Manufacture: Text composition by York Graphic Services, York, Pa., U.S.A.; printed in black-and-white gravure and offset by Conzett & Huber, Zurich, Switzerland; color separations by Leonardi Offset-Reproduktionen, Zurich, Switzerland; color printing by Fabag & Druckerei Winterthur AG, Winterthur, Switzerland; bound by G. Wolfensberger AG, Zurich, Switzerland.

Library of Congress Catalogue Card Number: 73–171523
College ISBN: 0-03-073585-8
Trade ISBN: 0-03-091403-5
First printing 1972.

Preface

In *Printmaking Today* it has been my purpose to offer for college students and generally interested adult readers an introduction to the fine art of making prints that would, in handbook form, be comprehensive and systematic in its presentation of the materials and processes fundamental to original, creative work in lithography, woodcut, intaglio, and screen printing, as well as in the major variants and combinations thereof.

Fifteen years ago, when I was preparing the manuscript for the first edition of this book, printmaking and print connoisseurship were fixed and respected parts of our cultural tradition, but they remained, in the minds and attitudes of most observers, a craftsman's patient, private, and highly technical preoccupation, the results of which could be appreciated mainly by knowledgeable specialists with a taste for the obscure. All this, of course, was relative to the blaze of public acclaim and enthusiasm accorded to the "major" arts of painting and sculpture. In recent years, however, prints have become the objects of such exuberant interest among a rapidly expanding population of collectors, many of whom have extreme youth as a distinguishing characteristic, that now there scarcely exists a European or American painter of any repute who is not involved in making prints of some sort. Print workshops have been formed the length and breadth of the land, and a number of professional *ateliers* offer skilled artisans to serve in collaboration with artists for the publication in limited editions of quality works signed and numbered by their originators. In addition, entrepreneurs handling prints abound, and virtually every commercial gallery on New York's Madison Avenue can provide lithographs and silk-screen prints along with the paintings and sculptures by its stable of established artists.

In brief, the "original" print has become a significant feature of contemporary life, a cultural phenomenon that seems quintessentially right for its time. For the print is not a one-of-a-kind, elitist masterpiece of such economic worth that only a prodigious fortune could procure it, but rather a quality work designed to be multiplied into an edition that, potentially, many can acquire to own and enjoy. There is something fundamentally democratic about prints that suits a culture grown sophisticated on the brilliance of modern poster art and commercial design.

Like other aspects of human experience, prints can be made and appreciated to the best advantage when approached with the control that only knowledge provides. Thus, I have wanted to revise *Printmaking Today* so as to make it respond to the much higher order of information

and understanding that burgeoning technology and a broadened and intensified modern sensibility require. My method has been, first, to characterize in the introduction the basic nature of prints and to draw distinctions among the four major systems of reproducing images: planography, relief, intaglio, and stencil. Following this, I have organized the main part of the book into sections dealing with these four basic processes. Each is introduced by a historical chapter that reviews the genesis and development of the medium. This leads in each section to a key chapter that rehearses in a practical, step-by-step way the procedures and describes the materials needed for preparing the plate, drawing upon it, making the "etch," proving, and printing. Subsequent chapters in each section do the same for variants on the basic technique, and concluding the section are chapters on color methods and on solutions to workshop problems.

Throughout the book I have been eager to stress, in both words and pictures, the best in traditional and modern work and to be clear, complete, and realistic in the explanations of sequential procedures. If my prose has failed in clarity and explicitness, surely the illustrations will succeed, for I have had an abundance of strong and effective work to select from in the legacy of splendid art left by generations of illustrious printmakers and from the production of their richly endowed progeny working in our time. My policy has been to discuss no work without reproducing it and to demonstrate all essential steps with related process photographs and line drawings. Together, the illustrations number almost 350 in black and white, all positioned in close physical proximity to their textual references, and some 45 in full color.

Supplementing the four-part text are a series of chapters on the print workshop, presses, inks, papers, rollers, and brayers and appendices composed of bibliography, checklists and sources of equipment and supplies, an inventory of films on printmaking processes, and a glossary of technical terms.

Finally, I should like to explain the organization in which I have preferred to place the section on lithography before those on woodcut, intaglio, and screen printing. In my associations with students lithography has attained a special significance, for I have found that it allows and encourages them to incorporate wholly new processes and techniques with the drawing experience they already have. Lithography immediately provides, from the first print pulled, a good and representative introduction to the principal elements of printmaking: plate preparation, calligraphic drawing, ink and paper selection, proving, and printing.

Toronto, Canada J.H.
January 1972

vi

Contents

Introduction

No one can dispute that the original print today enjoys high favor and a wide audience, for its success has been well nourished by the benefits of an exploding technology, bold research, expanding markets, and the talents and technical skills of many artists and artisans throughout the world.

In the decade and a half since the first edition of this work was published, new relationships have emerged between art on the one hand and science and technology on the other. The relative indifference once shown by artists toward commercial and industrial developments and scientific research is neither fashionable nor desirable any longer.

The many innovations of today reflect not only the continuing aesthetic inventiveness of artists, but also an expanding realization of what the processes themselves can be made to do. The possibilities are seemingly limitless. While not itself a print, Figure 1 suggests that new and unexplored fields still lie ahead. This "drawing" was made by an artist-engineer team using a computer, and it demonstrates one possibility that might equally well be applied for future research in the graphic arts. Richard Fraenkel (b. 1923), the artist of this team, explained the evolution of his idea as follows:

> The connection between the intention and the resulting object had been developed in my previous preoccupation in painting and sculpture with the surface repetition of countless dotted marks which, at first glance, appeared monotonous but which, I hoped, assumed a pervasive power precisely because of precision.

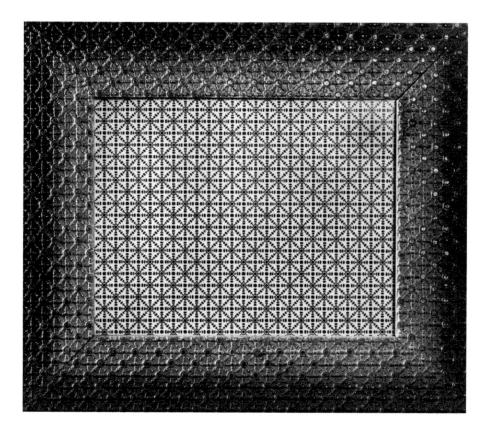

1. RICHARD FRAENKEL
and JEFFREY RASKIN.
Picture Frame. 1968.
Computer drawing, $12\frac{1}{4} \times 14\frac{1}{2}''$.
Courtesy the artist and engineer.

If things are to be precise and compulsive, why do them by hand?

In the development of this object an old embossed frame was found and purchased. From this arose the idea of reproducing two-dimensionally the "design" found in the frame and continuing it through the surface of the picture plane, linking the two-dimensional marks with the bas-relief frame to produce the idea-object, *Picture Frame.*

A computer programmer, Jeffrey Raskin, made this translation of the artist's idea into computer language:

Totally aside from its value as a work of art, Fraenkel's *Picture Frame* is of interest for the state-of-the-art list-processing graphics method used.

The drawing was executed on a CalComp Digital Incremental Plotter driven by an IBM 1401. The calculations were performed on an IBM 360/67. The program that produced the picture was written in FORTRAN IV and used the QUICK-DRAW Graphics System. This graphics system allowed a small unit of the picture to be defined in terms of short line segments. This small portion was then rotated, reflected, and translated to make up a basic diamond-shaped unit. A number of these units formed a row, and then a double row was defined. This double row was stepped across repeatedly to make the final picture. The entire picture, containing over a million line segments, could be stored in only a few thousand bytes of core storage because of the QUICK-DRAW Graphics System's ability to exploit the redundancy of the image. This allowed the entire image to be scaled, rotated, skewed, or otherwise manipulated internally prior to drawing. Finally,

the program used to produce the drawing in *Picture Frame* is considerably shorter and easier to write and use because of the extensive application of the list-processing graphics system.

If the pen that was driven to make these more than a million strokes carried a lithographic drawing ink and if an aluminum or zinc plate were substituted for computer paper, a lithograph could result. With variations and substitutions of materials and processes, a relief print, intaglio, or serigraph, or any combination thereof, could be achieved in one or more colors. The technology for such projects exists.

This brief excursion into the future contrasts sharply with the present state of knowledge held by the public about the printmaker's craft: A lecturer, preparing for an informal talk on contemporary art, may settle down to read an article called "Renaissance in the Fine Print" and find himself staring fixedly at such phrases as "inkless intaglio," "nervously worked lucite surface," "collagraph," "3-D print," "cellocut," "metal graphics," "cast epoxy," "embossed lithograph with soft sculpture," and "color relief lithograph."

A print collector, methodically surveying a current exhibition and making codelike references on the exhibition catalog, may suddenly stop before a large print on the wall, realizing that neither his great knowledge of technique nor the handsome catalog aids him in understanding how this work was accomplished. He can only turn to a printmaker of his acquaintance for clarification.

Within the past twenty years or so, the small, intimate, precious black-and-white impression on paper, known, collected, and loved since the fifteenth century, has been more and more displaced by prints that rival easel paintings in size, color, and importance. New equipment, new techniques, and new materials fuse in a new aesthetic to produce prints that confuse the old connoisseurs. The layman is even more bewildered by the advent of this dazzling display of complex technical virtuosity.

The revolution in printmaking continues. The once impossible is now accomplished with ease; a new chemistry has emerged from research in lithography; so-called commercial techniques of printing have been acquired and adopted by many printmakers; automation, the computer, and other twentieth-century tools and processes have spawned new concepts in the manufacture of printing presses, ink, paper, and plates, to awaken a new generation to undreamed-of possibilities for the printed multiple image.

More and more colleges and universities are adding printmaking to their curriculums. Print societies, clubs, and professional workshops spring up to meet the needs of the new collectors. Exhibitions of prints abound in art schools, museums, independent galleries, and universities, as well as in such unlikely locations as laundromats, theater lobbies, supermarkets, and city squares.

The Printmaker

The printmaker is a most peculiar being. He delights in deferred gratification and in doing what does not come naturally. He prefers the difficult and arduous approach to expression. He takes pleasure in working backward or in opposites: The gesture that produces a line of force moving to the right prints to the left and vice versa; a deeply engraved trench in a copper plate prints on paper as a raised line, while a raised line on a plate prints as a depression in the paper. Left is right. Right is left. Backward is forward. The printmaker, peculiar as he is, must see at least two sides to every question.

The Artist as Printer. It is often assumed that an artist will make the drawing or *image* for a print and that a professional printer will *pull* or print the edition. Experts may claim that it takes many years of painstaking apprenticeship, much trial and error, and an enormous output of labor before one can successfully pull a fine edition. Artists may think that the pursuit of fine printing is too strenuous and too complex a procedure for them to learn, or that it requires too great an expenditure of their time.

It is not to be expected that an artist with little experience can equal the professional printer in the techniques of printing. It is possible, however, for an intelligent person in the arts to become aware of the problems involved in printing and to solve these problems in a comparatively short time. The artist needs to know how much can be accomplished during the printing process to alter and develop the original drawing, and he should not be willing to give up to the professional printer the actual pulling of *all* his prints. It is categoric, for example, that the artist who does not print his own lithographs from the stone does not begin to know lithography. A print pulled by the artist who conceived it can be more than a drawing that was made on stone and then transferred to paper. In the very act of printing it is possible, and many times desirable, to alter, change, improve, or strengthen the initial visual statement. Only when the artist has explored the printing process on his own can he completely understand printmaking.

The Original Print

An *original print* includes each successive impression created through contact with an inked or uninked stone, block, plate, or screen that was worked upon by the artist alone or with others; it may be directly controlled or supervised by the artist and it must meet his criteria for excellence. Printed reproductions of art works in other media—gouache, watercolor, oil, and so on—no matter how aesthetically pleasing, are *not* to be considered original prints.

Original print is not a new term. In fact it is old enough to have undergone some changes of meaning as well as considerable argument. The *older* and more orthodox uses of the term have never been better explained than they were by the print scholar Carl Zigrosser; in his introduction to *The Book of Fine Prints* (rev. ed., 1956), Zigrosser makes the following distinction:

> One final word on the use of the word, "original." Since it is used in two different senses, confusion sometimes ensues. It is used as an adjective in contradiction to "reproductive." An original etching is one which the artist has conceived and executed himself. A reproductive etching is one in which the etcher has copied another artist's design or painting. This distinction has lost much of its force in the last fifty years since photography has taken over the reproductive function of prints. In any case the distinction is invidious because some so-called reproductive engravings, by Raimondi after Raphael for example, are infinitely superior to a multitude of original etchings by mediocre artists. When used as a noun, original refers specifically to a print. Some people have the mistaken notion that all prints are copies of some hidden and mysterious original. Every single impression of a woodcut, etching, or lithograph is an "original," the final and complete embodiment of the artist's intention, of which the plate, the paper, and the ink are the preliminary steps. The miracle of the process is that there are not one but many originals—the incarnation of the democratic ideal.

At the other end of the spectrum, we encounter Pat Gilmour who states her position eloquently in *Modern Prints* (1970):

> Several committees between 1960 and 1965 tried variously to define, protect, and elevate the "original" print, always equating it with artist handwork. But as the 1960's progressed, it became apparent that artists were eroding boundaries not only between traditional artforms, colouring sculptures and building paintings out into three dimensions, but also between all mark-making conventions, and while the technically "original" print could be little more than an artist's transposed drawing, or simulated painting, the photomechanical or commercial devices, outlawed by the committees, had great creative potential not exclusively depending on the artist grappling with all his material himself.

If the artist *alone* had to create the master image from which an original print would emerge (as was recommended in the 1960s by the Print Council of America and the Vienna Congress of Plastic Arts), if the artist was forbidden to employ the new technologies or the old mechanical or photomechanical means (decreed by the French National Committee on Engraving), then many of the contemporary works illustrated in this book would not qualify as *original* prints, nor would they be allowed entry into competitions and exhibitions throughout the world. Happily, artists are free agents and very much do their own thing.

The pointed visual comment by Kitaj (Fig. 325) on the confusion and contradiction found in the term *original* print is further intensified by a list of some of the *collage* elements that comprise the work: a *printed* nineteenth-century registration ticket for common prostitutes on which

is *printed* "Exciting Wives," the Print Council of America's *printed* circular entitled *What Is an Original Print?*, a carefully torn *printed* magazine photograph of Picasso, a column of print about Braque's innovations, a *printed* signature of a signature lettered by Braque, *printed* wrapping paper, and finally a *printed* title, *The Defects of Its Qualities.*

The Multiple

A print then is in no sense a copy or a reproduction. It is a *multiple,* that is, an original work that exists (or can exist) in duplicated examples. *Multiple* is a currently popular term that is by no means limited to the print field. Sculpture, for example, also has its multiples, and in fact it has had them since very early times; in antiquity, duplicate works could be created from a mold that was cast or stamped many times. However, the print is, by nature and history, a classic example of the multiple.

This does not mean that there *must* be many examples. An artist may even pull only one print with which he is dissatisfied and consign it to oblivion until, perhaps, it turns up in a collection; it is still a print because it was made by a printing process. There is one art form usually included in the print category, in which only one example *can* be made. That is the *monotype,* which is made by painting on a rigid surface, placing a sheet of paper over the wet paint, and rubbing on the back of the paper until the image prints. Except for this self-explanatory definition, the monotype will not be taken up, since the printmaker is primarily interested in making multiples.

The traditional rationale for the existence of the print lies in this possibility of multiplying original works of art, whether the artist arbitrarily limits himself to a small edition or aims at reaching a potentially wide audience. Many families can live with the same (or virtually the same) original from the hand of the artist—for quite dissimilar reasons and with the varying subjective, personal reactions possible from a fine print. Although the original print does not qualify as a mass medium of communication, the audience of the printmaker increases day by day. The feudal-like patronage of the great print collector of the past is giving way to the "democratic" patronage of the many small print collectors of the present. As compared with other works of art that are purchased by few for many dollars, prints are purchased by many for very much less.

Proofs

Some information about the various kinds of proofs involved in the making of a print will be of use not only to the printmaker, but to amateur collectors and student historians in the field as well. Proofs are never included in the numbered *edition* of a run of prints; they

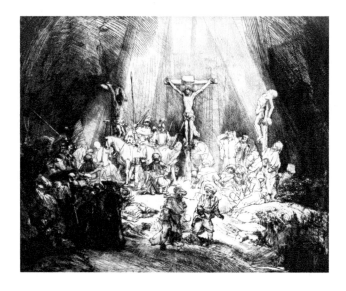

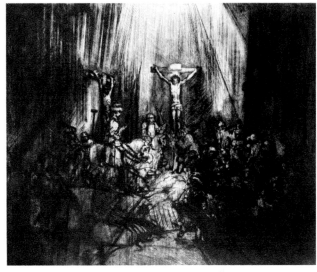

above: 2. REMBRANDT. *The Three Crosses.* 1653. Etching, third state; $15\frac{1}{4} \times 17\frac{3}{4}$". British Museum, London.

right: 3. REMBRANDT. *The Three Crosses.* 1653. Etching, fourth state; $15\frac{1}{4} \times 17\frac{3}{4}$". British Museum, London.

are, however, often sought by collectors, and they may be of great interest, and of quite considerable value, in analyzing an artist's method of working.

Trial Proofs. A *trial proof* is a stabilized impression, either on common newsprint or on fine printing paper, pulled *prior to* the running of an edition. Various trial proofs may be taken while the work is in progress, and thus they often show the artist's successive revisions in drawing or in choice of color for the printing ink. They sometimes have enlightening marginal notes written in the artist's hand. To the printmaker himself they are an invaluable record of how his various experiments with methods and materials worked out, and the serious student will keep an annotated file. Proofs showing successive stages of revision should be labeled *first state, second state,* and so on, so that they cannot become confused with prints of the regular edition showing the final state. (See Figs. 2, 3.)

The Bon à Tirer *or Printer's Proof.* The traditional French term *bon à tirer* means literally "good to pull" (or to print). When the artist achieves a proof that meets his requirements, he labels it with this or an equivalent term and signs it. This proof then becomes the standard by which the quality of the edition is measured. During the run of the edition the artist and/or his printer (if he uses one) will constantly check the prints coming off the press against the *bon à tirer,* and those showing any variations in inking or other imperfections will be destroyed. Thus, the quality of the run is guaranteed. The *bon à tirer* may remain in the

hands of the printer, or may find its way into a collection. At least two of the reproductions in this book were made from the *bon à tirer*. Figure 79 is labeled "Good to pull 'B à T'", and Figure 108 includes the notation "Printer's Print."

Artist's Proof. A print labeled *artist's proof* is one that is *not* a part of an edition but is retained by the artist himself, often for his own record, and sometimes for other purposes as well.

Cancellation Proof. Usually, after completing an edition of prints, the artist deliberately defaces the stone, block, plate, or screen and pulls an impression from the marred material. This disfigured impression, proof that the edition is limited, is called a *cancellation proof.* (See Fig. 4.)

The Edition

In a very special sense, pulling a cancellation proof fulfills a contract between the artist and his collectors; it testifies, in visual language, that no additional prints can be pulled from the image made on the stone, block, plate, or screen. The collector's confidence is further bolstered by the current practice of signing each print and inscribing on it the number of the print and the size of the edition. The notation 11/50, for example, assures the collector that the edition consists of only fifty prints and that he owns number eleven of that edition.

Printmakers have always tended to identify their work as their own. There is probably no more familiar device in the whole print field than the monogram Albrecht Dürer always designed into his blocks and plates (Fig. 130). The names of both designer and engraver appear engraved at the bottom of innumerable intaglio plates. And the Japanese artist stamped his seal on the print (Fig. 136) generally at the end of an inscription with which it formed an integral and characteristic part

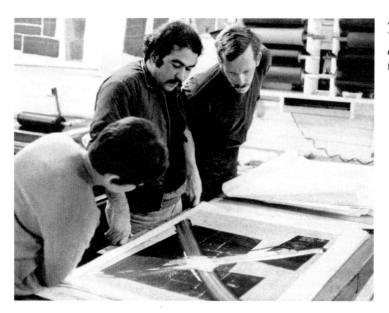

4. Curator and printers at Tamarind Lithography Workshop examining the cancellation proof from a Louise Nevelson stone.

of the design. The current method of signing prints with accompanying data is a recent innovation.

Most commonly, the artist records in pencil in the bottom margin of each print the title of the work, the number of the print and the size of the edition, his signature, and, if he wishes, the date. This documentation may become invisible when the print is photographed or reproduced, because it is often written lightly so as not to interfere with the impact of the work itself. It can be seen quite clearly in the untitled work shown in Figure 227, and it is also discernible in Plate 26 (p. 161), where the information was written in the normal way as follows: *Composition N-1957 2/25 Yunkers.*

There are naturally variations. In many prints—especially in *bleed prints,* where the image runs to the edges of the paper—the artist may sign and document his work on the back or within the picture area on the face of the print. He may enter information by hand or, as in the case of Gauguin's title in Figure 140, work it into the printed design.

Some prints also carry a *chop,* that is, an identifying mark or symbol impressed upon the paper. This is especially true of prints pulled for the artist by a master printer in a professional workshop, wherein two chops may appear on each print to reveal where and by whom it was printed. Some artists and some collectors also have their own chops.

THE FOUR BASIC PROCESSES

In the field of graphic arts the word *print* is used to encompass any one or all of the many media that may be employed by the printmaker. Yet, a brief examination of the illustrations in this volume reveals that each particular medium has a "look" all its own. How, then, can we differentiate between these several approaches to the fine print?

There are various ways of classifying prints, but the printmaker himself is most concerned with the classification based on the *method by which they are printed.* There are four separate methods of printmaking: (1) planographic, (2) relief, (3) intaglio, and (4) stencil. They are better known by some of their major forms: (1) lithography, (2) woodcut and wood engraving, (3) etching and engraving, and (4) serigraphy or screen printing. Let us examine each of these different processes briefly.

The Planographic Process—Lithography

A lithographic drawing is made with grease upon the surface of a block of limestone or a zinc, aluminum, or paper plate; there is no particular requirement about the drawing save that it leave a deposit of grease upon the surface of the material selected. After chemical treatment with gum arabic and nitric acid, an ink-charged roller is passed over the surface. Ink is accepted by the grease image and simultaneously repelled by the undrawn areas of the stone, which retain water. A print is obtained

by placing a sheet of paper upon the inked stone, which sits on the bed of a lithographic press, and then running the stone and the paper, with the necessary backing, under the scraping pressure of the press. Lithography is based upon the antipathy between grease and water; it is essentially chemical in nature. It may be considered a surface phenomenon, in that the image on the stone is neither above nor below but *on* the surface being printed.

The Relief Process—Woodcut

Woodcuts are made in a most direct fashion. Using a well-sharpened knife and a few gouges upon a plank of wood, the artist cuts away all those lines and areas not required in the finished print. What remains of the original wood surface, after the image is cut, is inked and printed onto paper. If you examine a rubber stamp or the type on the typewheel of an IBM Selectric, the principle of relief printing should be readily apparent. The woodcut is made with a knife on a piece of plank-grained wood; the image to be printed stands in relief on the block. Wood engravings are printed in the same manner as the woodcut. However, they are made on specially prepared end-grain blocks of hard wood, are cut with burins and other gravers, and demand greater printing pressure.

The Intaglio Process—Etching

In intaglio printing the image or design is engraved or etched so that it exists below the surface of a metal plate. Ink is forced into the grooves or channels, and the surface of the plate is wiped clean. A print is obtained when the plate and a sheet of damped paper are run through a press of the clothes-wringer type under great pressure. The pressure forces the damped paper down into the lines to pick up the ink confined in the grooves. The resultant print is actually a paper mold of the plate, and the lines stand in bold relief above the surface of the paper, as does ink on an engraved calling card. Engraving, aquatint, mezzotint, soft ground, drypoint, lift ground, and other processes employed in intaglio work are all printed in exactly the same manner. Each of these approaches, however, offers a unique look to the final print.

The Stencil Process—Screen Printing or Serigraphy

Serigraphy is the youngest medium of the group. Various stencils, which when printed one over the other will make a completed print, are fixed upon separate screens of silk stretched tautly over wooden frames. Each separate frame is an individual printing unit. Ink is introduced at one end of the frame and squeegeed across to the opposite end, forcing the pigment through the "open" silk areas onto a sheet of paper placed

A Comparison of Some Traditional Graphic Arts Media

	Planographic	Relief	Intaglio	Stencil
Common Name	Lithography	(a) Woodcut (b) Wood Engraving (c) Relief etching (d) Linoleum cut	Etching Engraving Aquatint Drypoint, etc.	Serigraphy or Screen Print
Materials	Limestone Zinc Aluminum Plates, etc.	(a) Plank-grain Wood (b) End-grain Wood, Linoleum, etc.	Copper Zinc Plastics, etc.	Silk Organdie Nylon, etc.
Basic Tools	Litho Crayon Tusche Litho Rubbing Ink, etc.	Knife Gouge Burin, etc.	Etching Needles Burins Acids Grounds, etc.	Squeegee Screen Nufilm Glue Tusche, etc.
Type of Press	Litho Press (Sliding, scraping pressure)	(a) Household Table- spoon, Baren (b) Washington Press or Letter Press	Etching Press (Clothes-wringer type)	None
What Prints?	Prints what is drawn *on* the surface	Prints what is left of the original surface	Prints what is *below* the surface of the plate	Prints open areas of the stencil
Line	Crayonlike (granular) As with a pen As with a brush	(a) Black line on white ground (b) White line on black ground	Etching—ends squared Engraving—swelling Drypoint—soft, fuzzy	Brushlike Pen Crayon
Value	Wide range of possibilities from delicate grey to rich black	Black or white	Grays obtainable through linear treatment or through aquatint, mezzo, etc. Wide range possible.	Color—unlimited
Texture	Stone given a grain by lithographer prior to drawing. Unlimited variations in texture possible.	(a) Grain of the wood block (e.g. pine could be utilized in the print). (b) None	Textures are man-made or man-controlled.	Silk leaves its texture on the print.

directly under the screen. Those areas of the stencil left "open" are the areas to be printed (the image); those stopped out by the stencil are the negative or nonprinting areas.

The chart above gives an overall view of some of the similarities and differences to be observed among the various print media.

5. Surface detail of a lithograph. (See Fig. 51.)

6. Surface detail of a woodcut. (See Fig. 140.)

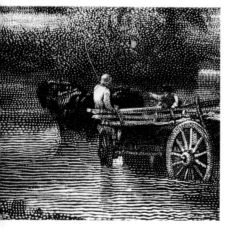

7. Surface detail of a wood engraving. (See Fig. 146.)

Some Qualities of Prints

If we set aside, for the moment, the personal reasons, desires, or drives that lead individuals to make prints in one medium and not another, we may ask, "What specific qualities are inherent in each method of printmaking?" And, "What are the advantages and disadvantages of each?" The details shown in Figures 5 through 15 give only a partial indication of the possibilities available.

Lithography. The stroke of a lithographic crayon on a prepared stone surface presents a line or tone that is grainy, dark, or light—dependent upon the pressure employed when drawing it. The line may be fine or coarse, subtle or powerful, wiry or heavy. Forms may be modulated from light to dark and dark to light with ease. The stone surface responds to every touch of the crayon. Drawing on stone seems to resemble drawing on paper except that it "feels" different. It appears, at times, that one works on a sort of permanent, 4-inch-thick piece of paper. (See Fig. 5.)

The "look" of the lithograph, therefore, may be dry, crayonlike, crisp, coarse, grainy, or seemingly luscious. It can be "wet" as water-color painting, scratchy as a white-line drawing on a black ground, or mottled and corroded as an old stone wall.

For those who feel most at home with crayons, brushes, pens, and the materials and tools employed in drawing and painting, or who seek a medium that possesses the property of multiplying images exactly as they are drawn and reworked, lithography provides an admirable vehicle for expression.

Woodcuts and Wood Engraving. Bold contrasts of black against white, powerful, vigorous lines and forms, stark simplicity and startling complexity are the hallmarks of the woodcut. If drawing a knife along a block of wood attracts you, if directness of expression and ease of printing are a consideration, if you feel no need for grays or softly modulated forms in your work, then the medium of woodcut will amply satisfy your needs. (See Fig. 6.)

A wood engraving, on the other hand, may offer the eye a rich network of white lines on a black ground; this variant of the relief method of printing can be mathematically precise, picturesque and romantic, vibrant and energy-laden, simple or complex. It requires patience and strength of will, but offers a unique manner of expression. (See Fig. 7.)

Etching and Engraving. The various intaglio processes offer astonishing variety—delicate linear effects similar to pen-drawn lines posed against powerful strokes, dynamic black areas, or wispy gray tones. Having learned to work on copper or zinc plates with acids, needles, and burins,

8. Surface detail of an etching.
(See Fig. 206.)

9. Surface detail of an engraving.
(See Fig. 196.)

10. Surface detail of a soft ground.
(See Fig. 263.)

11. Surface detail of a drypoint.
(See Fig. 213.)

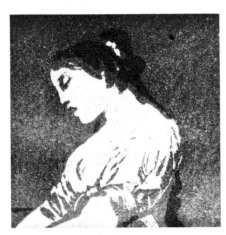

12. Surface detail of an aquatint.
(See Fig. 255.)

13. Surface detail of a mezzotint.
(See Fig. 275.)

you may choose at will the crisp line of engraving, the textural effects possible with soft ground, the velvety quality of the drypoint, the tonal potentialities of aquatint, mezzotint, or lift ground. If you relish the work and play involved in mixing chemicals and wiping and printing plates on a hand-powered etching press, then there is no doubt that you will enjoy making intaglio prints. (See Figs. 8–14.)

Screen Printing. Screened images are as varied as the personalities of the artists who make them. Screen printmaking provides a simple vehicle through which you express color in precise forms and knifelike edges, or in freely brushed images and "painterly" suggestions. Color may be applied flat or mottled, transparent or opaque, heavily textured or thin, either with a minimum number of screens or the employment of a great many. Truly large editions may be printed with relative ease. If the actual "stuff" of color is a requirement in your work, if you need

14. Surface detail of a lift ground.
(See Fig. 266.)

the look and feel of real paint, or if space and economic considerations are limiting factors, this color medium may well suit your mode of expression. (See Fig. 15.)

A print may be produced lovingly and patiently, or violently and impetuously, according to the nature of the printmaker. It can be adapted to any style. However, from the first fleeting idea wrested from the human experience, worked through the whole printing process to the final image on paper, the print should be thought of as a medium *in its own right*. Each process should be utilized by the artist for what it alone can accomplish in serving his needs.

15. Surface detail of a serigraph. (See Pl. 43, p. 278.)

The Planographic Process

LITHOGRAPHY
PHOTOLITHOGRAPHY
MULTIMETAL LITHOGRAPHY
COLOR LITHOGRAPHY

*I desire that soon it [lithography] shall be spread
over the whole world, bringing much good to humanity
through many excellent productions,
and that it may work towards man's greater culture.*

*Nobody has made a noteworthy improvement
in the branches of lithography without having received it
primarily or indirectly through me.*

Alois Senefelder, 1817

Lithography: Development of an Art Form

It is generally agreed that Alois Senefelder (1771–1834) of Bavaria—actor, author, lithographer, and printer—invented lithography in 1798. The discovery was not accidental, as is commonly supposed, for Senefelder was one of several men in Europe who were trying to perfect and control a process for chemical printing from stone. The invention was a major one, not only as a new medium for the fine arts, but also as a step in the evolution of commercial printing. Senefelder recounted the printing of his first lithograph as follows:

> I had just ground a stone plate smooth in order to treat it with etching fluid and to pursue on it my practice in reverse writing, when my mother asked me to write a laundry list for her. The laundress was waiting, but we could find no paper. My own supply had been used up by pulling proofs. Even the writing-ink was dried up. Without bothering to look for writing materials, I wrote the list hastily on the clean stone, with my prepared stone ink of wax soap, and lampblack, intending to copy it as soon as paper was supplied.
>
> As I was preparing afterward to wash the writing from the stone, I became curious to see what would happen with writing made thus on prepared ink, if the stone were now etched with aqua fortis. I thought that possibly the letters would be left in relief and admit of being inked and printed like book-types or wood-cuts. My experience in etching, which had showed me that the fluid acted in all directions, did not encourage me to hope that the writing would be left in much relief. But the work was coarse, and therefore not so likely to be under-cut

as ordinary work, so I made the trial. I poured a mixture of one part aqua fortis and ten parts of water over the plate and let it stand two inches deep for about five minutes. Then I examined the result and found the writing about one tenth of a line or the thickness of a playing card in relief.

In this passage from Senefelder's *The Invention of Lithography* his concern for effecting a relief image shows that his mind was still engaged upon earlier printing methods, dependent on a difference in levels on the printing surface. He had yet to grasp the chemical principle by which lithography came to be printed from a *flat* surface. Yet from this homely incident, after much trial and error, he perfected the process. His published research and patents reveal a masterful knowledge of the chemistry of lithography, the manufacture of appropriate inks, presses, transfer papers, methods of drawing and printing on stones, zinc plates, and other surfaces, and much pertinent technical information that is still valid today.

At first the most immediate and practical use for lithography was thought to be the reproduction of musical scores and dramas at prices that undercut the older printing systems. Senefelder himself, as an author and actor, was motivated toward this commercial advantage and quickly made connections with the André family, music publishers and printers in Germany and England. During 1800–1801 he visited London where he assisted Philipp André in setting up a lithographic press and advised artists on the process. From this press the earliest lithographs in England were issued. Later the process was also used for reproducing art works executed in other media.

Thus it was primarily in England that the early exploitation of lithography as an art medium developed. In 1803 a portfolio of a dozen impressions by English-based artists was published by Philipp André under the title *Specimens of Polyautography*. All were in pen and *tusche* (lithographic ink), though crayon lithographs were also being executed by that time. The word *polyautography,* of course, means the making of multiple copies from a handwritten or drawn original.

The artists represented were of little fame, except for the American-born Benjamin West (1738–1820), who had a highly successful career as a portraitist and painter of historical and mythological subjects, and the Swiss Henry Fuseli (1741–1825), an eccentric painter of Romantic literary visions and fantasies. Both mature artists attempted the new technique in terms of their earlier experience; West's *He Is Not Here: For He Is Risen* (Fig. 16) was drawn in 1801, Fuseli's *A Woman Sitting by the Window* (Fig. 17), in 1802.

William Blake (1757–1827), the great English mystic poet and painter, who earned his living as an engraver, probably prepared his first and only lithograph for a later edition of the same portfolio, though the print was not published there. Generally called *Job in Prosperity*, this Biblical subject (Fig. 18) is thought by some scholars to represent Enoch,

below: 16. BENJAMIN WEST.
He Is Not Here: For He Is Risen. 1801.
Pen-and-tusche lithograph, $12\frac{7}{8} \times 8\frac{7}{8}''$.
National Gallery of Art, Washington, D.C.
(Rosewald Collection).

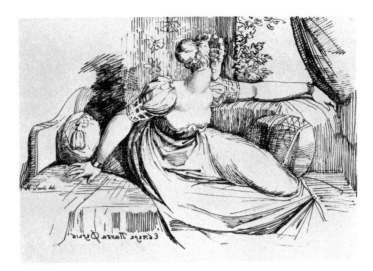

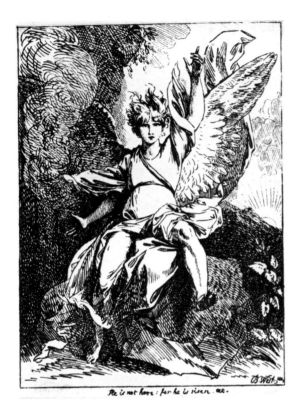

rather than Job. In any case, its style of execution reveals Blake's training as an engraver. Linear patterns in pen and tusche fill in the background, and there is almost no use of graduated shading. A certain awkwardness of forms possibly betrays the uncertainty of an artist who came late to the medium, in contrast to Blake's proficiency in engraving (Fig. 210). Many of the Classical Greek features so admired by the Age of Reason then prevailing are to be seen here—among them the symmetrical pedestal composition; the border of vine leaves, tendrils, and grapes; and the personifications of music in the lyre player, literature in the scribe, and art in the figure with a palette. At the same time, something in the emotional tone bespeaks Blake's own religious mysticism and the coming swing to Romanticism.

In Germany, during this early stage of lithography, artists turned out rather weak and pale impressions which did not foretell the richness

top right: 17. HENRY FUSELI.
A Woman Sitting by the Window. 1802.
Pen-and-tusche lithograph, $9\frac{1}{8} \times 12\frac{1}{4}''$.
National Gallery of Art,
Washington, D.C.
(Rosenwald Collection).

above right: 18. WILLIAM BLAKE.
Job in Prosperity. c. 1806.
Pen-and-tusche lithograph, $8\frac{1}{2} \times 12\frac{1}{8}''$.
British Museum.

and flexibility of the medium as it was to develop. However, in 1804, probably inspired by Philipp André's *Specimens*, the Berlin artist Wilhelm Reuter (1768–1834) published a large group of his lithographs and the work of others in *Polyautographic Drawings by Outstanding Berlin Artists.*

By chance, the lithographic process came into being almost simultaneously with the rise of Romanticism, and it offered to the artists of the movement an expressive means freer than woodcut or engraving and presenting far less resistance to the spontaneous action of the draftsman's hand. Experimentation with the medium revealed endless possibilities for dramatic tonal contrasts, fine-grained shading, and luscious blacks cut by fine white lines scratched into the stone. For the emotive drive, the human sensibilities, the worship of nature, and the awakening social conscience of the times, lithography was well suited. Its practicality for widespread publication brought about a spate of graphic output, both from defenders of the waning Neoclassical taste and advocates of the new movement. In its liberating force, the development of the new medium might be compared to the change from tempera to oil painting on canvas, an innovation that strongly affected European art from the fifteenth century onward. In particular, lithography proved itself sympathetic to the manual skills of artists familiar with paint, pencil, pastel, or crayon, whereas woodcut and engraving had generally been more accessible to jewelers, metalworkers, and sculptors, trained in the use of cutting tools on recalcitrant materials.

In France, under Napoleonic sanction and patronage, the art of lithography moved slowly toward a golden age. By 1816 numbers of presses were established in Paris to meet the demand for lithographs, and the quality of the impressions pulled attracted to that city many artists of importance. Jean-Auguste-Dominique Ingres (1780–1867), for example, gave lithographic expression to his familiar, haughty odalisque figures (Fig. 19). The cool, delicate lines merge imperceptibly into the

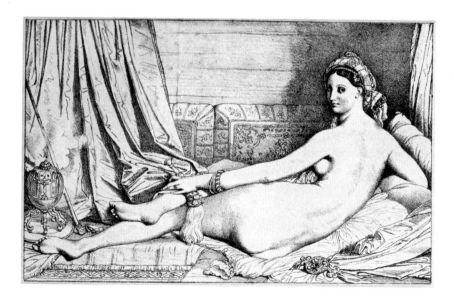

19. Jean-Auguste-Dominique Ingres. *Odalisque.* c. 1825. Lithograph, $4\frac{1}{8} \times 8\frac{1}{8}''$. Prints Division, New York Public Library (Astor, Lenox and Tilden Foundations).

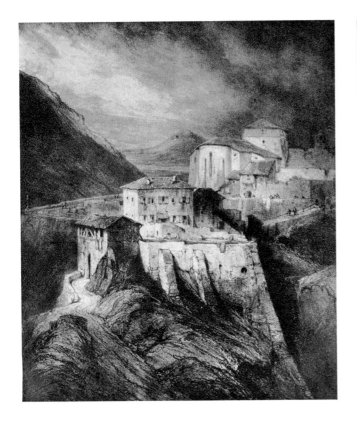

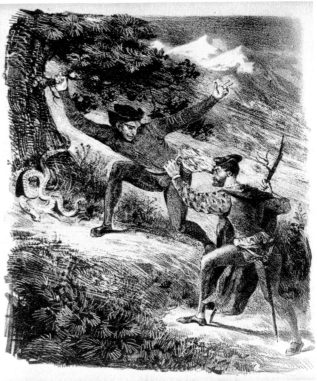

left: 20. Eugène Isabey.
L'Eglise St-Jean, Thiers, Auvergne.
1831. Lithograph, 22 × 16".
Metropolitan Museum of Art,
New York (gift of
William M. Ivins, Jr., 1922).

right: 21. Eugène Delacroix.
Faust and Mephistopheles
in the Harz Mountains. 1828.
Lithograph, $9\frac{3}{4}$ × 8".
Philadelphia Museum of Art
(purchase, McIlhenny Fund).

soft tones of modeled form, with much the same quality of linear refinement seen in his pencil drawings and portraits. His Neoclassical orientation is evident, as well as his predilection for exotic pattern and detail.

Eugène Isabey (1804–86), son of a prominent miniaturist, was among the many French artists attracted by the fluent line and varied tonalities obtainable in the new medium. Isabey turned these qualities to effect in picturesque landscapes (Fig. 20), seascapes, beach scenes, and representations of fishing boats.

In sharp contrast to the style and subject matter of Ingres, Eugène Delacroix (1798–1863) executed a series of lithographs on Goethe's *Faust*, one of which is reproduced here (Fig. 21). A preeminent exponent of French Romanticism, Delacroix publicly belittled not only Ingres' work, for what he considered its sterile academicism, but also his intelligence. Delacroix's masterly illustrations for *Faust* display the theatrical narrative character, vigorous action, and even a hint of the strong color sense that he brought to his canvases on historical and allegorical subjects, on Islamic and Jewish daily life, and on battles and hunting scenes.

A close friend and fellow student of Delacroix, as well as a strong influence on him, was J. L. A. Théodore Géricault (1791–1824), whose brief span of work carried surprising weight with his contemporaries

Lithography: Development of an Art Form 21

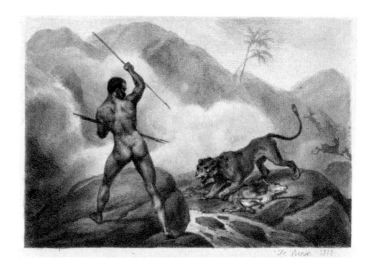

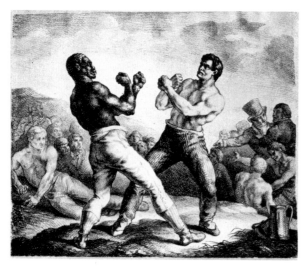

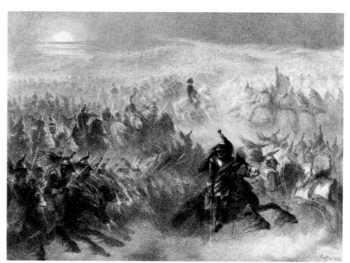

and successors. *The Boxers* (Fig. 22) is a dynamic example of his drafts-manship. Both in lithographic technique and in the careful distinction of racial types of the protagonists, this provides an interesting comparison with the crashing movement and the more abstracted, less personalized pugilists of George Bellows (Fig. 45) a century later.

Emile-Jean-Horace Vernet (1789–1863) was a member of a family of French artists who enjoyed the patronage of Napoleon and devoted themselves to scenes of battles, horse racing, and wild animals—a taste shared with Géricault and Delacroix. His *African Hunter* (Fig. 23) is thoroughly in keeping with the Romantic dreams of the "noble savage," of exotic landscapes in faraway places, and of the glorification of man and beast in a primitive state of nature.

Even war was idealized in the thought of the Romantic period, as may be seen in *The Nocturnal Review* (Fig. 24) by Auguste Raffet

(1804–60). A popular artist of the Napoleonic campaigns, he managed to invest his military scenes with an atmosphere of legendary unreality, mistily imagined under the diffused light of a clouded moon.

Along with these artists, many lesser-known painters and lithographers provided rich fare for the print connoisseur. Profusely illustrated folio volumes of lithographed, picturesque views to delight the traveler rolled off the presses in many countries. Books were compiled to depict walking tours through the south of France and parts of northern Italy, journeys along the Danube, and intimate corners of old and new Lyons, to name but a few. Of these, the monumental landmark in French lithography was produced through the efforts of Baron Taylor, who sought and found artists to make lithographs for his magnum opus—the truly remarkable *Les Voyages pittoresques et romantiques dans l'ancienne France.* The text for this almost lifetime project (1820–78) was written by Alphonse de Guilleux, J. Taylor, and Charles Nodier; it resulted in a series, initially, of 24 volumes containing more than 2,700 lithographs. The roster of artists who collaborated is varied and distinguished for craftsmanship, if not always world-famous. One of these was the Englishman Thomas Shotter Boys (1803–74), of whose life little is known except that he was an accomplished watercolorist, that he traveled widely in Europe, producing etchings and lithographs of typical views for travel books, and that he was among the first to use color effectively in lithographic prints. His scenes of city streets combine the meticulous clarity of architectural rendering with the elegance of high life and the folk jumble of vendors, tradesmen, and other ordinary citizens pursuing their business. The *Rue de la Grosse Horloge, Rouen* (Pl. 1, p. 25) was prepared for a volume of Boys' own work, *Picturesque Architecture in Paris, Ghent, Antwerp, Rouen, Etc.* (1839), which he described as "drawn from nature and on stone." All were color lithographs designed to convey the effect of his own watercolors.

Among other contributors to Baron Taylor's compendium, James Duffield Harding (1798–1863), another Englishman, produced crisp impressions of towering Gothic landscapes (Fig. 25); and his compatriot

25. James Duffield Harding.
Franche Comté: Abbaye de Baume, Baume-les-Messieurs.
1825. Lithograph, $6\frac{1}{8} \times 7\frac{11}{16}$".
Cleveland Museum of Art (a 25th-anniversary gift, Mr. and Mrs. Lewis B. Williams Collection).

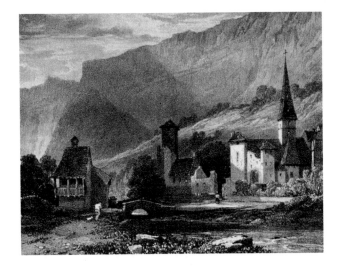

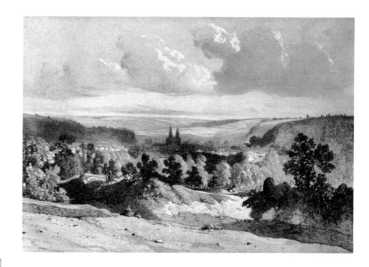

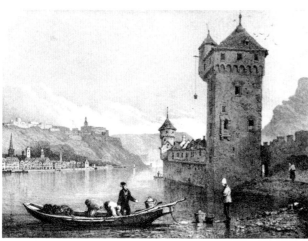

left: 26. SAMUEL PROUT. *St. Goar and Rheinfels.* 1824. Lithograph, $7\frac{11}{16} \times 10\frac{11}{16}''$. Cleveland Museum of Art (Mr. and Mrs. Lewis B. Williams Collection).

above: 27. EUGÈNE CICÉRI. *Bretagne: View of Quimper.* Lithograph, $10\frac{5}{16} \times 14\frac{13}{16}''$. Cleveland Museum of Art (a 25th-anniversary gift, Mr. and Mrs. Lewis B. Williams Collection).

Samuel Prout (1783–1852) left a similar graphic heritage (Fig. 26). In the same collection a sampling of the landscape of Brittany, as transmuted by Eugène Cicéri (1813–90), may be seen in his overall view of Quimper (Fig. 27).

In Spain at this time, the venerable master Francisco Goya (1746–1828) was already a virtuoso of the copper plate in such etchings as his *Caprichos* series, a savage, satirical comment on manners and customs, and his *Disasters of War* (Fig. 209), a condemnation of war crimes. A veteran of many royal commissions for portraits and frescoes, Goya tried his hand at the still-new process of lithography, at the age of seventy-nine, in an impressive suite of four prints on bullfighting (Fig. 28). Almost deaf, embittered, and the victim of many political vicissitudes, the old artist seems to have relived on stone his boyhood experiences with a traveling troupe of *toreros,* when he executed this powerful, original set of black-and-white lithographs.

The compassion for human suffering and the biting attack on oppressors that mark so much of Goya's graphic work are also the hallmarks of Honoré Daumier (1808–97). To the crayon, needle, and stone, Daumier brought a fiery imagination and a human sympathy rooted in love. The essence of this personality is visible in his more

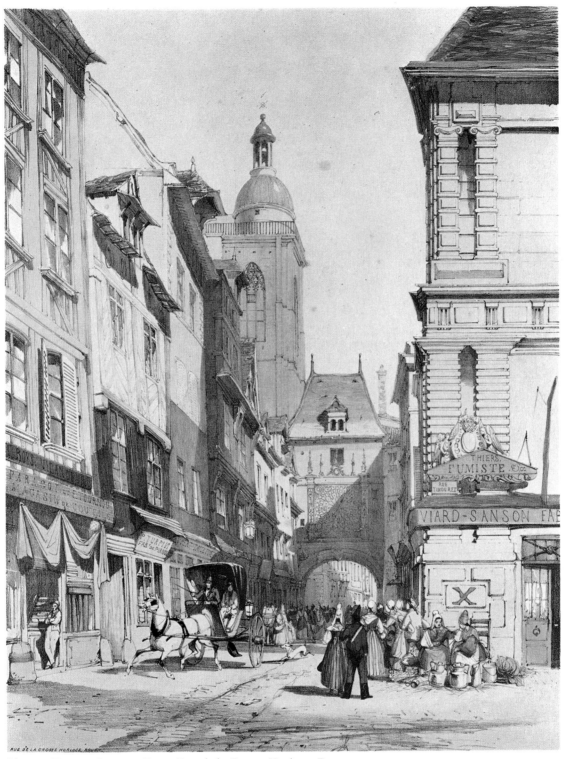

Plate 1. THOMAS SHOTTER BOYS. *Rue de la Grosse Horloge, Rouen*,
from *Picturesque Architecture in Paris, Ghent, Antwerp, Rouen, Etc.* 1839.
Color lithograph, 14½ x 10¾". Philadelphia Museum of Art (given by Staunton B. Peck).

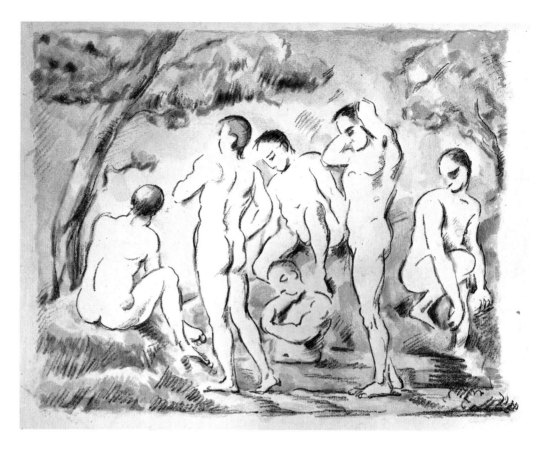

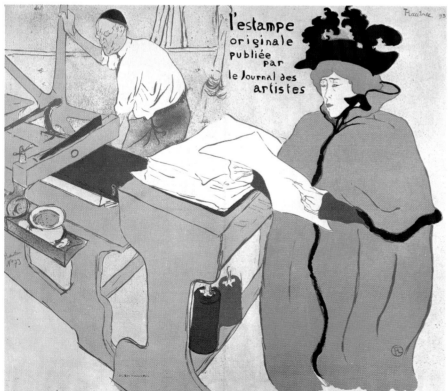

above: Plate 2. Paul Cézanne.
The Bathers. 1897.
Color lithograph, 9⅛ x 11¼".
Philadelphia Museum of Art
(bequest of Fiske and Marie Kimball).

left: Plate 3. Henri de
Toulouse-Lautrec. Cover no. 1
of *L'Estampe originale.* 1893.
Color lithograph, 17¾ x 23¾".
Metropolitan Museum of Art,
New York (Rogers Fund, 1922).

than 4,000 lithographs and 2,000 woodcuts, as well as in paintings, drawings, and sculpture. A swift worker, an incisive satirist, Daumier added another dimension to the art of lithography with his contributions to the weekly *La Caricature* and to the daily newspaper *Le Charivari*. For forty years he rocked the complacency of French society, skewering hypocrisy on the point of his crayon (Figs. 29, 30). His lithographic comments on the human comedy laid bare the truth as he saw it, and he spent six months in prison for daring to portray King Louis-Philippe as a Gargantua who gorged on the people's money in swinish gluttony. His influence on muckraking journalistic cartoonists has carried through even to the present.

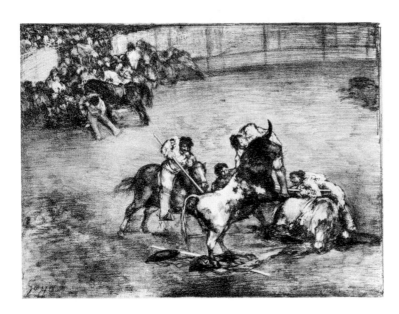

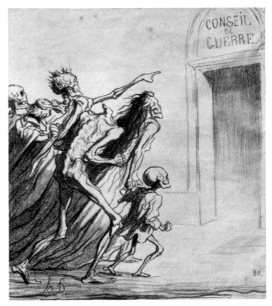

left: 28. Francisco Goya. *Bravo Toro.* 1825. Lithograph, $12\frac{1}{4} \times 16''$. Metropolitan Museum of Art, New York (Rogers Fund, 1920).

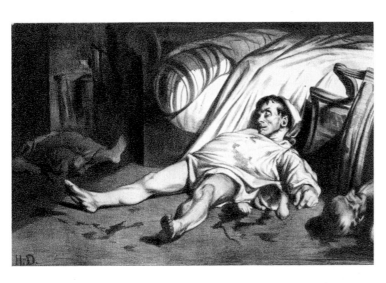

left: 29. Honoré Daumier. *Rue Transnonain, April 15, 1834,* from *L'Association Mensuelle.* 1834 Lithograph, $11\frac{1}{4} \times 17\frac{3}{8}''$. Metropolitan Museum of Art, New York (Rogers Fund, 1920).

above: 30. Honoré Daumier. *Council of War.* 1872. Lithograph, $10 \times 8\frac{3}{4}''$. Metropolitan Museum of Art, New York (Shiff Fund, 1922).

Lithography: Development of an Art Form 27

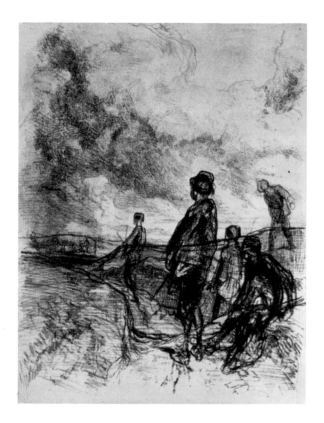

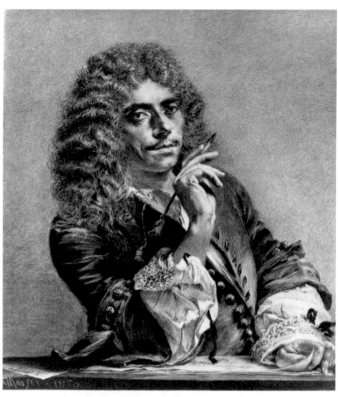

Friend and colleague of Daumier, the caricaturist Paul Gavarni (pseudonym of Sulpice Guillaume Chevalier, 1804–66) also contributed to *La Caricature* and *Le Charivari*, poking fun at bourgeois pretensions and feminine foibles. Many of his cartoons are lighthearted and comic, but the harsh reality of his *Embuscade* ("Ambush") reveals a serious concern for the human condition (Fig. 31). Like Daumier, Gavarni handled the medium freely, with rapid, decisive strokes of the crayon rather than detail of workmanship, and aimed for an immediate impact.

Perhaps to be regarded as Germany's recompense for the mediocre lithographs that prevailed there in the early period is the work of Adolf von Menzel (1815–1905), the son of a lithographer. There is little doubt that he was the most proficient of German printmakers in his time. His *Experiments on Stone with Brush and Scraper*, published in 1851, reveals his technical virtuosity and wide-ranging mind in a brilliant suite of prints. The portrait of Molière (Fig. 32) is impeccable in execution, combining minute details of texture with apt characterization of the sitter and more casually treated minutiae at neck, cuffs, and left hand. Menzel's versatility with the medium is evident, but at the same time recalls the sharp, hard detailing of sixteenth-century German wood sculpture and German woodcuts and engravings (Figs. 130, 203). To achieve some of his effects Menzel used turpentine tusche.

Although the technical means for producing color lithography were known and demonstrated by Senefelder, his experiments in this direction were not fruitful. It remained for others to perfect the evanescent variables that led most practitioners astray.

As with all the graphic arts in history, there appear to be bursts of feverish activity on the stone, plate, block, or screen followed by returns to unexciting normality or mediocrity. The rise of photography, the insatiable demands of industrial societies, and the need for an artist to satisfy his own curiosity explain, in part, the forces and counterforces responsible for a "renaissance" or a decline and fall. In addition, exciting new theories regarding the world of perception or the artist's role in communicating his view of that world may elicit a vast new production of art works.

In general the last quarter of the nineteenth century introduced a number of new philosophical-artistic ideas, even while it continued the concerns that had preoccupied artists in times past. During that period many of the seminal notions of modern art were promulgated, and from then on groups of artists, banded together to promote some particular aspect of art, began to proliferate. The names of some of these groups were chosen by the participants themselves; others were applied with opprobrium by baffled journalistic reviewers and after-the-fact historians.

The first concerted movement of modern art was Impressionism, initially a derogatory description of the work of several artists who began to exhibit together in Paris in 1874, under the name of *Société anonyme des artistes peintres, sculpteurs, graveurs, etc.* However ill-digested, the theories linking them derived from the new science of optical perception, as it related to the prismatic separation of light into the pure colors of the spectrum and the mixture of these colors in the eye of the observer. In attempting to paint reality according to these principles, the artists avoided mixing colors on the palette and eschewed the use of black, striving instead to capture the fleeting effects of light and shadow in quickly brushed strokes of high color and minimizing outline drawing. They chose their subjects from the everyday, even humdrum, world of still-life objects, fruits, flowers, figures, and land-scape elements—all painted from direct observation of the object. Public outrage and lack of comprehension prompted the epithet "Impressionism," derived from the title *Impression—Sunrise* of a painting by Claude Monet (1840–1926); to the shocked viewers this canvas appeared nothing more than a formless smear and blob. Before long, however, the artists accepted the label and used it in subsequent exhibitions. As a coherent group the movement was short-lived, lasting not much more than a decade, and thereafter the individual members pursued their own metiers or regrouped into dissenting factions under other names. But the effect of the movement has lasted far beyond its demise and the disbanding of the succeeding associations.

The Impressionists mentioned here have been chosen for their contributions to the art of lithography. Some of the artists working and exhibiting with the Impressionist group espoused the medium with enthusiasm and inventive talent; some produced only a few prints; others, such as Claude Monet, never attempted to create multiples at all, insofar as we know.

Edouard Manet (1832–83) did not willingly identify himself with the Impressionists, though he had friends among them and was considered by some of the critics to be the group's "spiritual father." However, his subjective realism must be recognized in the origins of Impressionism, and late in his life he altered his palette toward Impressionist color. Manet's early training had been academic, and in his rebellion against it, he developed an original style and a virtuosity akin to Spanish painting, with strongly contrasted light and shadow, a bold use of black, and otherwise muted colors. His figures, painted directly from the model, project a sense of immediate presence. These qualities may be seen in his lithograph *The Execution of the Emperor Maximilian* (Fig. 33). Manet experimented intensively with the lithographic medium, trying out transfer paper, color, and various techniques of working on the stone.

A towering figure to emerge from the Impressionists was Paul Cézanne (1839–1906), who first produced works notable for their Delacroix manner, vigorous execution, and shock-value content before becoming absorbed with Impressionist ideas. However, his intense interest in color analysis as a means of defining form eventually led him to part from the movement; while the Impressionists were concerned with the swift and evanescent qualities to be caught in the surface play of light, Cézanne probed slowly and painstakingly into the basic modeling of figures, landscapes, and still lifes. Throughout his long life he returned time and again to the patient study of a very few subjects, refining his concept of underlying forms toward the fundamental geometric shapes. In this respect he forecast the principles of Cubism. One of his recurrent themes was a group of nude bathers in a landscape, which he rendered in his color lithograph of 1897 (Pl. 2, p. 26).

Cézanne's interest in painting as a career and in the Impressionist view was fostered by his friendship with Camille Pissarro (1830–1903), a gregarious and good-humored, though unlucky, man of mixed Creole-Portuguese-Jewish parentage who had fled commerce to become an artist. Though several years older than the Impressionists in general, Pissarro was in many ways one of the most typical, exhibiting his favorite subjects of landscape and peasant life in all eight of their shows. He was strongly attracted to printmaking and turned out an impressive body of work in various techniques, including lithography (Fig. 34).

Joining Pissarro as one of the primary organizers of the group exhibitions was Edgar Degas (1834–1917). An independently well-to-do

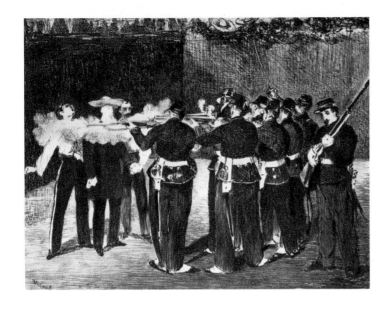

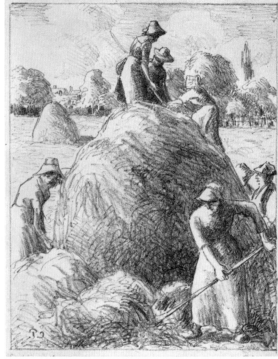

above: 33. EDOUARD MANET. *The Execution of the Emperor Maximilian.*
1867. Lithograph, $13\frac{1}{8} \times 17''$.
Cleveland Museum of Art (Dudley P. Allen Fund).

right: 34. CAMILLE PISSARRO. *Hay-Makers of Eragny, Eure, France.*
c. 1896. Lithograph, $8\frac{5}{8} \times 6\frac{5}{8}''$.
Cleveland Museum of Art
(Mr. and Mrs. Lewis B. Williams Collection).

Parisian with international family connections, Degas had begun his
studies under the influence of Ingres. Departing fairly early from the
academic and historical tradition, however, he turned toward the style
of Manet, the portrayal of contemporary life, and the theories of the
Impressionists. The mundane and lively scenes of the racetrack; the
sphere of the theater, ballet, and opera; people in cafés; musicians;
women going about their daily activities in shops and at home, bathing
and dressing—these engaged his eye and provided his subjects.
Whereas the outdoor nuances of light occupied his colleagues, Degas
seemed generally more at ease with interior lighting—lamps, candles,
chandeliers, rather than sunrise, sunset, mists, or clouds. Like Manet,
Degas was fascinated with investigating the techniques of lithography,
carrying his compositions through several stages, sometimes working
from a drawing on copper, transferring it to paper and then to stone,
and continuing to revise. Yet once the problem was solved, he cared
little about publishing his prints, leaving the bulk of his graphic work

to be issued posthumously. The illustration in Figure 35 shows one of his frequent themes, a woman after her bath.

Another colossal figure among the first generation of the Impressionists was Pierre-Auguste Renoir (1841–1919), whose admiration for Manet and close association with Monet, Cézanne, and others of the group led him to participate in the early exhibitions and to adopt their high-keyed palette and plein-air practices. Shimmering landscapes, softly sensuous nudes with pink and pearly flesh tones, and portraits of blooming, gossamer-haired children are unfailingly recognizable elements in his art. In time his intense study of the great painters represented in the museums—the Renaissance Italians and the French eighteenth century—caused a dissatisfaction with the formlessness of Impressionism; he then developed his own conceptions of the beauty of life and nature. The nude in his color lithograph *Standing Bather* (Fig. 36) embodies fully that feminine face and figure which he celebrated in so many guises. Committed throughout his long career to full-color painting, Renoir worked only occasionally in the print media.

About 1884 there emerged out of Impressionism a splinter group called *Neoimpressionists,* who carried the optical concepts to the extreme of "divisionism," or "pointillism." As explained by Paul Signac (1863–1935), the rationalist of the new style, the technique of the Neoimpressionists was "deliberate and constant," whereas that of the Impressionists was "instinctive and instantaneous." Furthermore, all mixture of colors was repudiated, not only on the palette but even by brush strokes on the canvas. Instead, the color was to be applied in

left: 35. EDGAR DEGAS.
After the Bath. c. 1890.
Lithograph, $9\frac{7}{8} \times 9\frac{1}{16}''$.
Cleveland Museum of Art
(gift of Capt. Charles G. King, III).

right: 36. PIERRE-AUGUSTE RENOIR.
Standing Bather. 1896.
Color lithograph, $16\frac{1}{4} \times 13\frac{1}{2}''$.
Philadelphia Museum of Art
(Louis E. Stern Collection).

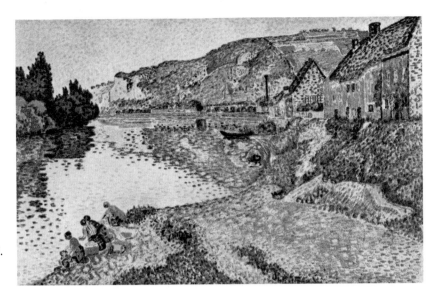

37. PAUL SIGNAC. *Les Andelys.*
1895. Color lithograph, $11\frac{7}{8} \times 17\frac{3}{4}''$.
Philadelphia Museum of Art
(purchase, McIlhenny Fund).

dots, or points, juxtaposed but separate. Among the characteristic
subjects Signac painted in this method were waterways with their
harbors, small boats, and life along the shores. Author of 17 lithographs,
he tested his color theory in this medium, as well as in oil. *Les Andelys*
(Fig. 37) is a notable example. As early as 1886, Signac had painted
in oil a composition of washerwomen on the banks of the Seine. The
idea recurred for a lithograph about 1895, when a preliminary sketch
was made in black crayon. The final version, reproduced above, was
printed in seven colors.

The giddy night life of Paris toward the turn of the century was
best described in the work of the tortured, deformed aristocrat Henri
de Toulouse-Lautrec (1864–1901), who stood more or less alone among
his contemporaries. He captured at a peak of excitement intimate scenes
in cafés; can-can girls; disillusioned singers, dancers, clowns, and
barmaids; the middle class promenading in their finery; the riotous
color and movement of the racetracks; the glitter and glamor of the
theater; and the vices, petty or gross, of ordinary mortals. His compo-
sitions were broadly conceived in bold outline and large color masses,
in the manner of Japanese prints then fashionable at the time (Pl. 20,
p. 149; Figs. 133–139). They lent themselves readily to color lithography
and served perfectly as posters and advertisements for the diversions
of the city. The print illustrated here (Pl. 3, p. 26) is of particular interest
in the history of lithography, for it catches the moment when a poster
is being evaluated. The printer has pulled a stack of impressions, and
the star represented quizzically scans her image with pursed lips,
narrowed eyes, and dubious knitting of the brows. Following a rough
sketch, Lautrec generally drew directly on the stone. He also developed
a spatter technique which lends sparkle to otherwise flat areas of color.

With Odilon Redon (1840–1916), another individualist, we enter a strange, haunting world possessed by its own logic. Though of the period of the Impressionists and an occasional exhibiter with them, Redon was more closely linked with the Symbolist writers, notably the French poet Stéphane Mallarmé. In his work two major categories stand out: on the one hand, delicate, glowing, and fanciful flower arrangements; on the other, mysterious, brooding faces, cryptically gesturing figures, and phantasmagorial metamorphoses of plant, animal, and human forms. Redon was among the French modern artists included in the famous Armory Show in New York in 1913, the innovations of which appalled the visitors and forever changed the dominating tendencies in American art. His prints are rich in craft and vision, deep within an inner life of dream (Fig. 38). As he stated, "I have given my imagination free rein in demanding from lithography everything it has to give. Each of my plates is the result of a passionate search for the utmost that can be extracted from the combined use of crayon, paper, and stone." Most of his transfers were considerably reworked on the stone, thus imparting their different quality. Redon was influenced to some extent by Rodolphe Bresdin (1822–85), a wanderer and a recluse who delighted in making reality unreal, after the tradition of the Netherlandish painters Hieronymus Bosch and Pieter Bruegel in the late fifteenth and the early sixteenth centuries. Bresdin surrounded himself with plants and animals, and yet his lithographs (Fig. 39) and etchings were created out of his imagination. The human, narrative element is often reduced to miniature proportions and surrounded with infinite macabre and grotesque details.

Also contributing to Redon's background was the advice of Henri Fantin-Latour (1836–1904), who was a Romantic in spirit, though a contemporary and friend of several Impressionists. Some of Fantin-Latour's work stems from the dramatic figure style of Delacroix, but his still lifes, and particularly his floral paintings, hark back to the miraculous realism of Dutch still-life artists. His lithograph *Bouquet de Roses* (Fig. 40) was taken from one of his paintings and executed by the transfer process, which he favored.

Two artists whose names are generally spoken in a single breath were J. Edouard Vuillard (1868–1940) and Pierre Bonnard (1867–1947), prime movers in a further offshoot of Impressionism which called itself *les Nabis*, a term derived from a Hebrew word for "prophet." Boyhood companions and fellow students, these men formed with several cronies a more or less closed society and met frequently to discuss their aims and ideas, which somewhat coincided with the Symbolist notions of the literary circle around Mallarmé. Because of their subjective and psychological view of the visual world, they disavowed the immediate optical representation of reality required by Impressionist theory, though, by way of Degas and others, some traces of Impressionist color and theme entered inescapably into their work. Thus they fall within

the sphere of art designated for chronological, rather than philosophical, reasons *Postimpressionism.* Vuillard and Bonnard concentrated on interior scenes with ordinary folk who carried on routine activities or on the streets of Paris under their most familiar aspects, so that their subject matter earned the title of "intimate" (or *Intimiste*) painting. These artists and their friends were fortunate in the patronage of Ambroise Vollard, who financed the publication of several stunning series of color lithographs. Vuillard's *Jardin des Tuileries* (Pl. 4, p. 43) offers striking evidence of the vogue for Japanese prints. *Les Boulevards* (Pl. 5, p. 43), by Bonnard, presents with playful vivacity an aspect of Paris life. Both men were prolific printmakers and gifted colorists.

above left: 38. ODILON REDON. *Yeux Clos.* 1890. Transfer lithograph, $8\frac{9}{16} \times 7\frac{3}{16}$". Metropolitan Museum of Art, New York (Harris Brisbane Dick Fund, 1925).

above right: 39. RODOLPHE BRESDIN. *The Good Samaritan.* 1861. Lithograph, $22\frac{1}{8} \times 17\frac{3}{8}$". Cleveland Museum of Art (gift of Mrs. George A. Martin).

left: 40. HENRI FANTIN-LATOUR. *Bouquet de Roses.* 1879. Transfer lithograph, $16\frac{3}{8} \times 14$". Cleveland Museum of Art (Mr. and Mrs. Lewis B. Williams Collection).

Lithography: Development of an Art Form 35

left: 41. Eugène Carrière.
Portrait of Alphonse Daudet. 1893.
Lithograph, $15\frac{11}{16} \times 12\frac{1}{8}''$.
Cleveland Museum of Art
(a 25th-anniversary gift,
Mr. and Mrs. Lewis B. Williams
Collection).

right: 42. James Abbott McNeill
Whistler. *Nocturne:*
The Thames at Battersea. 1878.
Lithotint, $6\frac{3}{4} \times 10\frac{1}{8}''$.
Cleveland Museum of Art
(bequest of Charles T. Brooks).

Another lithographer taken up by the publisher Ambroise Vollard was Eugène Carrière (1849–1906). His poetic portraits, singling out telling character traits in chiaroscuro, are grounded in black depths, so that the highlights tell the whole story without detailing of inessentials (Fig. 41). These arresting effects were produced by transferring impressions through a succession of stones.

American-born, but working primarily in London and Paris, the audacious but sensitive James Abbott McNeill Whistler (1834–1903) is as well known for his achievements in the graphic media as for his elegant portraits and dreamy nocturnal scenes on canvas. In collaboration with the printer Thomas Way, he created 166 lithographs of merit. Whistler, like so many others of the time, absorbed the atmosphere of Japanese prints. He also profited by the example of his French friends, Degas, Fantin-Latour, and Manet. The Japanese quality dominates his lithograph *Nocturne: The Thames at Battersea* (Fig. 42), with the misty, diffused tones that characterize so much of his work in both lithography and etching.

So far, little has been said about the spread of lithography to the United States, except for the efforts of such expatriates as Whistler and Benjamin West, much earlier. In a commercial sense the process flourished as a method that permitted reproduction and widespread publication of popular images. Before the middle of the nineteenth century, a firm consolidated under the name of Currier & Ives and by 1857 had begun to issue lithographic prints for a wide market. The subjects, treated by a number of artists, covered a tremendous range of city views, rural scenes, Civil War engagements, ships, trains, bridges, architecture, and episodes of hunting, fishing, and genre narrative—all drawn on stone and executed in color. One of the most active and prolific of the lithographers employed was Fanny Palmer (1812–76), an

Englishwoman whose husband had established the first of the lithographic enterprises that fed the ultimate business. During the course of her career, from those beginnings in New York in the early 1840s, she executed some hundreds of stones and achieved a distinctive style as well as broad circulation (Fig. 43).

However, not until the early twentieth century did the process bring forth a wealth of lithographs in the United States. In New York three generations of a family of printers, George C. Miller & Son, fostered the art and gave technical guidance to hundreds of artists. Among these was Joseph Pennell (1860–1926), a Philadelphian who found inspiration in the huge skeletons and ponderous machinery of industry (Fig. 44). The Miller studio also served George Bellows (1882–1925), a Middle Westerner transferred into the combative life of the metropolis. His social satire and topical comment were conveyed in dynamic compositions and effective tonal contrasts (Fig. 45).

left: 43. Fanny Palmer. *Partridge Shooting.* 1852. A Currier & Ives color lithograph, $12\frac{5}{8} \times 20\frac{3}{16}''$. Museum of the City of New York (Harry T. Peters Collection).

below right: 44. Joseph Pennell. *Pedro Miguel Lock, Panama.* 1912. Lithograph, $22 \times 16\frac{3}{4}''$. Metropolitan Museum of Art, New York (gift of Joseph Bucklin Bishop, 1924).

below left: 45. George Wesley Bellows. *A Stag at Sharkey's.* 1916. Lithograph, $18\frac{3}{4} \times 24''$. Philadelphia Museum of Art (gift of Mr. and Mrs. George Sharp Munson).

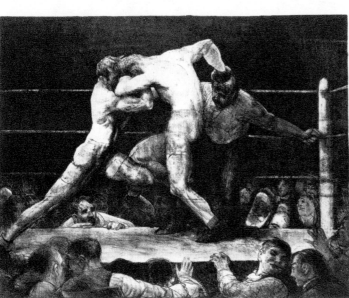

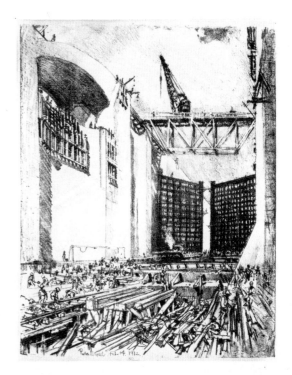

Meanwhile a peculiarly Nordic strain of sensibility had been developing in Europe, replacing the naturalistic study of perceptual reality with a search for emotive expression, sometimes joyous but more frequently tragic. Antecedents for this tendency may be found in the work of German religious artists of the fifteenth century such as Martin Schongauer (Fig. 196), but a closer forebear of the modern movement of German Expressionism was the Norwegian Edvard Munch (1863–1944). Probing the psychological states of the human spirit, Munch adopted linear distortion and melancholy color for his themes of death, love, and suffering, to which he devoted both paintings and a prodigious amount of superb graphic work (Fig. 46; see also Pl. 21, p. 150). Having learned his technique in Paris, he was invited to exhibit in Berlin during 1892, at a time when German painters were stirring in revolt against academic realism. His efforts, in spite of a hostile reception at the outset, profoundly affected the German Expressionist group called *Die Brücke* ("The Bridge"), founded in Dresden in 1905 in an attempt to link the various revolutionary art trends then in progress.

The philosophic and intellectual leader of Die Brücke, which lasted until 1913 and produced a flowering of graphic arts, was Ernst Ludwig Kirchner (1880–1938). Kirchner created almost five hundred lithographs in black and white and in color, enthusiastically printing them himself (Pl. 6, p. 44). His friend and associate Max Pechstein (1881–1955) shared the same passion (Fig. 47), declaring:

How versatile lithography is when you prepare the stone yourself for printing, etch it, and then print it yourself. Printing it yourself is the only way, in any case! Using the paints smoother or thinner, the paper drier or damper brings new

left: 46. EDVARD MUNCH. *The Cry.* 1893. Lithograph on red paper, 14 × 10″. Museum of Fine Arts, Boston (Mrs. Serai W. Mosby Purchase; William Francis Warden Fund).

right: 47. MAX PECHSTEIN. *Portrait of Erich Heckel I.* 1908. Lithograph, 17 × 12$\frac{5}{16}$″. Museum of Modern Art, New York.

fascination and new stimulus. The work is a reward in itself. The effect is obtained much more rapidly and directly than when painting, and you are fascinated by the work until the finished print lies before you.

Other members of the group who distinguished themselves as printmakers are discussed and illustrated in connection with woodcuts (Pl. 22, p. 150; Figs. 141–143).

During a brief period from about 1911 to 1913, *Der Blaue Reiter* ("The Blue Rider") functioned as an exhibiting group in Munich. Its aim was to permit the artist free expression in many methods and to treat natural forms as symbols of life, rather than to imitate nature directly. Thus the orientation of the group was more abstract than that of Die Brücke. The Russian Wassily Kandinsky (1866–1944) was one of the founders, and along with his colleagues he worked in various print media. His color lithograph (Fig. 48) was made after the group had disbanded and shows his continuing turn toward nonrepresentational subjects. (See also Fig. 144).

With George Grosz (1893–1959) and the early work of Max Beckmann (1884–1950) we come to exponents of the *Neue Sachlichkeit* ("New Objectivity"), whose caustic prints provide strong evidence of their feelings about their society (Figs. 49, 50). The members reacted against the excesses of Expressionism, representing reality in sharp and penetrating detail. Both of the artists illustrated here reflected the human tragedy they had witnessed in World War I and the grossness of the postwar period in Germany. Both eventually took refuge in the United States, where Grosz, in particular, focused his sarcasm on vices and vanities of the American scene.

left: 48. WASSILY KANDINSKY. *Composition with Chessboard—Orange.* 1923. Color lithograph, 16 × 15″. Philadelphia Museum of Art (Louise and Walter Arensberg Collection).

right: 49. GEORGE GROSZ. *Street Scene.* Lithograph, 10½ × 8½″. Philadelphia Museum of Art (Harrison Fund).

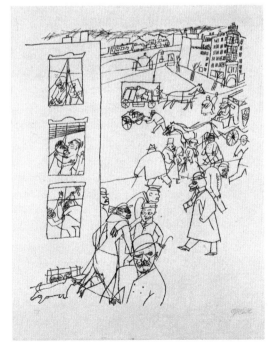

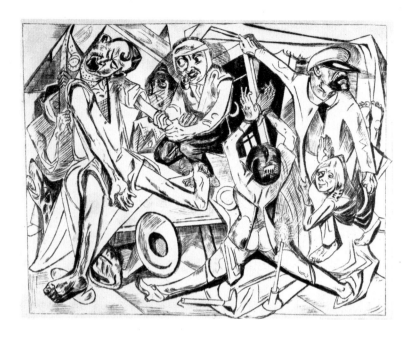

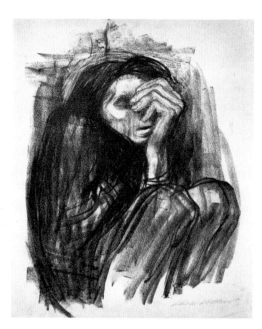

left: 50. MAX BECKMANN. *The Night,*
from the series *Die Hölle.*
1919. Lithograph, 21⅞ × 27⅝".
Museum of Modern Art,
New York.

right: 51. KÄTHE KOLLWITZ. *Death
on the Highway.* 1934.
Lithograph, 16⅜ × 11½" (stone),
U.C.L.A. Grunwald Graphic Arts
Foundation, Los Angeles.
(See also detail, Fig. 5.)

A similar concern with social ills in Germany engrossed another
artist, who held aloof from these specific movements but exerted some
influence as a teacher. The stark simplicity and resultant power of Käthe
Kollwitz (1867–1945) is felt in every work from her hand. Her sympathy
and understanding, and her alliance with the poor, the oppressed, and
the miserable, are gleaned from even casual acquaintance with her
prints (Fig. 51). The harsh social realism of Kollwitz is a bitter and brutal
truth, not without compassion, designed to stir one's conscience.
Throughout her work—in lithography, etching, and the allied arts—
there is ever present the dignity of man.

As a conclusion to this brief survey of the first century and a half
of lithographic history, three major twentieth-century painters provide
a fitting transition to the recent developments in the field—Henri
Matisse (1869–1954), Georges Braque (1881–1963), and the indestructi-
ble Pablo Picasso (b. 1881). Their combined careers span the period from
Impressionism, which affected the young Matisse, and continue through
Fauvism, Cubism, and successive experiments to our own days; their
searching invention and stupendous output in many media have in-
fluenced countless followers. Beginning in 1905 Matisse came to be
regarded as the leader of a loose fraternity of artists dubbed by the
critics *Les Fauves* ("The Wild Beasts") for their violent, flat color and
distortions of drawing. About a year later Braque also joined the circle.
Almost simultaneously, however, Braque and the Spaniard Picasso
were exploring a more intellectual analysis of form and color than could
be found under Impressionism—more akin to Cézanne's approach.
Their reduction of forms to geometric bases was designated *Cubism;*

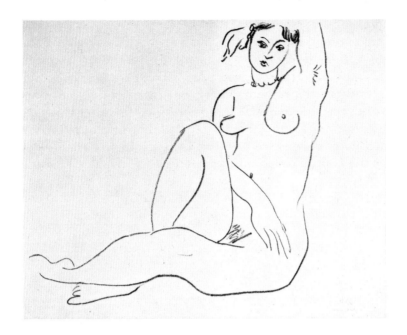

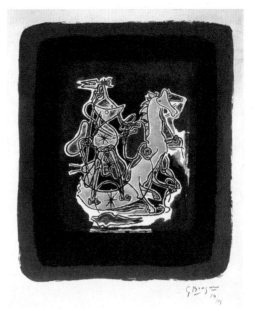

first exhibited in 1907, the new style became the parent of many abstract movements.

The scope of their work has extended beyond painting to include at one time or another sculpture, ceramics, collage, architectural decoration, stage design, tapestry, posters, prints, and book illustration. This diversity is amply demonstrated in the three lithographs appended here (Figs. 52–54). The impact of images from primitive cultures, such as African or Oceanic, will be illustrated later on in this book, for example in Gauguin's color woodcut in Figure 140.

Matisse's seated nude (Fig. 52) was executed entirely in assured and flowing line. Like the odalisque of Ingres (Fig. 19), this figure owes in part a debt to Greek Classical art. Yet the stroke of the draftsman here differs from that of Ingres—it is swiftly moving, unstudied in effect, without modeling in shadow or correction of form and gesture, faintly distorted in silhouette, and unfinished in contour and development.

Braque's *Helios* (Fig. 53) is one stage of a print which he carried through numerous trials and versions. Representing the Greek sun god in his chariot, warring against the darkness of night, it was executed in the Paris workshop of the printer Fernand Mourlot. It continues Braque's interest in Greek mythology, which was aroused by his assignment to illustrate Hesiod's *Theogony* in an earlier series of engravings. The lithograph is strongly fortified in line, linking the Cubist style with the ancient Greek Geometric period of about 900 B.C. The design was reworked many times to achieve the color values desired for its various appearances in Braque's oeuvre and, in some versions, required as many as nine runs through the press.

left: 52. HENRI MATISSE. *Seated Nude.* c. 1929. Lithograph, 16 × 17½". Prints Division, New York Public Library (Astor, Lenox and Tilden Foundations).

right: 53. GEORGES BRAQUE. *Helios.* 1947. Color lithograph, 20⅝ × 14⅞". Gallery Louise Leiris, Paris

Picasso's prosaically titled *Striped Blouse* (Fig. 54) very obviously echoes one of his myriad interests—Egyptian art—with its rigid frontal pose, its suggestion of the heavy royal headdress, and even a hint of the ceremonial Pharaonic beard. One need only compare this lithograph with the often-reproduced funerary mask of Tutankhamen, of about 1350 B.C., to detect the source of inspiration. At the same time this may be read as the portrait of a young woman of 1949. The forms are broken by well-defined color shapes, no longer in the geometric analysis of Cubism, nor in the many-faceted multiple views that fascinated Picasso later on. It represents still another twist on the part of this restless and pugnacious spirit, who burst into the art circles of pre-World-War I to turn their ideas upside down and who now in his nineties is capable of injecting a bald and unapologetic surprise. (See also Fig. 174.)

The look of the lithograph today often bears little resemblance to the tradition from which it derives. The diversity of visual phenomena is astounding. There are spatial displays of opaque, transparent, and semitransparent color; filmy veils of subtly modulated inks; infinite varieties of color relationships; the strictly ordered and the seemingly haphazard; ambiguous three-dimensional works and astringently hard-edged images; visions of disaster and decay or clean lines and surfaces—in fact, every facet of the contemporary art scene.

The frame of mind of a young lithographer today would scarcely motivate him to the production of images comparable to those illustrated in this historical introduction, except as one always returns to the past, both for understanding and for inspiration. However, his work is necessarily based on that same process that Senefelder discovered, and in his own turn he will go through just such experiences of exploration and innovation as his predecessors.

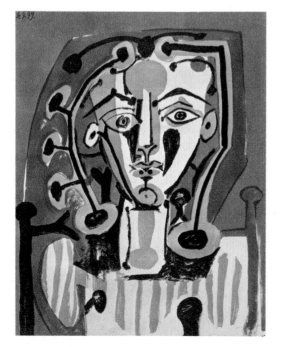

54. PABLO PICASSO. *The Striped Blouse.* 1949.
Lithograph, $25\frac{1}{2} \times 19\frac{3}{4}''$.
Museum of Modern Art, New York
(Abby Aldrich Rockefeller Purchase Fund).

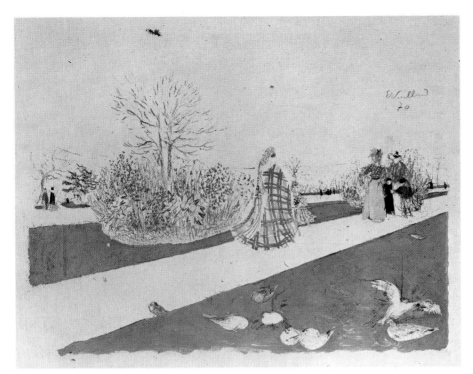

left: Plate 4. JEAN-EDOUARD VUILLARD. *Le Jardin des Tuileries.* 1896. Color lithograph, 12⅛ x 17⅛". Cleveland Museum of Art (Mr. and Mrs. Lewis B. Williams Collection).

below: Plate 5. PIERRE BONNARD. *Les Boulevards.* 1895. Color lithograph, 10⅝ x 13¼". Cleveland Museum of Art (Dudley P. Allen Fund).

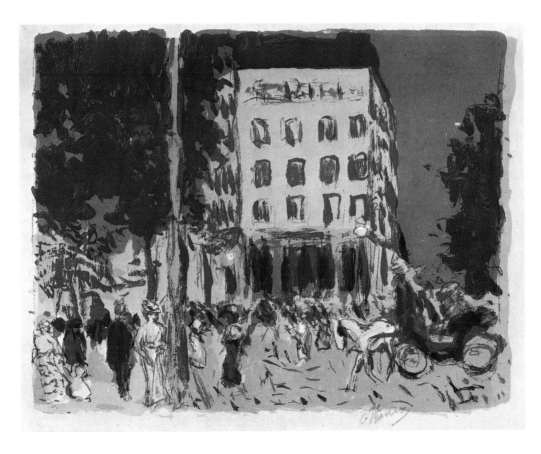

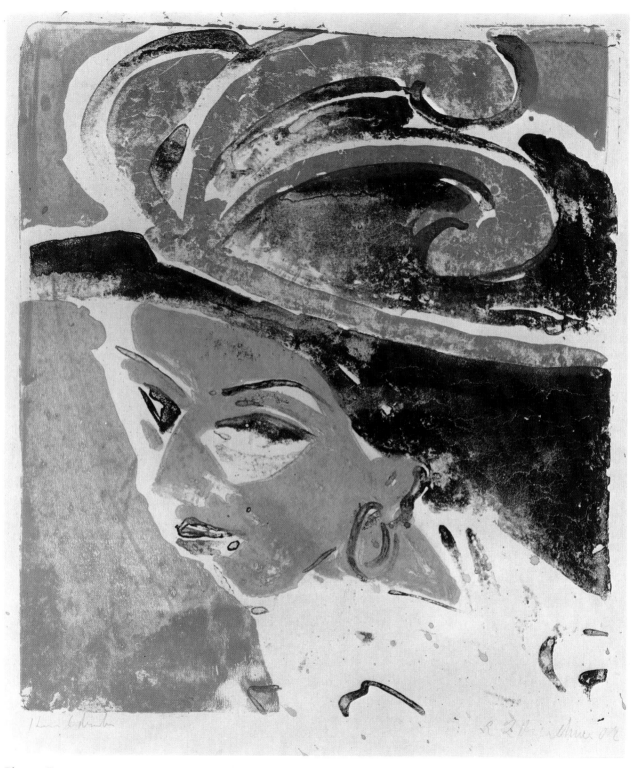

Plate 6. Ernst Ludwig Kirchner. *Woman Wearing a Hat with Feathers*. 1910.
Color lithograph, 17½ x 15". Staatliche Graphische Sammlung, Munich.

Making
a Lithograph
on Stone

Lithography can perhaps be explained best by an examination of what it is *not*. It is not a process wherein one mechanically copies on stone a drawing previously done on paper or another substance. *Lithography* does not describe the purchase of the services of a professional artist's printer in lieu of proving one's own work; nor does it denote a mysterious process that somehow turns out multiple originals, as folk in the Victorian era believed. Finally, it is not a precise, scientific, critical medium. And yet, though lithography is no one of these things, it does include each of them. The medium involves the act of drawing on stone and does not exclude the fact that some artists have their work attended to by professional printers. It is a scientific process, based upon the laws of chemistry, although no sole explanation of these laws has found unanimity.

For those who wish an introduction to or a resurvey of the lithographic process, this chapter begins with a basic procedure for making a black-and-white lithograph, using the traditional stone as the drawing and printing surface, and following well-established methods that are familiar (with variations) to many printmakers. Those who cannot obtain a stone or prefer to work on a plate will make use of Chapter 3, which discusses metal-plate lithography. The chief differences between working on stone and working on a plate concern the chemicals and solutions employed. The methods of drawing and the steps in the total procedure are more or less the same.

Briefly, lithography involves drawing upon a flat stone (or other surface) with a grease-containing substance, chemically treating it, verifying it, and printing it in an edition that multiplies the original visual statement. In the language of printmakers, the following steps must be followed:

1. Graining the stone.
2. Drawing upon the stone.
3. Desensitizing (or *etching*) the stone. The surface with the drawing will be treated chemically to allow multiples to be printed.
4. Proving the stone. This series of procedures includes preparing the ink, paper, press, and stone, then taking several trial proofs, making any desired alterations in the drawing, perhaps etching again, and finally pulling as many prints as meet your needs. The requisite materials are described in the text and listed on page 328.

GRAINING THE STONE

The limestones upon which lithographs are traditionally worked derive from quarries in Bavaria. These stones are becoming increasingly difficult to obtain, and lithographs are now often made on metal plates, on other types of stone, or on paper; even so the artist should make every effort to produce at least one lithograph on the traditional limestone surface. By doing so he will more fully understand the qualities inherent in the medium from its beginning, and he will experience the pleasure of working on what many artists consider to be the most receptive drawing surface in the world.

Given the opportunity, select stones that are gray or light blue-gray in color, 3 to 4 inches thick, and free from cracks, fine veins, and fossils. Cracks and veins may print as white lines, while fossils and other impurities may print lighter, darker, or not at all; it is wiser to avoid them, even though they are sometimes tempting as a possible design element. Yellow stones should be rejected because they are too soft and coarse; very dark stones tend to confuse the artist because there is not enough difference in value between the drawing and the stone surface. Stones are used and reground many times. When they become less than 2 inches in thickness, they should be either discarded, used as ink slabs, or cemented to other stones for future use.

Lithographic stones, to receive your drawing, must be freshly grained. The exact effect that graining has is not quite clear, though artists have traditionally offered various explanations: that it permits an even film of water to collect on the stone, that a grained stone can hold more water without flooding than an ungrained one, and that crayon drawings can best be made on a toothed stone. Whatever the reason, printmakers always grain their stones. It may be noted that both grained and ungrained surfaces are used by industry for commercial

lithography; readers interested in industrial developments should consult the publications of the Graphic Arts Technical Foundation in Pittsburgh.

The graining (or grinding) action can be accomplished in two ways: either by grinding two stones with an abrasive between them, or by using a levigator with an abrasive on a single stone.

Two-Stone Method of Graining

Move two stones to the graining table. Remember that the stone on which you will draw must be large enough to provide ample margins for your drawing. For the second stone, some artists prefer to use a smaller stone that is kept only for graining (Fig. 55); others simply grind two stones of the same size together (Fig. 56).

Flood the stones with water; remove all foreign matter and excess water with the cupped hand. Sprinkle 2 to 3 tablespoonfuls of No. 80 carborundum (or an equivalent abrasive) on the stone you have selected for drawing. With your fingers, distribute the carborundum evenly on the surface.

Slide the second stone on top of the first. If you use a smaller stone, it will, of course, always be kept on top. If you use stones of the same size, reverse their position by placing the top one on the bottom after each stage of the grinding, to prevent the concavity or convexity that is otherwise likely to develop.

Begin to spin the top stone counterclockwise or in a figure-8 pattern. Each printmaker seems to develop his own way of spinning the stone; the important point is to grain symmetrically, in a given pattern, in order to ensure level surfaces. Do not allow the top stone to travel too far beyond the edges of the bottom one.

After 5 to 10 minutes of grinding, the sludge between the stones will become creamy and lighter in value than at the start, and the stones will become more difficult to spin. The carborundum is beginning to cut into the limestone, removing the old drawing (if there is one) and *simultaneously* imparting the peculiar lithographic grain to the surface on which you will draw. Oddly enough, the stone, which will look and feel as slick and glossy as polished marble, is becoming a surface composed of minute hills and valleys.

When you observe the sludge getting stiffer and creamier, and before the top stone becomes too difficult to spin, gently slide the top stone from the bottom one. Hose down both stones with water to remove *completely* all the particles of carborundum, and repeat the procedure.

Inspect your stone to make certain the *ghost* (the previous drawing on the stone, which may barely be visible) is thoroughly removed. To do so, drain the water from the stones and fan dry. If the ghost remains, again repeat the grinding. Some ghosts are difficult to remove.

55. Graining the stone: two-stone method.

56. Graining stones of the same size.

Place a steel straightedge across the stone at *several* different locations. Sight along the juncture of the straightedge and the stone to check for concavity or convexity. Note the high or low spots and regrind, if necessary.

Flood the stones once more with water and, using No. 150 carborundum, follow the graining procedure as before. Repeat the graining with No. 150 or, for a finer grain, use No. 220. Again, gently slide the top stone from the bottom and hose both stones thoroughly with water. Stand the stones on edge to allow the excess water to drain off.

Place the stones on a flat surface to dry. The drying process may be accelerated by fanning or by employing sheets of clean newsprint to blot off the excess water. When dry, the stones must be inspected for surface scratches, which appear as white lines. Check their level once more, and regrain, if necessary.

Unless you intend to work on the drawing immediately, cover the newly grained stone with a sheet of newsprint taped to the stone with decorator's tape or an equivalent. Do not allow the tape to make direct contact with the proposed working surface.

If desired, the stones can be grained to still finer surfaces: After employing No. 220 carborundum, polish the stones (using water) with a block of snake slip, pumice, or Schumaker brick, or grind with abrasives graded F, FF, or FFF, dependent upon the grain that best meets your requirements. Usually, but not always, very fine grains are employed for wash drawings and line drawings employing tusche. Crayon work is normally done on a coarse or medium grain. The character of your drawing, or your idea for one, will dictate the quality of grain required for the stone.

Levigator Method of Graining

The *levigator* is a heavy, cast-iron or aluminum, cored, circular tool with an upright handle mounted eccentrically. In graining, the tool is grasped by the handle and spun on a wet stone containing the desired abrasive (Fig. 57). Follow the same procedure as in graining two stones.

left: 57. Graining the stone: levigator method.

right: 58. Beveling the edges of the stone.

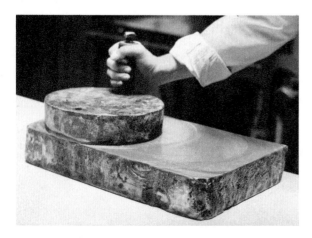

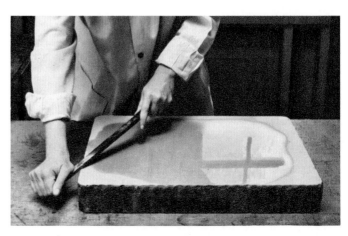

Certain professional print workshops are equipped with air-driven or electrically driven levigators for graining large stones. It is not recommended that beginners use these aids, even when available.

Beveling the Stone Edges

Using a stone file, rasp, or belt, bevel the edges (about $\frac{1}{4}$-inch radius) on all four sides of the stone (Fig. 58). Then polish the edges with pumice stone, Schumaker brick, or snake slip, and water. This step is necessary in order to avoid denting or cutting the ink roller or chipping the stone during printing, to keep the edges ink-free during the printing process, and to protect the printing paper from damage.

DRAWING UPON THE STONE

When an artist sits down before a stone for the first time, he is apt to have a feeling of "strangeness"; actually the surface is no more strange than the sidewalks and walls on which he probably scrawled crayon drawings as a child. He is also very likely to feel considerable anxiety at the thought of marring a beautiful surface which has reached its present state of perfection only after repeated grinding. You should disregard all such fears and anxieties and draw as freely as you would on any other surface. There is only one inhibition that need affect you at this point: Do not extend your drawing too close to the edge of the stone; an ample margin (at least $1\frac{1}{2}$ inches) must be left on all four sides to support the scraper that will be used when the print is pulled.

Various warnings are often issued to the beginning printmaker. He is usually told that he must not under any circumstances touch the freshly grained surface with his hands, since this might impart grease to the stone and ruin the work. He is advised against speaking, sneezing, or coughing while at work (for fear specks of saliva will mar the surface) and even against running his fingers through his hair. This is all good advice, no doubt, especially for meticulous work, but it tends to frustrate the beginner or, at least, causes him to work in an unnatural way—and this is far worse than an accidental blemish, which can often be disregarded.

Some artists make a preliminary sketch or series of sketches before drawing on the stone; others draw directly, simply following out an idea. There are some, also, who prefer to work from a complete statement made in advance on paper and then traced onto the surface of the stone. To trace a drawing, rub the back of it with sanguine Conté powder (or crayon), lay the drawing gently upon the stone, Conté side down, and trace with a hard pencil. The reddish, bricklike color of the sanguine Conté will appear on the surface of the stone and serve as a guide to drawing; it cannot appear, however, on the proofs and prints you will pull.

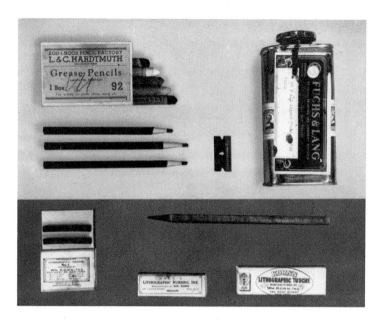

59. Drawing materials.

Keep in mind the fact that the drawing you make will be reversed in the print. You may check it by looking at it in a pocket mirror; if you are satisfied with the reversed image you see there, all is well. If you are tracing a drawing that you do not want reversed, first trace it backwards on another piece of paper and transfer that drawing to the stone. The print pulled from the stone will reverse the image again, thus restoring the aspect of your original drawing.

Various tools and many innovative techniques are now used for creating the image on the stone. At this point only the basic ones will be described (Fig. 59).

Lithographic Crayons and Pencils

Manufactured primarily of wax, soap, and lampblack, these square sticks and pencils are familiar to all art students. They vary from No. 00 (extremely soft) to No. 5 (copal, or extremely hard) both in the British and American system of grading. French crayons are graded in a system that reverses this order. These "grease crayons" and pencils handle in much the same way as the ordinary crayons and pencils with which everyone is familiar.

Those who wish to work solely or primarily with crayon or pencil should keep a freshly sharpened supply at hand. Sharpen a lithographic crayon or pencil in a manner *opposite* to that employed with the ordinary lead pencil; using a single-edge razor blade, sharpen the point *from* the end or tip *to* the body. The crayon may be sharpened to a flat end, for wider lines, and the side of the crayon is often used for covering larger areas.

Technically, a lithograph is not the precise equivalent of the drawing it would appear to duplicate with such exactitude. The *higher* the number of the crayon or pencil, the *less grease* it contains; therefore the value of the tone when printed will be *lighter.* At the same time variation in tone also results from the pressure of the crayon; the stroke may be applied so as to leave a more substantial deposit of grease in the "valleys" of the grain in the stone. Some artists are able to make a rich black using only a medium crayon, though others cannot, or do not attempt to. In general, if you wish to "build up" a drawing, you will work from the hardest to the softest crayons, that is, from No. 5 to No. 00. If you wish to work more directly, you will select the crayon that seems to approximate most closely the tone you have in mind—and you will strive to develop that tactile sense which permits a very sensitive relationship to take place between the crayon in the hand and the surface of the stone.

The true "do-it-yourself" printmaker who wishes to try making his own crayons might well begin with one of Senefelder's various formulas. A simple one is a mixture of 4 parts wax, 6 parts soap, 2 parts lampblack. Another contains 4 parts wax, 5 parts soap, 3 parts lampblack, 2 parts tallow, 4 parts shellac. Bring the ingredients to a boil for several minutes, and pour the molten mass into well-oiled molds. Those interested in pursuing such experiments may consult Bolton Brown, *Lithography for Artists* (1929).

Rubbing Ink

Rub your finger over a block of lithographic rubbing ink to load it with grease and then "paint" or draw with your finger tip. Pass lightly over an area on the stone or plate to produce a soft tone. The harder you press, the darker will the area print. To avoid fingerprints (unless you wish to exploit them), load the ink-smeared finger after each light pass over the area, or wrap a piece of silk or nylon around the finger.

Tusche

Lithographic tusche is a material having, like crayons, the necessary grease content for lithography, but which enables you to work with brush, pen, or other tool, much as you would work with India ink or on any wash drawing (Fig. 60). Solid, rich black lines and areas may be obtained, as well as a variety of gray values, that are produced by diluting the mixture. Drybrush effects will also print successfully. For tusche drawings some artists give the stone a fine grain with FF or FFF carborundum (or an equivalent).

Tusche is available in two forms: *stick tusche,* which is supplied as a solid block that may be mixed to form a liquid, and *liquid tusche,* which should be shaken thoroughly before use. Tusche can be mixed or

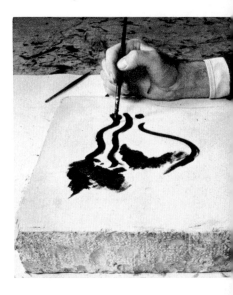

60. Drawing on stone with tusche.

thinned with lithotine, gasoline, or distilled water. (Note: The Graphic Arts Technical Foundation developed lithotine to replace turpentine, which can irritate the skin.) The effect of tusche in a drawing varies according to what you mix it with; you should try out all these diluents and record the results for future use. Liquid tusche, unthinned, is particularly convenient for applying a solid coat of rich black.

Crayons and tusche are freely combined when drawing, though a complete print can be made with either. A lithograph composed entirely of wash tones is known as a *lithotint*. A term no longer in common use, it will sometimes be encountered in museum labels, as in the instance of the Whistler print shown in Figure 42.

Scratching and Scraping Techniques

Steel needles and razor blades can be used to scratch white lines into areas of crayon or tusche. With the razor blade, it is possible to scrape middle tones from a black area or white from middle tones. These tools are also used for corrections, to remove unwanted flecks, lines, or areas, or to lighten the work.

DESENSITIZING ("Etching") THE STONE

The process of lithography is based upon the antipathy of grease and water on a flat surface.

At this juncture, you have made a drawing on a flat, limestone surface with crayons, pencils, and tusche, all of which contain grease in the form of fats, waxes, animal and vegetable oils. The ink with which you will print also has a grease content. The *non-image* (undrawn) areas of the stone must be chemically prepared to make them attract and retain water. When thus prepared and wet, they will repel the grease-based ink. The *image* areas must be made receptive to the ink. This aspect of the process is known as *desensitizing* the stone. In sum, *the effect of desensitization upon the flat stone surface is to create two kinds of areas: printing areas that attract grease and repel water, and nonprinting areas that attract water and repel grease.*

Desensitization is a term recently adopted for what was formerly (and still often is) called *etching the stone. Etching,* which by derivation means "eating into" a surface, is an inaccurate description of the process, since no part of the surface is removed by the so-called etch; for all intents and purposes, the stone presents as flat a surface after etching as it did before.

Preparation of the Acidified Gum Etch

Before proceeding to make a batch of etch it may be helpful to know something of the nature and effect of its two components—gum arabic

and nitric acid. As Senefelder discovered, gum-arabic solution fulfills the requirements of a desensitizing agent both by being *hydrophilic* (water-loving) and by adhering firmly to the surface of the stone in the nonprinting areas. The gum solution is adsorbed on the non-image surfaces of the stone and, upon drying, forms a thin, tough, invisible bond with it, which cannot be washed off with water.

Various-sized nuggets of gum arabic, a noncrystalline carbohydrate, are derived from the hardened sap of the acacia tree in Africa; they are soluble in water, but not in turpentine or alcohol. Gum-arabic solution is a mixture of the calcium, magnesium, and potassium salts that make up arabic acid; it has a variety of other technical uses, as in the preparation of foods and adhesives and as a binder for paints. The fresh gum-arabic solution that you will prepare is tasteless, amber-colored, and sweet-smelling.

The addition of a certain number of drops of nitric acid to the gum-arabic solution acidifies the solution and further desensitizes the undrawn areas on the stone surface. The effect of the nitric acid has been variously explained. Traditionally, it is said to remove unwanted grease and dirt from the undrawn areas and the margins of the stone; it has also been suggested that it acts as a sort of catalyst to bring about the desired chemical reaction of all the ingredients; that it opens the pores of the limestone; or that it makes the drawn areas or printing areas hold better on the stone surface. Another explanation is that the acidified gum etch, when thinned and dried on the stone, locks around each grease spot on the hills and valleys or peaks and pits of the stone so as to guarantee the repetition in the print (if properly handled) of all the lines and values drawn by the artist. Experts in surface chemistry tend to distrust the traditional explanations of artists relating to the chemical processes of lithography. It would appear that more research is necessary for a better understanding of what, from a practicing printmaker's viewpoint, seems to be a disarmingly simple set of phenomena.

61. Gum arabic: crystals, water, and resulting solution.

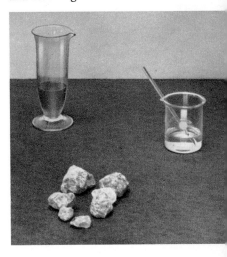

Preparing Gum-Arabic Solution. Add water to gum-arabic crystals or lumps to produce a syrupy mixture which, when tested for its viscous quality, will allow almost $\frac{1}{4}$ inch of tension before breaking. *Test as follows: Dip your thumb and index finger in the mixture. Remove. Bring thumb and index finger together. Pull apart gently.* If necessary, add more water or crystals until the tension is correct. Strain this mixture through a discarded nylon stocking or a wad of cheesecloth into a clean graduate or jar to eliminate impurities such as bits of bark picked up from the acacia tree (Fig. 61).

Gum-arabic solution can also be made from powdered gum arabic by adding warm water to obtain a Baumé hydrometer reading of 12° to 14°, more or less. Or it may be purchased in various commercially prepared versions with similar Baumé readings. The commercial prod-

ucts are seemingly unaffected by temperature or by long periods of storage.

Gum-arabic solutions made from crystals or powder should be made up anew each time one is ready to print, since they are about as impermanent as sweet cream unrefrigerated. Some printmakers add a few drops of carbolic acid to the gum-arabic solution as an aid to preservation, but it is suggested that you simply mix a fresh batch when ready to pull a print.

Mixing and Testing the Etch. There is no such phenomenon as the "correct" etch for each of the many kinds of lithographs produced in the many print workshops throughout the world. The temperature of the workshop varies from day to day, as does the humidity. The quality of the limestone, the acidity of the particular batch of gum arabic, and the temperature and age of the nitric acid are all variables with which the printmaker must contend.

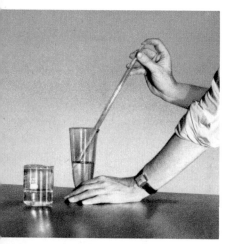

62. Adding nitric acid to the base of gum arabic.

63. Testing the etch on margin of stone.

Furthermore, the strength of the etch needed will depend on the character of the drawing. The more grease used in the drawing, the more vigorously you will etch the stone, in general. (You will recall that the softer pencils, crayons, and tusche impart more grease to the surface than do the harder ones.) However, if you *underetch* an area, that is, if you use very little nitric acid, it will go dark when you print. A truly black black will naturally result from underetching. Therefore, flat tusche areas that you may want to print as solids will require little, if any, acid. Rubbed tones should be etched more strongly than non-rubbed tones made with the same number of rubbing ink, but it should be noted that rubbed tones are rather tricky to handle.

To take care of these variables, you will mix an etch to the strength you require (Fig. 62). Test it on the margin of your stone immediately before use, and alter it if it is not working properly under the prevailing conditions. A mild, medium, or vigorous etch may be mixed and tested as follows:

To make a mild etch, strain $1\frac{1}{2}$ ounces of gum-arabic solution into a 6-ounce graduate. With a pipette and nipple, add 5 or 6 drops of nitric acid to the mixture. Agitate thoroughly with a glass stirring rod. Make a tentative test of the correctness of this etch by swabbing the stirring rod on the margin of the stone to be etched. A slight effervescence (the appearance of bubbles of carbonic gas) should be noted after a few moments (Fig. 63). If not, add drops of acid until an effervescence appears, within approximately 10 seconds.

Using the same method, you may make a *medium etch* by adding 8 to 10 drops of nitric acid to $1\frac{1}{2}$ ounces of gum-arabic solution, testing it, and, if necessary, adding acid until effervescence is noted within approximately 5 seconds. To make a *vigorous etch*, use at least 15 drops of nitric acid, adding more if effervescence fails to appear within a few seconds.

The test you conduct on the margins of the stone to be etched will within limits provide the particular solution for the conditions that prevail at the time and in the place in which you are working.

Since the etch must be fresh and must be tested at the time of use, you will not prepare the mixture until you are ready to carry out the following outline of the whole desensitizing procedure.

Desensitizing Procedure (Etching the Stone)

In general there are two popular methods of etching, and many variations, followed by printmakers today: the visual approach and the nonvisual one. The former, as you might expect, allows you to judge by eye the effects of the etch upon the stone; the latter, obviously, does not.

Visual Approach. A representative procedure for the visual method is as follows:

1. Dust the drawing with a half-and-half mixture of talc (powdered French chalk) and powdered rosin. Tamp gently but firmly over the whole stone. Do not rub. The rosin adheres to the grease particles, reinforcing the drawing against the action of the etch. The talc provides a means whereby the gum can be laid down smoothly. Without talc, the gum arabic will not lock completely around the grease particles and the drawing will print with a loss of quality. (It was formerly thought that powdered French chalk and powdered rosin should be kept in separate containers and applied separately, but recent research by the Graphic Arts Technical Foundation suggests otherwise.)
2. Using a light, dusting action, remove the excess powder from the stone with a pad of cotton wadding.
3. Mix a mild etch (5 or 6 drops of nitric acid added to $1\frac{1}{2}$ ounces of gum-arabic solution). Adjust the etch to existing conditions, by adding gum arabic *or* nitric acid, so that you have a mild effervescence within 10 seconds or so.
4. Test the etch on the margin of the stone. Add more gum arabic or more nitric acid if needed to achieve the desired effect: a mild effervescence within 10 seconds or so.
5. Pour about half of the etch on one of the margins of your stone. Quickly, using the heel of your palm or a 3-inch rubber-set brush, carry the etch over the entire stone surface and move it about—working from the light to the dark areas—for no less than 4 minutes (Fig. 64.)
6. Add a drop or two of acid to the remainder of the etch. Stir the mixture with a glass rod. Dispense this portion of the etch *in particular to dark tonal areas* and scratched or scraped work. Do not

64. Desensitizing the stone with acidulated gum etch.

allow this stronger etch to remain too long on any area. Now, move the etch from the dark to the light areas as the acidulated gum etch begins to expend itself, that is, as the effervescence lessens.

7. With a sheet of clean newsprint, quickly blot the excess etch from the stone. Repeat, if necessary.
8. Before the gum becomes tacky, rub the etch down vigorously to a fine, thin coat with a pad of cheesecloth.
9. Fan the etch dry.
10. Allow the etch to remain on the stone at least overnight for best results. Certain types of work may require that you proceed with the printing process as soon as the gum is *dry to the touch*.

Nonvisual Approach. The nonvisual procedure is also called *spot etching*, or *localized etching*. Instead of using a single etch moved about on the whole stone, as in the previous method, you will apply several etches of varying strength to different parts of the drawing. The method is *nonvisual* because, with etches ranging from mild to vigorous operating on the stone at the same time, you work by a predetermined plan rather than by observation. For this purpose, you can mix the mild, medium, and vigorous etches already described (with gradations, if needed); or you can adopt, or prepare for yourself, an etching guide specifying the mixture and the time required for each grade of crayon or wash. The Etch Table on page 57 was devised for assistance in printing large editions, but it will be found useful as a guide for experimentation with this method of desensitizing. The suggested procedure is as follows:

1. Dust the drawing with a half-and-half mixture of talc (powdered French chalk) and powdered rosin.
2. Remove the excess with a pad of cotton wadding.
3. Mix an etch for *each* of the various crayons and washes used in your drawing, making use of the mild, medium, and vigorous etches already described or, if you prefer, trying out the Etch Table. Remember to add the acid *to* the gum.
4. Using small watercolor brushes and the appropriate etches, paint out the darkest darks first. Next, with the medium etches, paint the middle values. Finally, with the mildest etch, paint those areas. (If you use the Etch Table, follow the time noted there for each value of crayon or wash.) Move from the center of a tonal area outward until areas of etch join and the whole stone is covered with acidulated gum varying in strength. Carefully thin the gum layer and repeat the process.
5. With sheets of newsprint, blot the excess etch from the stone.
6. Quickly thin the etch down with a pad of cheesecloth.
7. Fan dry.
8. Clean up your work area and all materials and tools and store the gummed-up stone overnight before proceeding.

Etch Table of Ernest de Soto

First Etch CRAYON	Second Etch	Third Etch
No. 5 crayon or pencil Straight g.a.* *5 mins.*	Straight g.a. *5 mins.*	Straight g.a. *5 mins.*
No. 4 crayon or pencil g.a. 1 oz. 3 d. n.a.** *5 mins.*	g.a. 1 oz. 3 d. n.a. *5 mins.*	g.a. 1 oz. 2 d. n.a. *3 mins.*
No. 3 crayon or pencil g.a. 1 oz. 6 d. n.a. *10 mins.*	g.a. 1 oz. 5 d. n.a. *10 mins.*	g.a. 1 oz. 4 d. n.a. *8 mins.*
No. 1–#0 crayon or pencil g.a. 1 oz. 10 d. n.a. *7 mins.*	g.a. 1 oz. 9 d. n.a. *8 mins.*	g.a. 1 oz. 6 d. n.a. *6 mins.*
WASHES		
Full-strength Korn's tusche g.a. 1 oz. 13–14 d. n.a. *6 mins.*	g.a. 1 oz. 10–11 d. n.a. *5 mins.*	g.a. 1 oz. 7–8 d. n.a. *5 mins.*
Full-strength Charbonnel autographique tusche g.a. 1 oz. 12–13 d. n.a. *5 mins.*	g.a. 1 oz. 10–11 d. n.a. *5 mins.*	g.a. 1 oz. 6–7 d. n.a. *5 mins.*

*g.a. = gum arabic.

**d. n.a. = drops of nitric acid.

N.B. For $\frac{1}{2}$-strength washes, reduce n.a. by $\frac{1}{3}$.

For $\frac{1}{3}$-strength washes, reduce n.a. by $\frac{1}{2}$.

For $\frac{1}{4}$-strength washes, reduce n.a. to 1 drop.

For $\frac{1}{10}$-strength washes, reduce all formulas by 2 drops n.a.

PREPARATION FOR PRINTING

Now that lithographic drawing on the stone rests beneath a protective gum etch, you will turn to the other preparations necessary before you can make a print.

Paper

The paper required for a lithograph must be soft enough to make good contact with the ink, yet hard enough to hold together without tearing

when run through the press and "peeled" from the stone. The question then arises as to what paper or papers will meet these requirements though actually, nowadays, prints are made on almost anything from newsprint to two-dollar sheets of fine paper. Beginners can obtain fair to excellent prints on Fiesta Cover Stock or Basingwerk Parchment, especially when printing with black ink. Professionals employ a wide variety of papers including Rives BFK, Arches, Crisbrook Waterleaf, Copperplate Deluxe, German Etching, J. Barcham Green, and Magnani Italia, to name but a handful.

Those who desire to experiment further with different colors, weights, and surface qualities of paper are referred to the section on paper (pp. 323, 325). You will find that each kind has an optimum set of conditions for printing quality and that your choice of a "good" paper will be closely related to your own manner of drawing on the stone. You should try a number of good papers before selecting one for your personal use.

Prior to printing from Fiesta Cover Stock or an equivalent paper, carry out the following steps:

1. Sponge the paper on both sides. Although present practice questions the wisdom of automatically damping paper for lithography, there are occasions when it absolutely must be dampened in order to make it soft enough to take the ink well.
2. Stack the paper, in groups of 7 to 10 sheets, between wet blotters in a damp press. Place the cover on the damp press, and weight it down with a large lithographic stone.

 You may prefer to use a *damp book* made of oilcloth, rubber sheeting, or a strong, flexible plastic sheeting. If so, cut a piece that is about $2\frac{1}{2}$ times the size of your blotters. Wrap the dampened paper between the wet blotters in this "cover." Then place a large drawing board on top and a stone on top of the drawing board.
3. Leave the paper in the press or damp book overnight to allow it to dampen evenly.

Ink and Roller

The next step in the printing procedure is concerned with the preparation of the ink and roller. First, you should understand the part played by the roller in the printing process. The leather lithographic hand roller is an instrument of primary importance in the production of an edition of fine prints. It must be in excellent condition so that it can impart ink perfectly to the grease-drawn areas upon the stone. The leather roller has certain other functions: It must be able to remove ink from the stone when rolled quickly across the surface; it should be able both to reduce the dampness of the stone surface and to increase it when necessary (by appropriate pressure and speed of rolling); it should

pick off lint and paper particles, and eliminate *hickies* (ink spots with a white halo, caused by dirt or skin in the ink). When the roller performs these functions satisfactorily, it is in good condition.

The traditional lithographic hand roller is similar in appearance to an old-fashioned rolling pin. Averaging about 14 inches in length and 4 inches in diameter, it is made of a solid wood core, covered with a heavy flannel cloth which has an outer covering of horse or calf skin mounted rough side out. The seam on a good roller is barely visible, and it can remain so if it is not scraped over when it is being cleaned or when ink is being removed by a spatula. The handles of the roller are fixed rigidly to the core. The roller is used with two leather hand-grips, or cuffs, which protect the hands and at the same time allow the roller to turn easily when it passes over the ink slab and the stone. These leather grips or cuffs can easily be made from heavy scrap leather by cutting two rectangles measuring $3\frac{1}{2} \times 4$ inches. Grips are also available from a roller manufacturer.

The ink you will use is black lithographic crayon (or chalk) ink, sometimes called *stone ink* because it is specifically manufactured for printing lithographs by hand. (While commercial printing inks are sometimes used, as noted on pages 320–323, they create problems because of their fast-drying properties.) Black crayon ink can be purchased in 1-pound cans, a convenient size for both workshop and classroom. It is quite stiff and must be removed from the can with a heavy ink knife or its equivalent. Temperature and humidity will affect lithographic ink, though this is difficult to believe when first you try to scrape ink from a pound can. Do not dig the ink out of the container. For each printing session it is recommended that you scrape from the surface of the can no more than a heaping tablespoonful of ink. Put the ink on an ink slab or a piece of plate glass or marble that is wider than the roller and long enough to provide a *good roll* (close to 2 feet). You must then work up the ink with the knife until it will flatten slowly by the force of gravity when piled up in one corner of the slab (Fig. 65). Here is one method:

65. Working the ink on an ink slab.

1. Employing a heavy ink knife, bear down with considerable force upon the gob of stiff ink and pull the knife across the whole ink slab as many times as it takes to cover the entire slab with a thin ink film.
2. Scrape the ink together again and repeat the process until the original consistency of the ink has been radically altered—until a mound of it will flatten slowly on the slab.

If you are printing on a particularly cold morning, you may need to add a very small amount of lithographic varnish to the ink to achieve the proper state.

Another method for preparing ink is as follows: Bear down on the gob of ink with the ink knife. Rock and twist the knife from side to

side as you let the knife travel toward you in a straight line. When you reach the end of the slab, or have overridden the ink, turn the ink knife over and scrape up all the ink. Turn the knife over again so that the ink is once more on the bottom side and repeat the operation until the condition of the ink meets the gravity test mentioned above (a slow flattening on the slab).

Be certain that the ink is free from scum, bits of dried ink, and other flaws. To keep lithographic ink from skinning over after the can is opened, cover the surface of the ink in the can with dipentene, or water, or with Ink-o-seal or a similar commercial product.

The Wash-out

The wash-out will remove the acidulated gum etch that has by now dried on the stone. Prepare in advance $1\frac{1}{2}$ ounces of strained gum-arabic solution.

1. Remove the etch by hosing it down with water. Verify the removal by passing your fingers lightly over the margins of the stone; you once again feel the peculiarly slick surface that you noticed after graining.
2. Gum up the stone with pure, strained gum-arabic solution, rubbing it down to a fine, thin coat with a clean pad of cheesecloth. Polish this coat of gum to a very thin layer.
3. Fan the stone dry.
4. Pour a liberal amount of lithotine (or turpentine) in the center of the stone and, with a clean woolen rag or a small sponge, carry it all over the stone so as to wash out the drawing (Fig. 66). Do not be alarmed at the sight of the stone; it will appear that you have "erased" your crayon and tusche drawing. This is not so. The lithotine has merely removed the lampblack from the crayon or tusche. Lampblack is chemically inert and plays no part in the chemical process of printing; it has served its purpose by enabling you to see the relative values in your composition while you were drawing. The grease-drawn areas which are essential still remain in the same position in which they were drawn or brushed on, and in the same condition to receive precisely the amount of ink which will reflect your original lights and darks. When you have thoroughly washed out your composition, you proceed to the rub-up.

66. The wash-out with lithotine.

The Rub-up

The rub-up is one of the messier aspects of the process, and the fastidious person may wish to arm himself by wearing rubber gloves. Prepare in advance a supply of thinned ink (or thinned asphaltum) and a half-and-half mixture of gum-arabic solution and water. To prepare

left: Plate 7. HENRY PEARSON. *Red and Blue,*
from the series *Horizons.* 1964.
Color lithograph, 30 x 22".
Tamarind Lithography Workshop, Inc., Los Angeles.

below: Plate 8. SAM FRANCIS. *Untitled.* 1969.
Color lithograph, 38¼ x 26".
Tamarind Lithography Workshop, Inc., Los Angeles.

Plate 9. ALLEN JONES. *Concerning Marriage No. 1.* 1964.
Color lithograph, 29⅝ x 22″. Richard L. Feigen & Co., Inc., Graphics, New York.

thinned ink, liquefy black lithographic ink with lithotine. Asphaltum may be thinned with the same solvent. Either of these mixtures should be kept in a closed container.

1. Saturate a sponge (an old one may be used) with thinned lithographic ink (or thinned asphaltum) and, moving in tight little circles across your drawing, rub it into the stone (Fig. 67).
2. Follow quickly with a second sponge saturated with a half-and-half mixture of gum-arabic solution and water, moved about over the stone in a similar way. This will retard the action of the inked sponge. Continue until the drawing is "up." To check your progress, you may wipe the stone as clean as you can with the gum sponge. When the entire drawing is visible, it should appear slightly darker than when it was drawn.
3. Sponge the stone with a clean sponge and water.
4. Fan the stone dry.

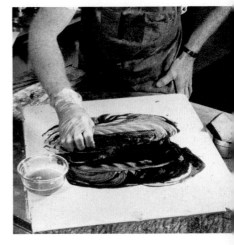

67. The rub-up.

The Second Etch

1. Dust the stone with a half-and-half mixture of talc (powdered French chalk) and powdered rosin.
2. Etch the stone with a mixture of 6 drops of nitric acid to $1\frac{1}{2}$ ounces of gum arabic.
3. Thin the gum down with a pad of cheesecloth, making certain that this is a thin layer of etch.
4. Fan the stone dry.

The Roll-up (Inking the Stone)

At this point you will move the stone to the bed of the press.

1. Wash out the rubbed-up image, through the gum, with lithotine and a sponge or clean rag.
2. Sponge the stone thoroughly with clean water, using a clean sponge. Keep the stone damp at all times when it is *open*, that is, when grease-drawn areas are unprotected by a layer of ink.
3. Charge a leather roller with a minimum quantity of ink. Pass the ink-charged roller over the ink slab several times to freshen it up.
4. Dampen the stone with a sponge, and quickly pass the roller up and back across the entire stone (Fig. 68). You do not need to lean heavily upon the roller handles. Continue to roll, bending your wrists and thus turning your knuckles down each time you pass the roller up and back across the stone. In this way you will start the roller in a new place each time and distribute the ink more evenly across the image on the stone. You will observe the stone slowly accepting ink from the roller, especially as the moisture on the surface evaporates from the friction created. You can slow

68. The roll-up.

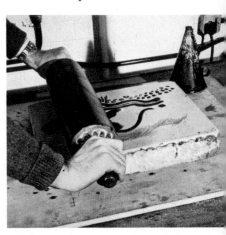

down the rolling speed, but do not slow it so much that you smut the stone and clog the open areas.

5. Before the stone dries out—and you should be watching it carefully—dampen the stone with your sponge once more and recharge the roller on the ink slab. Continue inking in this manner until the composition approximates your original drawing. At this juncture, you do not need to redampen the image area, but only the margin (to remove any scum). Your stone can now receive a sheet of paper.

PROVING AND PRINTING PROCEDURE

You are now ready to make a trial proof. It is assumed that the average person following these basic instructions will be making use of a press already available in some workshop or classroom facility. The press most commonly used for original lithographic prints is a side-lever scraper hand press such as that shown in Figure 69. The most familiar version is shown in Figure 334. (If you do not understand the operating principle of your press, or wish to select a press for your own use, you are referred to the section on presses.)

Adjusting the Stone and the Press

Make certain, first, that the stone is placed in such a position on the bed of the press that the *scraper*, the leather-covered blade that makes the impression, will travel across the entire compositional area. The scraper should be smaller than the width of the stone and wider than the drawing on the stone. The scrapers may be cut in various lengths to accommodate different sizes of stones and drawings; with time, a stack

left: 69. Pulling down the press lever.

right: 70. The scraper.

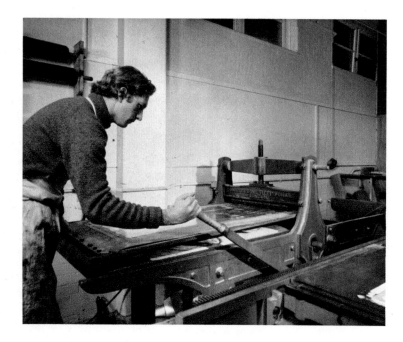

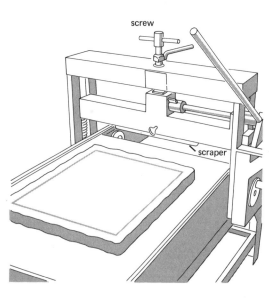

of them will accumulate in the workshop, but, if necessary, you will cut one to fit. The scraper is attached simply by pushing it up in a slot underneath the yoke of the press and securing it with a hand screw or screws (Fig. 70).

Take a sheet of newsprint and place it on the stone's surface, holding it at opposite corners in order to center it easily over the drawing. On top of the sheet of newsprint place two clean blotters, and on top of all place a *tympan* (a sheet of tympan paper, red pressboard, or glass epoxy, the last being preferred). The tympan should be well greased with mutton tallow or cup grease on its upper surface. The leather scraper also should be well greased and free from nicks and breaks, since the scraper and the tympan will be forced to "kiss" and slide against each other under great pressure.

Rotate the screw on top of the yoke of the press in a counterclockwise position so that the scraper is drawn higher up under the yoke. Push the press bed so that the leading margin of the stone comes under the scraper, that is, until the scraper is resting *over* the leading edge of the stone, and $\frac{3}{4}$ to 1 inch or more *on* the stone.

In order to *approximate* the correct pressure for the particular stone upon which you are working, pull down the press lever until it seems to be locked in position. Turn the screw that runs from the scraper box up through the yoke of the press clockwise all the way down toward the stone until you can turn no more. Release the press lever and turn the screw approximately two turns more. This is merely a rough estimation of the required press pressure. Pressure may vary from as little as 6,000 pounds per square inch on the stone to more than 10,000 pounds. It will be necessary to adjust and readjust the pressure for optimum results, that is, until you are using the minimum pressure required to make a good print. It should be stated at this time that it is most important throughout the printing process in lithography to use a minimum of means (that is, a minimum of pressure, ink, varnish, etc.) to produce the maximum effect possible in the print.

Making Trial Proofs

Pull down the press lever and crank the stone through the press with an even motion (Fig. 69). *Do not stop* before you reach the opposite margin from your starting point; stopping at any point will cause a dark line to be made through the print parallel to the position of the scraper in the press. *Do not go beyond the stone;* if you allow the scraper to run off the stone under its present press pressure, you will crack or damage it. Allow the crank handle to come to rest, release the press lever, and, being sure to hold the tympan down firmly with your left hand, smartly pull the press bed back to its original position with your right hand.

Remove the tympan and blotters, and then slowly peel the print from the stone (Fig. 71). *Immediately* go over the exposed stone with

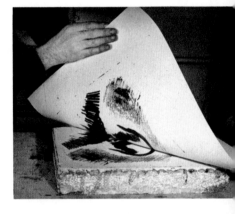

71. Peeling the first proof from the stone.

a damp sponge. Be sure that the stone is fully dampened with water before stopping to examine the proof.

On examination, you may find that the proof is quite pale and not yet up to full strength. Proceed to roll up again and prove the stone on newsprint until the print is rich and equal to your original drawing. Then make a proof on a sheet of good printing paper. The difference between a proof on newsprint and one on a fine sheet of paper is always astonishing.

At this point you may decide that you are ready to make your prints. However, if you are not satisfied with your drawing, as you now see it in a good proof, you will want first to make revisions.

Revisions, with a Third Etch

If, after studying the trial proof, you decide that you want to make changes in your drawing, you can either remove lines and areas or you can add work; or, you may wish to do both things at once by working in their respective localized areas. If your revisions are extensive, local regraining of the stone may be needed, and is possible. The bottom of a glass stopper, which is usually finely ground, makes an excellent tool for this purpose, as many professional printmakers have separately discovered for themselves. If regraining is done, all the steps of the process have to be repeated for the affected areas from making the drawing onward. If the mistake is serious enough to require regraining, you may feel that you have learned sufficiently from it and that it is easier and more rewarding simply to start with a fresh stone.

To Remove Lines or Tonal Areas. Ink the stone as though you were going to pull another print. Fan the stone dry. Press a half-and-half mixture of talc (powdered French chalk) and powdered rosin into the inked design and, with a damped sponge, remove the excess powder from the stone surface.

Work into the stone by scratching, scraping, or grinding with any device or instrument that accomplishes your purpose. Do not dig any deeper into the stone than you must. (You are not making a bas-relief; all that is necessary is to expose the surface of the stone.) Suggested tools and materials include razor blades, lithographic needles, a strong solution of nitric acid, sandpaper, steel wool, sharp knives, Erasol or an available commercial equivalent, and gum arabic. Sponge the stone once more with water. Spread a medium etch over the stone and, with a watercolor brush, paint a frothing etch (about 50 or so drops of nitric acid in $1\frac{1}{2}$ ounces of gum arabic) over the newly worked lines or areas. Do not allow the frothing etch to be wiped across the stone; keep it *localized.* Remove the excess with newsprint, and then rub the acidulated gum etch down hard with a fresh pad of cheesecloth. Then wash out, roll up, and print.

To Reopen the Stone and Add Work. Reopening the stone to add work is called *resensitizing* or *counteretching.* As above, ink the stone, fan it dry, apply the rosin-talc mixture, and remove the excess powder.

Wash the stone with a mixture of 1 part glacial acetic acid added to 6 to 30 parts of water (using a weaker solution for delicate drawings and a stronger one for black, dense, or heavily scratched drawings). Move the counteretch solution about on the surface for approximately $1\frac{1}{2}$ minutes. Flood the stone with water and fan dry. At this juncture, redraw or add new material. Then spread a mild etch over the stone. Blot the etch with newsprint, polish lightly, and dry. Then wash out, roll up, and print.

Pulling Prints

When you are satisfied with the proof, regard it as your *bon à tirer* (see p. 7), that is, the authorized proof by which the quality of each print pulled is to be measured. Proceed to pull prints, keeping the stone damp with a wet sponge at all times so that the ink is not allowed to dry out. Re-ink the stone for each print desired, using a minimum of ink, enough to keep your blacks rich and your grays in scale but no more. Check each print carefully against the *bon à tirer.* If the margins smut badly, clean them off with snake slip and a mixture of phosphoric acid and gum-arabic solution, adding sufficient acid to accomplish the cleaning.

Prints on heavier papers can be interleaved with dry blotters and set aside to dry. If you are using a thin paper, tack or tape the sheet to a board. Keep all drying prints (in fact, *all prints*) out of direct sunlight.

VARYING THE PRINTING PROCESS

There are many methods of desensitizing and printing from a stone, and each printmaker, sooner or later, appears to evolve his own, sometimes a new one. Furthermore, each method of drawing on a given stone may require special consideration in the printing process. Experience with more and more stones will enable you to take liberties with any given procedure and eventually to evolve the one you prefer. As a step in that direction, a brief sampling of other methods is provided below.

A Simple Demonstration Print

You may recall that at the beginning of this chapter (p. 46) four steps were named as basic in the process of lithography. The following is a quick way of demonstrating those steps to persons not familiar with the lithographic process at all. It was devised by the author primarily to convince beginning students that the process is direct,

straightforward, and not too difficult. Usually, at the first meeting of the class, a freshly grained stone was offered as the surface for a group "doodle." Each person was urged to make some mark, line, or form on the stone with lithographic crayon or tusche in order to see if and how it would print. The last person to work on the doodle was requested to "pull it together." Then it was printed (in less than an hour) using the following technique:

1. Etch with about 60 or more drops of nitric acid added to $1\frac{1}{2}$ ounces of gum arabic. Since editions are not pulled from these demonstration stones, the etch is not too critical. Thin and dry the etch.
2. Sponge thoroughly with water.
3. Apply pure gum-arabic solution. Thin and dry.
4. Wash out with lithotine.
5. Sponge stone with water. Repeat, with dampened sponge.
6. Roll up. Print.

A Traditional Editioning Procedure

The following twelve steps, based on one of the traditional methods, summarize the total requirements for pulling an edition of prints. Assume that the drawing was accomplished entirely with crayons (Nos. 2, 1, and 0).

1. Tamp a half-and-half mixture of talc (powdered French chalk) and powdered rosin into the drawing. Remove the excess powder.
2. To 1 ounce of gum-arabic solution add 10 drops of nitric acid and 3 drops of phosphoric acid. Pour this etch into a glass bowl. Dampen a 3-inch rubber-set brush with water. Soak the etch into the brush. Brush the surface of the drawing for 3 minutes, moving the etch from the light to the dark areas of the stone.
3. Rub down the etch to a very thin coat with a pad of cheesecloth. Fan dry.
4. Wash out the stone with lithotine and rub up with an application of diluted printing ink or thinned asphaltum.
5. Sponge the stone with water and roll up with black crayon or proving ink. Use only a small amount of ink on your leather roller.
6. Pull about 6 proofs and stop. If there is no appreciable darkening or smutting of the stone, re-ink. Dry. Powder as in step 1.
7. Gum-etch with 5 drops of nitric acid and 2 of phosphoric acid added to 1 ounce of gum-arabic solution.
8. Repeat steps 3 through 6.
9. Pull about 30 prints.
10. Re-ink. Powder as in step 1.
11. Repeat steps 3–6 and pull 30 more prints.
12. Continue for the remainder of the edition.

Method Employed by the Taller de Grafica Popular, Mexico City

1. To 1 ounce of gum arabic add 4 drops of nitric acid. The gum arabic mixture is used in a thick, viscous state by this excellent group of printmakers. Mix well and spread with the hand. Blot with newsprint and fan dry.
2. Wash off acidulated gum with water.
3. Add turpentine and wash out the crayon and tusche. Sponge the stone clean.
4. Roll up with black crayon ink. Sponge the stone with water. Roll again, until the image reaches full strength.
5. Pull no less than 2 proofs.
6. Re-ink the stone and fan it dry.
7. Tamp rosin over the inked design. Remove excess powdered rosin with a cotton wad.
8. Do the same with talc (powdered French chalk).
9. Snake-slip the edges and make corrections.
10. Etch with 30 drops of nitric acid to 1 ounce of gum arabic. (Protect very delicate grays by first painting them out with pure gum arabic.) Blot with newsprint and hands, and thin to a very fine coat.
11. Leave overnight to dry.
12. Wash the stone with water and regum with pure gum arabic applied as a very fine, thin coat. Fan dry.
13. Wash out with turps.
14. Sponge the stone clean with water.
15. Roll up, and print edition.

Bolton Brown's Technique

Bolton Brown, author of influential works on lithographic techniques in the 1920s, provided this very graphic account of the method he evolved for his own use. (Bolton Brown, *My Personal Usage in Getting a Stone Ready to Print*, 1921.)

Every drawing varies, of course; but assume an ordinary design drawn on grey stone with Korn's crayon, from which I desire to pull prints neither lighter nor darker, but just as it looks.

I will probably apply a layer of gum, working some water into it immediately with my hand. When thinned and evenly distributed, I pour on a little solvent naphtha, or turpentine, perhaps carrying a little kerosene or linseed oil—at the same time charging a dry woolen rag with the same.

With the rag I sop the crayon entirely off, then sluice the stone with much clean water, washing it finally with a clean cloth or sponge and water. I invented and domesticated this heresy.

The roller being now passed, the design now reappears, not doubtfully and with pain, but firmly and willingly. I do not overload it, but work on a water film that grows constantly thinner by evaporation. The tendency is for the stone

to roll rather lighter as it gets dryer, the stopping-point being a question of judgment.

I fan the stone dry, dust on pulverized gum mastic, using my hand, brush off excess with a wad of cotton, apply talcum powder (French chalk) similarly, and am then ready to etch.

To as many drams of gum as there are units of 32 square inches in the stone, I add my acid in the proportion of 48 drops per liquid ounce. That is to say, if the stone has 224 square inches, I pour into my graduate 7 drams of gum (224 ÷ 32 = 7), to this adding 42 drops (from the dropper, or else 28 minims by measure) of acid (48 ÷ 8 = 6; 6 × 7 = 42). This is well stirred. It is made fresh each time. [The formula for the acid used by Bolton Brown is 3 ounces 65 percent nitric acid (chemically pure); 10 ounces 33 percent muriatic acid (chemically pure); 13 ounces distilled water.]

With brush or fingers, I apply a trifle along the edges and over the borders of the stone. If these need cleaning, I here grind them off with pumice, then give a similar quick thin coat of the etch all over the design. The mass of the etch still is held in the graduate. If stray specks exist or I desire to add lights, I quickly, through the wet film, cut or scrape them out. The stone is now as it is supposed to print.

I throw on the main body of the etch, instantly distributing it with a thin, flat, soft brush, several inches wide. A thick brush drinks up too much of the etch, and I am apt to discourage even a thin one from doing this by wetting it a little to begin with. I brush the fluid about, sometimes favoring the design, until it no longer tastes sour; push the excess off the stone; and let it dry.

It may be printed at any time after a few hours, but it is safer if a few days are allowed.

Method of Albert W. Barker

The following method, devised by Albert W. Barker, makes possible the printing of a lithograph without an etch.

1. Pour gum arabic on the stone.
2. Let it stand, and delay evaporation by resting a sheet of glass a fraction of an inch above the stone. (Rest the glass on tiny strips of cork.)
3. Tip up the stone, and allow it to drain and dry.
4. Next day, wash out and roll up in the usual way.
5. Fan the stone dry, and dust with talc. Again, gum down and allow to stand for several days.
6. Wash out and roll up lightly. . . . Sponge freely with magnesium-chloride solution and allow to soak for 5 to 10 minutes. To make this solution magnesium chloride is added to water to produce, when measured with a hydrometer, a specific gravity of 1.0222 (about that of sea water). If, lacking a hydrometer, you make too strong a mixture, your blacks will not ink up. The stone, however, is unhurt; simply wash off thoroughly with water, dilute the mixture, and try again.
7. Finish rolling up. Use magnesium-chloride solution throughout the entire printing instead of damping water.

SOME CONTEMPORARY LITHOGRAPHS

The lithographer of today, looking at an exhibition of prints by his contemporaries, may very likely be struck by two observations simultaneously. One is, of course, the tremendous amount of technical innovation that makes possible a variety of effects not conceivable a generation ago. The other is, almost ironically, the renewed realization that lithography, from the time of its invention, provided artists with an extremely flexible medium which can still, even within its traditional techniques, serve the most advanced of aesthetic concepts.

In the prints reproduced here, while most are in color (as most prints are today), the drawing on the various stones or plates was executed with the traditional tools and materials that have already been introduced in this chapter. Figure 72, for example, a recent print by Clinton Adams (b. 1918), is completely traditional in its execution, having been made entirely with lithographic crayon. Adams has done many other prints by complex and experimental methods, but he admits that "the seductive feel of the stone beneath the crayon never loses its attraction" and that he finds lithography "uniquely responsive to images of great subtlety." A distant descendant of Cubism, with Surrealist affinities, Adams created this as one of a series of images concerned with ambiguous references to the female nude within an abstract context. The atmospheric depth of the composition reflects his interest in a metamorphic relationship that links the landscape of the American Southwest to the forms of the figure.

72. CLINTON ADAMS. *Figure in Green.*
1969. Color lithograph, 18 × 20".
Tamarind Lithography
Workshop, Inc., Los Angeles.

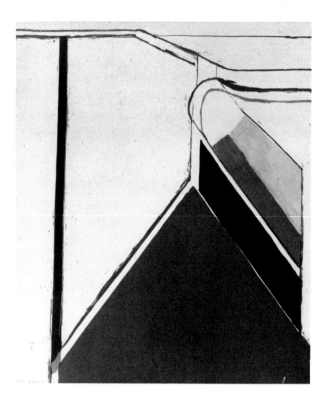

Doyle's Glove (Fig. 73) by Jack Beal (b. 1931) was, he reports, his first lithograph except for a few experiments in a one-semester course in the graphic arts—a demonstration of the fact that the artist who has an idea will find a ready way to cut through technical difficulties. Beal chose lithography as the medium that seemed to him "closest to painting." This print, abstracting a simple, homely object, was executed in crayon and tusche, with tracings made for the five colors from a master sketch in pastel.

In Figure 74, a print by Richard Diebenkorn (b. 1922), the artist has deliberately approached lithography as if he were making a painting; he has utilized here the principles of collage and the superimposition of forms and shapes to create this abstract design. The image developed, he says, "by application and deletion." After brushing on washes made of stick and liquid tusche, Diebenkorn eliminated areas by using a rubber hose. He proved the work a number of times, changing color balances and adding areas by counteretching until the final result was obtained. This spontaneous freedom in creating on the stone or plate, as the painter so easily does on canvas, was too often thwarted by some of the earlier teachers of meticulous lithographic craftsmanship.

The overall design (Fig. 75) by Bruce Conner (b. 1933), with its provocative suggestions of faces and symbols, was created with ordinary drawing pens and Charbonnel Zincographique liquid tusche against a background of brushed-on Korn's tusche. The completely spontaneous

left: 75. **Bruce Conner.** *Return to Go.* 1967.
Color lithograph, 30 × 22″. Collectors Press, San Francisco.

above: 76. **Peter Voulkos.** *Untitled.* 1967.
Color lithograph, 30 × 22″. Collectors Press, San Francisco.

drawing was carried out from one end of the stone to the other, with no alterations, and occupied two and a half days of the artist's time. The image, related in style to the calligraphic aspect of Abstract Expressionism, was realized in a black-brown color.

The sculptor Peter Voulkos (b. 1924) derived the image for Figure 76 from collage shapes, but he actually executed it in the drawing materials of lithography—Korn's liquid tusche applied with a brush on zinc plates. The artist was attempting to interpret in the two dimensions of the lithographic medium the emphatic three-dimensional quality of his abstract sculpture.

The print in Plate 7 (p. 61) by Henry Pearson (b. 1914) is one of a series of *Horizons*, though the horizon is real only in the sense that it represents a contact or collision of forces—a large mass of symbolized pulsations bearing downward on a small opposing mass. To approach this concept the artist used a sable watercolor brush and Charbonnel's Zincographique ink, to provide, as he says, an "unsubtle flatness." In the printing (two colors on zinc plates) the red was given some transparency in order to allow the white of the paper to provide luminosity,

77. Dick Wray. *Untitled.* 1964.
Lithograph, $14\frac{1}{4} \times 19\frac{1}{4}''$.
Tamarind Lithography Workshop, Inc.,
Los Angeles.

and the cool blue was given some white in order to make it more opaque and allow it to be overprinted on the red. This print demonstrates the way in which the lithographic drawing technique can be used to meet the meticulous demands of optical (or Op) art. The artist feels, however, that he "was placed" arbitrarily in the Op category, when actually he had been concerned for some time with the effect of linear relationships, which he views as timeless and universal:

> It is done more expertly by cartographers, topographers, oceanographers, planners of weather maps; and less expertly by small children. It is done by nature in the rings of a weather-tortured tree, in the watery ripples caused by dropped pebbles and the skittering-about of water bugs, in the cross-section of a cabbage, in the drops of oil on a wet pavement, in the wind-driven sands of the dunes.

Figure 77 by Dick Wray (b. 1933) is a black-and-white lithograph done on a single zinc plate with crayon and tusche mixed with lithotine and applied with a brush. In the sense that the word *color* is sometimes applied to tonal qualities of black, the print does not lack it; the rich wash tones were achieved in part by flooding tusche off with streams of water.

Plate 8 (p. 61), an untitled work by Sam Francis (b. 1923), was executed with stick tusche, mixed with varying amounts of water and applied with a brush. This seven-color lithograph was printed in three runs, with each of the seven colors applied individually. The first run, on a zinc plate, printed separate elements of red, blue, and green. The second run, also on zinc, printed orange and yellow. The third run was on stone, providing purple and a different green. This nonobjective design has a strong focus on marginal interest, framing a relatively negative center penetrated by lively and more delicate movement.

With a deceptively simple drawing, John Dowell (b. 1941) has posed a provocative image against a blank background (Fig. 78), demonstrating to the beginner, who may tend to overwork the stone, that the surface is available for whatever the artist has to say, whether fulsome or economical. Dowell is a distinguished black artist, born in Philadelphia in 1941, a fellow at Tamarind, and subsequently on the art staff at the University of Illinois. However contemporary his theme, which bears the title *It's Time*, he seems to approach it with a sense of universality, deep subtlety, and even mysticism.

The possible range of lithography, from the softest of tones to the strongest of blacks, can be seen in *Concerning Marriage No. 1* (Pl. 9, p. 62) by the British Allen Jones (b. 1937), a work drawn on stone with crayon and tusche. The theme is, according to the artist, "a marriage of two problems—color and image," the black hat having a male (phallic) symbolism and the color harmonies being essentially feminine. This print is one of a series of eight based on the idea of "marriage as the perfect balance of all aspects of the personality," an idea which, in the artist's view, likens creativity to procreation. He is interested in the "ways in which we perceive images and what we accept as 'real.'" In other works he has embedded photographic fragments, "to include the full force of the in-focus, high definition of the photograph and match it with autographic statement."

The variety available in lithography appears in another way in the work of David Hockney (b. 1937). Hockney has often been called the "Raphael of the jet set," since he likes to take for subject matter the

78. JOHN DOWELL. *It's Time.*
1969. Color lithograph,
$30\frac{1}{8} \times 22\frac{3}{8}''$.

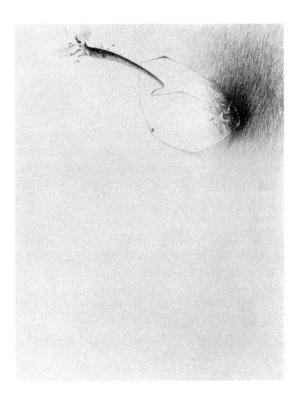

left: 79. DAVID HOCKNEY.
Picture of a Portrait of a
Ticket Taker in a Silver Frame. 1965.
Color lithograph, $30\frac{1}{2} \times 22\frac{1}{8}$".
Copyright © 1965
Gemini G.E.L., Los Angeles.

right: 80. PLA NARBONA. *Act V*
of Extraordinary Iberian Visions.
1969. Color lithograph, 30×22".
Collectors Press, San Francisco.

more plush surroundings of the so-called affluent society, bringing to his depictions a combination of gentle satire and unexpected imagery. In Figure 79 he has imprisoned a very loosely drawn, almost amorphous figure of a man in a stiff, rigid frame that provides an almost shocking textural contrast. This contrast was achieved within the lithographic medium as follows: The frame is not "silver," of course, but made to appear so by juxtaposition with a flat blue background. It was printed from aluminum in two shades of gray—a dark gray made of G.P.I. black and opaque white; and a light, transparent gray made of black, blue, white, and transparent base. Precise crayon lines completed the indentions. The drawing of the man, on the other hand, was executed freely on stone with crayon on the torso and a wash of tusche diluted with water on the face (printed in black). The remaining one of the five colors is a bright pink, drawn with crayon to provide the skin color. The pink is picked up elsewhere in the print with a splatter sprayed on with an atomizer—the only nontraditional technique employed in a very unusual print.

Pla Narbona (b. 1928), one of the leading figures in Spanish graphic arts, created the basic image in Figure 80 by executing the linear work and tonal areas with lithographic crayon on stone. To this he added three aluminum plates, including a sepia color produced with crayon and a gray plate executed with brush and tusche; intermediate values of gray were created by making the ink very transparent. The theme deals with the nature of Iberian thought as suggested by eighteenth-

century Spanish drama. This work is instructive in regard to handling the preliminary sketch. The image evolved, not from a single drawing, but from various sketches, and was freely improvised and modified on the stone as the lithographic medium dictated. The somewhat Surrealist combination of faces or masks may suggest collage but was derived in actuality from the multiple sketch.

Another Spanish printmaker, Antoni Clavé (b. 1913), though also a painter and recently an etcher, may be described as primarily a lithographer. He has executed close to three hundred lithographs, the larger number of them for book illustration—a field in which he is considered to be one of the major exponents of his time. This richly worked print (Fig. 81) demonstrates the freedom and versatility available to an artist so experienced in a particular medium.

Since lithography is a medium with infinite possibilities for minute detail and complete range of values, it is well to be reminded now and again that much can be accomplished with very little. Tetsuo Ochikubo (b. 1923) plumbs the subconscious to find nature-oriented "symbols and nonsymbols," which he presents with the fluid brushwork and the economy of design that one tends to associate with Oriental artists. Figure 82 was printed in five colors on four stones—yellow, dark yellow, dark gray, and a combination of black and gray-brown applied with separate rollers on the same stone. The entire drawing was executed with tusche, using a brush and, in the case of the yellow stones, also a sponge. For halftones, diluted nitric acid was used over rolled ink.

left: 81. Antoni Clavé. *The Concert.* 1952. Color lithograph, $16\frac{3}{8} \times 22\frac{1}{4}''$. Prints Division, New York Public Library (Astor, Lenox and Tilden Foundations).

right: 82. Tetsuo Ochikubo. *Untitled.* 1961. Color lithograph, $25\frac{1}{2} \times 18''$. Tamarind Lithography Workshop, Inc., Los Angeles.

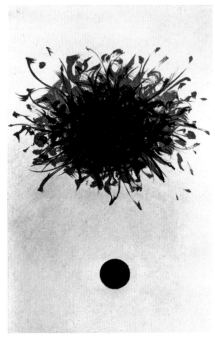

Making a Lithograph on Stone 77

Making a Lithograph on Plate

Chemical printing was the term employed by Senefelder to describe his invention of lithography on stone. This accurate description of the process suggested that zinc and aluminum plates would be equally receptive to lithography. Senefelder himself patented the use of the zinc plate, and Joseph Scholz, in 1892, received a patent for lithography on aluminum. Glass, iron, rubber, paper, and, in recent times, plastic have also come into use.

The advantages of using zinc or aluminum plates instead of stones include the obvious weight factor (the plates used vary from .012 to .025 inches in thickness), the relatively inexpensive cost per plate, and the variety of types and grains available, including deep-etch, multi-metal, and surface plates, and ever-new variations of these (developed to meet the needs of the burgeoning offset printing industry, but also serving experimental printmakers).

Improved chemical and other procedures for making metal plates have eliminated most of the disadvantages formerly experienced by artists, who once found that they had limited freedom in drawing, erasing, and redrawing on metal and who had difficulty in finding suppliers of plates. Numbers of workshops now prefer plates over all other surfaces for lithography, some favoring zinc and others aluminum. It is advised that you try both and discover your own preference.

The preparation and processing of metal-plate lithography is similar to that required for lithographs on stone, with certain few exceptions:

(1) Most plates must be counteretched before being drawn upon. (2) Different etches are employed. (3) Certain deep-scratching techniques are not advisable.

A basic procedure follows for making a plate lithograph on either zinc or aluminum. All steps are included for the entire process; however, it is recommended that those making a first lithograph on plate, without having used stone, refer to Chapter 2 for a *fuller description* of the tools, procedures, and materials that are used with both stones and plates. For this purpose, the procedures that are the *same as for stone* have been noted.

RESENSITIZING (Counteretching) A METAL PLATE

Resensitization or counteretching removes any residue of dirt or foreign substance from the grain, clears away oxides from the metal surface, and prepares the plate to receive your drawing by making it sensitive to grease. If you entertain any doubts as to the freshness of a metal plate already prepared, it would be advisable to counteretch it.

1. Place the plate in the graining sink, or in a hard rubber or enameled photographer's tray.
2. Wash the plate thoroughly with water. Pour off the water.
3. Mix *one* of the following counteretch solutions in sufficient quantity to cover well a plate of the size you use.

 For zinc: Mix a saturated solution of powdered alum and water to which you can add the slightest trace of nitric acid, *or* add 1 liquid ounce of hydrochloric acid to a gallon of water, *or* prepare a commercially made counteretch solution per the manufacturer's instructions, e.g., 1 part Prepasol to 8 parts of water.

 For aluminum: Add 4 liquid ounces of phosphoric acid to 1 gallon of water, *or* 4 liquid ounces of acetic acid to $2\frac{1}{2}$ quarts of water, *or* 8 liquid ounces of sulphuric acid to $2\frac{1}{2}$ quarts of water, *or* $\frac{1}{2}$ liquid ounce of nitric acid and $1\frac{1}{2}$ ounces of potassium alum to $2\frac{1}{2}$ quarts of water.
4. Flood the plate with your counteretch solution and move it about on the plate with a clean, soft brush for about a minute. (Some printmakers believe that one must move the solution about in *tight little circles.*)
5. Drain off the counteretch solution.
6. Flood the plate with water and wash it thoroughly.
7. Dry the plate immediately by blotting with clean newsprint and fanning it dry.

The plate is now highly sensitive to grease. Some printmakers, at this stage, insist on painting in a 2-inch margin of gum arabic all

83. Drawing on a metal plate.

around the plate to keep the margins free from grease; others are not so concerned.

DRAWING ON A METAL PLATE

Soft lead pencils, lithographic crayons and pencils, felt-tipped pens, ballpoint pens, oil pastels, and tusche mixed with water, turpentine, or lithotine can be used freely on the plate when working the drawing (Fig. 83). The methods used and the effects obtained will seem familiar to those who have worked on stone, with a few exceptions.

Drawing on Zinc

It is not advisable to engrave or scratch deep lines in a grained zinc plate. Minor erasures may be made with a pencil eraser, a razor, or a typewriter eraser, after which the erased area must be resensitized. More extensive erasures can be made with benzine or carbon tetrachloride rubbed gently into the area to be removed with a clean, soft cloth; resensitize locally.

It is possible to obtain varied effects with tusche washes on zinc plates: Tap water mixed with tusche produces the not uncommon texture called *peau de crapaud* ("toad skin"). Distilled-water tusche provides its own "look," as does turpentine tusche. These washes can be painted on dry areas of the plate, on areas wet with tap water or with distilled water, on wet gum-arabic "spots," or on other experimental wet or dry plate surfaces—all of which, obviously, produce particular textures.

Drawing on Aluminum

Avoid scratching or other techniques that would abrade the surface of the aluminum plate. For erasures some printmakers use lacquer thinner in local areas.

PREPARATION OF THE ETCH

A variety of etches is available to the printmaker from commercial sources. If you use a commercial proprietary etch (e.g., Hanco Acidified Gum Etch No. 571), merely follow carefully the directions for use. The chemistry has been worked out for you.

The remainder of this section has been included *for those who prefer to mix their own etches.* Two basic formulas are offered:

An Etch for Zinc Plates

Dissolve $2\frac{3}{4}$ avoirdupois ounces of tannic acid in 40 liquid ounces of water. To this mixture, add 4 avoirdupois ounces of chrome alum, and

stir. When these chemicals have dissolved, add $2\frac{3}{4}$ liquid ounces of phosphoric acid and 88 liquid ounces of gum-arabic solution, 14 degrees Baumé. (The concentration or density of solutions is measured on the Baumé hydrometer.) Keep stirring the solution until all the ingredients are thoroughly mixed. Pour the etch into a glass bowl.

An Etch for Aluminum Plates

Add 1 liquid ounce of phosphoric acid (85 percent) to 32 liquid ounces of gum-arabic solution, 12 to 14 degrees Baumé. Stir thoroughly. The *pH* value of this etch should lie within the range of 1.8 to 3.5. (An explanation of pH follows.)

Measuring Acidity or Alkalinity on the pH Scale

The *pH value* indicates the immediate acidity or alkalinity of a solution or material. If the optimum pH readings were known for all the materials and solutions used in metal-plate lithography, presumably successful editions would always result. There are too many variables at work simultaneously to ensure success for all printmakers all the time. Despite this, it is an advantage to understand and use pH—even in a limited way.

pH Readings for Certain Common Lithographic Solutions

Acetic acid counteretch	pH 2.8–3.0
Aluminum plate etch (gum and phosphoric acid)	pH 1.8–3.5
Aluminum plate counteretch (water and phosphoric acid)	pH 2.0
Cellulose gum etch	pH 2.0–3.5
Fountain solution	
(*e.g.,* Harris Non-Tox; mix 1 oz. to 1 gal. distilled water)	pH 5.0–5.5
Gum arabic solution (not acidified)	pH 4.2–4.3
Sodium hydroxide (*lye*)	pH 13.0–14.0
Trisodium phosphate (TSP)	pH 12.0
Water, pure distilled	pH 7.0

Acidity or alkalinity is measured on the pH scale from 0 to 14. Pure, distilled water has a pH of 7; it is neutral. Acid solutions have values lower than 7. The stronger the acid, the lower the pH. Alkaline solutions have values higher than 7. The stronger the alkalinity, the higher the pH value.

The pH measurements stand in logarithmic relationship to each other: for example, your aluminum plate counteretch (pH = 2) is ten times as acid as acetic acid counteretch (pH = 3), 100 times as acid as a pH of 4, and 1,000 times more acid than a pH of 5, etc.

There are two methods of pH measurement employed in the graphic arts industry. The *electrical* method involves the use of a portable, battery-operated pH meter or a 110–120 volt, 50–60 cycle, a.c. meter, which is read by comparing the voltage of a solution of known pH with one that is unknown. Such meters are accurate within 0.05 pH units or less, and are too sophisticated for the average print workshop. You are more likely to use, therefore, a method of *colorimetric* testing by means of short-range pH papers (including litmus papers) and liquid indicators that are composed of colored, complex, organic compounds. Both tests are founded upon color changes, the former being used for solutions and the latter for surfaces.

Short-range pH Papers. To ascertain the pH of a solution, immerse a 1- or 2-inch strip of *pHydrion* or equivalent paper in the solution for no more than a few seconds. Remove it and compare the color that now appears on the paper strip with the pH color chart provided with the product. If necessary, keep testing with different strips until the color resulting on a strip falls, not at the end, but *between* the colors at either end of the chart. Accuracy obtaining from this test varies between 0.3 to 0.5 pH units.

Colored Liquid Indicators. To measure the pH of ink, paper, or other material, dip a glass rod into one of these indicators and swab it or allow it to flow on to the material being tested. Note the color change to determine the pH. These liquid indicators all change color over a range of about 2 pH units; below and above this limit they remain static. Thus, you may have to try several different indicators before you obtain a proper answer. For example, Bromcresol Green is yellow at a pH of 4.0; it changes through various hues of green until, at a pH of 5.6, it turns blue. If a swab of this indicator turns blue, you know that your material has a pH of 5.6 *or higher,* so you will test it with an indicator in a higher range. Suppose that you try Thymol Blue, which is yellow at a pH of 8.0, ranges through various hues of green, and becomes blue at a pH of 9.6; if the swab turns green your material has a pH within that range.

Here are the color properties of a few other indicators:

Bromcresol Purple is yellow at a pH of 5.2; it becomes purple near a pH of 6.8.

Methyl Red is magenta at a pH of 4.4 or below; it turns yellow at or above a pH of 6.0.

Phenol Red is yellow at 6.8; it turns red at or above a pH of 8.0.

Application of pH to a Problem. An example of the usefulness of pH is the following: It is known that the pH of a particular etch for zinc plates (gum arabic, ammonium bichromate, and phosphoric acid) will increase from 3.5 to 4.5 in about $1\frac{1}{2}$ minutes when applied on the plate.

The fact that the etch shows definite weakness so quickly may explain why your plates scum up on the margins. The results may suggest that you try *two* applications of the etch, so that you are sure to obtain good desensitization all over the plate.

Singer's Basic Salt Etch

Arnold Singer, a New York printmaker, searched for and found a "universal" etch for metal-plate lithography (see *Artist's Proof, No. 8,* 1965, pp. 40–41). He states that it works admirably for crayon areas, rubbed tones, solid tusche areas, and transfer work, though it may not perform well for tusche washes or for cleaning smutty areas. To prepare his etch, dissolve ½ ounce of sodium chloride (common table salt) in 4 ounces of a slightly warm gum-arabic solution. When the mixture cools, add 28 drops of nitric acid and 8 drops of phosphoric acid. Mix well. Singer's recommended procedure for using this etch is as follows:

1. Dust working surface of the plate with talc.
2. Brush etch evenly over entire surface (30 to 60 seconds).
3. Blot up excess etch with newsprint or newspaper.
4. Smooth remaining etch to very thin film with slightly dampened cheesecloth pad.
5. If plate is not to be printed within two hours, wash etch off with water and gum up plate.

THE FIRST ETCH (DESENSITIZING THE PLATE)

1. Dust the plate with a half-and-half mixture of talc (powdered French chalk) and rosin, and remove the excess powder with cotton wadding (Fig. 84).
2. Damp a 3-inch rubber-set brush with water. Soak into the brush the etch you have prepared for the plate you are using (either zinc or aluminum). Brush the surface of the drawing for about 3 minutes, moving the etch from the light to the dark areas of the plate. For this procedure a sponge can also be used (Fig. 85).
3. Repeat step 2.
4. Rub down the etch to a very thin coat with a pad of cheesecloth or a kim wipe.
5. Fan the etch dry.

PRINTING FROM PLATES

The preparation for printing and the proving and printing procedures are exactly the same as those described for printing from stone in Chapter 2, though some of them have been illustrated here to demonstrate the process on plate. As a reminder, you will damp your paper

below: 84. Dusting the plate with rosin and talc.

bottom: 85. Applying the etch to the plate with a sponge.

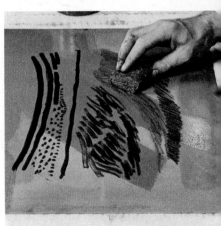

the day before. On the plate you will proceed with the wash-out (Figs. 86, 87), the rub-up (Fig. 88), and the roll-up (Fig. 89). Then make proofs; it is recommended that you pull about six to check the quality of the printing. Next, either make corrections or proceed to print.

If you intend to pull a very large edition, it will be useful to mention *fountain solutions*. Normally, you damp the drawing on the stone or plate with water while printing. It has been found that a slightly acid damping solution, on long runs, helps keep proper desensitization, so a fountain solution of from pH 4.0 to 5.5 could prove helpful. Use Harris Non-Tox on another proprietary agent as directed, or mix 1 avoirdupois ounce of ammonium biphosphate and 1 avoirdupois ounce of ammonium nitrate to 20 liquid ounces of warm water. Use this *sparingly* (less than half the time); use ordinary damping water most of the time.

below left: 86. The wash-out.

below right: 87. A clean, washed-out plate showing the previously black image as grease areas repelling water.

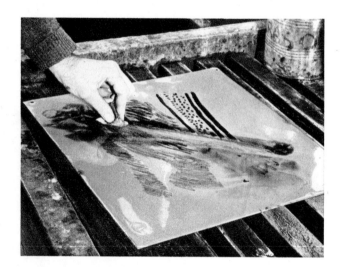

88. Rub-up with brush and thinned ink.

89. The roll-up.

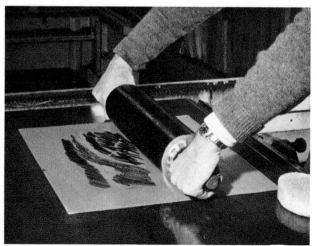

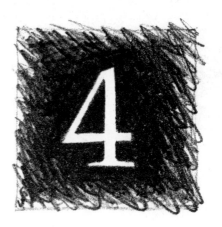

Various
Lithographic Techniques

Attempts to circumscribe what is and what is not lithography seem to be destined for the scrap heap of history. Many lithographs seen in recent print exhibitions have furnished cogent evidence that the range of approaches within this medium is almost limitless. Of the techniques described here some, such as the many possible uses of the transfer process, are an evolution of established methods. One (*photo-lithography*) is a major innovation in the lithographic repertoire. Others are offered merely as a sampling of the possibilities available in the medium. They are offered in the spirit of an exchange of craft ideas between artists. It is hoped that ever-new variations will further enrich the medium and clarify solutions to craft problems. Note that the techniques described for use on stone can be applied also to work on zinc or aluminum plates.

TRANSFERS

The term *transfer*, in printmaking, denotes any image that is offset from one surface to another. A print pulled according to the procedures described in Chapter 2 was made by direct contact with the drawing on the stone. By the transfer process a print can be pulled *indirectly:* You can first make the drawing on a special *transfer paper* and then transfer it to a stone from which the print can be made; or you can start with a drawing made on stone, transfer it to paper, and then

90. Transfer, showing the residual image on paper and the transferred image on stone.

transfer it to another stone which serves as the printing surface (Fig. 90). These are well-established methods having a variety of uses. In general they require moisture, great press pressure, and, with some papers, an assist from temperature.

There is also a process of *direct transfer*, by which the inked image of a three-dimensional object or the pattern of a material such as cloth or net, can be transferred directly onto the stone without the necessity for making a drawing.

Today the possibilities for use of the transfer process seem virtually unlimited. With the variety of commercial transfer papers available, artists employ both direct and indirect methods to transfer the imprint of materials or objects, printed matter, drawings or other art work, from stone or plate to paper to stone or plate again, and again in any sequence that meets their needs. Any two surfaces that come in contact can be transferred one to the other, chemically or mechanically.

Transfer Papers

If you use a commercial transfer paper (e.g., Kesmoi, Charbonnel à Report, German Everdamp, or the brand available from your own source of supplies) be sure to ascertain whether the paper you have purchased must be *dampened* or *used dry* and whether there are any other requirements specified by the manufacturer. (Some papers require that you first damp the stone, others that you first heat the stone.)

If you prefer you can make your own transfer paper by the following method:

1. Measure equal portions of fine dental plaster and household flour in a quantity sufficient to cover your sheet of paper.
2. Make a soft, creamy paste of the plaster; add water from time to time and stir constantly for 15 to 20 minutes.
3. Make a similar paste of the flour; stir it into cold water and allow it to boil for about 5 minutes.
4. Add the plaster paste to the flour paste and boil for 1 minute.
5. Using a soft, wide brush, apply the mixture to a strong sheet of a good grade of paper. Two coats of sizing should be adequate. Hang the sheet from a line, and let it dry.

It is suggested that you try etch procedures and formulas pertaining to crayon drawings made with Nos. 5 or 4 as models when working with transfer papers.

Transfer from Paper to Stone

1. Using lithographic crayons and lithotine tusche, execute your drawing on the transfer paper of your choice.

2. Damp the transfer paper, if called for. Place the transfer paper face down upon a freshly grained stone. The grain should be compatible with your drawing. For example, do not attempt to transfer a delicate No. 5 crayon drawing to a stone grained only with No. 80 carborundum; although most of the drawing may transfer, it will probably be evident that you will have lost certain nuances on the very coarse grain.
3. Place blotters and tympan over the transfer paper, and run through the press with *more than normal pressure* 2 or 3 times.
4. Lift a corner of the transfer paper to check results. Repeat step 3 until the drawing is transferred to the stone. If the transfer paper sticks to the stone, remove it with warm water, as with a decal. Set the stone aside for a day.
5. Gum-etch *lightly.* Thin the gum and fan dry.
6. Wash out with lithotine, and rub up, using a piece of sponge saturated with the rub-up ink, or asphaltum (thinned with lithotine), or lithotine-diluted black crayon (chalk) ink.
7. Roll up with stiffer ink. Gum-etch. Thin the gum etch, and fan dry.
8. Proceed to print in the usual manner.

Method of T. E. Griffits. The opening steps in this procedure are unusual and therefore of interest. They are followed by a second etch that corresponds quite closely to the formulas of most other lithographers.

1. Transfer the drawing from paper to stone in the normal manner.
2. Gum and dry the stone.
3. Wash out stone with turpentine and allow it to dry.
4. Roll up the dry stone with a thin layer of ink. (It will black up entirely.)
5. Pour a 6-inch circle of gum over the stone; begin to clear the stone by smearing cotton wads over the gummed surface.
6. When the stone is somewhat clear, add a little water and continue wiping until it is perfectly clean.
7. Damp the stone with a sponge and quickly ink it.
8. Continue with a second etch and normal printing procedure.

Transfer from Stone to Paper to Stone

1. Roll up the image on the stone as for pulling a print.
2. Fan dry.
3. Place a sheet of transfer paper face down on the stone.
4. Add backing paper and the tympan.
5. Run through the press with *more than normal pressure* 2 or 3 times.
6. Remove transfer; place it face down on a freshly grained stone.
7. Follow the remainder of the procedure for transfers from paper to stone (steps 3–8).

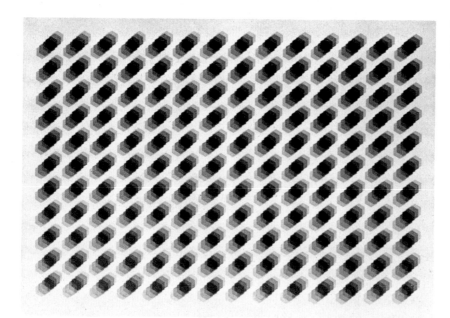

91. NORMAN ZAMMITT. *Untitled.*
1967. Color lithograph, $19\frac{1}{2} \times 28\frac{1}{8}''$.
Tamarind Lithography
Workshop, Inc., Los Angeles.

For the untitled work shown in Figure 91, Norman Zammitt (b. 1931) used transfer paper to facilitate the printing of his design—a six-color image printed from a single stone in six runs (turquoise-blue, blue, purple, violet-red, orange, and yellow). Printing Op Art images of this type requires a carefully calculated production. In the execution a stone was first fully inked with a half-and-half mixture of Charbonnel Retransfer Ink and Noir à Monter. A template was placed on the inked stone as stop-out, transfer paper was placed over the template, and all were run through the press; the image was transferred to the stone. At this point some proofing was done, and the artist deleted parts of the image by honing with a snake slip. The resulting image was then transferred to German Everdamp transfer paper and transferred to a new stone from which the edition was printed. The other colors were executed in the same manner for the succeeding runs. Fourteen trial proofs were made with variations in registration and color of ink before the edition was printed.

Direct Transfer

There are various ways of transferring the shape or pattern of an actual object directly onto stone or transfer paper. If you want to make use of the pattern from a three-dimensional object, such as a manhole cover, a chunk of wood, or a soft-drink bottle, you can lay a piece of transfer paper face up over it, anchor it firmly, and transfer the pattern by rubbing over it with lithographic crayon, rubbing ink, or an ink-charged roller (Fig. 92). This image can then be carried from the transfer paper to a stone and incorporated into your print.

Sufficiently flat objects, such as pieces of torn or cut-out fabric, bristles from brushes, and arrangements of string, can be rolled in ink, laid out on the stone (Fig. 93) or on transfer paper and run through the press. This will create a black image on the stone, to which you can add other elements as you choose. It is also possible to make a white image by applying gum-arabic solution to the material (instead of ink) and letting it dry; the areas covered by gum arabic will resist ink and stay white as you work over the drawing with crayons or tusche.

You can create interesting textures on a black ground by first coating the stone or a piece of transfer paper with stiff ink; simply arrange your materials on top of the inked stone, add backing and tympan, and run through the press. By a variation of this method, you can ink the stone, place a sheet of transfer paper *face down* on it, and arrange your materials on top of the transfer paper; for this purpose the materials should be sufficiently open-meshed and hard-surfaced to make a good impression, and you should use a stiff tympan and more than normal pressure when running through the press.

Transfers from Printed Material

Fresh proofs can be offset from any sort of graphic arts material. Senefelder himself devised a technique for transferring all or part of the printed matter from books. As a simple experiment, select a page from a *freshly printed* copy of *Life* or *Time* and then place the page or a detail of it face down on a freshly grained stone. Anchor the illustration and coat the back of the page with transparent base (aluminum oxide). Burnish the back of the page with any tool that will achieve the desired result. It would appear that everything from a ballpoint pen to a spoon to a plastic burnisher has been used for this purpose. Some artists place a sheet of plastic over the image to be transferred and burnish on top of the plastic. Others substitute lighter fluid for the aluminum oxide. Whether you see it or not, the grease content of the image has been transferred to the stone and will show in a print.

left: 92. Direct transfer from a three-dimensional object.

right: 93. Inked fabric being removed from stone after transfer.

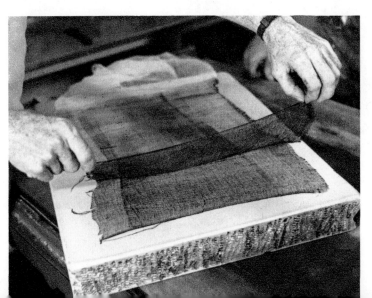

While the transfer process has many uses for lithographers working in a variety of styles, it has been spectacularly effective as a medium for Pop or other artists concerned with mass-media images as related to art, since it enables them to incorporate in their work actual elements of the subject matter that concerns them.

The Mona Lisa image in Figure 94 by Jasper Johns (b. 1930) was an iron-on transfer, bought by the artist with bubble-gum wrappers for a quarter and applied to the stone with an electric iron. The rest of the work was drawn on the same stone, which was printed in black, and an aluminum plate was used to add a transparent flat tone of gray. Johns was a prominent figure in the avant-garde movements associated with the development of Pop Art, and this work illustrates two of the innovations that attracted attention in the 1960s. One was the use of the mass media as source material for the artist (exemplified here by the incorporation of a cheap commercial reproduction in the work); another was the interest in numerals and letters as design elements, in this case, the large figure 7. Unlike some other artists of the time, Johns maintained his interest in the "painterly" quality, as his handling of the tusche in this print demonstrates. (See also Pl. 12, p. 105.)

Figure 95 is one of a series of prints by a Hawaiian-born artist, George Miyasaki (b. 1935), who wished to show the "stereotyped sex images that are used by the mass media to sell products." The images were magazine reproductions transferred onto zinc plates, printed in black, pink, and blue. The subtle background was achieved by a spray technique, used with a screen.

left: 94. JASPER JOHNS. *Figure 7.* 1968.
Color lithograph, 37 × 30″. © 1968 Gemini G.E.L., Los Angeles.

below: 95. GEORGE MIYASAKI. *A Face to Glow with Every Fashion.* 1967.
Color lithograph, 20 × 29″. Brooklyn Museum (Bristol Myers Fund).

OTHER "DRAWING" METHODS

The traditional method of drawing on stone with crayon or tusche has certainly not been replaced, but now supplementing it are a variety of other techniques, of which a few may be offered for experimentation at this point.

Drawing with Acid

The technique of drawing with acid, called *acid cut-back* by some, removes the grease from a dark ground and thus creates an image in lighter tones or in white. As you work, keep a sponge full of water close at hand so that you can quickly wipe the acid away and see what effect you are getting; if you leave it down long, the area will go completely white. This method creates a special kind of texture, and variations can be controlled by the length of time etching is allowed, and by touching out with tusche.

Acid on a Tusche Ground. Cover a freshly grained stone with 2 coats of tusche, leaving an adequate margin on all sides of the stone. Work a design or trace a drawing with Conté crayon on the dried tusche. Using an almost undiluted nitric-acid solution and a stick or a brush, paint out the areas intended to be lightest in value. (Keep a water-wet sponge in one hand to stop the action of the acid, by wiping, whenever desired.) The acid will quickly begin to bubble; the longer it is allowed to remain on the stone, the lighter will that area become. A unique and not undesirable textural treatment may be obtained if one works slowly, by degrees. Move on to the succeeding dark tones until the desired image emerges from the black ground. Pour unacidulated gum-arabic solution on the stone when the drawing is completed. Thin the gum, and let it dry. Set the stone aside for a day or so, etch mildly, and print in the usual manner.

Acid on Wash. Wet a freshly grained stone with water. Work a drawing into it with a solution made from a stick of solid tusche and warm distilled water. As a variation of this wet stone approach, you can employ drops of gasoline on the surface before drawing with water tusche, providing you recognize the potential hazard. Still other variations are possible with water or lithotine tusche and salt, sugar, drops of water, or other household stocks. Mix a very strong solution of gum arabic and nitric acid for an etch that "boils" on contact with the stone. Dependent upon conditions, it may be necessary to add up to 50 or more drops of nitric acid to 1 ounce of gum-arabic solution to produce a *frothing* etch. Delicate textural effects can be protected during etching by painting them beforehand with gum arabic alone. Thin and dry the etch, and print as you would for any drawing containing much grease.

left: 96. Reverse image made by William Dole, using the shellac reversal method. Courtesy Tamarind Institute, Albuquerque, New Mexico.

below left: 97. First plate of Figure 96, printed in blue.

below right: 98. Second plate of Figure 96, printed in orange.

Acid on Heavy Crayon Drawings. Heavily applied grease drawings made with lithographic crayon or other substances can be processed with a frothing etch (up to 50 or more drops of nitric acid added to 1 ounce of gum-arabic solution) and made to produce variations in effect. Drawings of this character invariably require etches that are exceptionally strong.

Reverse Images

The following are two methods for making prints that will reverse your drawing from a positive to a negative; that is, black areas in the drawing will show as white in the print, while white areas will appear as black (Figs. 96–98).

Shellac Method. Roll up the image. Dust the stone with a half-and-half mixture of rosin and talc. Counteretch with acetic acid and water, about 1 to 20, for 1 minute. Wash off with water. Mix a solution of shellac and denatured alcohol in the proportion of about 1 to 3 or 4. Tilt the stone and pour the mixture evenly from the leading edge all over the surface. Fan dry. Wash out with gasoline, kerosene, lithotine, or paint thinner. (The inked or positive image will wash out.) Gum immediately with a mild etch of nitric acid and gum-arabic solution. Proceed as in normal printing.

Gum Method. Pull a good, rich print from the stone on transfer paper, or on a hard-surfaced paper of good quality. Dust the freshly pulled print with finely powdered gum arabic. Press the powdered gum gently but firmly onto the ink-charged areas. Remove the excess powdered gum carefully. Moisten a freshly grained stone or plate with water. Place the dusted proof face down on the stone and pull it through the press several times as with a transfer. Gum the margins of the stone and dry. You now have a gum-resist stencil. Pass an ink-charged roller over the stone and roll up from several directions. Fan dry. Proceed to print. (There is no need to etch, unless you wish to make corrections on your reversed image.)

Metallic Effects

The graphic arts industry has developed and continues to develop metallic and other special inks to meet the needs of printers. Printmakers find certain of these products useful, sometimes after considerable trial and error.

Those interested in the traditional method will make use of bronzing powders (available in effects of silver, gold, bronze, aluminum, etc.). Pull a rich-bodied print on fine paper. Immediately dust and press bronzing powder onto the inked surfaces of the sheet. Shake the sheet to remove the excess powder. Polish the bronzed surfaces thoroughly with a swab of cotton, especially if you intend to overprint.

Negative Resist with Gum Arabic

A gum-arabic solution can be employed with a brush to *stop out* (keep white) certain areas of a proposed print. The areas not stopped out will accept crayon, tusche, or even an inked roller across the surface without interfering with the whites protected under the gum. A toothbrush can also be employed to spatter gum on the surface of the stone, if a series of white dots is desired. (Some printmakers keep margins free from scumming by initially painting them with gum arabic.)

Three-Value Lithographs

There are two popular modes of working a lithograph so that it ultimately emerges in three values as a white-gray-black print. (1) Brush 2 coats of tusche over the drawing area. Fan dry. With a razor blade, scrape the black down to a gray. Using an assortment of needles and points, pick and scratch out the whites. Add blacks with crayon or tusche. Etch strongly, and print in the usual manner. (2) Stop out white areas with gum arabic. Fan dry. Roll up from several directions across the drawing. Allow the ink to "sit" before proceeding. Paint blacks with tusche or asphaltum. Etch and print in the normal fashion.

Intaglio Methods

Coat a finely grained stone with at least 2 layers of tusche, or, after applying gum-arabic borders to your stone and allowing the gum to dry, rub in a coat of Triple Ink. When the tusche or Triple Ink is dry, scratch your composition through the tusche or ink layers with a lithographer's needle, an etching needle, or a diamond point to expose the stone. Apply a half-and-half mixture of talc and rosin. Remove the excess and etch mildly. Fan dry. Wash out the stone, roll up, and apply a slightly stronger etch. Follow the normal procedure and prove the stone. This technique provides a white line on a black ground.

For the opposite effect, a black line drawing on a white ground, brush on the stone surface 2 coats of gum arabic to which you have added a few drops of phosphoric acid per ounce and about a teaspoonful each of tannic acid and red iron oxide. (The former hardens the gum and the latter ingredient darkens it.) Dry the gum down tightly. Engrave the composition with any of the tools mentioned above, making sure to cut through the gum (Fig. 99). When the engraving is done, rub up several times with thinned asphaltum or thinned ink and a piece of sponge. Allow the stone to "sit." Gum the stone tightly. Wash out, roll up, etch, and print in the usual fashion. The print pulled from the stone shown in Figure 99 will be the reverse of what you see; it will be a black line drawing on a white ground.

Various "Drawing" Tools

With the suggestions that have been made it must be obvious that the printmaker who applies a little imagination to his aesthetic requirements will think of various other tools and materials that could serve his purpose. The following are a few examples of things that artists have used and found effective for their art:

left: 99. Intaglio method; lithographic line engraving on stone.

right: 100. Roy Lichtenstein. *Crak!* 1964. Offset lithograph, 19¼ × 27¾". Leo Castelli Gallery, New York.

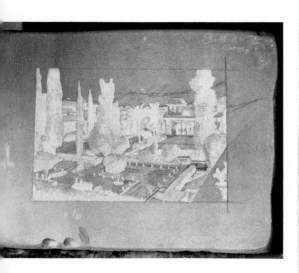

94

Plate 10. Jean Dubuffet. *Person in Red Costume*. 1961.
Color lithograph, 20½ x 15". Museum of Modern Art, New York (gift of Mr. and Mrs. Ralph E. Colin).

Plate 11. JAMES ROSENQUIST. *Busy Signal*. 1970.
Lithograph on reflective mylar, 16 x 21".
Leo Castelli Gallery, New York.

101. PETER SAUL. *Golden Gate Bridge.* 1968.
Color lithograph, 22 × 30″.
Collectors Press, San Francisco.

1. Recognizing the fact that it is the grease content of the lithographic crayon or pencil that enables a lithograph to be printed, some artists have substituted bars of soap, certain types of lipstick, oil pastels, and other greasy substances.
2. Fine sandpaper or emery paper can be used to soften certain hard edges.
3. A small roller can be rolled up in tusche or asphaltum and applied to the stone surface.
4. A pattern of white line segments can be effected by employing a broken or otherwise useless knife in "jumps" across a given area.
5. Steel wool can be employed for special effects, particularly in dark gray or black areas.
6. A piece of sheet gelatin placed over a low-valued area or black *crayon* area will, when drawn upon with a very hard lead pencil, provide a certain kind of white line upon removal.

Possibilities of this sort will be suggested by a study of almost any group of contemporary prints. For example, the focus of Pop artists on mass media concepts and effects has inevitably influenced aspects of the "drawing" in their lithographs. *Crak!* (Fig. 100) by Roy Lichtenstein (b. 1923) and *Golden Gate Bridge* (Fig. 101) by Peter Saul (b. 1934) reflect a comic-strip style, in which bold forms, strong linear outlines, and flat tones are emphasized. Both of these prints incorporate the dotted areas widely used in commercial printing to create tones (though the dots appear here in an enlarged and exaggerated form). Other comic-strip devices evident are the balloon lettering and the representation of the gunshot by a literal flame shape, in Figure 100, and the dripping teardrops in Figure 101.

Walasse Ting (b. 1929) exploited the spatter technique in *Sunset Strip* (Fig. 102), part of his *Hollywood Honeymoon* suite, a work that is essentially abstract though with overtones of content. It was executed with tusche, mixed with water and applied with a brush, and one grade of lithographic crayon (No. 3). Four colors were printed from two stones (red and blue) and two aluminum plates (green and yellow). The print bleeds to the edge of a deckle-edge paper. The artist, who is also a poet, was a member of the avant-garde *Cobra* group, who had their first exhibition in Amsterdam in 1949.

Masuo Ikeda (b. 1934) made a striking use of the airbrush in Figure 103, thus creating the soft, smooth, and seemingly remote cloud formations in the four corners, which contrast so effectively with the extremely vigorous and sharp central motif. Zincographique tusche was used in the airbrush. The central drawing was executed with crayons and tusche, enhanced by strong superimposed stencils. The border and other solids were brushed on with Korn's autographique tusche. Three aluminum plates were used, with a key drawing on stone. The artist's purpose was "to create a surreal effect by assembling various remembered images (some used in previous works) into a new juxtaposition."

PHOTOLITHOGRAPHY

There has been considerable argument and discussion about the influences, good or otherwise, of commercial offset lithographic tech-

left: 102. WALASSE TING. *Sunset Strip.* 1964. Color lithograph, 28 × 38". Tamarind Lithography Workshop, Inc., Los Angeles.

right: 103. MASUO IKEDA. *Behind the Garden,* from the suite *Some Town Without a Name.* 1970. Color lithograph, 26 × 21". Collectors Press, San Francisco.

niques and certain mass-communication ideas upon the printmaker. Whatever the effect on the art of printmaking, it seems only natural that the various types of plates and other products developed for the printing industry should attract interest and experimentation on the part of many artists.

Of the many possibilities in photolithography the procedure outlined at this point is one which can readily be adopted by any printmaker having the experience and the press equipment for making a traditional lithograph. It involves the use of a *surface plate* with a *wipe-on* (light-sensitive) coating. The image is created on film or acetate, projected onto the plate, developed, and then printed like any other lithograph.

There are probably, at this juncture, well over a hundred kinds of wipe-on plates manufactured in the United States, Canada, and Europe. Since there are slight to major differences among them, you should follow the instructions of the particular manufacturer very carefully. Do not intermix plates and/or processing materials.

In the procedure that follows it will be assumed that you are using a plate that is identified commercially as an *ST plate,* with the coating and developing materials supplied for it. (This is an .012 gauge aluminum lithographic plate; 7 microns, coarse.) If you use a different plate you will study the manufacturer's instructions and adjust the procedure accordingly. You will also require a vacuum frame and a light source for making the exposure (e.g., a Pulse-Xenon arc, a quartz iodine lamp, a white-flame carbon arc light of 35 amperes, or a No. 2 reflector-type photoflood lamp).

Procedure for Using Surface Plates

Work under yellow insect bulbs, yellow fluorescent tubes, or other subdued lighting in the workshop. Do not expose coated plates to direct sunlight.

1. Following the manufacturer's instructions, prepare the wipe-on or coating solution by adding all of the light-sensitive S.T. Diazo Powder to the S.T. Base Solution. Shake the mixture thoroughly until all of the powder is dissolved. (S.T. Diazo Powder and equivalent preparations are, usually, a condensation product of formaldehyde and diazo diphenyl amine. If refrigerated, the powder will be useful for 6 months. The mixed coating may be useful for as long as 2 weeks.) Pour a pool of the coating on the dry plate. With a damp cellulose sponge, spread it over the whole plate. Using S.T. wipes, go over the plate with overlapping horizontal and vertical strokes until the coating becomes tacky. Quickly (with another wipe) thin, polish, and dry the coating to smoothness. Your plate is now sensitive to light. Protect it.

104. A negative, film positive, and drawing on acetate arranged on a sensitive plate.

105. A plate in a vacuum frame being exposed to light.

2. The "drawing" may be composed of photographic negatives, film positives, and/or opaque lines and areas drawn on acetate (Fig. 104). Remember that photo *negatives* are transparencies in which the non-image areas are opaque and the image areas are transparent. *Positives* contain non-image areas that are transparent and image areas that are opaque.

3. Place your "drawing" (i.e., the film and/or acetate) on top of the coated plate in a vacuum frame (Fig. 105). Block out the margins with the pressure-sensitive tape used for this purpose, or with paper. Close the vacuum frame.

4. Expose the vacuum frame for 2 minutes at 3 feet to 3,000 foot-candles of a white-flame carbon arc light (35 amperes). *Or,* expose for 4 minutes at 2 feet to a No. 2 reflector-type photoflood lamp. *Or,* you may use one of various special lamps, following the manufacturer's advice.

5. Remove the plate from the vacuum frame and place it on your work table. For approximately 30 seconds, shake the Super D Developer. With a damp, coarse cellulose sponge charged with the Developer, work over the entire plate until the image becomes intensely black. (This should take about 1 minute.) Immediately flood the plate with water to remove excess Developer. Swab the plate with kim wipes until the water on the surface is reduced to a fine film.

6. Employ the final solution, S.T. AGE, with a sponge all over the plate. Work the AGE in well by rubbing into the image area. Apply another coating of AGE with a light touch. Thin the AGE down to a fine film with cheesecloth and work it until dry.

7. From this point onward, treat the plate as you would any other aluminum plate. If an oxidation or "ink-dot" scum appears, treat it immediately with a mixture of $6\frac{1}{2}$ ounces of oxalic acid (or of 85 percent phosphoric acid) in a gallon of water. Etch with the formula provided for aluminum plates (1 ounce of 85 percent phosphoric acid to 32 ounces of gum-arabic solution). Thin the etch and dry by fanning. Wash out, roll up, and print.

Some Applications of Photolithography

The absorption of photolithography into the fine printmaking field is probably the most conspicuous innovation in modern lithography. If today's commercial photo-offset printing owes its existence to the artist's original invention of the lithograph, that debt has been repaid at least in part by the techniques and products made available through commercial development to the artist-printer. In the hands of the artist, however, photolithography is not merely a means of "reproduction." It offers a means of using photographic elements in the print, of combining them into original designs, and of combining them with other drawing techniques and other printing processes, all in such a way that

an "original print" results. Today some original lithographs are actually printed on commercial presses (about which some information is given in Chapter 26). This method makes possible the efficient and rapid production of very large editions, a factor which may in time influence the creation as well as the distribution of original prints. At present, however, the tendency seems to be to retain the "limited" edition. Lichtenstein's *Crak!* (Fig. 100; see also Fig. 302) was printed on an offset press, but it was limited to an edition of 300, which is not excessively large even for an edition pulled by hand. The extent to which the artist can supervise printing quality (a requirement of the fine print) may prove to be a problem if commercial facilities are extensively used.

The possibilities of this method are remarkable, even by the relatively simple procedure outlined above. In *Flags* (Pl. 12, p. 105), for example, Jasper Johns made use of a full-scale photograph derived from a detail in one of his own paintings.

In Figure 106 Mel Ramos (b. 1935) used a photo of the female nude to create a vast field on which he superimposed the dramatic image of an eagle, drawn with Korn's lithographic crayons. The photograph was combined with a mezzotint screen enlarged to a double-size pattern and shot onto a presensitized aluminum plate; in psychological effect the solid three-dimensional human figure was converted to a two-dimensional overall spatial background. The area to be occupied by the eagle was removed from this plate by the use of nitric acid and cotton. The eagle was drawn on an aluminum plate, and a third plate added a solid yellow (again omitting the area of the eagle), applied with a brush and autographique tusche.

Sky Garden (Fig. 107) by Robert Rauschenberg (b. 1925) is a combination of photography, color lithography, and silk screen. For this

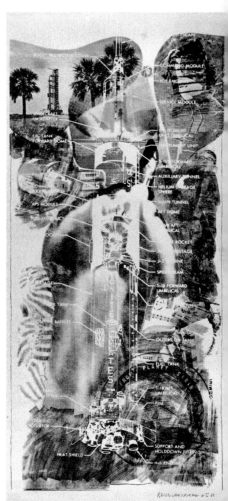

right: 106. MEL RAMOS.
Eagle Beaver, from the suite
Leda and the Swan. 1969.
Color lithograph, 28 × 22".
Collectors Press, San Francisco.

far right: 107.
ROBERT RAUSCHENBERG. *Sky Garden.*
1969. Color lithograph
and silk screen, 7'5" × 3'6".
Copyright © 1969 Gemini G.E.L.,
Los Angeles.

comment on the space age he has derived from photographic sources landscape elements, candid shots of the human figure, and a symbolic bird. With these he has incorporated drawn and patterned elements and a diagram of a space mechanism printed in reverse.

EXAMPLES OF OTHER INNOVATIVE TECHNIQUES

Innovations in the process of lithography are so numerous and varied that to illustrate them all would require a discussion of almost every printmaker working today. Examples of a few major techniques, as adapted and applied by different artists, must suffice.

The French artist Jean Dubuffet (b. 1901) has been exploratory in many fields: oil painting, collage, gouache, assemblage, drawing, and graphics. He even used waste paper from his lithographs in his collages of the 1950s. His art is rooted in earthy materials and based on images deliberately akin to those of untrained child artists, graffiti scribblers, psychiatric patients, and primitives. In the lithograph illustrated here (Pl. 10, p. 95) these fundamental traits of his work are evident. The delineation of the figure in proportion and in simplification recalls the drawing of a young child, and the handling of the color conveys the roughness of sand and soil that he often mixes into his pigments.

Using plastic as a printing surface has produced some startling effects. James Rosenquist (b. 1933) created *Busy Signal* (Pl. 11, p. 96) in two panels on reflective Mylar, a polyester plastic sheeting. When set up, somewhat in the manner of a diptych, the drawing on one panel is reflected so as to become a design element in the other, again with an interesting play of angle and varying depth.

The enigmatic image of Queen Isabella (Fig. 108) by José Luis Cuevas (b. 1933) combines printing on plastic with collage, and a small stencil with other interesting techniques. The face was drawn with lithographic crayon on stone and then printed on chrome Mylar, which is often used as a facing to prevent sticking under pressure; the shape of the face was then die-cut from the printed plastic. Free-form cut-out shapes were used for the design elements, the headdress being treated with a blended roller technique and the addition of a small doily stencil. The solids (black and blue) were brushed with Korn's autographique tusche on aluminum plates, and wash was brushed on a zinc plate with Charbonnel's liquid tusche. An embossing plate was made from two pieces of Lucite on two levels. The print is from a suite called *Homage to Quevedo,* and the suggestion of a masked, three-faced image was inspired by passages in that author's writings. The different textures and printing surfaces used seem to enhance the artist's purpose, which was, as he has put it, to "create mystery."

Figure 109, by Rauschenberg, also uses plastic and exemplifies another departure in recent lithography as well, that is, the creation of a work in depth that escapes the two-dimensional limitation of

traditional printing. In this work the various impressions were pulled on movable Plexiglas panels and mounted one behind another with intervening space. The work, mounted in a metal frame, can be re-arranged and can be viewed like a sculpture from all sides, thus revealing a play of images seen through the transparent Plexiglas with changing relationships from different angles. The word *multiple*, as applied to prints, is particularly apt for a work such as this, which, while it was definitely made by the lithographic process, takes on something of the aspect of a kinetic sculpture.

One feature that makes contemporary prints difficult for the beginner to analyze is the frequent use of mixed media. Artists no longer limit themselves to a single process but combine freely in a single print any of the processes that will create the desired effect for a particular element. Other examples of mixed media will be illustrated later, but two are included here in which lithography is basic or major.

Figure 110 is a work that might actually be called an *assemblage*—an innovation unusual in itself, but not surprising as the creation of an artist considered to be one of America's outstanding sculptors, Louise Nevelson (b. 1900). The print consists of a three-color central panel in red, gold, and black with six additive elements or "flaps," four

left: 108. José Luis Cuevas. *La Máscara,* from the suite *Homage to Quevedo.* 1969. Color lithograph, 30 × 22". Collectors Press, San Francisco.

below: 109. Robert Rauschenberg. *Shades.* 1964. Color lithograph on Plexiglas in metal frame, 15 × 14 × 12". Leo Castelli Gallery, New York.

bottom: 110. Louise Nevelson. *Untitled.* 1968. Color lithograph, 3'6" × 4'5". Tamarind Lithography Workshop, Inc., Los Angeles.

printed in gray and two in red. The black impression was pulled from a stone used in a previous print, deletions having been made with Lithpaco Plate Cleaner and snake slip. The red was printed from zinc and the gold from aluminum, both executed with gum stop-out and asphaltum rub-up. Rags were used to create forms and textures. The elements are all bleed images and make use of torn edges. The edition has variations: five impressions like the one illustrated were pulled, and four impressions have five flaps all printed in red.

In Figure 111 Andrew Stasik (b. 1932) has combined lithography with stencil and screen printing in a work laboriously evolved from a number of hand-drawn and cut-paper screen stencils used to delineate the badminton racket and the birdie that are central to this "auto-biographical" expression. A collage of photographic images taken in the Adriatic was printed within the racket from an ST (light-sensitive) aluminum plate. The flat areas of vibrant screened color used for the racket suggested to the artist that the surrounding field be the rich, dense, yet luminous black special to lithography. Bronze paint, first sprayed through a hand-cut paper stencil of circular forms, was over-printed in black, pulled from a zinc plate drawn with crayon and tusche. This last plate was also used to print the intersecting lines, spattered areas, and the letters A and S, which overlap the imagery within the racket. The artist describes the work as a "visionary yet nostalgic amalgam of experiences real and fantasized," in which "past, present, night, day, atmosphere, and reality are presented through metaphor, color, form, and photographic images." A leading printmaker, Stasik is also the current director of the Pratt Graphics Center in New York and managing editor of *Artist's Proof.*

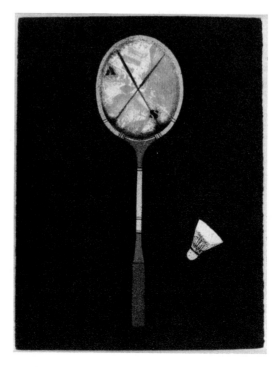

111. ANDREW STASIK.
Night Game/Self Portrait. 1970.
Lithograph, silk screen, and
stencil; 30 × 22".
Courtesy the artist.

Plate 12. JASPER JOHNS. *Flags.*
1967–68. Color lithograph printed
in the following progression:
1) metal plate for gray,
overprinted from
separately prepared stones for
2) green, 3) orange, 4) black,
and 5) gray, on the lower flag;
and from rubber stamps for
6) the black outline encircling
the white dot
on the upper flag,
and 7) the black dot on the lower flag.
34 x 25½". Published by
Universal Limited Art Editions,
West Islip, New York.
above: Progressive proofs
for states 1, 2, and 3.
right: A signed and numbered
impression of the finished print.

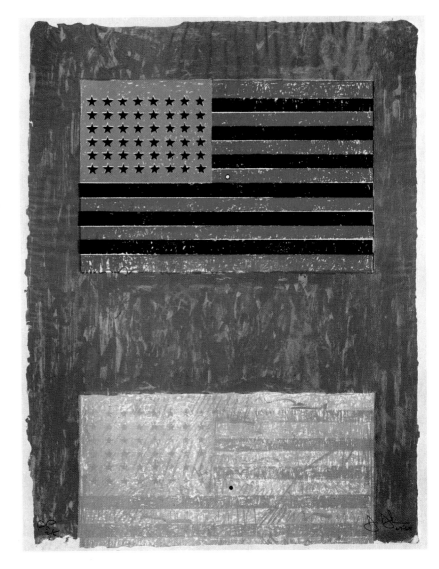

right: Plate 13. JOSEF ALBERS.
White Line Square, from the series
Homage to the Square. 1966.
Color lithograph, 21" square.
Copyright © 1966 Gemini G.E.L.,
Los Angeles.

below: Plate 14. GARO Z. ANTREASIAN.
Plate VI from *Octet Suite.* 1969.
Color lithograph, 23 x 19".
Tamarind Lithography Workshop, Inc.,
Los Angeles.

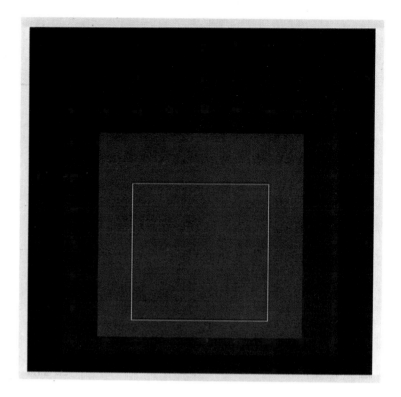

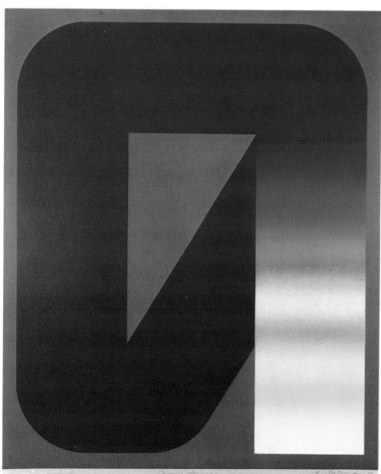

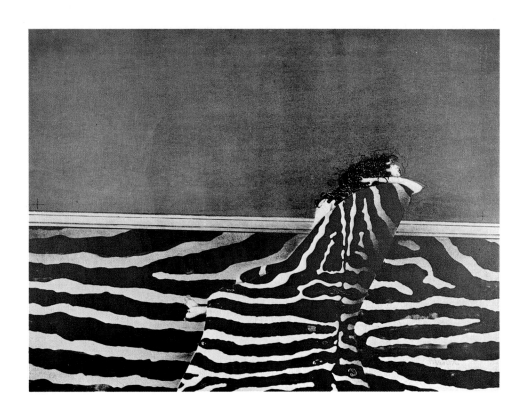

above: Plate 15. PAUL WUNDERLICH.
Joanna in the Easy Chair. 1968.
Color lithograph, 19¾ x 25½".
Associated American Artists,
New York.

right: Plate 16. JIM DINE.
Midsummer Wall. 1966.
Color lithograph, 38 x 27½".
Whitney Museum
of American Art,
New York (gift of
Mr. and Mrs. Herbert C. Lee).

Plate 17. FRANK STELLA. *Empress of India II*. 1968.
Color lithograph, 16¼ x 35⅜". Copyright © 1968 Gemini G.E.L., Los Angeles.

Plate 18. PAUL JENKINS. *Phenomena: Passing Noon*. 1967.
Color lithograph, 20 x 28". Martha Jackson Graphics, Inc., New York.

Multimetal Lithography

The multimetal plates originated for commercial offset printing have made possible a new technique that can be applied to the creation of original prints. Professor Maltby Sykes of Auburn University has tested or investigated the plates supplied by six different manufacturers, in regard to their adaptability for use by artist-lithographers. The author is indebted to him for permission to condense in this chapter the results of some of his researches.

Multimetal plates differ from single-metal plates in that they consist of two or more layers of metal, one of which is receptive to grease and another to water. Some metals, such as copper, have a natural affinity for grease. Others, such as aluminum or stainless steel, have a greater affinity for water than for grease. When copper is plated over stainless steel or aluminum, a *bimetal plate* is created. A printing image, which is to hold the ink, is put on the copper layer in the form of an acid resist, which protects the copper during the subsequent etching process. Unwanted copper is etched away, exposing the aluminum or stainless steel. Either aluminum or stainless steel is easily made receptive to water and thus provides a nonprinting area. In printing, the copper image accepts ink and prints, while the aluminum or stainless steel accepts water and rejects ink.

Trimetal plates, which consist of a base sheet plated first with copper and then with chromium, work by the same principle. Chromium is

the top metal and accepts water more easily than grease. For this reason, it is used to form the nonprinting areas. The printing image is etched through the chromium to expose the copper, which will accept printing ink, and the image is therefore tonally reversed or negative. The base metal (usually stainless steel, mild steel, or aluminum) is simply a support and plays no part in forming the printing image on an etched plate.

All these plates can be etched; that is, unwanted copper or chromium can be eaten away with acid. It is also possible to engrave a trimetal plate made with mild steel by cutting through the chromium top layer with a burin or diamond point, or with abrasives, to expose the underlying copper. If one happens to cut through the copper layer to the base sheet, the mild steel will also hold ink. Halftones can be secured with the roulette, carborundum grit, snake slips, scotch stones, or any abrasive.

Multimetal plates are generally available in thicknesses ranging from .012 to .025, though small plates may be of a lighter gauge. For large plates, heavier gauges are easier to manipulate. However, light gauges have certain advantages in that they can be cut with shears or other instruments for metal collage, embossing, or special effects. Also, they are cheaper. Stainless steel base sheets can be replated many times.

An advantage in using multimetal plates lies in the fact that the image and non-image areas are permanently fixed in grease-receptive and water-receptive metals, and will remain unchanged unless the plate is abused. The image will not fill in or become blind if properly processed. Deletions are simple for multimetal plates. Additions, while more complicated, are possible; manufacturers furnish instructions for replating local areas on a plate. The plates can be printed on either a lithographic press or an etching press, they are light, and they store easily. More important, multimetal lithography makes possible a wide range of visual effects, some related to traditional lithography, some to intaglio techniques, and some peculiar to itself.

PROCEDURES FOR MULTIMETAL PLATES

The processing materials marketed by manufacturers for their plates should be employed for best results. The processing instructions furnished should also be consulted; however, they apply to photomechanical platemaking and must be interpreted by the artist-lithographer to meet his needs. Much of the difference lies in creating the image, which the artist would do by hand rather than by photomechanical means. Some manufacturers make substitutes for traditional lithographic items, such as gum arabic, that are superior to the original product. They also market copper activators, scum removers, wash-out materials, and other products that are highly useful.

Cleaning and Counteretching

1. Place the plate in an acid tray or sink.
2. Rinse with water, scrubbing lightly with a soft bristle brush (do not use nylon), rag, or paper wipe to remove the protective gum coating applied by the manufacturer.
3. Flush the plate with counteretch solution. Suggested formulas for counteretches are as follows:
 Aluminum-base bimetal plates: 2 ounces nitric acid (HNO_3 71.0) to 1 gallon of water.
 Stainless steel-base bimetal plates: 2 ounces nitric acid (HNO_3 71.0) and 2 ounces phosphoric acid (H_3PO_4 85.0) to 1 gallon of water, or $2\frac{1}{2}$ ounces sulfuric acid (H_2SO_4 95.6) to 1 gallon of water.
 Trimetal plates: $2\frac{1}{2}$ ounces sulfuric acid to 1 gallon of water.

 Let the solution stand on the plate for about 30 seconds. Rub stubborn spots of grease or oxidation with FFF pumice. (Counteretches actually dissolve some of the metal forming the plate surface, and, if left too long on the plate, will eat away some of the grain; 30 to 60 seconds is usually enough.)
4. Rinse immediately with water and fan dry.

Creating the Image

1. Proceed *at once* to draw, paint, transfer, or otherwise create the image to be printed. If the plate is allowed to stand before use, it will oxidize and have to be counteretched again. The drawing can be made with any acid-resisting material. Lithographic crayons, tusche, rubbing ink, wax crayons, and grease pencils all work. So do spray enamels or lacquers, asphaltum, powdered rosin, and all acid resists used in intaglio printmaking. The acid-resisting image will print as a positive from bimetal plates and a negative from trimetal plates.
2. Allow the image to dry or "set up," if tusche or spray paints have been used.
3. Shake a half-and-half mixture of rosin powder and talc over the image; remove excess with a dust brush. This step is optional.

Etching to Establish Image and Non-Image Areas

The usual etches for bimetal aluminum plates are basically ferric nitrate, while etches for stainless steel bimetal plates generally contain ferric chloride. When used on the plates for which they are intended, they remove only copper and do not attack the base metal.

Most etches for chromium contain hydrochloric acid, and very irritating fumes are produced. Downdraft ventilation or a respirator with acid filter is usually required, although the chromium etch manufactured by Printing Developments, Inc., is nonfuming and can

be used without special ventilation. Chromium etches do not attack copper or the base metal, and copper etches do not attack chromium.

Proprietary etches are provided by manufacturers under several trade names, such as the following:

Aluminum-Base Bimetal Plates: PDI Lithengrave Etch, Levey No. LS-401, or Lith-Kem-Ko No. 3020.

Stainless Steel-Base Bimetal Plates: PDI Copper Etch for Stainless Steel Lithengrave Plates, Levey No. LS-400, or Lith-Kem-Ko No. 3022.

All Trimetal Plates: PDI Lithure Etch, Levey No. LS-149 Chrome Etch, or Lith-Kem-Ko Chromium Etch No. 3016.

1. Cover the plate quickly and evenly with etch. Rock the tray to agitate the etch, or manipulate the plate to move the etch over the surface. A developing pad is convenient but not essential.
2. With bimetal plates, watch for the base metal to begin showing through copper, which takes between a minute and a minute and a half, usually about 80 seconds (Fig. 112). When this occurs, remove the plate from the etch and rinse with water. Pour off the old etch and apply fresh etch to the plate. The base metal should become clear of copper quickly (usually from 20 to 30 seconds), forming the non-image area. Repeat if necessary. Rinse thoroughly with water.

 With trimetal plates, watch for copper to appear through the chromium (Fig. 113). As chromium dissolves, it will form bubbles and then discolor. Copper will begin to show through in 50 to 80 seconds, depending on the type of plate. When this occurs, remove the plate from the etch, rinse with water, and inspect it.

 The time indicated above for copper and chromium to dissolve in etching is approximate, and is intended to serve only as a guide until necessary experience is developed. Many variables are involved such as room temperature, thickness of copper and chromium layers, and properties of the etch employed.
3. Pour off the old etch and apply fresh etch to the plate. The copper should clear in about 30 seconds.
4. Remove the plate from the etch immediately and then rinse with water.

Washing Out and Rubbing Up

1. Flood the plate with counteretch solution.
2. Keeping the plate wet with counteretch solution, wash out the acid-resisting image with turpentine or other appropriate solvent.

left: 112. Bimetal plate; base metal showing through copper etch.

right: 113. Trimetal plate: (*left*) Copper showing through chromium etch; (*right*) corrections made by etching through copper to expose base metal.

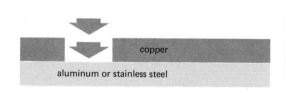

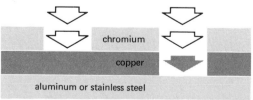

3. Flush the plate clean with water.
4. Rub up the plate as follows: Dampen a small area with the counteretch solution, using one rag, and charge another rag with a small amount of rub-up ink. (It is better to put a drop or two of turpentine on the ink rag prior to inking it.) While the area to be inked is still damp, rub the ink rag over it with a circular motion. The dampened non-image area will reject ink, while the copper image area will accept ink. If the copper does not take ink well, rub it with dilute phosphoric acid (8 ounces of 85 percent phosphoric acid to a gallon of water) or dilute sulfuric acid ($2\frac{1}{2}$ ounces to a gallon of water) and a little fine pumice; or use one of the preparations made by most manufacturers to activate the copper. If the nonprinting area takes ink, rub with counteretch solution and pumice to clean it. Continue to dampen and rub up small areas until the entire image is inked.

Final Desensitizing Etch and Gumming

1. Immediately apply a plate etch consisting of 1 ounce of 85 percent phosphoric acid to 32 ounces of 10° Baumé gum-arabic solution, using a brush or viscose sponge.
2. Gradually smooth out the etch. With a dry rag or paper wipe, rub the etch to a thin, dry film. This also serves as final gumming.

Rolling Up and Storage

1. Wash the rub-up ink out of the image with asphaltum and rub dry.
2. If the plate is to be stored, leave it under asphaltum.
3. If printing is to proceed, sponge off the dried etch with water, roll up with printing ink, and proceed with printing.

Printing from Multimetal Plates

To print multimetal plates under the scraper on a lithographic press, a lithographic stone slightly larger than the plate itself is needed as a support. The back of the plate and the surface of the stone are both dampened. When the plate is placed on the stone, it will adhere firmly. Printing then proceeds in the usual manner.

Multimetal plates can be printed also on an etching press, using felts as one does for intaglio printing. To many artists, who work in intaglio as well as planographic techniques, this is a great advantage. When printing multimetal plates under felts on an etching press, best results are obtained by soaking the paper, as for intaglio printing. A blotter should be put over the paper and plate when printing with coarsely woven felts, otherwise the texture of the felt will show in large areas of the print.

Color Lithography

Before making a multicolor lithograph, presumably you will have gained some experience in printing lithographs in black and white. The new techniques required—which involve making more than one impression, in correct register on the same print, and using colored inks—will be described first, followed by a discussion of three methods of procedure exemplifying different ways of approaching color lithography.

Whichever method you use, the color lithograph is normally made by printing first one color, then a second, a third, and so on, on the same sheet of paper. *Progressive proofs,* showing the effect obtained as each succeeding color is added, should be kept for each color print made. For *Flags* (Pl. 12, p. 105), by Jasper Johns (b. 1930), a metal plate was used to print gray. Over this impression the following colors were printed from separately prepared stones: green, orange, black, gray (overprint on lower flag), and a second gray (overprint on background). Finally, two rubber stamps provided the black outline encircling the white dot on the upper flag and the black dot on the lower flag. Progressive proofs appear with the reproduction. (See also Fig. 94.)

The procedures described in this chapter can be used for either stones or plates, though stones are usually referred to.

PLANNING A COLOR LITHOGRAPH

Preliminary Color Sketch

The preliminary color sketch can be worked in transparent watercolor, colored crayon, pastels, tempera, oils, casein, duco, vinylite, or any other color medium either on paper or on grained or sheet plastic. However, none of these materials singly or in combination will duplicate the color quality of the printed lithograph—nor should they be expected to equate with the colored inks. Partly for this reason, some printmakers prefer to work up a color lithograph, not from a sketch prepared in another medium, but directly from a color impression of the first stone. Others make only a rough preliminary sketch as a base from which they will similarly improvise. Still others may work out a complete color statement from which they do not wish to deviate. Those who make a complete color drawing in scale will probably use it as a *master color sketch* or *key drawing*, from which a tracing can be made for each color and applied to each stone. This manner of working is described in method 1 on page 119. More improvisational procedures are described in methods 2 and 3 on pages 120 and 121.

Number of Stones and Colors

Generally, color lithography presupposes that you have a separate stone for each color of ink you use. It is entirely possible, however, to make a multicolored print from a single stone, if you have only one. This is done by printing one color and then partially regraining the stone (with No. 180 carborundum or a finer grain) but not sufficiently to remove the ghost. Work the drawing for the second color over the ghost, add the second color to your edition of prints, and grain again, if you wish, for a third. You will still have made a separate drawing for each color and printed it separately, but from the same stone.

There are other exceptions to the general rule of a separate color for each ink: By using two or more small rollers you can print two or more colors simultaneously provided no overlap of drawing occurs. You can also use an oversize roller with different colors of ink rolled onto it at the same time, to produce an effect of "rainbow" printing; where the colors meet they naturally blend, and the technique is sometimes called *blended roller*. It can be seen in Cuevas' *La Máscara* (Fig. 108), among others.

Assume, however, that you have available stones and will print each color separately. Before you consider doing a 17-stone lithograph, call to mind a principle stated earlier: Use a minimum of means for the maximum effect. Now, analyze your sketch in terms of its component parts. How *few* stones can be used to equal and, you may hope, go beyond this color statement? The accompanying diagrams (Fig. 114) show the *theoretical* possibilities of variations in color available through

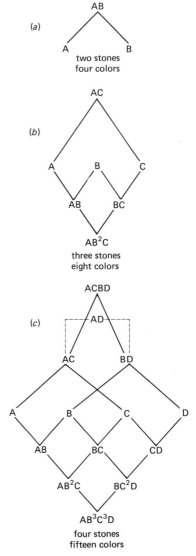

114. Color possibilities for two, three, and four stones.

the use of 2, 3, or 4 stones. Substitute any colors for the letters in the diagrams. You can see that it is *theoretically* possible to arrive at 15 different hues from 4 stones, and these hues will further vary in value and intensity, depending upon what and how you "draw," the lightness or darkness of given areas in the stone, the textures, the coarseness or fineness of the various graining materials employed, the order of printing, the transparency or opacity of the inks, and other factors. When you realize, too, that your palette is similar to that of the painter, the possibilities increase enormously. Color lithographic inks need not be used in their pure form "right from the can," but, like artists' paints, can be mixed in hue, grayed, lowered in value, or made more or less opaque.

THE COLOR INK PALETTE

If you have difficulty in obtaining the stone inks (direct lithographic inks) preferred for printmaking, you should refer to the section on ink (pp. 320–323). (You will find there also a list of stone inks available from specific manufacturers, with notes on some of their printing characteristics.)

A good commercial lithographic shop would generally stock no less than the following: 2 yellows, 2 oranges, 4 reds, 1 or 2 purples, 4 blues, and 2 greens, plus blacks and whites and a set of the *process color* inks (yellow, magenta, and cyan) widely used in commercial printing.

The ink palette stocked by one very well-equipped *artists'* lithographic workshop includes 2 yellows, 3 oranges, 3 reds, 4 blues, 1 purple, 4 greens, and 3 browns, in addition to 4 black inks, 2 opaque whites, transparent white, silver, and gold.

Ink Mixing

The principles and practices followed by the painter when employing oil, watercolor, gouache, or acrylics are, to a degree, applicable when mixing color inks. Hue, value, and intensity can be controlled by mixing appropriate amounts of one or more color inks with black, white, or transparent white. Differences between painting and printmaking effects lie in the transparency or opacity of one film of ink color printed over or under another. There are an infinite number of possibilities with which to experiment.

Mix color inks on a clean slab of plate glass, marble, a lithographic stone, or a piece of vitrolite measuring no less than 20 × 24 inches. With an ink knife remove from the cans of color ink appropriate amounts of the several components which will approximate the desired hue, using a related ink color at the outset. Work the inks on the slab by rubbing until streaks have disappeared. Test the mixed color by touching a finger to the ink and running it along a scrap of the paper

which will carry the finished print. This test (the *tap-out*) should reveal the full strength of the ink at the point first touched on the paper, continuing through medium values to a high tint. Study the color under more than one condition of lighting. Adjust the color, if necessary. Repeat for each color required. Make tap-outs over one another *in different order* to obtain some idea of the final effect.

Some Notes on Color Printing

A film of ink deposited upon a sheet of paper can be very thin, thin, or of medium thickness. It can present a transparent, semi-opaque, or opaque hue. The paper may be a white that is either cold or warm, or it may be of any hue including black. The paper can be laid or wove, smooth or rough, absorbent or not, metallic or transparent. The combination of thickness of ink film, opacity or transparency of hue, the nature of the paper, the order of printing the inks, relationships of color to color, and the decision whether to print wet-on-wet color offer both hazards and unexpected pleasures, as well as infinite possibilities for expression.

The so-called orthodox order of printing is yellow, red, and blue, but the printmaker is not likely to be greatly influenced by that fact. To demonstrate how the order of printing affects, for example, warmth and coldness, mix a semi-opaque violet and print it over a green of equal strength. Reverse the order of printing. The former produces a warm gray; the latter a cool one.

Surprisingly, perhaps, high-valued color tends to deepen or to gray and soften medium- and low-valued hues, and transparent tints can darken or make subtle certain dark colors when printed in a particular order. For example: a transparent pink will deepen a red if the former is printed over the latter; a transparent violet will create a low-valued brown when printed over a yellow; a semi-opaque, high-valued green, on the other hand, will gray blues, reds, and blacks when overprinted; and transparent grays and light blues will darken blues.

The artist who enjoys "taking a chance," or one who is already experienced with color or has learned to trust his own intuition, needs little encouragement and less advice at this point. Perhaps the soundest advice to be offered on the subject of color is that you ignore all suggestions, including those given here—that you work freely, and simply observe what happens when color X is printed over Y and vice versa. The following are a few examples of observations and experiments gleaned from studio practice that may help to start the beginner on his own investigations:

1. When precise edges are required in abutting areas of color without overlap, print a transparent first color and a semi-opaque or opaque second one.

2. Before graining off one of your black-and-white drawings, substitute opaque or semi-opaque white ink for the black and print on black paper.
3. Change the hues, the transparency and opacity, and the order of printing of a recently completed 2-color print, 3-color print, and 4-color print.
4. To keep a lively color surface, employ a different grade of graining material for the various stones in a particular multicolor print.
5. To intensify a color ink when printing, add tiny quantities of starch, water, and formic acid; or, add a drop or so of phosphoric acid.

REGISTRATION

When a print of more than one color is pulled from more than one stone the problem arises of *registration*, that is, of placing the paper so that each succeeding color impression is made in the correct relationship to the first one. Suppose, for example, that you have included a green bottle in your print, and that you expect to achieve the green by printing the area of the bottle first in yellow and then in blue. If the paper is not placed in exactly the correct position over the drawing on both the yellow and the blue stones, the bottle will emerge with a blue line on one side and a yellow line on the other. When that happens your print is not in register.

There are various methods of registration. The most common is the use of *register marks* in the form of hairline crosses or T marks placed at diagonally opposite ends of the drawing, *outside* the picture area by no less than an inch but *within* the printing area of the stones. These register marks are drawn on the master color sketch (if you use one) and traced and redrawn on each stone to be printed.

The register marks are printed on each sheet of paper when the first color is run. You then cut out a small hole at the intersection of each hairline cross or T mark (Fig. 115); use a single-edge razor blade and cut a small triangle or rectangle or punch out a circle with a paper punch. You will then have little difficulty in positioning the paper on the second and other stones: Place the top hole directly over the top intersection on the stone; then, sighting through the bottom hole in the paper as though down a rifle barrel, place it over the bottom intersection on the stone. Unfortunately, this method defaces the margins, and this destruction of the paper is not highly regarded by some, even though the cut holes can be placed well outside the picture area.

Another procedure, which meets the requirements of those who insist upon pristine margins, makes use of needles or points with which the paper, instead of being marked and cut, is merely pricked. Two needles pierce the paper at the two points of registration and are inserted into corresponding depressions made in each of the stones (Fig. 116). Assume that you have a master sketch drawn on sheet acetate.

115. Register marks.

Draw the register marks on the acetate and make needle holes at the intersections. Place the acetate over the paper, piercing each sheet of paper with corresponding needle holes. Pick up the paper through the pierced holes with dull needles mounted in wooden handles. Insert the needles in holes drilled lightly in the stone to match the holes in your acetate master sketch. Release the paper and print.

Ernest de Soto, while on a senior printer grant at the Tamarind Lithography Workshop, invented a registration device that avoids marking the paper in any way. You may find it well worth your while to build a copy of this device (Fig. 117). Basically it consists of 2 brass rods connected by a $\frac{3}{8}$-inch universal joint, allowing 45-degree movement. One of the brass rods is mounted against a brass backplate and can be adjusted by 3 setscrews to the height of the stone. The other rod accepts 2 different sizes of telescope-type extension rods (allowing for a wide range of margins). These rods terminate in a small T–mark bar, which registers the paper. The device is attached to the stone by an adjustable nylon web belt and is designed to swing away from the stone when the print is pulled so as not to interfere with the scraper. The same artist has designed a paper notcher as an aid in registering deckle-edge papers. (Details are available from the Tamarind Lithography Workshop in Los Angeles.)

PROCEDURES

Method 1: Working from a Master Color Sketch

Assume that you plan to do a 3-stone lithograph, making use of a master color sketch on which you have drawn register marks in the margin at opposite ends. Using grained or sheet plastic (or vellum tracing paper) make a separate tracing from the master sketch for each of the three colors to be used. Powder a sheet of thin paper with Conté

left: 116. Registration with needles.

below: 117. Paper register device after invention by Ernest de Soto.

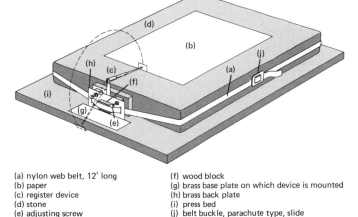

(a) nylon web belt, 12' long
(b) paper
(c) register device
(d) stone
(e) adjusting screw

(f) wood block
(g) brass base plate on which device is mounted
(h) brass back plate
(i) press bed
(j) belt buckle, parachute type, slide

powder, and place it, Conté side down, on the stone. Place over it your tracing of color A, which you will then transfer to the stone, making certain that you have also traced the register marks accurately.

Work up your drawing of color A on the stone, using lithographic crayon, tusche, and/or rubbing ink. Since these materials are *black,* you have at this point the problem of mentally translating the range of values from black to white into tones of the *color* with which you will print. The densest blacks drawn on the stone will only be as dark as the color rolled up on the ink slab, which can, for example, be a very light yellow. This is an adjustment that will not seem difficult after you have completed your first color lithograph.

When the drawing is completed, etch and proceed as with a black-and-white lithograph, proving with black ink. If the etch "holds" the drawing, print color A. (A slab of plate glass, 24 × 26 inches, is useful for mixing color inks, since, by putting a clean piece of white paper underneath the glass, you can see the color accurately.) Pull several trial proofs on newspaper. Check to see that the register marks are printing accurately. If not, before removing an impression from the stone, rub your fingernail on the back of the paper over the registration mark to make sure that it prints. If it is satisfactory, pull from this first stone a number of prints somewhat larger than your intended edition. To avoid adding to your problems at this time, print on dry paper.

If you wish to preserve the work on stone A, roll it up with black chalk ink and gum it down. If you wish to use this same stone for color B, grain it down with No. 180 and No. 220 carborundum or a finer grain, but not sufficiently to remove the ghost, and let it dry.

On a second stone (or on the same stone regrained) trace your drawing for color B and proceed as before until you get a satisfactory proof. You are now ready to add color B to the prints you have already pulled for color A. Be careful to check the top and bottom of the print so that you do not place it upside down on stone B. Position the paper by means of the register marks you have made, first at the top and then at the bottom of the stone, and run it through the press. On removing the sheet from the stone you will see the effect of two colored inks fused in the print. Pull all the prints that have previously been printed with color A, and proceed in the same manner for color C.

Method 2: Improvising a Color Lithograph

This is to work directly on the stone without a preliminary drawing. Trace a picture rectangle on the freshly grained stone and begin a design. Use a tusche and a fine pen point or ruling pen to place two register marks at diagonally opposite ends of the rectangle. Etch as with a black-and-white print. Lay out a palette of litho ink near the ink slab and mix a color on the slab. Roll the composition roller in this ink. Wash out the stone and roll up with the color mixed. Take trial proofs

118. Mirror arrangement
for reverse drawing.

118. Mirror arrangement
for reverse drawing.

and examine the print. If the impression is not acceptable, run only a few sheets, and alter the ink color by adding another ink. Repeating this can obtain a number of small editions from stone A in different colors.

On one of the proofs, with watercolor or any other medium, paint another color or colors to make a "color sketch" for continuing work. On a second stone, or on the same stone partially regrained, make a drawing for color B. Do this in one of two ways: (1) From the color sketch make a tracing, trace it in reverse onto the stone with Conté powder, and transfer the register marks. (2) Trace onto the stone only the picture rectangle and register marks and continue to draw freely, looking at the sketched design. Remember to draw backwards on the stone, since all direct-method printing surfaces reverse the image. Use a mirror to see the image in reverse (Fig. 118).

Dust, etch, wash out, roll up, and print stone B. Continue for as many stones as may be necessary to complete your color lithograph.

Method 3: Color Lithography by Substraction

This too is a one-stone color method, and it requires careful pre-planning. Make the image on the stone with crayon and/or tusche, place registration marks at opposite ends of the picture rectangle, etch, and then follow this procedure: Print the entire stone in one color; substract portions of the stone and print what is left in another color; then remove more from the stone and print the remainder in a third color; and so on. Drawing, dusting, etching, wash-out, roll-up, printing, and registering are accomplished normally.

Areas can be removed from the stone by such means as scratching, graining with a small glass bottle stopper and carborundum, or painting with a strong solution of nitric acid and a small amount of water. Immediately gum-etch the removed areas. If you stop between successive color printings, roll up in black with your leather roller and gum down with about 6 drops of nitric acid to $1\frac{1}{2}$ ounces of gum arabic. To start again, wash off the old etch, gum down with a very thin layer of gum-arabic solution, then dry, wash out with lithotine, sponge the stone with water, and roll up with the new color.

Printing Water and Oil Colors Simultaneously

This technique is for the experienced lithographer. Senefelder suggested

that after a stone has been inked with an oil-based colored ink, one or more water-based colors can be added to the design (by stencils?) and printed in one operation. To the (powdered?) color, add 2 parts of gum-arabic solution and 1 part of sugar. Allow the color to remain on the stone a minute or so before pulling the print.

This technique would seem to suggest the possibility of reversing the whole theory of lithography by using oil instead of water on the stone for stamping and printing with a water-based ink.

SOME EXAMPLES OF COLOR LITHOGRAPHS

The Bauhaus master Joseph Albers (b. 1888) is the great color theorist of our time. In both oils and lithography Albers has pursued his series called *Homage to the Square*, a long analysis of the optical power of color. In Plate 13 (p. 106) hard-edge color fields are oriented around an inner square. A white line tracing a square shape divides a color field so as to suggest two separate values, thus obtaining from three color runs the effect of four colors.

In Plate 14 (p. 106) Garo Z. Antreasian (b. 1922) has conveyed three-dimensionality by means of carefully considered color values. The first stone blended dark blue through rose to light yellow. The second and third stones were violet-gray and a dark slate-gray. Interested in the latent or disused possibilities of lithography, this artist has here avoided the "touch" and tonal textures characteristic of lithography so as to focus on the image itself. Much as this work may resemble a silk-screen print, Antreasian prefers the aesthetic qualities unique to lithography.

Paul Wunderlich (b. 1927) is a German graphic artist who compounds into a unique style elements of Art Nouveau, Surrealism, and the popular world of fashion, where he has collaborated with a fashion photographer (Pl. 15, p. 107).

In *Midsummer Wall* (Pl. 16, p. 107) Pop artist Jim Dine (b. 1935) has transformed the commonplace hammer into symbolic significance, and introduced calligraphy with the aid of a mirror. "Lithographs take enough time, more than anything else I do, so that they make me think about everything."

Working with Gemini G. E. L. in California, Frank Stella (b. 1936) derived Plate 17 (p. 108) from a 1965 painting entitled *Empress of India* and achieved the "shaped canvas" effect by the silhouette on the paper, which eliminates the normal print rectangle.

The young printmaker who first approaches color after working in black and white on stone may find that he tries to "translate" his ideas into color when he should begin to "think" in color. Paul Jenkins (b. 1923) thinks in color and gets away altogether from any idea of a key drawing in black. Plate 18 (p. 108) has been realized completely in the interplay of color movements.

Workshop Solutions
to Lithographic Problems

During the roll-up the image does not take ink, or does not get dark

Cause: Ink too stiff.

Solution: Add a drop or so of varnish, rework the ink and try again.

Cause: Insufficient ink on the roller.

Solution: Add a line of ink across the ink slab. Work up the roller. It should have a dull, velvetlike gloss evenly distributed over its surface.

Cause: Too much damping water on the stone.

Solution: Use less water in the sponge and use a small piece of another clean, dampened sponge to "polish" the surface of the stone after damping with the first one.

Cause: The stone has been overetched.

Solution: There is no remedy for this but to start anew.

Cause: There seems to be a film covering the stone.

Solution: Rub the stone with a rag and some fine pumice or carborundum while the stone is dampened. Rub in some ink or asphaltum. Redamp stone. Roll up. Etch moderately. Print.

Cause: Too much lithotine used in wash-out. Rubbed too hard.

Solution: Use asphaltum in wash-out. Repeat until image, hopefully, improves.

Cause: Unknown. But it is clear that parts of the image or design are weak and do not take ink.

Solution: Ink the design as best you can. Powder with a half-and-half mixture of rosin and talc. Gum down image and fan dry. Wash out with lithotine. Pour some Holtite Plate Lacquer on a clean rag and rub same onto the design. Fan until *tacky.* Rub asphaltum on *immediately* with clean rag. Fan and wash off and roll up before Holtite gets a chance to set up and ruin (completely blacken) your work. *Recommended only for experienced printmakers.*

Image on the stone looks good, but prints are very light
Cause: Press pressure too light.
Solution: Assuming all other factors are controlled, turn down screw on yoke of press one-half revolution, and repeat until print comes up.

Cause: Paper too wet.
Solution: Place between dry blotters, or wave in the air before use.

Cause: Paper too dry.
Solution: Place in damp press or sponge down individually before use.

Stone and prints scumming, image coarsening
Cause: Ink is poorly ground. (May contain abrasive pigment agglomerates.)
Solution: Regrind or obtain finer ground ink.

Cause: Too much ink on roller.
Solution: Scrape down roller with spatula and remove some ink from the ink slab. Check results on next print.

Cause: Ink too soft (needs stiffening or tack).
Solution: Scrape off old ink from roller and slab. Use fresh ink with some magnesium carbonate: or add an ounce of body gum or water-resistant varnish to the pound of ink.

Cause: Stone underetched.
Solution: Wash out with lithotine. Roll up with crayon black. Erase scum. With a small piece of sponge, wash over the stone with this solution: 10 drops of phosphoric acid, 10 drops of gum-arabic solution, and 1 ounce of water. After a few minutes wash off with clean water. Pass roller over stone once or twice and proceed to print. Should clear up after a few proofs. Repeat, if necessary.

Cause: Gum was sour.
Solution: Use procedure above as for underetched stone.

Cause: Pressure too great.
Solution: Back off the screw on the yoke of the press and check results.

Stone blacks up entirely
Cause: Stone dried during rolling. The roller deposited ink mechanically all over the stone.
Solution: Immediately flood the stone with water. Quickly charge the roller on the ink slab. With much pressure, high-speed rolling, and a kind of snap, briskly pass the roller over the stone to pick off the ink. (The roller must be in excellent condition to accomplish this.)

Paper sticks to stone, picks, splits, or tears
Cause: Paper too wet and soft, or too weak.
Solution: Remove bits of paper from the stone with sponge and water. Place paper between dry blotters. Or, use a different paper.

Cause: Ink too stiff (tacky).
Solution: Remove old ink from scraper and ink slab. Add varnish, rework. Or, add a drop or two of mineral oil in your damping water.

Cause: Low temperature.
Solution: Reduce tacky ink (soften).

Cause: Too much press pressure.
Solution: Reduce to minimum possible without losing print quality.

Borders of stone scum up
Cause: Mechanical adhesion, or grease spots, or insufficient etch, or foreign matter.

Solution: With pumice stone, Schumaker brick, or snake slip, clean off borders on wet stone. Re-etch the borders with a strong solution of nitric acid and gum. (Use a brush to paint this strong etch on the stone.) Dry without having the etch get on the visual image. Wash off and print.

Scratches or scraped areas fill in and go dark
Cause: Underetched, or overinked.
Solution: Remove inked-in areas by reworking with needle, razor blade, knife, snake slip, etc., and re-etch. Set aside. Wash out. Roll up. Print.

Dark streaks across stone parallel to axis of roller when rolling
Cause: Seam of roller has been badly scraped.
Solution: It may be possible to eliminate this difficulty by rolling across the stone in another direction. Or, use a different roller.

Dark streak across the stone and print parallel to axis of scraper
Cause: Stopping on the design when cranking the scraper across the stone.
Solution: If possible, pick off with the roller on the next inking.

Light area in an otherwise well-inked print (stone looks good)
Cause: The light area may coincide with a hollow in the stone caused by faulty graining over a period of time. (Check stone with a steel straightedge to determine if it is level.)
Solution: Add another blotter or two under the tympan and check your results. If this hasn't helped, you have a choice of making a printer's makeready, or abandoning this stone until you level it by grinding.

Cause: Faulty coverage with the roller.
Solution: Ink the stone from several different positions.

The gummed stone, on drying, forms a myriad of cracks or bubbles
Cause: Gum layer too thick, uneven, or effect of extreme temperature changes. (Gum usually flakes off and peels ink from the stone.)
Solution: Add a tiny amount of sugar to the gum before putting it on stone. Rub down. Use asphaltum or ink with a little solvent and rub up image. Wash out through water. Repeat until undesired marks disappear.

Tones inconsistent on successive prints
Cause: Roller not charged evenly with ink.
Solution: Roll longer on the ink slab, turning the roller constantly.

Cause: Paper not evenly dampened.
Solution: Place paper between dry blotters and save for another time. Prepare a fresh batch of paper taking care to avoid this difficulty again.

Ink bleeds
Cause: Ink is *hydrophilic* (water-loving). (Poor manufacture.)
Solution: Use *hydrophobic* (water-hating) ink; or add magnesium carbonate; or add stiff varnish; or add commercial fountain solution to damping water.

Dark streaks in unwanted places
Cause: Wash-out was too vigorous; gum rubbed too hard or too thin; rags employed in gumming or etching were greasy.
Solution: Clean off and remove streaks with appropriate tools. Re-etch. Thin gum with light pressure. Employ clean rags or cheesecloth.

Light streaks across the design
Cause: Scraper is uneven or nicked.
Solution: Increase press pressure or add backing material; or, plane or grind scraper level; or, change scraper.

Ink sets off
Cause:　Ink not adjusted to the paper being used.

Solution:　Add less than $\frac{1}{2}$ ounce of boiled linseed oil per pound of ink; add magnesium carbonate to ink; add less than a teaspoonful of cornstarch per pound of ink.

Cause:　Using too much ink on stone or plate.

Solution:　Reduce quantity; desensitize stone or plate.

Ink smudges, although dry
Cause:　Too much mineral oil, tallow, or other nondrying component.

Solution:　Have ink manufacturer add a stronger dryer in ink.

Solid areas of print are mottled
Cause:　Too much press pressure.

Solution:　Reduce pressure; stiffen the ink.

Cause:　Too much damping water.

Solution:　Reduce.

Cause:　Ink too soft or short.

Solution:　Add cornstarch (see above) or increase tackiness with appropriate varnish.

Stone or plate prints a tint on non-image areas
Cause:　Ink is hydrophilic; emulsifies in damping stone or plate.

Solution:　Add small amounts of heavy varnish to soupy ink; add small amounts of water-resistant varnish to short, easily water-logged ink.

Cause:　Ink too fresh. Vehicle has not wet pigment thoroughly.

Solution:　Allow ink to stand a week or more before using.

Cause:　Non-image areas poorly desensitized.

Solution:　Desensitize. On aluminum plates apply rag or sponge with phosphoric or oxalic acid to 1 gallon hot water. Wash plate well with water. Re-etch. Thin. Fan dry. Wash with water. Proceed in normal fashion.

Hickies (irregular white spots in solids or dark areas) appear
Cause:　Dried ink particles or skin on ink slab and roller.

Solution:　Scrape leather roller and slab. Mix fresh ink; avoid ink cans containing bits of dried ink; prevent ink from oxidation drying and skin formation.

Cause:　Lint or foreign particles in or on the paper.

Solution:　Change paper; reduce tack of ink.

The Relief Process

WOODCUT
WOOD ENGRAVING
LINOLEUM CUT
COLOR WOODCUT
REVERSE ETCHING
COLLOGRAPH

*Do not that which your finite members are capable of,
but that which, in moments of greatest tension,
you dimly guess at as a transient possibility
and let your fingers look to it how they can manage to
get along.*

Meier-Graefe

Woodcut:
Development
of an Art Form

Curiously enough, such heterogeneous factors as the desire for gambling and the need for forgiveness of sin combined to create a thriving market for the first printmakers in the Western world. During the fifteenth century, playing cards (Pl. 19, p. 149) were produced in great number and variety, to satisfy those who dreamed of riches; while images of St. Christopher (Fig. 119), St. Sebastian, St. Gertrude, the Virgin Mary, and others met the needs of those seeking salvation or honoring the patron saint of their professions or occupations. In 1414 the Council of Constance debated the system of indulgences and pondered the propriety of selling or distributing these popular woodcuts of saints, as an alternative to penance for the faithful.

Some six centuries earlier, Chinese artists were already making religious illustrations in the woodcut medium. Our oldest example of these is thought to have appeared in the *Diamond Sutra* (Fig. 120), a Buddhist scripture found in the Caves of the Thousand Buddhas in western China. Thus, the Chinese both made printmaking possible by their invention of paper and developed the technique of relief printing.

Paper came to the Western world from the Far East by way of the Levant and North Africa to Spain, where it was made about A.D. 950. Two centuries later the first paper mill in the West began to function at Xativa, Spain. By 1276 the first sheet of handmade paper had been

above left: 119. *St. Christopher.* German, 1423. Woodcut, $11\frac{3}{8} \times 8\frac{1}{8}''$.
John Rylands Library, Manchester, England.

above right: 120. *Diamond Sutra.* Chinese, A.D. 868.
Woodcut; $9\frac{3}{4} \times 11\frac{1}{2}''$, length of scroll $17\frac{1}{2}'$. British Museum, London.

left: 121. *The Annunciation,* fragment from burial grounds
at Akhmin, Upper Egypt. Coptic, c. 5th century. Printed linen.
Victoria & Albert Museum, London.

manufactured at Fabriano, Italy, in a mill that functions today. Paper
mills were erected in Germany before 1400, in England before 1500,
and in the Netherlands shortly thereafter.

By the time paper arrived in the West, fabrics had already been
printed from wooden blocks. In Early Christianity, Egyptian Copts used
woodcut to produce the remarkable textile in Figure 121. The technique
spread, serving twelfth-century Italians and Spaniards for the commer-
cial manufacture of printed fabrics. Movable type, perfected by Johann
Gutenberg in c. 1437, launched the rapid dessimination of the printed
word, supplemented by art work prepared in woodcut.

The earliest Western relief prints appeared as black lines (woodcuts)
on a white ground. After the artist completed the drawing, the cutter
removed the undrawn areas from the block, inked the block, and pulled
an impression. White-line (Fig. 122) and dotted manner or *criblé* prints
(Fig. 123) were not seen until after 1450. In white-line (wood engraving)

the background was left intact and the lines defining the image were removed; criblé prints came from blocks, or metal plates, hammered by metal punches.

Many variations on the woodcut process were soon invented. The *paste print* (Fig. 124) may have been made by affixing gold leaf to thick paste on paper, then printing an inked or uninked block on top. The *tinsel print* came from applying bits of sparkling metal or quartz crystal to impressions of paste; the velvety surface texture of the rare *flock print* (Fig. 125) from dusting the tacky impression with fine wool shearings. Too, the color print could be given raised surfaces, lines, or textures by impressing it on an uninked, deep-cut block or plate. Called *blind*

above left: 122. Urs Graf. *Standard-Bearer of the Canton of Unterwalden.* 1527. White on black woodcut, 8 × 4⅞".
Print Room, Kunstmuseum, Basel.

above center: 123. Master of Cologne Arms (?). *Christ and the Woman of Samaria.* c. 1450. Hand-colored metalcut (criblé print), 7 × 4¼".
Staatliche Graphische Sammlung, Munich.

above right: 124. *St. Dorothy.* Woodcut (paste print with gold tinsel, and incrustation applied to paste), 8 × 5⅝". British Museum, London.

left: 125. *Christ on the Cross, Between the Blessed Virgin Mary and St. John.* First half 15th century. Woodcut (flock print), 10½ × 7½". Ashmolean Museum, Oxford.

left: 126. *Patron Saints of Ratisbon: St. Denis, St. Emmeram, and St. Wolfgang.* German, 1460–70. Woodcut (seal print). Metropolitan Museum of Art, New York (gift of J. Pierpont Morgan, 1917).

right: 127. *Coronation of the Virgin.* 1470. Woodcut (seal print). New York Public Library (Astor, Lenox and Tilden Foundations).

embossing or *gauffrage,* this process can produce what are sometimes described as *seal prints* (Figs. 126, 127).

Color often was applied by hand or by stencil, and by 1508 the chiaroscuro woodcut had been developed. To imitate drawings made on tinted paper and heightened with white or gold, these woodcuts were printed in values of a single color, some in closely related colors.

More significant, however, was the advent of an elementary type of printed book—the so-called *block books,* in which each page of pictures and text was cut and printed from a single block. The famous *Ars Moriendi* (Fig. 128), a Netherlandish treatise on the "art of dying well," served to comfort and instruct the sick on their deathbeds. Its eleven woodcuts illustrate the struggle of a dying man, helped by angels and saints, to overcome a series of temptations represented by devils.

The fifteenth century also saw the serial issuance of groups of prints, a practice common today. The example in Figure 129 is from an early French series on the Passion of Christ. Sheets from three blocks have survived, one of them virtually intact. Each contains three scenes organized within the Classical device of an architectural framework. The Latin above gives the words of Christ; below are four lines of French commentary. The result is a beautifully unified arrangement of pictures and text. In all, forcefulness and a direct quality of expression characterize these prints made anonymously when the medium was new.

From this time on, the woodcut and the book have been interwoven in their history. This divides relief prints into two categories: *book illustrations* and *single cuts,* the latter including the series prints issued on separate sheets and, over the years, generally separated. Here might also be added *popular prints,* for woodcut—because simple to execute, direct, and immediate in communication—has always had close associations with ordinary people. It served not only for playing cards and

saints but also for such popular enterprises as lampoons, chapbooks, theatrical bills, and gameboards.

The first celebrated artist to whom we can assign a series of significant woodcuts was the German painter Albrecht Dürer (1471–1528). Having traveled in Italy and studied its painting, Dürer introduced Italian Renaissance ideals and forms into Northern art, an influence that was all the more widely disseminated through the medium of his prints, both engravings and woodcuts. Along with many single prints, he produced four woodcut series: the *Great Passion* and the *Small Passion* illustrating Christ's agony; the *Apocalypse* based on Revelations; and the *Life of the Virgin*. Unlike other artists of the time, Dürer drew his design on the block and cut most of the block himself. The infinite detail of *Rhinoceros* (Fig. 130), in his "decorative style," indicates the exacting

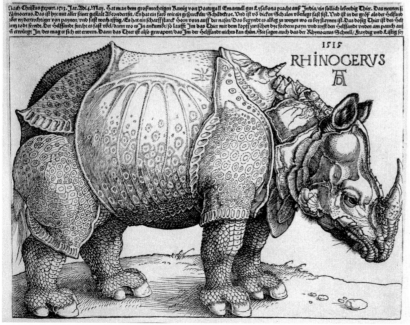

above left: 128. *Impatience,* from *Ars Moriendi.* c. 1465. Woodcut, $8\frac{3}{4} \times 6\frac{1}{4}''$. British Museum, London.

above right: 129. *The Kiss of Judas,* scenes from the *Passion of Christ.* French, 15th century. Woodcut. Metropolitan Museum of Art, New York (bequest of James Clark McGuire, 1931).

left: 130. ALBRECHT DÜRER. *Rhinoceros.* 1515. Woodcut, $8\frac{3}{8} \times 11\frac{5}{8}''$. Metropolitan Museum of Art, New York (gift of Junius S. Morgan, 1919).

133

standards that Dürer imposed on the medium. Quite distinctive is his approach to a different subject in Figure 203.

Subsequently, many important artists worked in wood. At first, however, the "specialists" in woodcut were illustrators. As the printed book replaced the calligraphed manuscript, a means of printing illustrations had to be found to replace the drawings and paintings made in manuscripts. Woodcut was a natural medium for this, since it could be printed along with type. Though by nameless or obscure artists, the early illustrated editions of literary works are justly famed (Fig. 131).

In time, etching and engraving, with their greater potential for expressive, three-dimensional realism, tended to eclipse woodcut both for illustration and for reproducing images from other media. However, Thomas Bewick (1753–1828) developed white-line wood engraving in such delicate detail (Figs. 167, 168) he greatly expanded the graphic power of the medium as well as its usefulness in reproduction.

In the Far East meanwhile, the woodcut had a remarkable development, one scarcely recognized in the contemporaneous West. In China, where it originated, the medium continued, from the tenth century, to be used primarily for book illustration. Encyclopedic works were given profuse woodcut illustration. The *Mustard-Seed Garden* (Fig. 132) is a seventeenth-century painting manual in which the work of many artists has been analyzed by means of woodcut illustration, subtly colored by what is assumed to have been a gradated wash technique. Single prints appeared in the seventeenth century, but they did not become common until the twentieth, when modern Chinese artists began to recognize the advantages of this traditional skill and when its usefulness as a propaganda medium became apparent.

Despite its great tradition, the Chinese woodcut remains poorly known in the West, its influence having arrived indirectly—from Japan.

The Japanese were quick to import the invention and to evolve it into the greatest school of woodcut artists of all time. Known as *ukiyo-e*, the school arose before 1750, coincident with the flowering of the people's theater (*kabuki*). *Ukiyo-e* means literally "pictures of the floating (i.e. transient) world," and the works were popular, concerned with scenes of everyday life. The *ukiyo-e* printmaker recorded for pleasurable consideration the images of actors and actresses costumed and posed for their great roles, the famous Yoshiwara district, favorite birds and flowers, legends and folklore, waterfalls, and views of Mount Fuji. The prints appeared in every household and, like Currier & Ives prints in America, were hawked on the streets, even pasted on walls of buildings. Japanese prints—their strong decorative design and brilliant, flat colors—had a profound influence on modern European art after they were discovered as wrappings for objects imported from Japan.

Moronobu (c. 1623–94) was an initiator of the *ukiyo-e* style who produced vast numbers of striking black-and-white prints (Fig. 133). In the eighteenth century commenced the age of Japanese color woodcut, made golden by the rich color and exotic girls of Harunobu (c. 1725–70; Figs. 134, 135); the candid eroticism of Utamaro (1753–1806; Fig.

below: 133. HISHIKAWA MORONOBU. *A Garden.* 1691. Woodcut, 9¾ × 7″. Philadelphia Museum of Art (gift of Mrs. Anne Archbold).

below left: 134. SUZUKI HARUNOBU. *Geisha Masquerading as Dharma Crossing the Sea on a Reed.* 1766. Color woodcut, 10⅞ × 8¼″. Philadelphia Museum of Art (gift of Mrs. Emile Geyelin in memory of Anne Hampton Barnes).

below center: 135. SUZUKI HARUNOBU. *Girl with Lantern on a Balcony at Night.* c. 1768. Color woodcut, 12¾ × 8¼″. Metropolitan Museum of Art, New York (Fletcher Fund, 1929).

below right: 136. KITAGAWA UTAMARO. *Yama Uva Combing Her Hair with the Infant Kintoki on her Back.* c. 1795. Color woodcut, 14⅝ × 10″. Metropolitan Museum of Art, New York (gift of Samuel Isham, 1914).

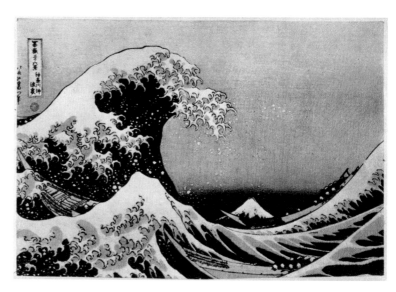

below: 138. KATSUSHIKA HOKUSAI. *The Great Wave of Kanagawa.* c. 1823–29. Color woodcut, 10 × 15″. Metropolitan Museum of Art, New York (Rogers Fund, 1936).

above: 137. TOSHUSAI SHARAKU. *Ichikawa Ybizō (Danjulo V) in Role of Washizuka Kwandayū.* 1794. Color woodcut, $14\frac{7}{16} \times 9\frac{5}{16}$″. Metropolitan Museum of Art, New York (purchase, Rogers Fund, 1936).

136); the powerful portraits on mica grounds by a Noh actor, the "mysterious" Sharaku (act. 1794–95; Fig. 137); Hokusai (1760–1849), who fused people, animals, and their world with his extraordinary "touch" (Pl. 20, p. 149; Fig. 138); and Hiroshige (1797–1858), the master of land- and seascape (Fig. 139).

Hokusai's *View of Fuji from Seven-Ri Beach* (Pl. 20) offers several principles significant for the Japanese woodcut. The "bird's eye view" was common to Eastern art long before the airplane. It transforms the landscape into a daring yet delicate vision. The resulting asymmetrical composition and sensitively arranged areas are a hallmark of the art. The subtle gradations of color suggest rather than represent the subject, offering evidence of "inner" reality instead of external "facts." Finally, the calligraphy in the upper left corner and its placement are essential elements in a carefully balanced whole. Such signs and symbols range from devices and signatures of artists, artisans, and professional printers to data on the scenes depicted and words of sage advice.

In order to meet the popular demand for these prints the Japanese organized the process into a systematic division of labor. The blocks were designed by the artists, turned over to professional cutters, and then to printers, and finally perhaps issued by a different person altogether. Specific names were even given to the sizes of prints, an *ōban*, for example, being a print measuring 15 × 10 inches.

For Europeans, Japanese woodcuts not only exhibited unanticipated color possibilities but they also brought unique qualities of paper. Even

now Oriental papers are preferred by most woodcut artists. The overall impact of Japanese woodcuts was probably as great as that of primitive art, affecting both prints and art style in general. This combination of aesthetic and technical impetus can be found full force in the modern European art then evolving (Pl. 3, p. 26; Pl. 21, p. 151; Figs. 35, 140).

The woodcut proved to be particularly adaptable to the art of the Expressionists, whose dramatic concepts and predilection for vigorous, even violent, color and line were well served by the bold lines cut so readily on the wooden block. The work of the German Expressionist group known as *Die Brücke* has already been mentioned in Chapter 1 (Pl. 6, p. 44; Fig. 47) as well as the movement's indebtedness to the psychological and emotional content in the graphic art of the Norwegian Edvard Munch (Fig. 46). Munch's woodcut *Two Figures by the Shore* (Pl. 21, p. 150) provides additional evidence of his prowess as a printmaker and demonstrates the period's concern with intense human feeling.

The German Expressionists also took inspiration from the work of the maverick Paul Gauguin (1848–1903), born in Paris to a life colored by childhood memories of Peru and early wanderings in tropical places. Learning first from the Impressionists (Figs. 34–36, 263), even exhibiting with them, Gauguin's mature style developed after he renounced the conventions of "civilized" art in favor of the primitive vision first embraced by the Romantics in the early nineteenth century (Pl. 1, p. 25; Figs. 20–31, 209–211). The style Gauguin developed was, however, far removed from that of the exoticism of the earlier period. His mixture of the Far East, the primitive, and the medieval is characteristic of Symbolism and Synthetism, the latter a method of abstracting from the imagination rather than from nature. Gauguin's most original works derive from his long self-exile in Tahiti. They proclaim the ripe color, lush physical beauty, and psychological *laissez-faire* that Gauguin found so seductive in Polynesia. Representative are a number of extraordinary color woodcuts (Fig. 140).

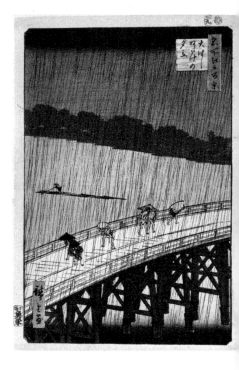

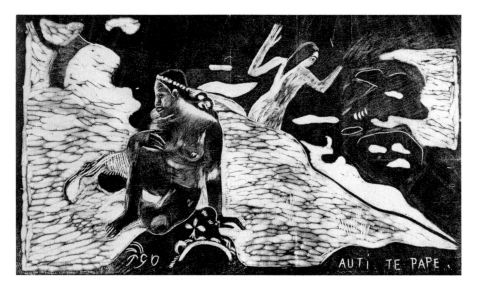

above: 139. UTAGAWA HIROSHIGE. *Storm on the Great Bridge.* 1857. Color woodcut, $14\frac{1}{2} \times 9\frac{3}{8}''$. Philadelphia Museum of Art (gift of Mrs. Anne Archbold).

left: 140. PAUL GAUGUIN. *Auti Te Pape* ("Women at the River"). 1891–93. Woodcut, printed in color with the aid of stencils; $8\frac{1}{8} \times 14''$. Metropolitan Museum of Art, New York (Rogers Fund, 1921). (See also detail, Fig. 6.)

137

From these strains of emotionalism, with their accompanying freedom of color and expressive distortion of drawing, the artists of Die Brücke evolved their own Dionysiac trends, revealing a love for the polarities of black and white, as well as for strident, poisonous color, and a worship of the dynamic slash of the knife on a block of wood—all combining to foster an outpouring of prints early in the twentieth century. Representative is the work of Christian Rohlfs (1848–1938; Fig. 141); Erich Heckel (1883–1970; Pl. 22, p. 150); Karl Schmidt-Rottluff (b. 1884; Fig. 142); and Emil Nolde (1867–1956; Fig. 143).

In Chapter 1 the modern turn toward geometric abstraction was illustrated in a lithograph by Wassily Kandinsky (1866–1944), a Russian closely associated with the German Expressionist groups. Here we have a woodcut of almost chaotic energy (Fig. 144), its sweeping curves and sharp thrusts conveying a sense of planetary bodies swirling toward the center or flying apart to ultimate disasters or inconceivable ends.

In America wood engraving was widely used by 1850. Thomas Nast (1840–1902) personally used the burin for his smaller cartoons (Fig. 145), and so powerful was his art that the use he made of woodcut influenced the whole development of the political and social cartoon. Timothy Cole (1852–1931), one of the period's most skillful illustrators, made independent wood engravings for purely artistic purposes (Fig. 146). About the turn of the century, a particularly interesting development was taking place in Mexico. In this country, which is famous in any case for its folk art, there was a remarkable flowering of the folk print—a reminder that the woodcut had from its beginnings always served as

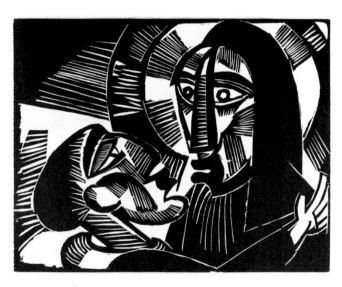

left: 141. CHRISTIAN ROHLFS. *Two Dancers.* c. 1913. Woodcut, 11 × 11¾". Museum Folkwang, Essen.

below: 142. KARL SCHMIDT-ROTTLUFF. *Christ and Judas.* 1918. Woodcut, 15½ × 19⅝".
McMaster University Collection, Hamilton, Ontario.

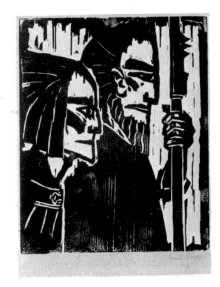

right: 143. EMIL NOLDE. *Wayfaring Warriors.* 1917. Woodcut, 12 × 9½".
Nolde-Museum, Seebüll, West Germany.

below left: 144. WASSILY KANDINSKY. *Kleine Welten VIII.* 1922.
Woodcut, 10⅝ × 8". Collection Kenneth Lindsay, Binghamton, New York.

below right: 145. THOMAS NAST. *A Group of Vultures
Waiting for the Storm to "Blow Over"—"Let Us Prey."*
Illustration for *Harper's Weekly* (Sept. 23, 1871). Wood engraving, 14½ × 9½".

bottom: 146. TIMOTHY COLE. *The Hay Wain.* 1899.
Wood engraving after Constable, 5 3/16 × 7 13/16". Philadelphia Museum of Art.
(See also detail, Fig. 7.)

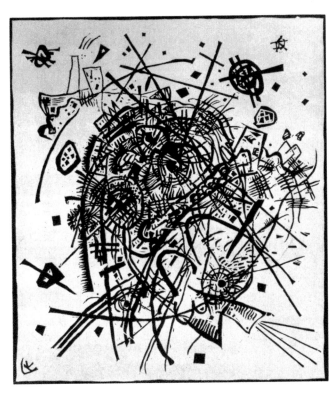

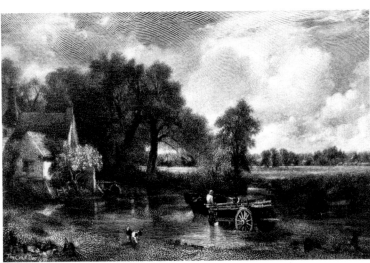

139

an admirable means of popular expression. The people of Mexico are intimately acquainted with the art of the woodcut because it is the traditional medium of the *corrido*, a brilliant or a gaily colored, tissuelike piece of paper on which may be printed a topical political, social, or economic satire, a pungent piece of poetry, or a trenchant ballad, illustrated with forceful woodcuts. The *corrido* is sold in the marketplace and at fairs, where the words are often heard sung by a man with a guitar. For a few pennies one can acquire a *corrido* with an original woodcut which may have been designed by one of the leaders in the field of graphic arts in Mexico. One of these great "artists of the people" was José Guadalupe Posada (1851–1913). *The Jarabe Dance Beyond the Tomb* (Fig. 147) illustrates an unusual technique in addition to the startling content. Posada developed the metal relief print after many years of painstaking cutting of innumerable popular prints on wood blocks. With this new technique, he drew on a zinc plate with an acid-resistant substance and allowed the mordant to do the cutting for him. The plate was then printed as a woodcut. Skeletons, or *calaveras* (Fig. 148), are favorite themes of the Mexican graphic artist; their tradition originates in the November celebrations of the Day of the Dead, and they are enmeshed in the complex fabric of Mexican life. The prints in the illustration shown were engraved upon ordinary battleship linoleum with single and multiple-toothed tools.

A late renascence of the woodcut as book illustration stemmed from England under the aegis of William Morris (1834–96), who promoted, among many other things, a revival of interest in hand lettering and the handmade book. Once again original woodcut illustrations were introduced, including, for example, those of the Pre-Raphaelite Edward Burne-Jones (1833–98; Fig. 149). This interest was carried on into the

below: 147. José Guadalupe Posada. *The Jarabe Dance Beyond the Tomb.* c. 1890. Relief etching, $4\frac{5}{8} \times 8''$. Achenbach Foundation for Graphic Arts, California Palace of the Legion of Honor, San Francisco.

right: 148. Taller de Gráfica Popular. *Calaveras.* c. 1947. Linoleum engraving, $14 \times 22\frac{1}{2}''$. Collection Jules Heller.

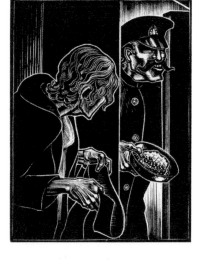

above: 149. EDWARD BURNE-JONES. *Adam and Eve.*
Frontispiece for William Morris, *Dream of John Ball*
(London: Kelmscott Press, 1892). Woodcut, $7\frac{1}{8} \times 5\frac{1}{8}''$.
New York Public Library
(Astor, Lenox and Tilden Foundations).

twentieth century, specifically in America by the "woodcut books" of
Lynd Ward (b. 1905), initiated with *God's Man* in 1929 (Fig. 150), in
which a continuous theme or narrative was given shape almost exclu-
sively in pictures, with either little or no text—as well as by the work
of the fascinating and controversial Rockwell Kent (1882–1971). Kent,
a prolific illustrator enamoured with the Far North, illustrated accounts
of his journeys to those icy regions with brilliantly stylized and highly
popular woodcuts and produced many independent prints as well
(Fig. 151).

The difficult art of wood engraving has had a distinguished Ameri-
can practitioner in this century in Fritz Eichenberg (b. 1901), both as
an illustrator and a printmaker. A superb draughtsman, capable of
tightly organized compositions within striking silhouetted shapes, he
made maximum use of the black-and-white contrast of the medium.
He also brought to his work the psychological insights and sometimes
almost surrealist approach that have preoccupied various artists of this

top right: 150. LYND WARD.
Illustration for *God's Man:
A Novel in Woodcuts*
(New York: Jonathan Cape
and Harrison Smith, 1929).
Woodcut, $5 \times 3\frac{1}{2}''$.

above right: 151. ROCKWELL KENT.
Northern Light. c. 1928.
Wood engraving, $5\frac{1}{2} \times 8\frac{1}{8}''$.
Philadelphia Museum of Art.

century, seeming to choose, as in his illustrations for Dostoevsky (Fig. 152), works that were ideally matched to his own genius.

Perhaps the most important development of the twentieth century, in terms of its indirect effect on the woodcut, has been the technical advance in commercial printing, which has made possible excellent photomechanical reproduction of many kinds of art. This released artists from the laborious demands of making woodcuts for printed illustrations. While it still has commercial applications, the relief print was thus freed to become, as it is today, primarily a fine-arts medium, bringing to fruition in an almost "new" art form the innovations introduced by various fine printmakers during the earlier decades of the century. Contemporary technology has also enhanced the medium with numerous new materials, tools, and methods, and many artists have added an unorthodox personal contribution to the distinctive style inherently provided by the cut block; examples of some of these innovations will find a place in the following chapters.

The woodcut is the oldest print medium, as well as the simplest and least expensive. This accessibility, which made possible its position from the beginning as a major popular art, has also encouraged its use as an amateur and elementary craft form. As a result the reputation of the woodcut has suffered somewhat: The bold, direct qualities that emerge naturally from the technique have sometimes been cited as evidence of crudity, technical deficiency, or poverty of expression. That view is now long outmoded, and the woodcut, as both a popular and a sophisticated art form, has come to rank with the other print media in the eyes of collectors, dealers, and critics.

152. Fritz Eichenberg.
Illustration for Dostoevsky's
The Grand Inquisitor.
(New Haven, Conn.: Haddam House, 1948). Wood engraving.

Making a Relief Print: Woodcut, Wood Engraving, and Linoleum Cut

The relief method of printing is simple, direct, and inexpensive. That which remains *in relief* on a smooth-surfaced block, after the white lines and areas have been cut away from the design, is inked and impressed upon paper. No complicated chemistry is involved, and a press (while one may be used) is not required. The nineteenth-century woodcut shown in Figure 153 accurately captures the various stages in this process.

Strict technicians make a sharp distinction between the woodcut and the wood engraving. The *woodcut* is worked on the plank grain of the wood, is cut with a knife, and is essentially composed of black lines and areas on a white ground. The technique, in general, is utilized for dynamic contrast between black and white. The *wood engraving,* on the other hand, is executed on the end grain of the wood, is cut with fine burins (or *gravers* as they are usually called in England) and other hand tools, and essentially provides an image composed of white lines against a black ground. The finer cutting possible on an end-grain block allows for a more subtle combination of the black-and-white components of the print than is expected in the woodcut. In the nineteenth century the wood engraving was considered by many to be the "drawing-room version" of its poor relative, the woodcut. This distinction has no meaning today, when each technique is valued for its own qualities.

143

MAKING A WOODCUT

The Wood Block

While cigar boxes and the ends of orange crates have been employed advantageously by the amateur, there are certain woods which are held in high regard by the printmaker. For broad effects, a simple pine board is adequate, but the fine printmaker will probably prefer either pear or cherry (the former providing a finer line). Other suitable woods are poplar, beech, bass, apple, maple, willow, and sycamore. The blocks are cut *plank grain,* that is, parallel to the grain of the wood, just as ordinary lumber is cut. Actually, any new or old plank of wood that meets your needs, and is not so soft that it crumbles, will be workable. If you intend to print the block on a press, it is advisable to secure wood that is *type-high,* that is, the height of type used for letterpress printing (0.918 inch) or, for your purposes, roughly $\frac{7}{8}$ inch.

Cutting the Block

As in all media of the graphic arts, your first step is to draw something. Using lithographic crayon, pencil, brush and ink, or any other drawing tool, make a clear image on the face of the plank. If you prefer, make the drawing first on paper and then trace it on the block with carbon paper and a hard pencil. You may also adapt the traditional Japanese method of handling the drawing. Draw with India ink on mending tissue, fine tracing paper, or other thin paper. Paste the drawing *face down* on the block with flour paste. When it has dried, the back of the

153. KUNIYOSHI UTAGAWA. *Various Stages of Making a Color Print.* 1857. Color woodcut, $9\frac{3}{4} \times 14\frac{1}{2}''$. Victoria & Albert Museum, London.

drawing can be oiled lightly, so as to make the drawing more visible, and then you can cut out *through the paper* those areas and lines that are to remain white.

Having completed the drawing on the plank, begin to cut away those lines or areas which you wish to remain *white* or unprinted. A word of caution might be offered at this point: Before you reduce the block to wood splinters in an effort to perfect your work, take a proof and study it. In fact, you will find it interesting to make, and to keep for future reference, several proofs of your blocks at different stages of cutting.

A successful woodcut can be made with an ordinary pocket knife. The cutting tools especially manufactured for the purpose, however, include a knife of traditional design and two basic types of gouges (Fig. 154). They can be obtained in different sizes and in matched sets from a supply house. Japanese woodcutting tools are also available, some in inexpensive sets to be found in Japanese or art and craft stores. Most printmakers will make use of any cutting tool with which they happen to feel at home.

The Knife. The traditional knife of the woodcutter is of Japanese origin. It is made of a 4- to 5-inch blade held firmly in a slotted wooden handle by a tapered ferrule. Any knife, however, that "feels" well in your hand may be substituted for the traditional one. John Buckland-Wright (*Etching and Engraving*, 1953, p. 199) mentions surgeon's scalpels, pocket knives, and refashioned watch springs as excellent woodcutting implements.

The knife is usually held in the hand so that it can make a diagonal cut (at about 45 degrees) into the wood and *away from* the edge of the drawn line (Fig. 155). With the block turned around, another cut at the same angle will remove a V-shaped sliver of wood from the plank. If you prefer, instead of rotating the block, you can change the position of your cutting fist, turning it through an arc of 90 degrees from its previous position; making an incision with the knife held at this angle will also remove a V-shaped sliver. All cutting should be done so that the line or area left for printing is narrower at the surface than at the base of the cut; if sections to be printed are undercut, they will break off when printing pressure is applied. The various types of cuts can be seen in Figure 156.

Gouges. Many printmakers prefer the V-shaped gouge (the English call it a *scrive*) and the U-shaped gouge to the traditional knife. The V-gouge, also termed a *veiner*, accomplishes in one stroke the removal of a V-shaped sliver (Fig. 157). The U-gouge is scoop-shaped and sometimes called a *spoon gouge*. These tools are available in many sizes and with various sweeps, and they can be supplemented by chisels of various sizes.

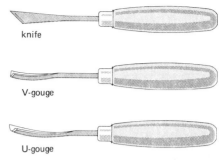

154. Tools to cut plank-grain block.

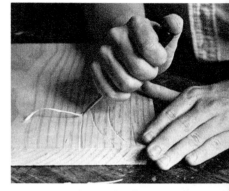

155. Cutting with a knife.

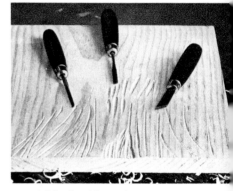

156. A block with various cuts.

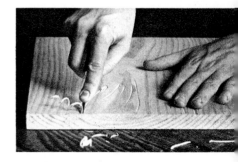

157. Cutting with a gouge.

Making a Relief Print: Woodcut, Wood Engraving, and Linoleum Cut 145

If you have trouble with a gouge "slipping" along the block, you will probably find that the cutting edge is too short; this can be remedied by resharpening the bevel to make it longer. The V-gouge should be sharpened at a different angle if you desire to cut across the grain, as is demonstrated in Figure 158.

Printing Materials and Tools

The requirements for printing a woodcut are very simple, and they can be met, according to your interests, either by purchasing the products especially manufactured for the purpose (see the list of suppliers at the end of this book) or by using easily available substitutes.

The Ink Slab. As a surface for working the ink, you can purchase an ink slab made of Plexiglas, stone, or other material. A slab of marble or a sheet of plate glass, about 15 × 20 inches in size, or a discarded lithographic stone will serve the purpose equally well.

The Ink. Block-printing inks are manufactured in two types, oil-based and water-soluble, each producing its own quality in the print; various conditioners are available for stiffening, thinning, or controlling the *tack* of the ink, and these should be used according to the manufacturer's instructions.

Woodcuts can also be printed with the *printer's ink* readily obtainable from a local print shop. If the ink is too stiff (as it sometimes is, especially on very cold days) you can soften it by adding a drop or two of lithographic varnish, or a bit of Vaseline (petroleum jelly) or of artist's oil paint. Use too little rather than too much of any of these softeners for best results. Artist's oil paint can also be used for printing wood blocks. In fact, printmakers tend to use a variety of paints and materials for printing.

The Brayer. The tool used for *rolling up* or inking the block is the *brayer,* or roller (Fig. 159), usually made of gelatin. Do not allow it to rest too long on the slab, and, when it is not in use, hang it on the wall by its handle so that it is freely suspended; otherwise, it may flatten out beyond use. The brayer can be cleaned with kerosene and then powdered with talc before being stored away. Blocks can also be inked with a *dabber,* which is a cotton pad covered with leather or silk; or you may simply use a stiff brush or a sponge.

Papers. Soft, thin, tough "rice paper," also called "Japanese paper," is best for woodcuts, although both terms are misnomers. More often, other kinds of plant material are used to make the traditional handmade Japanese papers. Also, comparable papers are manufactured in Europe and America, as well as some heavier papers suitable for relief printing.

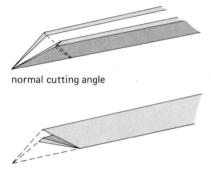

normal cutting angle

resharpen in this manner

158. How to sharpen a V-gouge to cut across the grain of a block without ripping the wood.

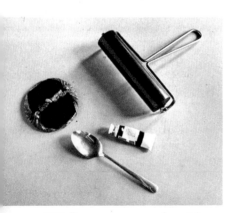

159. Brayer, spoon or burnisher, dabber, and ink.

It is recommended that you try many varieties of paper, not hesitating to experiment with anything that comes to hand.

Successful prints can be made with dry paper, though you may dampen it if you prefer. For those who want to dampen rice paper, here is a procedure that was recently observed by this author: Trim a newspaper to a size slightly larger than your printing paper, so as to make a "book" of newsprint. Load a large wallpaper brush with clean water and pass it over every fourth page in your newsprint book. Insert several sheets of dry rice paper between each wet section. Place the book on a drawing board, set another drawing board on top of it, and weight this with a lithographic stone or some other heavy object. In about an hour, the paper should be in excellent printing condition.

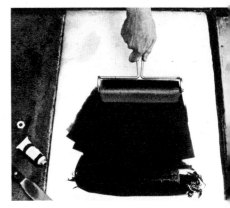

160. Loading brayer on ink slab.

Burnishing Tools. A *burnisher* (Fig. 159) is a rubbing or polishing implement. In relief printing, it is an oval-sectioned hand tool made of highly polished bone or metal, used to rub over the back of the paper as it rests on the inked block in order to make the impression. An ordinary tablespoon works satisfactorily as a burnisher. It is also possible to substitute a *baren*, the traditional Japanese burnishing tool. The baren measures about 5 inches in diameter, is slightly convex on the under side, and is covered with a lightly oiled bamboo sheath to allow it to travel smoothly over the paper.

Having assembled these materials, and having dampened the paper if you wish to do so (or having dampened a few sheets for experimental purposes), you are ready to pull a print.

Printing by Burnishing

Remove a small quantity of ink from the can or tube with an ordinary table knife. Work the ink on the slab with a stiff putty knife or similar tool, until it can be manipulated across the slab in a thin film by the brayer. Do not hurry this process.

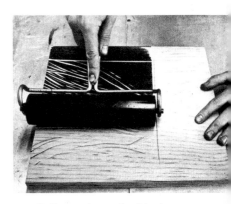

161. Rolling ink on the block.

Load the brayer with ink by passing it across the ink slab, and ink the wood block (Figs. 160, 161). Do *not* pass the brayer repeatedly across and back on the block in the same place—this is wasted motion. All that is required is a thin, even film of ink.

Pick up a sheet of your printing paper and, holding it at diagonally opposite ends, place it properly on the block. In order to line it up squarely, check in both directions before laying the paper down. After the first few trials, you will center your paper without difficulty.

With a burnisher, baren, or common tablespoon, briskly rub the back of the paper. If you use a tablespoon, place your fingers in the bowl of the spoon with your thumb alongside the spoon to ensure a good grip and even burnishing action (Fig. 162).

If you are using rice paper, the image will emerge clearly on the back as you burnish. If a heavier stock is used, pick up a corner of

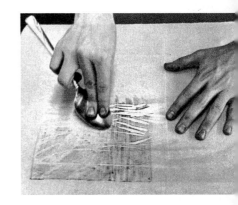

162. Burnishing with a tablespoon.

Making a Relief Print: Woodcut, Wood Engraving, and Linoleum Cut 147

the paper from time to time to determine whether more pressure is required for a rich black. Rub evenly all over the paper. Then remove, slip-sheet by placing tissue over each print, and stack the prints between dry blotters. Repeat the inking and burnishing for each print in your edition.

After pulling the whole edition, clean the block with lithotine or other solvent. Clean and powder the brayer with talc. Clean the ink slab with lithotine or, if you have used a water-based paint, with water. These cleaning operations will enable you to do other prints without having ruined your tools or encrusted your block. There is nothing more frustrating for the printmaker than trying to scrape old ink from an encrusted surface.

Printing on a Press

Printing the woodcut on a press is not a recent development, since almost from its beginning the woodcut was a method of book illustration. In the nineteenth century, the earlier, cumbersome wooden presses were supplanted by three major types of presses for relief printing: the Albion, the Columbian, and the Washington presses (Figs. 342–344). Various small presses on the market today are suitable for original relief prints.

In general, a relief print press is operated as follows: A type-high block is placed *face up* on the bed. To make an even, strong, full-bodied impression, the block will probably require packing directly *underneath* areas that might otherwise print poorly; for this purpose use paper or thin cardboard built up with glue until even printing is attained. If embossed effects are sought, thick, soft packing (layers of newspaper, for example) can be placed on top.

Provide for register of the paper and block on the press with cardboard stops fastened to the press with tape. Place a sheet of printing paper within the stops on top of the inked block (Fig. 163).

Pull down the tympan. Run the bed under the platen. Operate the hand lever which activates the press pressure from a knuckle joint and allows the platen to exercise its function (pressing the paper against the block) with great force.

Remove the packing. Lift the print and examine it. If the block is level, but the print is unevenly inked, you can check the *level of the platen* and then correct it, should this be required, by adjusting the platen screws.

Examples of Black-and-White Cuts

Examples of various innovative and complicated woodcut techniques will be shown later in this section, but three works are illustrated here to demonstrate that completely different effects can be achieved in the

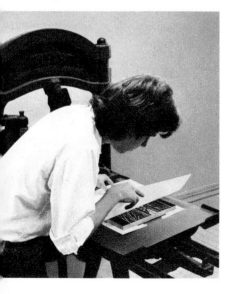

163. Block and paper on press, registered.

right: Plate 19. Playing cards, from Provence. c. 1480.
Wood-block prints, hand-colored.
Cincinnati Art Museum
(John Omwake Playing Card Collection
on permanent loan from
the United States Playing Card Company).

below: Plate 20. KATSUSHIKA HOKUSAI. *View of Fuji
from Seven-Ri Beach.*
Later recut of the original dated 1823–29.
Color woodcut, 10⅛ x 15″.
Metropolitan Museum of Art, New York
(Rogers Fund, 1914).

above: Plate 21. Edvard Munch. *Two Figures by the Shore.* 1898.
Color woodcut, 18 x 29¼". Munch-Museet, Oslo.

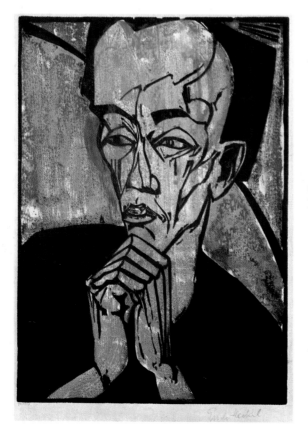

left: Plate 22. Erich Heckel. *Portrait of a Man.* 1919.
Color woodcut, 18½ x 13".
National Gallery of Art, Washington, D.C.
(Rosenwald Collection).

hands of different artists, using the simple, fundamental process already described.

The Japanese artists, despite the fame of their color prints, have always maintained a strong devotion to the traditional black-and-white woodcut, finding in it an important part of their artistic heritage. Shiko Munakata (b. 1903; Fig. 164) might be considered "the grand old man" of the Japanese print; he has been a tremendous force, not only in the graphics field, but in the preservation of Japanese folk arts as well. He works at high speed and very intuitively, following a favorite precept of his own, that "the mind goes, and the tool walks alone." His direct, forceful, and powerfully simple forms (Fig. 164) are cut, typically, with a straight and a curved chisel, used respectively for sharper and softer lines. Munakata holds the chisel like a brush, turning the block as he works. On occasion he will tint a print by simply brushing color on the back of the paper and letting it soak through.

Fumio Kitaoka (b. 1918) is another Japanese who, despite the modern look of his works (Fig. 165), is quick to acknowledge his debt to the past. He devoted considerable time to the study of Chinese black-and-white prints and continues to prefer working in the Japanese way with the baren and handmade rice paper.

The prints of Jacques Hnizdovsky (b. 1915) evolve gradually, and he enjoys the woodcut "for the resistance of the wood, for the slowness of the whole process, which enables the artist to think, to weigh, and

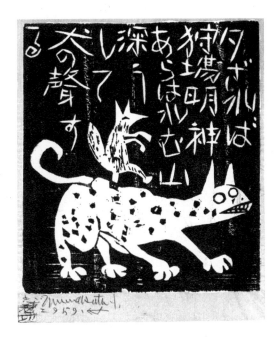

left: 164. SHIKO MUNAKATA. *The Barking Dog.* 1959. Woodcut, 18 × 15$\frac{11}{16}$". Museum of Modern Art, New York.

below: 165. FUMIO KITAOKA. *Harbor.* 1952. Woodcut, 19$\frac{3}{4}$ × 27$\frac{1}{2}$". Museum of Modern Art, New York (Abby Aldrich Rockefeller Fund).

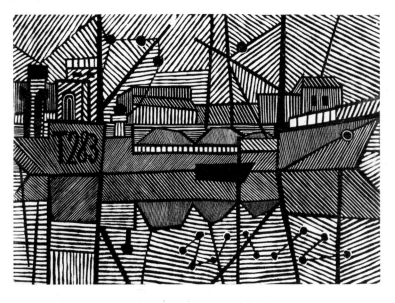

Making a Relief Print: Woodcut, Wood Engraving, and Linoleum Cut 151

to naturally ripen with his work." His print of a field of wheat (Fig. 166) was executed on a pearwood block. He traced his drawing in reverse, then drew again with ink on the block. Before cutting, he rubs his blocks with linseed oil, which partially prevents cracking and darkens the surface of the wood, making it easy to distinguish the surface from the cuts. After the first impression, made by hand by rubbing with a spoon, the process of correction begins, and sometimes, he says, it takes more time than the original cutting, with as many as ten proofs being made before the final stage. Hnizdovsky's style might be described as hyper-realist, with its intricate but very selective detail set forth against tremendous space. He describes his work as follows: "I always start with an abstract idea. In the case of *Wheatfield*, I was first fascinated by two horizontal stripes. Only later I discovered the same rhythm in nature, and I attempted to catch the synchronization of my abstract idea with the form of nature, where, I believe, all our ideas are hidden."

MAKING A WOOD ENGRAVING

The traditional white-line-on-black approach that characterizes wood engraving was highly developed, though not originated, by the Englishman Thomas Bewick (1753–1828). Compare the illustration of one of his blocks (Fig. 167) with that of the print taken from it (Fig. 168). The print is reproduced actual size; the enlargement of the block enables you to see the strokes of the graver by which Bewick achieved his three-dimensional effects in the end-grain wood. An end-grain block is employed in wood engraving because it can be engraved in any direction without tearing or splintering. Either boxwood or maple is employed; maple costs about half as much as boxwood, though it performs in general equally well. The commercially supplied block is

166. Jacques Hnizdovsky. *Wheatfield.* 1965. Woodcut, 38 × 23". Associated American Artists, Inc., New York.

152

type-high (approximately $\frac{7}{8}$ inch) and highly surfaced on one side. Turning the block over to the rough side reveals the labor involved in its preparation.

Cutting an End-Grain Block

The preliminary drawing can be transferred to the block by using carbon paper and/or can be worked up on the block with India ink. As you start to cut, remember that this is *engraving*, rather than cutting as was done in the woodcut. In the act of engraving the gesture is away from the artist rather than toward him. It may be helpful to darken the surface of the block with a mixture of India ink and water before drawing upon it. Each movement of the cutting tool through the material will then expose a lighter line, surrounded by a dark ground.

It must be obvious after a look at Thomas Bewick's print (Fig. 168) that lines of this kind could not be accomplished with the knife and gouges used for making a woodcut on a plank-grain block. Modern prints are not likely to be either so detailed or so minute as Bewick's, which measures something less than 2 × 3 inches. Figure 169 shows a more recent work, by the American graphic artist Leonard Baskin

below left: 167. THOMAS BEWICK. Block for *Bison* (Fig. 168). 1800–04. Wood engraving, 2 × 2$\frac{3}{4}$″. Los Angeles County Museum of Art (anonymous donor).

bottom left: 168. THOMAS BEWICK. *Bison.* 1800–04. Wood engraving, 2 × 2$\frac{3}{4}$″. Los Angeles County Museum of Art (anonymous donor).

below right: 169. LEONARD BASKIN. *Man with Spring Plants.* 1953. Wood engraving, 13$\frac{5}{8}$ × 5$\frac{5}{8}$″. U.C.L.A. Grunwald Graphic Arts Foundation, Los Angeles.

lozenge, or standard graver

spitsticker, or tint tool

scorper, or graver
(flat or round on bottom)

vélo, or liner or multiple lining tool

170. Types of burins employed
in wood engraving.

171. A bench hook.

172. Engraver's pad.

(b. 1922), which is far freer both in style and execution. Even so, special tools and a special skill are required to cut into the end grain of a block. You will use an assortment of burins or gravers, along with a bench hook or other device for supporting the block during the process of cutting it.

Burins are available in various shapes and sizes, with handles that may be either bent or straight. They are classified in several ways, and various names may be applied to the same type, since they are supplied by various manufacturers and often imported. The English system for classification divides the major types (Fig. 170) into lozenges, spitstickers, scorpers, and vélos; other names for these tools in the same order are standard gravers, tint tools, round or flat gravers, and liners or multiple lining tools. Certain of the tools employed in the woodcut can also be used here. All engraving tools must, of course, be kept well sharpened.

Sharpening the Tools. Graving tools must be kept in fine cutting condition in order to function properly. One manufacturer of specialty tools (J. Johnson Co.) gives the following advice on the subject:

> Since each artist holds his tool slightly differently, he may find the angle of the tool's bevel should be changed. This must be done with great accuracy, for the bevel face must be perfectly flat or it will impair the tool's cutting efficiency. The rebeveling or sharpening is done by holding the tool close to its edge against the sharpening stone and moving it in an elliptical motion with the wrist stiff so that the face remains flat. This takes some considerable practice, but once achieved the rewards are obvious. Should the artist desire a swifter and surer way of sharpening his tools, there is a tool sharpening instrument of great precision which locks and holds the tool in any bevel position. The tool is first sharpened on an India stone with light oil and then polished on an Arkansas hardstone. To remove the burr after polishing, jab the tool into a piece of soft wood.

The graver should be held in your hand in such a way that it becomes, in a sense, an extension of your hand, as it moves through the block in front of you. A single stroke of the graver would produce a positive white line on a black ground were it to be printed at *this* juncture. The image or design you are about to engrave will emerge slowly from the many white lines obtained from your tools. To obtain a clean line when cutting curves, lean the tool toward the outer edge of the arc as you swing the plate or block around.

The Bench Hook. Some printmakers support the block during the cutting process by using a bench hook on a tabletop. A bench hook can easily be made in the form shown in Figure 171. The traditional rest for the block is an engraver's pad. This is a circular, sand-filled bag covered with a good grade of leather. The block is placed upon the pad and rotated as required with one hand as you engrave with the other (Fig. 172).

Printing a Wood Engraving

In printing a wood engraving, you can use any press that normally prints type-high material. The old Washington hand press is excellent and produces the proper pressure required for a print of high quality.

MAKING A LINOLEUM CUT

Even when you purchase a mounted linoleum block from a graphic-arts supplier, the cost of making a linoleum cut is very low; it is even less if you use a scrap of ordinary battleship linoleum. This is no reason to regard the medium with disdain. Many fine artists make prints from linoleum, and the material behaves admirably. It cuts readily in any direction, and this easily swerving line tends to give the linoleum print a quality of its own (Fig. 173). Also, the block will hold up for a remarkable number of impressions. In Mexico City in 1947, this author witnessed an occasion when more than 2,500 impressions were obtained from a single linoleum block.

An artist who has lent a great deal of prestige to this medium is Pablo Picasso. He has used linoleum so extensively that the term *linocut* is strongly identified with his name. The print reproduced here in Figure

left: 173. JOSEPH GIELNIAK. *Sanitorium IV (Saint Hilaire)*. 1958. Linoleum cut, $7\frac{7}{8} \times 10\frac{3}{8}''$. Museum of Modern Art, New York (gift of Dr. and Mrs. Arthur Lejwa).

below: 174. PABLO PICASSO. *Still Life Under the Lamp*. 1962. Color linoleum cut, $24\frac{1}{2} \times 29\frac{5}{8}''$. Museum of Modern Art, New York (gift of Mrs. Donald B. Straus).

174 serves to demonstrate how brilliantly and how boldly a design can be executed in this medium. For an artist who is prolific and who likes to work with more speed than the cutting of wood normally allows, linoleum should prove to be very rewarding.

Cutting the Linoleum Block

Commercially supplied blocks are type-high to allow for printing on a press should you wish to do so. They come in many colors. If you use the ordinary battleship linoleum available in any floor-covering establishment, purchase a piece that is white, egg-shell, or of any plain light color that will enable you to see your drawing clearly.

Transfer or work up a drawing directly in India ink. A razor blade, lightly employed, can be used to scratch trial white lines or areas in certain solid black portions of your drawing, or to make corrections.

You can cut into a linoleum block in any direction with almost any sharp tool. Inexpensive sets of linoleum cutters are available, or you can use the knives, gouges, and burins that are employed for cutting wooden blocks. Test the sharpness of the point of each tool by using your thumbnail as the proving ground. If the tool slips when run over the thumbnail, sharpen it until, on another try, it sticks. Tools dull rather quickly when cutting linoleum because of the grit within the material, so they should be sharpened throughout the cutting process for maximum ease and pleasure when working. It is possible to cut a block even with dull tools, but you run the risk of slipping over the surface and cutting lines you do not want—or of cutting yourself.

If you desire to make a fine-line engraving on linoleum, first scrape the surface thoroughly with a razor blade and a small quantity of benzine. A few moments of scraping will produce an excellent working surface. The same effect can be obtained by sanding the surface, using "wet or dry" sandpaper of the finest grade that can be secured, and being careful to remove all scratches.

Printing from Linoleum

The printing procedure for linoleum is precisely the same as for wood-cut. Ink the block with a brayer. Place a sheet of rice paper on top of the inked surface, making sure to center the paper over the block. With a burnisher, baren, or tablespoon, rub the back of the paper sufficiently to bring up the image; or use a press.

The Relief Print
in Color

Many printmakers have now forsaken the black-and-white print entirely for the pursuit of the multiple-color block, and an extensive use of color in relief printing has become more and more evident in exhibitions. The cutting of the blocks is similar to the method used for black-and-white prints; the main differences emerge during the planning stage. There appear to be two basic approaches to the color woodcut: (1) A relief print in color can be conceived as basically a black *key* block enhanced or enriched with one or more color blocks; (2) a color relief print can be built up of many separate color blocks, no one of which is a complete picture in itself, but which printed together make a complete, unified whole. Obviously, there are wide variations between these two extremes, and the choice would seem a question to be resolved by each graphic artist in his own terms.

The order of printing colors has much to do with securing particular effects. For example, different greens are produced if yellow follows blue, blue follows yellow, the yellow is wet and the blue is dry, the blue is wet and the yellow dry, both are wet, or both are dry. Try different combinations of the same and different colors, and analyze the results.

Gradated color can be applied to your block by rolling the color more heavily on one side than on the other. If you work with a large brayer it is possible to roll *more than one color* on the brayer. Obviously, for best results, prints should be designed with this end in view.

COLOR PRINTING FROM ONE BLOCK

Method 1: The Block as a Jigsaw Puzzle

A simple device for obtaining multiple colors from a single block was employed by the late Edvard Munch (Pl. 21, p. 150). The design was drawn on the wood block, which was then cut by a band saw into a set of jigsaw-puzzle shapes. Each of these wooden shapes was inked separately in its own color, then all of them were locked in their original position, as in a chase for a printing press. The color woodcut could thus be printed in many colors simultaneously. The narrow white line that divides the color areas in Munch's color relief prints reveals the bite of the band-saw blade.

Method 2: Subtraction

This procedure requires the ability to visualize and carry out a long-range plan. Work out a sketch *in color* that can be printed in color by a process of subtraction from one block. Print the whole uncut block; or, with a minimum of cut lines or areas, print the block in one color. Pull as many prints of this color as you wish for your edition. Then remove the ink or paint, and cut into the design again, removing more areas from the printing surface. Ink with your second color and print it over the first. You can repeat this procedure until you have removed virtually the whole surface of the block, though you will stop, of course, when you have arrived at a print in color that coincides with your original conception.

Method 3: Use of Stencils

Mechanically this is an easier variant of Method 2. Work out a complete color sketch in the scale of your block. Cut a stencil for each separate color you wish to employ, using stencil paper or a substitute. On the uncut block, with oil paint and a gelatin brayer, roll stencil A on the block. With a second color and a second brayer, do the same with stencil B. Repeat this for as many stencils as you wish to use. At this point, you will have an uncut block with many wet colors upon it. Place a sheet of printing paper on the surface of the block and burnish with a tablespoon, thus printing all the colors at the same time. After printing your entire edition with these colors, cut the same block with a woodcut knife and other tools to work your design. Print the completed block over the previously applied colors in another color or in black.

Method 4: The Japanese Technique

A version of the traditional Japanese approach (Pl. 20, p. 149; Figs. 133–139) can be employed to advantage in one-block color printing.

right: Plate 23. UMETARO AZECHI.
Stand on Snow Gorge. 1956.
Color woodcut, 21¼ x 13⅞".
Museum of Modern Art, New York
(gift of the International Graphic Arts Society).

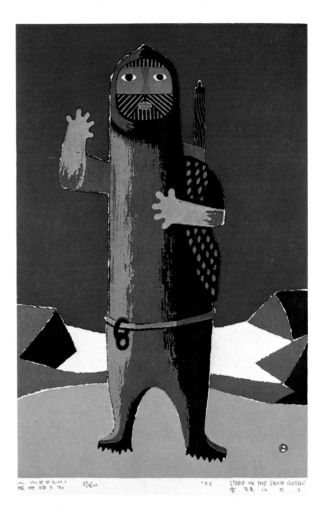

below: Plate 24. ANSEI UCHIMA. *Into Space.* 1971.
Color woodcut, 20 x 29". Courtesy the artist.

Plate 25. WILL BARNET. *Singular Image*. 1964.
Color woodcut, 32½ x 22″. Brooklyn Museum (Dick S. Ramsay Fund).

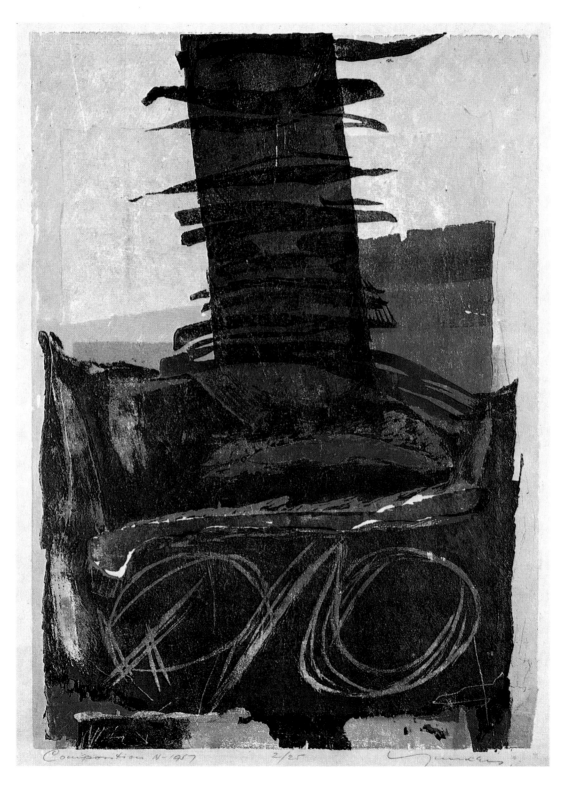

Plate 26. Adja Yunkers. *Composition N-1957*. 1957.
Color woodcut, 21½ x 15¼". Courtesy the artist.

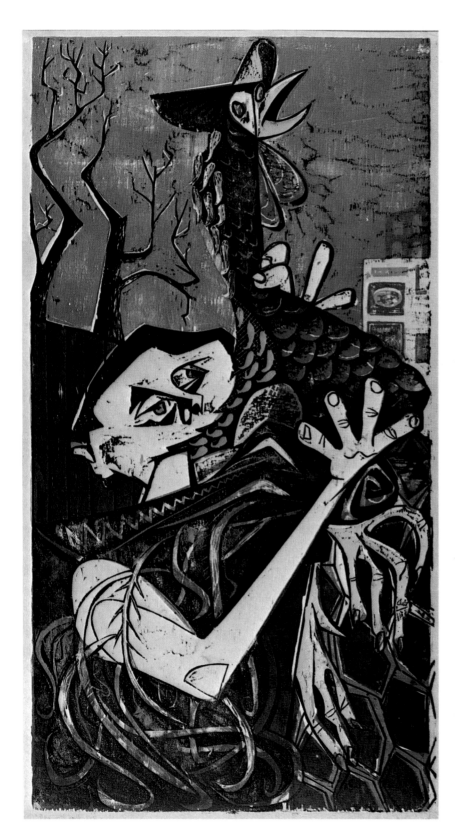

Plate 27.
ANTONIO FRASCONI. *Boy with a Cock*.
1947. Color woodcut, 27 x 14".
Prints Division,
New York Public Library
(Astor, Lenox and Tilden Foundations).

With a stiff-bristle brush, put a few strokes of color (dry pigment plus distilled water) in the area to be printed. Quickly add a tiny bit of rice paste to the same area. The formula for rice paste is as follows: Boil $\frac{1}{2}$ pint of water. Mix 2 teaspoonfuls of rice flour in a cup of distilled water until the mixture is smooth and creamy. There should be no lumps. Pour the mixture into the boiling water and stir well until it boils again. Allow it to simmer for 5 minutes. Cool. The mixture should not be stiff, but rather almost fluid enough to pour.

With a semi-stiff brush, work the color and the paste together over the required area, rubbing vigorously. Before the color dries out, place a lightly dampened sheet of rice paper on the block, and burnish it with either a Japanese baren, a tablespoon, or a steel burnisher.

Method 5: Inking Separate Areas

Using small gelatin rollers and/or stiff-bristle brushes, you can ink separate areas of one woodcut in different colors. By using oil paint instead of ink, or a mixture of the two, you will be able to burnish easily with a tablespoon.

As we have seen (pp. 135–137), Japanese color technique had considerable influence on modern art in the West. At the same time, modern Japanese printmakers have themselves responded to this tradition. Umetaro Azechi (b. 1902), for instance, brushes water-based colors onto the block in the usual way and prints on rice paper (Pl. 23, p. 159). Personal are the roughened edges of the forms (scraped with the chisel) and the strong color in parts of the flat areas, obtained by roughening the block or by reprinting additional color onto the print. Also modern is the fresh vividness of this imagery. Azechi says: "I have progressed from seascapes to city scenes to mountains and mountain people. I like climbing and like to use simple illustrations. I don't think much about technique, but use the simple lines to give an impression of the roughness of nature and the people I find in it. I find satisfaction in my work and that is enough."

Incredibly, *Into Space* (Pl. 24, p. 159) by the Japanese American Ansei Uchima was executed in basically the same method as the *ukiyo-e* prints (Fig. 133). In the traditional Japanese way the artist applied water-based pigments (gouache watercolors and Japanese *sumi* ink) directly onto the block with horsehair brushes, and printed by hand with the Japanese baren. Brushing allowed many kinds of gradations (a *ukiyo-e* technique), as well as sharp and semisharp edges. This produced the spatial effects the artist sought. He made the print with three surfaces ($\frac{1}{4}$-inch plywood faced with birch) and pulled it on Kizuki-Hosho paper, whose absorbency is precontrolled by sizing on front and back. The special paper permits seepage of the pigments into the fibers, about halfway through the paper, creating subtle textures like dyed cotton cloth. The print reveals the artist's concern for "inner and outer space-landscapes." Also

a painter, Uchima has an interesting attitude toward his two media: "The concept cannot be noble in one medium and banal in the other. I think like a painter as well as a printmaker."

COLOR PRINTING FROM TWO OR MORE BLOCKS

The traditional approach to color printing is to cut a separate block for *each* color to appear in the final proof. Obviously, this method permits wide color possibilities because of the color fusion that results as succeeding colors are printed over the first. Try printing the second color before the first is quite dry on the paper; this produces a further possibility of color variation.

In this procedure a tracing is made from a master drawing for each block (each color) to be cut. The blocks are then cut separately and printed separately. The chief problem lies in *registration*, that is, in the placing of the paper on each block so that the impression taken from each is lined up correctly with the others in the final print. A good number of effective solutions have been worked out in satisfaction of this most fundamental of technical problems.

Methods of Registration

Registering the Block over the Paper. The easiest system of registration, by far, is one that is probably regarded as foolish or dangerous by the professional printer. This method assumes that all the blocks for a given color print are the same size. To attempt this procedure: Pull a proof from block A. Place that proof *face up* on a flat, smooth tabletop. Ink block B with its color. Turn block B *face down,* and place it squarely and surely on top of the proof just pulled. With one hand on the block, and the other hand maneuvering the paper from underneath, slide the block and the paper from the table. Holding the paper in place, reverse the position of your hands. The paper is now on top of the block. Burnish the print, or set it in the press. This procedure can be repeated as many times as there are colors to print.

Japanese Method of Registration. Figure 175 shows the Japanese woodcutter's use of the *kento* (registration guides). Notice that a right-angle notch and a straight cut are made on the long side of the block. This allows the damped paper to slide into proper alignment on each block. These cuts penetrate the surface of the plank to a depth of $\frac{1}{16}$ inch. They should be placed in the margin 2 inches or so away from the edge of the image; therefore, if you intend to use this method, be sure to select a block that is sufficiently longer and wider than your design. The "secret" of registration in the Japanese color woodcut is based upon the high degree of accuracy and craftsmanship used by these skilled artists in planning and cutting the *kento.*

The registration cuts and the linear design must be accurately transferred from the first or *key* block to every other block used. This may be done (1) by *offsetting wet proofs* onto each block; (2) by precisely *tracing the master design* on every block; (3) by *pasting a black-inked proof face down* on each block. If you use the third method, proofs should be pulled on *very thin* paper. A few drops of linseed oil rubbed on the back of each pasted-down impression will make a black-inked proof transparent; this will enable you to identify and mark different cutting areas, with a colored pencil, for example. Cut through the transparent, pasted-down paper. With careful handling, this method should result in accurate registration.

Use of Needles and Depressions in the Blocks. Two tiny holes drilled in diagonally opposite ends of each color block to be printed provide still another system for registration. These holes should be drilled or pierced in inconspicuous places *within* the design. The paper must be marked with register crosses or T marks placed to correspond to the depressions in the block and pierced, at their intersections, with a needle. To obtain accurate registration, repierce both holes with two long needles and carry the paper to the block. Sighting underneath your printing paper in order to see the block, place first one needle in the proper hole, and then the other. Now, lower the paper onto the block as you remove the needles.

Use of a Right-Angle Guide. Another method of registration calls for making a wooden right angle, which, when anchored to a base such as a drawing board, will serve as a jig or guide against which it is possible to fit the bottom and one side of each block as you print. The jig should be the same height as your blocks (type-high, approximately $\frac{7}{8}$ inch) and the blocks and the printing paper should be standardized and square. Draw register marks on the outer ends of the jig corresponding to register marks traced on each sheet of paper. Slide the first block tightly into the right angle. Match the registration marks

175. Japanese method of registration.

176. Registration with
two-corner guide.

on your paper with those on the wooden jig. Burnish the print. Repeat for each block in the series.

A variation of this method is accomplished by hinging the paper at the bottom (or side) to the wooden jig, using two strips of decorator's tape or similar material. This allows you to pull a complete color print, *printing wet on wet,* by folding the paper down and back again on its hinge. Slide each inked block in succession into place, fold the paper down over it, burnish the proof, and fold the paper back to insert the next block. Repeat for the whole edition.

Use of a Two-Corner Guide. The two-corner method of registration requires that the woodcut be printed with the block *face down* on the printing paper. A Los Angeles printer uses plywood guides with right-angle ends and two circular windows for color-block registration (Fig. 176). His guides vary from 3 × 10 inches to 3 × 30 inches, depending upon the size of the blocks to be printed.

The guide is placed *on the paper,* and register dots are made with a hard, well-sharpened pencil through the holes in the windows of the guide. Block A is placed against the right angles, *face down.* The printing guide is then removed without disturbing the "set" of the block or the paper, and the sheet is printed. In printing the succeeding blocks in the design, place the printing guide back on the paper and line up the dots on the paper with the holes in the windows. Ink block B and place it into position against the right angles of the guide. Remove the guide and print. Repeat for each print in the edition.

Sample Procedure for Making a Color Woodcut

The noted American artist and teacher Will Barnet (b. 1911) has been generous enough to summarize for this book the procedure he followed when making the print illustrated in Plate 25 (p. 160). The method used for this work, which exemplifies procedures that are commonly followed for making a color woodcut, indicates the choices that one particular artist has made among the various possibilities outlined. It reveals something of the subtle preferences and discriminations that will always be exercised by a fine artist working in the medium.

Before working on the block I prepare many small color studies and sketches. Next I work up a drawing that will be the actual size of the woodcut. I then transfer this finished drawing to the key block by placing either graphite or carbon paper underneath the drawing and rubbing the image onto the block with a pencil. Sometimes I draw directly on the block with a 3B or 4B pencil and allow these lines to guide my cutting.

The key block now contains the basic outlines of my image, and this enables me to make transfers to other blocks. For the blocks I use a pine plank without knots. My image is cut with a woodcut knife, and the white areas are scooped out with a chisel or a U-shaped gouge.

In creating *Singular Image* I transferred several black and white outlines from the key block to other blocks of the same size. For a perfect register in transfers and color printing the block is locked in place in a right angle formed by two wooden stretchers nailed tightly together.

When all my blocks are ready for printing I take a large plate of glass and place it on a white blotter. I mix my paints on this. Siebold Litho Ink and a separate roller are utilized for each color. I vary the size of the roller according to the area I wish to ink. Transparent base is used to cut the opacity of a color.

The printing method is simple. I use either a baren or a large tablespoon for pressure. I always take my time in building up the print. In the main my layers of ink are transparent to retain luminosity of color and to preserve the natural grain of the wood. A medium or heavy Japanese paper has proved most durable in repeated printings and most sensitive to the inking.

Barnet finds the woodcut a natural medium for his work, since the cutting gravitates toward the large, bold forms indicative of his style. He has abandoned dependence on single forms directing single movements and tied to other forms by linear means. His concept of the "tension between masses" necessitated a more dynamic concept of form—one in which he utilizes the total ground of the block. This concept led him over many years to the birth of a style wherein "relationships are multiple, gripping the entire surface and bringing the whole into highly integrated action."

He has described the experience from which *Singular Image* stems as follows:

One hot summer day I was walking along the city sidewalk when I looked down into the street and was struck by how one particular crack resembled a human figure that had long lain dormant somewhere on my mind. The gash in the pavement acted as a catalyst with the tall monumental forms and stretched vertical masses I had long been working with. The connection immediately snapped into sharp focus the raw concept of an image that I was to struggle with for many months, a figure pressured on all sides by severe subconscious forces.

Latvian-born Adja Yunkers (b. 1900) has also used the whole ground of the block, in Plate 26 (p. 161), as a great space in which to re-create experience. Here too is a personal inner reaction made to an external stimulus. Originally called *Veronica,* one of the bullfighter's most beautiful moves, the print bears the sensation felt by the artist on seeing a bullfight. The free and painterly style may seem alien to the woodcut medium, but Yunkers chose it because "a medium *always* serves as long as it covers an experience." The print derives from a period when Yunkers' work still related to Expressionism but showed evidence of passing into other things.

During a career that has spanned almost twenty-five years, Antonio Frasconi (b. 1919) has brought his mastery of the woodcut to a level of almost consummate skill. In *Boy with a Cock* (Pl. 27, p. 162; Fig. 185) can be seen his painstaking devotion to detail and texture and his unerring mixture of angularity and rhythmic cadence.

New Approaches to the Relief Print

The young printmaker of today continues to confound and bewilder his elders with unusual approaches to materials and techniques in the relief print. Some of these innovations have been brought about through individual ingenuity and exchanges of ideas among fellow artists. Other avenues for experimental research have been opened up in graphic workshops and print studios, stimulating numbers of printmakers to explore the possibilities of work with new materials and tools—sometimes as an end in itself, sometimes as a better solution to an old problem, sometimes out of necessity.

VARYING THE PRINTING SURFACE

As was pointed out in Chapter 8, wood blocks were once widely used for printing textiles (Fig. 121). That fact might be elaborated by noting that a wood block can be made to print on almost anything, when paint or ink has been applied to it. Furthermore, it transfers to the print any variation in its own surface, such as the pattern in the wood. These capabilities of the block-printing method are fully exploited by contemporary artists in some of their more unusual innovations. Many artists continue to use the traditional block, of course; many others continue to use wood but in a different way; and still others have

substituted a different printing surface altogether—plywood, Masonite, cardboard, chipboard, matboard, plastic sheets, and various others. A few examples of specific works follow, with some explanation as to how they were executed.

Robert Conover (b. 1920) executed *Ascension* (Fig. 177) on $\frac{1}{4}$-inch plywood, a wood surface that makes possible prints of large size—in this instance 39 × 30 inches. Conover used a Magic Marker to make a small sketch, 6 inches square. He enlarged it seven times and transferred the drawing to the master block (for black), which he cut with a knife and a $\frac{3}{4}$-inch U-gouge. After pulling a trial proof, the artist transferred the image to the second block (blue) by rubbing on the back of the wet trial proof with a Japanese rice spoon. This enabled him to work out the pattern of blue shapes. Conover followed the Japanese method for registering the two blocks. Since the blocks were larger than the image, the paper could be tacked to the edge of the block. To print Conover employed I.P.I. ink and Suzuki rice paper in sheets 36 × 37 inches. The artist has said that he prefers woodcut for the large, simple masses and the flat, angular shapes that it can produce, helping to create a "rigorous feeling." He describes this particular image as "an attempt to express conflict and a dominant upward movement with abstract shapes and diagonal thrusts. The dark blue and black in the lower part of the picture express a somber mood, changing, as the shapes move upward, to a lighter and more optimistic mood."

Wörden Day has long been working with a wide variety of veneers (both inlay and plies) and "found" woods. For *The Great Divide* (Fig. 178) she used Japanese Tamo veneer $\frac{1}{4}$ inch thick. The artist began with a "found" log end, cut by a chain saw in interesting configurations (Fig. 179). She then took a proof and a print from the log, with which she made a collage sketch. On the basis of the sketch she chose other

177. ROBERT CONOVER. *Ascension.* 1968. Woodcut, 39 × 30".

left: 178. WÖRDEN DAY. *The Great Divide.* 1968. Color woodcut, $19\frac{3}{4}$ × $24\frac{1}{8}$". Courtesy the artist.

right: 179. WÖRDEN DAY. Trail proof for *The Great Divide* (Fig. 178). Courtesy the artist.

New Approaches to the Relief Print 169

materials, such as the Japanese Tamo for its subtle contrast in relation to the coarse texture of the log. Day achieved further contrast by adding the flat effect of stencil-color striae. Finally, she followed a favorite procedure in overprinting color with white. The different thicknesses of the woods—$\frac{1}{4}$ inch for the veneer and 5 to 7 inches for the log end—required two types of registration and a special device for the log end. Day has worked successfully in all the major art forms and is a committed experimentalist. An idea can be approached, she says, "through an infinite number of views and various media." Day finds the color woodcut unique for the variety of surfaces it can provide. Figure 178 is from the *Mandala* series, on which the artist has worked for over a decade, focusing on what she calls a "compelling and insistent circular image-idea."

below left: 180. JACOB LANDAU. *Yes-No.* 1966.
Woodcut, 21 × 15".
Associated American Artists, Inc., New York.

right: 181. VINCENT LONGO. *Quarter Turn.* 1968.
Color woodcut, 26$\frac{1}{2}$ × 26$\frac{1}{4}$".

below right: 182. H.A.P. GRIESHABER. *Monkey,*
from the portfolio *Sudwest 62.* 1962.
Woodcut, 21$\frac{1}{16}$ × 14$\frac{15}{16}$".
Museum of Modern Art, New York (purchase).

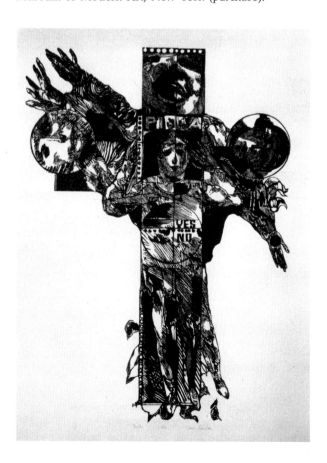

Plate 28. CAROL SUMMERS. *Chief's Blanket*. 1970.
Color woodcut, 37 x 37½". Collection Holt, Rinehart and Winston, Inc., New York.

Plate 29. CLARE ROMANO. *On the Beach II*. 1969. Color collagraph of cardboard, papers, and sand; $11^{5}/_{8} \times 29''$. Associated American Artists, New York.

Jacob Landau (b. 1917) cut *Yes–No* (Fig. 180) on type-high, long-grain cherry wood, a traditional material here composed in many small pieces laminated together to form a silhouette measuring 21 × 15 inches. The artist worked from a rough sketch on paper and drew freely on the block, improvising details. He cut with standard tools and unusually small gouges ($\frac{1}{32}$ inch). He also employed a flexible shaft tool with variously shaped burrs to make both fine detail and background routing. *Yes–No* was commissioned for *Boy's Life* to illustrate a science-fiction story so slight in content it permitted the artist to introduce his own concerns. Thus, the cruciform symbol operates on one level, while on another functions a montage of technologically based images—the whole combined with a somewhat "apocalyptic feeling." Of the woodcut Landau has explained: "Woodcut is for me a challenge—technically demanding, indirect, it calls for a high degree of planning and improvisational skill. Its image is, therefore, more emotionally tense, more suited, for me, to expressions about man's condition than more sensuous media. I like its spareness, its lack of beauty, its links with pure drawing. Even its indirectness, obliging the artist to create tones out of lines, seems appropriately demanding, perhaps even punishing."

Vincent Longo (b. 1923) derived from assembled pieces his *Quarter Turn* (Fig. 181), a four-color woodcut executed from one hundred $2\frac{1}{2}$-inch squares of pine wood lath. The squares were inked separately, then placed in order on the press, and printed. The design is based on a turning pinwheel. The four colors were laid out in identical placement, but each was moved clockwise on a central pivot a "quarter turn" of the circumference from the preceding one. No edition was made of this print; it exists in proofs of two versions. The first (Fig. 181) was hand-rubbed in red, blue, purple, and golden ochre to provide three proofs on Suzuki rice paper. Another version was proofed once in white, yellow, orange, and green on an off-white paper. Longo's technique gave him the possibility of easily rearranging his patterns and colors as his idea evolved. It may thus have allowed more spontaneity than would have the meticulous execution of a work of this type by painting, supposedly a freer medium than printmaking.

For *Monkey* (Fig. 182) the German artist H.A.P. Grieshaber (b. 1909) enhanced three wooden blocks with a plate of Eternite. Grieshaber identified the subject as "rhesus—the ape I live with," but it is known that he lives surrounded by birds and animals in his home near Stuttgart. For forty years Grieshaber has used his energies and his art to attack injustice and war and to defend man's freedom and dignity. One of Germany's outstanding artists, he has published several volumes containing woodcuts, among them *Totentanz von Basel* ("Basel Dance of Death") and *Kreuzweg* ("The Way of the Cross"). He has also made monumental woodcut murals; seven panels measuring 7 × $2\frac{1}{2}$ feet for the German Pavilion at Expo '67, and five woodcuts totaling 9 × 39 feet on *The River Rhine* for the State Theater in Bonn.

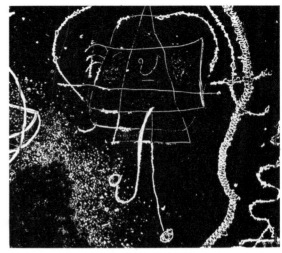

left: 183. ARTHUR DESHAIES.
Cycle of a Large Sea:
The Unanswered Question. 1961.
Relief print (plaster), 4'6" × 3'3/4".

right: 184. JOAN MIRÓ. Detail
from *Young Girl Skipping Rope,*
Women, Birds. 1947. Relief print
from etched and engraved plate;
12 × 9". (Figure 219 shows the
entire work printed by the
intaglio method.)

Figure 183 was cut by Arthur Deshaies (b. 1920) from a plaster block, which provided the large scale he sought and, in his words, "enabled him to break away from the 'hard-edge' effect of ordinary relief cutting." Made of fine-gauge, quickset molding plaster, the block was cut with gravers and chisels, as well as with motorized tools, rasps, wire brushes, sanders, and "invented tools." The print is one of a series entitled *Cycle of a Large Sea*, in which the artist attempted to equate inner turmoil with the sea and its unrest and to depict "constant change from a quiet, glassy surface to storm and violent squall, from fog to clarity and back endlessly—a statement of 'question.'"

REVERSE ETCHING

Though the technique is not new, it may be noted at this point that relief prints can be made from any deep-etched metal plate. Those who have pursued (or who will pursue) the intaglio process may wish to try printing from some of their plates in this way. Simply treat the plate as if it were an ordinary wood block cut for a print in black and white: Ink the surface of the plate with a brayer, lay the paper over it, and burnish. Prints of this type are sometimes called *reverse etchings*. An example is a print by Joan Miró (b. 1893) called *Young Girl Skipping Rope, Women, Birds* (Fig. 184; see also Fig. 219). The various techniques taken up in Part III can be adapted in one way or another to relief printing.

OTHER INNOVATIONS

Unorthodox Tools and Materials

. The average toolshop is one of the most useful sources for instruments capable of deliberate damage to the physical surface of the woodblock,

for the purpose of achieving a new solution. This repository of "weapons for wood" contains hammers, nails, files, rasps, screwdrivers, glue, shellac, and many other things that can enrich the wood surface prior to proving a block. Here are a few examples:

Pieces of wire screen can be cut to fit certain areas of your design. Pound them into the woodblock surface, then remove them, and print.

Nails of various sizes can be used to puncture particularly dull areas and enliven them. As discussed in Chapter 8, the *manière criblée,* or "dotted manner," is a very old technique in which various stamps and punches were used to produce dotted or textured areas (Fig. 123). Entire compositions in the manner of the *criblé* print can be attempted.

Various hand tools and small power tools score surfaces in particular ways. Rasps, for example, leave telltale marks, and a screwdriver jumped across a woodblock makes tracks that are visible in a print.

Experiments in Inking and Printing

The search for innovations is carried on through the entire printing process, as these few procedures indicate.

On an etching press or a standard press that prints type-high blocks, you can experiment with Charles Smith's technique. Ink with a solid color an uncut block of wood or linoleum mounted type-high. Place a sheet of dampened rice paper on the inked block. On top of this, face down, place a collage mounted on mat- or chipboard, but *not inked.* The solid color will print darker where the raised portions of the collage rest. The interesting color block this produces can be combined with other blocks cut and printed in the usual manner.

Antonio Frasconi (b. 1919) has employed, among a number of other useful devices, the technique of printing several small color blocks within a large block. His interest in designing with block shapes and with the collage is evident in the woodcut called *Reflection* (Fig. 185).

185. Antonio Frasconi. *Reflection.* 1966.
Color woodcut, 24 × 36".
Terry Dintenfass Gallery, New York.

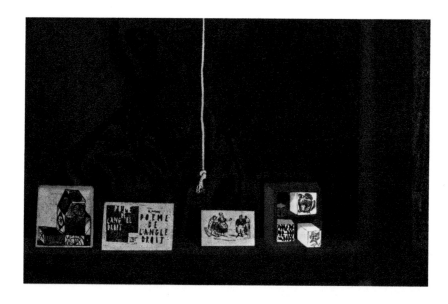

186. CAROL SUMMERS. *Palazzo Malatesta, Rimini.*
1961. Color woodcut, $36\frac{1}{4} \times 36\frac{7}{8}''$.
Museum of Modern Art, New York
(gift of Mr. and Mrs. Peter A. Rübel).

The following revival of an old practice might also be of interest to contemporary printmakers: A cut but uninked block can be printed in combination with one or more inked blocks for its textural interest in certain areas. Uninked blocks can also sometimes be employed to pull away ink from wet printed areas to reveal color printed underneath.

Carol Summers (b. 1925) varies the woodcut printing technique by rolling the ink, not on the block, but directly on the paper laid over the block (Pl. 28, p. 171). The ink adheres only to the raised portions of the block offering resistance to the roller. This results in variations in the thickness of the ink film and a fluctuation in the density of the color areas, also in the hardness and softness of the edges. This is the method used for making *rubbings,* an art form long popular in the Far East, where "prints" are often made from bas-relief sculpture. For *Palazzo Malatesta, Rimini* (Fig. 186) Summers took as his theme "institutionalized inhumanity." The print does not represent a palace but refers to the tyrannical Malatesta of the Renaissance: "The crowding of the picture surface, the strong and jangling conflict of colors, and the multidirectional thrust of the shapes were meant to convey a sense of discordance and conflict—a portent of violence and upset."

Mixed Media

The relief print, following the general tendency in the printmaking field, lends itself to mixing with the techniques of other art media. Figure 187, *Black Pagoda* by Michael Rothenstein (b. 1910), derives from a combination of wood and metal relief, plus letterpress plates. Rothenstein says: "My feeling is that each technique in printmaking is like

a single instrument, producing its own range of 'sound,' but that these separate instruments need not always be played separately, as they have been in the past. We live at a time when transformation between techniques is made more available, and in this way the single instruments are made less separate. They are capable of merging—of producing a symphony with a new kind of orchestration."

In *Plato IV* (Fig. 188) Angelo Savelli (b. 1911) has combined paper with Plexiglas to make a three-dimensional relief print that has both a front view and a back view, creating an effect that seems to be related to sculpture as well as to graphic art.

PRINTING A COLLAGE: THE COLLAGRAPH

The collage was a Cubist form developed in 1912 and 1913 by Georges Braque and Pablo Picasso. The term comes from *papiers collés*, meaning "pasted papers," for the first collage compositions were put together from such cut and torn, and essentially unrelated materials, as newspapers, wallpapers, menus, and labels to form a design, often enhanced with drawing. The idea of collage seemed workable for multiples, and it has now been explored in all the print media. The direct lithographic transfers discussed in Chapter 4 (pp. 88–90) incorporate the collage principle, as does the collage intaglio to be described in Part III (pp. 260–262). Frequently today, collage elements are printed variously by relief and intaglio in the same print.

left: 187. MICHAEL ROTHENSTEIN. *Black Pagoda.* 1970. Relief print (multi-media), 29 × 23". Courtesy the artist.

right: 188. ANGELO SAVELLI. *Plato IV.* 1967. Three-dimensional relief print, 23 × 22⅛ × 9⅝". Paper and Plexiglas.

189. A collage being mounted.

Procedure for a Sample Collage Print

The Support.　　The following materials can be used as a support for each design: Upsom board, Collins board, matboard, tempered and untempered Masonite, Formica, plywood (veneered), sheets of plastics. Almost any fairly rigid material $\frac{1}{8}$ to $\frac{3}{16}$ inch thick can serve. Spray or brush plastic sealer on one side of the support. (Both sides may need to be sprayed, depending on the thickness of the material.) Preferred surface sealers are white brushing lacquer and polyester resin with the recommended catalyst.

The Collage.　　Almost any material—paper, textiles, strips of thin metal, wire gauze, leather—can be used for the objects and shapes in a collage. Tonal grounds can be added with a variety of substances: graining sands, sawdust, carborundum, and crushed walnut shells (producing effects resembling those of drawing). Attach the collage to the surface of the support with Elmer's Glue-all, Liquitex, gesso, Wilhold, or other polyvinyl acetates (Fig. 189).

The Sealer.　　Spray or brush the assembled collage with one of the surface sealers mentioned above, or any other that dries quickly, is insoluble in water (or in any solvents employed in the printing process), and can withstand the pressure of a press and continued wiping. When dry, the sealer may be scored, roughened, engraved, and otherwise treated.

Printing.　　Follow the procedure for printing a relief block. You can also print the collagraph as you would an intaglio plate, as described in Part III. Further, there may be occasions when you will want to print the collagraph as both a relief *and* an intaglio plate.

Evolution of the Collagraph

The term *collagraph* was first applied to collage prints by Glen Alps (b. 1914). A teacher at the University of Washington in 1956, Alps was conducting the experiments he has described thus:

> Some of the experiments included the printing of natural and man-made textures, surfaces, cutout shapes, areas, and forms by roll-up, rubbing, relief, and intaglio methods of printing. Most of these were printed as loose, individual pieces in arranged complements. Then the impressions were evaluated, selected, cut up, rearranged, and glued to form collage units.
>
> The next step was obvious. We felt the necessity to arrange these final impressions into more substantial, physically immobile arrangements. To accomplish this, we stapled or glued them to plywood, Upsom board, cardboard, or Masonite panels. As proofs were pulled and the technique improved, the knowledge of the potential of this procedure grew into an overwhelming conviction that our experiments were leading to a vital force in contemporary graphics.

During this period of experimenting, the group realized that we must have a name for our new approach, or philosophy. After enthusiastic discussion, it was unanimously agreed that we call this additive positive way of developing a matrix *collagraphy.*

The first works called "collagraphs" were exhibited in the Northwest Printmakers Annual at the University of Washington in 1957. In 1958 Alps' *Collagraph No. 12,* a cutout matboard print, was shown in the Brooklyn National Print Exhibition. A recent work by the artist is reproduced in Figure 190.

Because of its experimental origins and character, the collage offers a category for highly original inventions, having to do with pasting and assembling, that do not fall into one of the specific print classifications. But some printmakers prefer more finely descriptive labels, such as *collage relief print, collage intaglio,* or *cardboard relief.* Sentiment exists for considering collage, like mixed media, an independent process, added to the traditional forms of lithography, relief, intaglio, and stencil. Since, however, collage remains dependent on one or more of the basic printing processes, it seems useful to describe collage here, where a beginning printmaker might be prepared to undertake experiments of his own.

190. GLEN ALPS. *The Color Duel.* 1971.
Collagraph printed in intaglio and relief, $19\frac{1}{2} \times 19\frac{1}{2}''$.
Courtesy the artist.

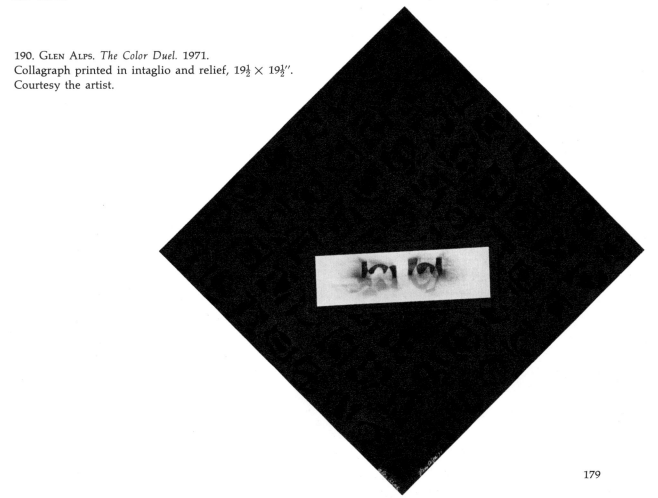

A collage technique particularly suited to relief printing is sometimes called *cardboard relief*, for which cardboard shapes are cut and assembled, possibly with other materials, and printed. Seong Moy (b. 1921) printed *Changes No. 2* (Fig. 191) by the procedure normal for color woodcut. On a board base the artist arranged a design of matboard and cardboard shapes. After coating the cardboard pieces with acrylic modeling paste, he embedded selected materials in the semidry paste to attain textural contrasts with the flat color areas provided by the cardboard. Moy prefers to attach his pieces to the base with double-faced tape, which permits him to shift and replace them at will. This procedural flexibility inspired the work's name.

Cutout shapes can be inked separately and then assembled on the press, which permits brilliant color combinations printed with relative ease. The four-color collagraph by Clare Romano (b. 1922) in Plate 29 (p. 172) was from a cardboard plate with three sections which, reassembled on the press, were printed all at once. Variations were sand used for depth of tone in some areas, in others different thicknesses of cardboard combined with acrylic gesso, and some areas inked for intaglio and others for relief.

Jack Sonenberg (b. 1925) used two plates for *Dimensions No. 3* (Fig. 192). The color plate was made of several parts—inked separately, assembled on the bed of an etching press, and printed together. While the ink was still wet, the artist placed the print face up over the multilevel second plate and covered it with newsprint. When pressed, the second plate embossed the paper and, at the same time, blotted off some of the ink, thus achieving tonality as well as the embossment. The print makes use of a red that crosses over and seizes both the circle and the square essential to the design.

left: 191. SEONG MOY.
Changes No. 2. 1968.
Relief collagraph, 20 × 28″.
Courtesy the artist.

right: 192. JACK SONENBERG.
Dimensions No. 3. 1970.
Collagraph, 25½ × 28″.
Brook Alexander, Inc.,
New York, Publisher.

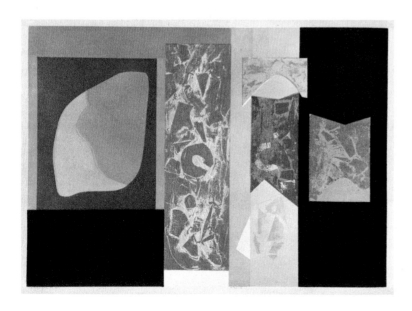

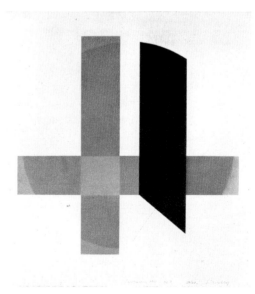

Workshop Solutions
to Relief-Print Problems

You cut a line or area that was not intended
Cause: Error in cutting.
Solution: Fill the line or area with plastic wood and scrape or polish it to surface height; or, cut out the undesired area and fit in a plug of the same material.

When printing the block on a press, certain areas are too light
Cause: Uneven packing; faulty platen; improper inking.
Solution: Cut out, from a proof, the poorly printed area; paste it down on the back side of the block, exactly under the low area. Keep building up this low spot by pasting added pieces of paper until the entire block prints properly; or, build up an overlay in the same way until the print is revealed as desired; or thin your ink and use a larger roller to ink the block before reprinting. You can also try turning the block 180 degrees, without removing the proof, and reprinting. If these methods fail, check the platen and, if it is unevenly worn, have it reworked by a specialist.

In using a press, the print gets darker with each succeeding proof
Cause: Too much ink; ink too thin; pressure too great; block of wood too soft; paper too dry.
Solution: Adjust one or more of the above.

In using a burnisher, you cannot obtain a good or dark black
Cause: Ink too thick; paper too thick or too dry.
Solution: Use a thinner, tougher rice paper and damp it; or, add a miserly drop or two of varnish to the ink; or, try adding some oil paint to the ink; or, print in oil paint.

Paper sticks to the block, picks, splits, or tears
Cause: Paper too wet and soft, or too weak.
Solution: Place paper between dry blotters, or use a different paper.

Cause: Too much press pressure.
Solution: Reduce pressure as much as possible without losing print quality.

Cause: Low temperature.
Solution: Reduce (soften) tacky ink.

Tones are inconsistent on successive prints
Cause: Roller not charged evenly with ink.
Solution: Roll longer on ink slab, turning the roller constantly.

Cause: Paper not evenly damped.
Solution: Prepare a fresh batch of paper; place the original sheets between dry blotters and save them for another time.

The print you want to make is larger than your block
Cause: Wood block too small.
Solution: Without benefit of glue, butt two or more blocks together; clamp each block tightly to your work surface; cut and print as though you were working on one block.

The desired dense, solid, unbroken printing area from a lino block refuses to appear as you desire
Cause: Slight grain on the surface of linoleum; scratches, etc.
Solution: With the edge of a razor blade, scrape the surface of the linoleum block (occasionally, it is helpful to use turps or equivalent as you scrape; or, use a soft etching blanket or equivalent *above* the paper, when printing).

Your wood block is warped
Cause: Improperly cured wood; humidity, and so forth.
Solution: Steam or slightly dampen the plank, or soak it in water if badly warped. With clamps or heavy weights, apply pressure as required. Repeat. In time, the plank will straighten out.

Despite precautions, your color print is out of register
Cause: One or more blocks not seasoned enough or contracted across the grain.
Solution: Redo the block or blocks out of register. In future, keep all blocks at the same degree of moisture or dryness in the course of making a color woodcut.

When using a water-based ink, you wish to make a gradated color passage
Cause: Aesthetic considerations.
Solution: Employing a wide flat brush, dip one end into your ink and the other into water. Squeeze the brush between your fingers. The edge of the brush should then be charged with gradated color. Dip the edge into rich paste, brush it onto wood block, and print in the normal fashion.

When using oil-based inks, you wish to employ a "rainbow" effect
Cause: Aesthetic considerations.
Solution: Place two or more color inks on your ink slab (any colors in any order). With a large roller, begin to work up an even layer of ink. Keep the roller in the same track on the ink slab. The result is a "rainbow" effect, which can be rolled onto your block consistently.

Print shows an unexpected light area surrounded by dark
Cause: Wood block has a bruise.
Solution: Level the surface of the block by lightly moistening the bruised area and passing a lighted match over it until the block regains its original height.

The Intaglio Process

ETCHING
AQUATINT
DRYPOINT
LINE ENGRAVING
MEZZOTINT
REVERSE ETCHING
COLOR INTAGLIO
PHOTO-INTAGLIO
RAISED INTAGLIO
INKLESS INTAGLIO
CELLOCUT
COLLAGE INTAGLIO

While there is copper there is hope.

Maxime Lalanne

Intaglio:
The Development
of an Art Form

Man seems always to have had a propensity for incising images into hard, intractable materials. In Paleolithic times stone implements were used to scratch symbols and figures of animals and human beings into rock surfaces. Perhaps the longevity of the images, or *petroglyphs*, thus created possessed for these prehistoric artists a magical quality; men may have hoped that the visual representation of an animal would not only "capture" the creature—a most important consideration in an economy dependent upon the hunt—but would also serve as a supernatural aid in the struggle against nature. The quality of the traces cut in the Old Stone Age suggests that early man had a profound understanding of the visual world around him.

The art of engraving on various metals for decorative purposes was highly developed many thousands of years ago. Metalworkers in bronze, silver, and gold learned early to incise fine lines with cutting tools. They used their skill to embellish weapons, armor, horse trappings, elegant household furnishings, and jewelry—all with stylized patterns, elements from nature, and scenes from every aspect of human life. It is known that these craftsmen sometimes "proved" their designs by taking reverse impressions from the metal in soft clay or by blacking the incisions and pressing the work against some absorbent material. These tests, however, did not constitute "prints" in the sense of multiples from a master matrix.

With the invention of paper, the ancient skills were turned to another form—printmaking. Rich handmade paper, strong-bodied black pigment, and burnt plate oil were the materials that allowed the engraver's designs to travel through the early cumbersome presses and that made visible in a new way the expressive images created by anonymous masters of the burin and, later, of the needle. Printmakers of today, with all their advanced presses and innovative techniques, continue to incise metal in much the same way as did the armorer, goldsmith, gunmaker, and metal-chaser far in antiquity.

Line engraving for prints, dominated by goldsmiths, emerged only in the fifteenth century. An engraving made in 1446, one of a suite depicting the Passion of Christ, is the earliest we have, and because he worked anonymously, the artist has been called the "Master of the Year 1446." The technique he used in Figure 193 consists of parallel engraved lines for shaded areas and of short strokes and flicks of the burin for surface enrichment. Like most artists of his time, the 1446 Master no doubt took his themes, forms, and compositions from model books.

In this period emerged two printmakers whose work was the first in the West to reveal mature technique and eloquent expression. Also unknown, they are identified as the "Master E. S." and the "Master of the Playing Cards," the latter so called for a set of cards engraved by his hand, in a style so distinctive that over a hundred engravings have been attributed to its author. Stylistically, these undated works appear to have been made a decade before those of the Master of 1446. His series of birds and beasts are remarkable for their detailed observation of nature. In Figure 194 he created textural range with shallow, short strokes placed at varying slants. Scholars have associated this master with Germany and Switzerland, and his work with Gutenberg.

left: 193. MASTER OF THE YEAR 1446. *The Flagellation of Christ.* German (?), 1446. Engraving, 4 × 3½″. Print Room, Staatliche Museen, Berlin.

right: 194. MASTER OF THE PLAYING CARDS. *Flower Queen.* German (?), c. 1450. Engraving, 5½ × 3¾″. Print Room, Staatliche Kunstsammlungen, Dresden.

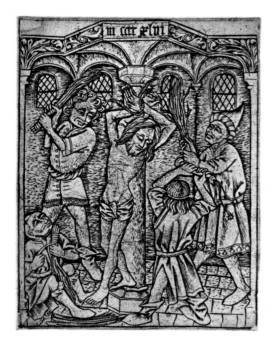

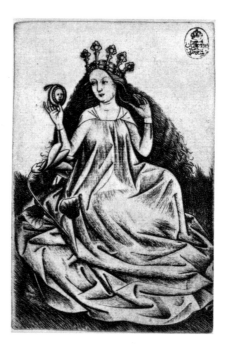

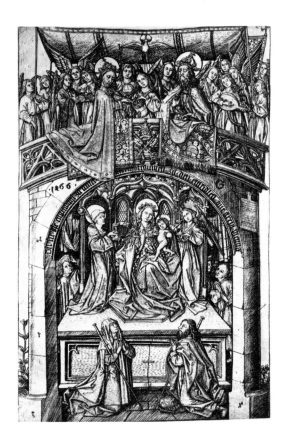

The engraver with the initials E. S. was active in the upper Rhineland just after 1450. His compositions, brilliant in their Gothic technique and religious in content, reflect the German preference for detail over unity. Of the 316 engravings attributed to him the most famous are three plates (Fig. 195) of the Virgin commissioned in 1446 for the monastery at Einsiedeln, Switzerland. With crosshatched passages and dots he elaborated on the style of the Master of the Playing Cards.

In the next generation Martin Schongauer (c. 1430–91), son of a goldsmith, brought German engraving to new heights of technical and artistic excellence. Known for one famous painting of the Virgin in Colmar, which forms the basis for other attributions, the artist left fifteen undated engravings signed "MS" flanking a symbol of a combined cross and crescent, a device often copied by admiring imitators. Figure 196 illustrates a technique more painterly than that of Master E. S., one that models the forms with a crisp, curving, vital line. The effect of deep perspective is evidence of the international breadth of Schongauer's art and the influence it had all the way into Italy.

An early master of Italian engraving was Maso Finiguerra (1426–64). First goldsmith and niello worker, he became an engraver of prints and led one of the two stylistic "schools" of Florence, influencing artists through his *Fine Manner*: tenuous, subtle, tasteful short strokes cross-

left: 195. MASTER E. S.
Einsiedeln Madonna.
German, 1466.
Engraving, $8\frac{1}{4} \times 4\frac{7}{8}''$. Print Room,
Staatliche Museen, Berlin.

right: 196. MARTIN SCHONGAUER.
Temptation of St. Anthony.
c. 1470–75. Engraving, $12\frac{1}{2} \times 9''$.
British Museum, London.
(See also detail, Fig. 9.)

MERCVRIO E PIANETO MASCHVLINO POSTO NELSECONDO CIELO ET SECHO MAPERCHE LA
SVA SICITA EMOLTO PASSIVA LVI EFREDO CONQVEGLI SEGNICH SONO FREDDI EVMIDO COG
LI VMIDI ELOQVENTE INGENGNIOSO AMA LASCIENSIE MATEMATICA ESTIVDIA NELLE DIVI
NASIONE A ILCORPO GRACILE COE SCHIETTO EL SVO TTILI ISTATVRA CHONPIVTA DE
METALLI A LARGIENTO VIVO ELDI SVO E MERCOLEDI COLLA PRIMA ORA 9 · 16 E22
LANOTTE SVA ELDI DELLA DOMENICHA A PERNICO ILSOLE PER NIMICO AVENE
RE LASVA VITAOVERO ESALTATIONE EVIRGO LASV MORTE OVERO NVMILIAEIONE
EPISCE HA HABITASIONE GEMINI DIDI VIRGO DINOTTE VA E 12 SENGNI IN SE
DI COMINCIANDO DA VIRGO IN SO DI E2 ORE VA VN SENGNO ⊛

SIBYLLALIBI
CA

ECCE VENIENTEM DIEM
ET LATENTIA APERIEN
TEM TENEBIT GREMIO
GENTIVM REGINA

ILDI VERRA CHELLET TERNO SIGNORE
LVME DARA ALLE COSE · NAS COSE
ELEGAMI ISCORA DELNOSTRO ERRORE
FARA ELESINAGOGE LVMINOS E
ESOLVERA EELABRA AL PECHATORE
E FIE STADERA DITVTE LECHOSE
ENGRENBO ALLA REINADELLE GENTE
SEDRA QVESTO RESANTO EVIVENTE

above left: 197. MASO FINIGUERRA (?).
The Planet Mercury. c. 1460–65.
Engraving, $12\frac{1}{2} \times 8\frac{1}{2}''$.
British Museum, London.

above right: 198. *Libyan Sibyl.*
c. 1470–75. Engraving, $7 \times 4\frac{1}{4}''$.
British Museum, London.

right: 199. ANTONIO POLLAIUOLO.
Battle of the Nudes. c. 1470.
Engraving, $16\frac{3}{8} \times 24\frac{1}{8}''$.
Metropolitan Museum of Art,
New York (purchase, 1917,
Joseph Pulitzer Bequest).

188

hatched and engraved to establish shadows. Figure 197, attributed to Finiguerra, is one of seven engravings based on astrology. It illustrates the Florentine commerce and art influenced by Mercury—sculpture, metalwork, fresco, astrology, music, and scholarship.

The other stylistic school of Florentine engraving was the *Broad Manner*: wide, expansive, sometimes heavy parallel lines, between which fluctuating flicks and short strokes combine to characterize mass (Fig. 198). A noted exponent was Antonio Pollaiuolo (c. 1431–98) whose influential workshop in Florence produced jewelry, goldsmith's work, sculpture, and oil paintings. Reputed mainly for a single signed print (Fig. 199), he has been consistently admired as a powerful designer and fine craftsman of the burin.

A northern Italian contemporary of Pollaiuolo, the painter Andrea Mantegna (1431–1506) enjoys an equal fame among dedicated engravers, though only a few plates can be securely attributed to him. The *Virgin and Child* (Fig. 200) displays the vigorous line and deep modeling of forms characteristic of his paintings and pen drawings.

A trio of engravers of the late fifteenth and early sixteenth centuries stands over all others, linking Italy, the Netherlands, and Germany through the genius of their prints and challenging the skill of intaglio printmakers for more than 200 years after their deaths. Marcantonio Raimondi (c. 1480–1530), Lucas van Leyden (1489/94–1533), and Albrecht Dürer (1471–1528) form this printmaker's trinity.

Raimondi, a Bolognese, worked exclusively as an engraver. He began, like so many others, as a goldsmith and became a technical virtuoso. Raimondi looked to Northern masters for subjects and compositions and borrowed so extensively from Dürer that the German master entered a formal protest in Venice, where Raimondi worked for a time. But copying was not then regarded as it would be now,

200. ANDREA MANTEGNA. *Virgin and Child.* c. 1470.
Engraving, $8\frac{7}{8} \times 8\frac{5}{8}''$.
National Gallery of Art, Washington, D.C.
(Rosenwald Collection).

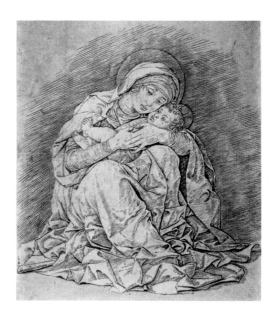

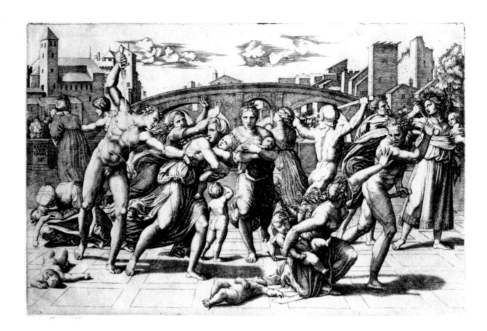

201. MARCANTONIO RAIMONDI
(after RAPHAEL). *The Massacre
of the Innocents.* c. 1515.
Engraving, $10\frac{7}{8} \times 16\frac{3}{4}''$.
Metropolitan Museum of Art,
New York (Rogers Fund, 1922).

and Raimondi did develop a style and technique of his own, softer and less severe than Dürer's. Much in demand to make engravings after drawings by painters, he formed with Raphael a type of designer-printmaker partnership that later would become more common. Figure 201 is a product of their collaboration.

Lucas van Leyden was both painter and engraver. An extremely precocious artist, he turned out accomplished prints well before he was twenty and early won the praise of Raimondi. *The Milkmaid* (Fig. 202) shows prodigious technique applied to the creation of significant form and a close observation of the bucolic scene, in which later Dutch painters would excell. Subsequently the artist worked in a more Classicizing, Italianate manner.

Dürer, whose woodcuts have already been discussed (Fig. 130), was an engraver of unparalleled ability. His was an intellectual world, complex and troubled. Poring over his engravings and etchings, we sense the answerless questions, conflicts, and contradictions that beset man in his relations with other men.

This complexity is abundant in *Melencolia I* (Fig. 203). Its symbolism, the subject of much scholarly analysis, functions on several levels. In its barest essentials, the downcast personification of Melancholy derives from the medieval theory of the four "humors" of man. The melancholic temperament was thought to be withdrawn, inactive, mournful, and studious—in this instance of science and mathematics, as indicated by the instruments in the composition. In contrast to Melancholy is the child, unafflicted by reflection and unperplexed by the world. Other emblems and symbols relate to Saturn, which governs

the melancholic, or saturnine, disposition. A short stroke and flicks or dots enrich the print surface; one of the many pleasant surprises is the tiny landscape framed by the ladder.

Following the technical and artistic triumphs of these three masters, the growing demand for reproductions and book illustrations resulted in a decline, after 1550, of original engraving in favor of wide publication and sale of commercially printed reproductions.

Though known early in the sixteenth century, the technique of etching did not mature fully until the seventeenth. Chemistry entered into the print process in a new way. Instead of the skill and physical force needed for engraving, the artist could now use the action of acids on metal to bite lines into the plate. Etching was therefore a technical breakthrough, comparable in importance to the invention of lithography at the end of the eighteenth century.

Jacques Callot (1592–1635), one of France's most accomplished etchers, studied in Rome and Florence under both Italian and French practitioners. In all, this prolific artist executed about 1,500 plates. Many of them were images of *Commedia dell'Arte* characters and of hunchbacks, beggars, mountebanks, and masqueraders—all from his early years in Italy (Fig. 204). Following the French invasions of Italy in 1632

below left: 202. LUCAS VAN LEYDEN. *The Milkmaid.* 1510. Engraving, $4\frac{1}{2} \times 6\frac{1}{8}''$. National Gallery of Art, Washington, D.C. (Rosenwald Collection).

below right: 203. ALBRECHT DÜRER. *Melencolia I.* 1514. Engraving, $9\frac{3}{8} \times 6\frac{5}{8}''$. California Palace of the Legion of Honor, San Francisco (Achenbach Foundation for Graphic Arts).

bottom left: 204. JACQUES CALLOT. *Gobbie.* 1616. Engraving, $3\frac{1}{8} \times 2\frac{5}{8}''$. Huntington Library, San Marino, California.

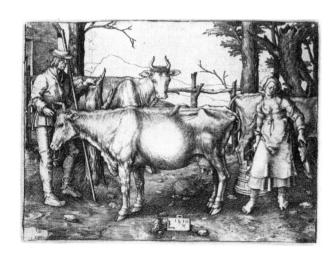

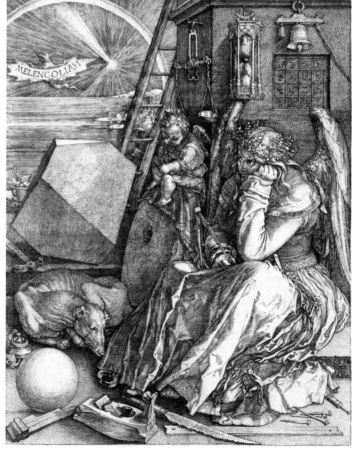

and 1633, Callot produced *Les Petites Misères* and *Les Grandes Misères*, suites of etchings on the theme of man's inhumanity to man (Fig. 205). Callot perfected the use of the *échoppe*, a chisel-edged tool capable of obtaining a swelling line. He also employed a second biting and supported certain of his etched lines with a burin.

The graphic production of the great Dutch master Rembrandt van Rijn (1606–69) is almost as well known and admired as the artist's remarkable oils. In etching as in painting he frequently turned to Biblical scenes, to portraits and self-portraits, and to character studies, but the incidence of landscape is more frequent than in the canvases. At first the artist used the etching as a study, rather in the manner of a pen sketch. Then in religious scenes he developed it in strong chiaroscuro and in greater detail. In portraiture he used etching to explore

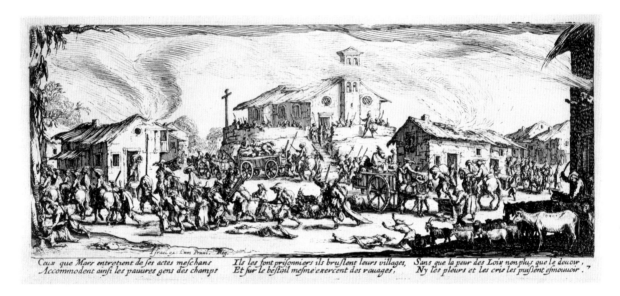

Ceux que Mars entretient de ses actes meschans / Accommodent ainsi les pauvres gens des champs *Ils les font prisonniers ils bruslent leurs villages, / Et sur le bestail mesme'exercent des rauages,* *Sans que la peur des Loix nonplus que le deuoir, / Ny les pleurs et les cris les puissent esmouuoir.* 7

above: 205. JACQUES CALLOT. *Disasters and Horrors of War: Firing the Village,* from *Les Grandes Misères.* 1633. Etching, $3\frac{5}{8} \times 7\frac{1}{2}''$. Philadelphia Museum of Art (purchase, Lisa Norris Elkin Fund).

right: 206. REMBRANDT. *Three Trees.* 1643. Etching, $8\frac{3}{8} \times 11\frac{1}{8}''$. Metropolitan Museum of Art, New York (bequest of Mrs. H. O. Havemeyer, 1929; the H. O. Havemeyer Collection). (See also detail, Fig. 8.)

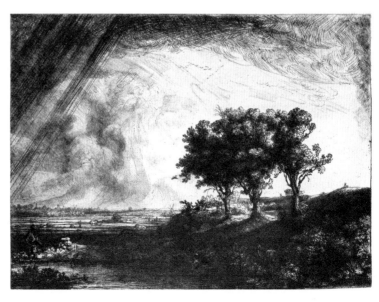

the potentialities of facial expression. The landscapes came mostly from the neighborhood of Amsterdam, during the decade after 1640, the period of Rembrandt's greatest activity as an etcher. *Three Trees* (Fig. 206) is perhaps the most ambitious of the artist's landscape etchings. A striking feature in it is the cloudy, atmospheric sky.

Though disputed, the total number of Rembrandt's etchings is set at something like 300. His early work can be distinguished by its pure etched line, his middle period by the drypoint accents, and the later work by a more vigorous and liberated use of drypoint. Whatever his technique or theme, the legacy Rembrandt left is an enduring one.

Rembrandt's esteemed friend Hercules Seghers (b. 1589/90) was an accomplished etcher whose innovative techniques had difficulty finding an audience. He tried various needles and gravers, replaced the hard etching ground by a soft one, and was the first genuine experimenter with intaglio color printing (Pl. 30, p. 205). He used pigments instead of inks, printed on tinted linen, canvas, or paper, and often enriched his etchings with hand coloring. Seghers' daring and adventure ally him with the modern spirit.

In the century following Rembrandt's death, intaglio was improved for reproductive art, but its use for the original print was somewhat neglected. After 1700, however, several major artists did original work notable in both power and volume.

Eighteenth-century England produced several satirists who worked in intaglio, among them the trenchant and immensely popular William Hogarth (1697–1764). His moralizing suites on infamous subjects are fine examples of this artist's bold, unacademic style (Fig. 207). At first

207. WILLIAM HOGARTH. *The Cockpit.* 1759. Etching and engraving, 16 × 22″. Metropolitan Museum of Art, New York (Harris Brisbane Dick Fund, 1932).

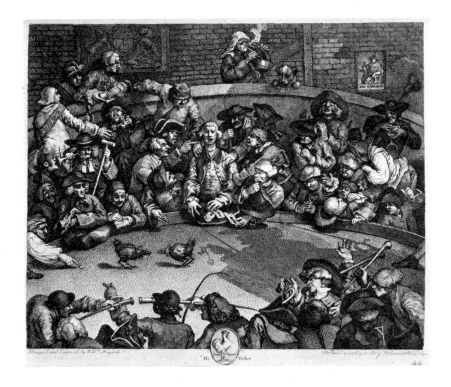

he made conversation pieces, but the goal of Hogarth's mature work was dramaturgic: "I have attempted to treat my subjects as a dramatic writer; my picture is my stage, and men and women my players, who, by means of certain actions and gestures, are to exhibit a dumb show." *The Harlot's Progress* relates in six plates the ruin of a simple country girl subjected to the sophistication of London dandies. Its counterpart, *The Rake's Progress,* describes in eight scenes the progressive debauchery of a young man intent on the high life of London. The twelve prints of *Industry and Idleness* tell of the lazy apprentice who "falls into poverty and ends fatally." Hogarth realized most of these scenes as paintings before publishing them as prints, which he said "were done in a way that might bring them within the purchase of whom they most concern." The price was therefore right, at twelve shillings per set (for *Industry and Idleness*); on "better paper" at fourteen shillings, available through the artist. Hogarth's famous cycle of six prints called *Marriage à-la-Mode* was engraved by other hands.

Though most of his larger plates are burin engravings over a lightly etched line, *The Cockpit* (Fig. 207), a late print, reveals an etching with some burin work. When published in 1759, the sport the print pictured was enjoyed by British toffs and roughs alike, and it may refer obliquely to an election. Many Hogarth satires portray actual personalities of the time, only vaguely identified.

The etchings of Thomas Rowlandson (1786–1827) are yet more exuberant than Hogarth's. One of England's most prolific etchers, with a genius for caricature, Rowlandson executed scenes from social life that ranged from fishmongers to the aristocracy. *The Successful Fortune Hunter* (Pl. 31, p. 205), an etching tinted with watercolor, exhibits the verve and accuracy of observation characteristic of his style.

Giovanni Battista Piranesi (1720–78) was an architectural scholar with vaulting imagination who created fantastic compositions of Roman ruins and Renaissance structures, real and imagined, that invite, confuse, and capture the eye. The sixteen plates of *Carceri d'invenzione* ("Imaginary Prisons") combine archaeology and fancy to overwhelm shadowy little people in curiously malevolent environments filled with such contrivances as blocks, tackles, and scaffolds. Figure 208 demonstrates the large scale and the free, dramatic, and poetic metamorphosis that Piranesi wrought upon his subject. His *Vedute,* or Roman views, ran to more than 130 etchings. Eagerly collected, they were formative in the lasting popularization of the Eternal City.

Some artists leave a visual record so imbued with the life of their times it virtually challenges the viewer's involvement. Francisco Goya (1746–1828), whose lithographs were discussed in Part I (Fig. 28), was such a figure. From his prints peer out the empty, uneasy faces of the would-be powerful; in them demonic monsters fly in black skies; the brutality of war is made deathly clear (Fig. 209); vice, love, and hate in a beserk world are conjured; as are dancing, music, and ro-

mance. The prints of Goya tell of Spain's Inquisition, of her pageant in the bullring, of the nation's glorious people, her creative genius, of Spain in misery and degradation. Figure 255, plate 32 of a cycle extended to 80, called *Los Caprichos,* is filled with the pathos of Goya's life view and with his anger against social and clerical abuses. Figure 209 is plate 30 from the 85-plate suite *Los Desastres de la Guerra* ("Disasters of War"), which documents the bestiality of the Napoleonic occupation of Spain. Technique in Goya's work grows out of content. There is no evidence that the artist ever pondered over a method or a tool to use. It is interesting to compare Figure 209 with the print by Callot in Figure 205. Artists who appeal to the social conscience seem to be drawn naturally to the graphic media, for these are the multiple means of disseminating ideas, for making a broad appeal in behalf of man's condition.

The English artist William Blake (1757–1827), a contemporary of Goya, produced in intaglio works of such individuality their essential genius did not become apparent until well after Blake's death. Despite loneliness and poverty, Blake possessed a radiance of vision that inspired him to engrave some of the most poetic prints ever conceived. He also made one attempt at lithography (Fig. 18). Having long been experienced in reproductive engraving, Blake had to unlearn old habits

so as to achieve the stunning work that is *When the Morning Stars Sang
Together* (Fig. 210), an illustration for *The Book of Job.* Here are the sweep
of artistic power, the unity of text and illustration, an entire system
of symbols (complex and obscure but wedded to the realities of his
time), and the breadth of conception (dealing with good and evil) that
distinguish Blake's graphic production. Blake was an extraordinary
technician, developing a method of relief printing from metal plates
and of printing colors simultaneously. From 1804 to 1820 he worked on
Jerusalem: The Emanation of the Great Albion (Pl. 32, p. 206), which, like
Job, is one of the artist's grandest accomplishments. The theme is man's
fall and his redemption by Jesus, and the swirling forms and simplified
linear style of the title page (Pl. 32) express this metamorphosis of soul.
Albion is Blake's symbolic name for man; Emanation is Jerusalem. The
mystic visual imagery seems only tenuously related to the text, which
simply adds to the richness of the poem's content and design.

By 1800, "commercial" etcher-engravers had become so skillful
their reproductions of paintings threatened to rival the originals in
depth and dimension. They also supplied (as did Currier & Ives lithographs, Fig. 43) the popular demand for the sporting print, the fashion
plate, the souvenir travel views, and royal portraits, as well as book
illustrations.

Following a decline in original etching, Charles Meryon (1821–68),
a Parisian artist of French and English parentage, was one of the first
to revive it. He first learned the art by copying and then perfected his

style in plates of seascapes and, especially, scenes of Paris (Fig. 211), tending toward fantasy in form and image. The series *Eaux-fortes sur Paris* is controlled in technique and Romantic in spirit. The delicate line, richly contrasted textures, and carefully managed lighting made his architectural views influential in both England and France—and admired by the modern American artist Edward Hopper (Fig. 222). Meryon's mental illness may have intensified the bizarre element in his visions.

The new freedom and experimentation of the late nineteenth century elicited a fresh regard for the intaglio processes, most notably etching, in which painters could develop the tonalities and coloristic effects they found in lithography. James Abbott McNeill Whistler (1834–1903) worked in both media, making something superb out of the art of omission. The fluidity, decisiveness, and variety of his etching line are abundantly evident in *Black Lion Wharf* (Fig. 212).

Many of the ideas revolutionizing the art and society of France and Germany at the turn of the century found their strongest statements in woodcut and lithography, but new styles were also evolved in intaglio. Among their major exponents were the great German artist Lovis Corinth (1858–1925) and the Belgian genius James Ensor (1860–1949), both pacesetters in modern art whose imagery verged on the macabre. Influenced by Impressionism, Corinth matured in the Expressionist style, and his handling of soft-ground etching and drypoint was highly effective in the weird, violent, or pathetic scenes he so often chose to depict (Fig. 213).

212. James Abbott McNeill Whistler. *Black Lion Wharf.* 1859. Etching, $5\frac{7}{8} \times 8\frac{7}{8}''$. Metropolitan Museum of Art, New York (Harris Brisbane Dick Fund, 1917).

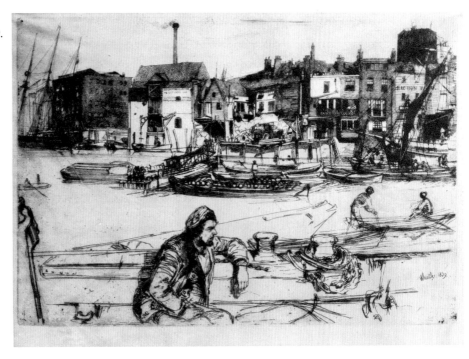

Ensor expressed his themes through a symbolism he found in the stock of his family's store, which dealt in puppets, masks, novelties, and souvenirs. His best-known painting is *The Entry of Christ into Brussels*, a work he etched as one of his more than 150 engravings and etchings. *The Cathedral* (Fig. 214), with its foreground density of mask-like faces, may be Ensor's most distinguished etching. An experimental technician, he exploited new processes and intricate manipulations of materials to convey both humor and the strangeness of the subconscious and the supernatural.

An artist typically French and more at peace with his world was the Impressionist Pierre-Auguste Renoir (1841–1919). The technique he used for soft-ground etching (Fig. 263) reflects the facility and freedom of his work in other media (Fig. 36).

The restless innovative temperament of twentieth-century art finds many of its facets in the graphic production of such practitioners as Georges Rouault (1871–1958), Jacques Villon (1875–1963), Paul Klee (1879–1940), Max Ernst (b. 1891), and Joan Miró (b. 1893).

Rouault, a Frenchman, took as his subject prostitutes, clowns, judges, and the Bible and treated them all with a moral, strongly religious tone. If examined with feeling, his figures reveal a lifelong concern with the problem of *contour*, a preoccupation possibly deriving

left: 213. LOVIS CORINTH. *Death and the Artist II.* 1916. Drypoint, $7 \times 4\frac{3}{4}''$. Brooklyn Museum (gift of Benjamin Weiss). (See also detail, Fig. 11.)

right: 214. JAMES ENSOR. *The Cathedral.* 1866. Etching, $9\frac{3}{4} \times 7\frac{1}{2}''$. Museum of Modern Art, New York (gift of Abby Aldrich Rockefeller).

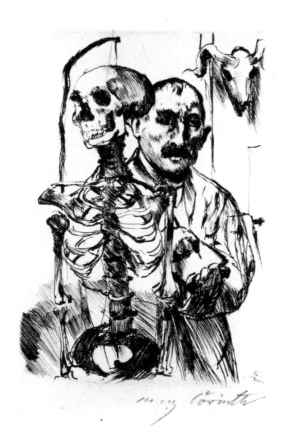

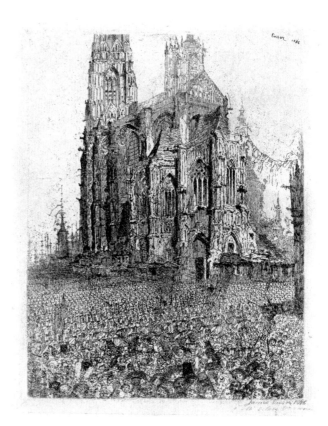

from an apprenticeship in stained glass. The style is fully evident in Rouault's masterpiece of printmaking, the *Miserere* (Fig. 215), a cycle of 58 aquatints prepared for publication by Ambroise Vollard. The artist developed the scenes over many years, until 1927, out of the distress he felt for the human suffering sustained in World War 1. Though not known for certain, it is thought that Rouault first drew the designs in India ink and then realized them as paintings. Once these were transferred photomechanically to copper plates, Rouault reworked them with aquatint, etching, the roulette, and several unorthodox tools to achieve the final appearance. Figure 215 is number 31 in the series and bears the admonition to "love one another."

Jacques Villon (born Gaston Duchamp) was a brother of Marcel Duchamp, the irrepressible father of the Dada and Pop themes in modern art. Villon himself was an original member of the Cubist group. A master printmaker, Villon produced so many graphics for a publisher he had little time for original creation. He also collaborated in graphics with Renoir, Cézanne, Braque, and Picasso, among others. *The Wrestlers* (Fig. 216) is characteristic of his later technique of etching. The forms have been abstractly conceived in terms of light and spatial structure and then realized through the subtle meshing of fine straight lines.

left: 215. GEORGES ROUAULT. *Crucifixion,* from *Miserere.* 1927. Aquatint, $23\frac{7}{8} \times 17\frac{1}{8}''$. Courtesy Mlle. Isabella Rouault, Paris.

right: 216. JACQUES VILLON (GASTON DUCHAMP). *The Wrestlers.* 1939. Etching, $10\frac{15}{16} \times 9\frac{3}{4}''$. U.C.L.A., Grunwald Graphic Arts Foundation, Los Angeles.

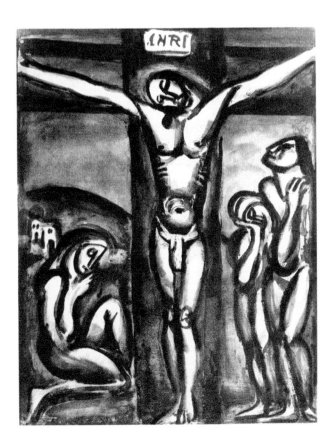

The Swiss-born Paul Klee (Fig. 217) was an individualist whose ambition was to be "as newborn . . . to be almost primitive. . . . Then I want to do something very modest, to work out by myself a tiny formal motif, one that my pencil will be able to encompass without any technique." Klee created 54 etchings, in addition to lithographs and woodcuts, and the subjective is apparent in all of them. Passionately attached to music, Klee found many pictorial ideas in music theory and notation. The quality of line and texture he developed in etching and drypoint is very much his own. In Germany Klee was affiliated with the Bauhaus and the Blue Rider group (Fig. 48). His essay on the graphic arts appeared as *Creative Credo* (1920).

A Surrealist of ingenious and polemic spirit, Max Ernst (Fig. 218) has had a long career in Germany and America, using various media with great invention. Delighting in puns and nonsense verse, humorous sexual allusions, and forms and materials metamorphosed into the surreal, he has created poetic figures of mystery and fantasy. For his graphics Ernst has added collage and *frottage* (surface rubbing) to pen drawing and normal etching.

The Spanish Surrealist Joan Miró (b. 1893) has on occasion collaborated with Ernst, but his style tends more toward nonrepresentational abstraction. To Miró it seems vital "that a rich and robust theme should . . . give the spectator an immediate blow between the eyes before a second thought can intervene." His joyous and childlike playfulness has expressed itself in pictographs and ideograms and in free woodcuts, printed at the Atelier Lacourière, lighographs, serigraphs, and mixed techniques, as well as in etchings. An example of Miró's prolific and

left: 217. PAUL KLEE. *The Pergola.*
1910. Drypoint, $3\frac{13}{16} \times 5\frac{1}{8}''$.
Museum of Modern Art,
New York
(gift of Curt Valentin).

right: 218. MAX ERNST.
Composition. 1950.
Etching and aquatint, $7\frac{1}{8} \times 5\frac{1}{8}''$.
Museum of Modern Art,
New York
(gift of Phyllis Clarke Wright).

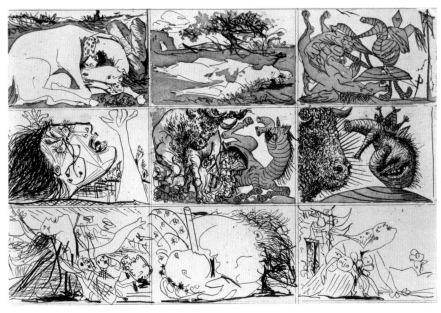

witty graphic production is Figure 219, produced by both etching and engraving, and subsequently printed by the relief method to realize what is known as a *reverse etching* (Fig. 184).

Pablo Picasso (b. 1881), a Spaniard long resident in France, has quite probably been the single most powerful and enduring presence in the art of the twentieth century—a genius virtually limitless in his creative resources and in his technical and stylistic range (Figs. 54, 174, 266). His *Dream and Lie of Franco* (Fig. 220) is one more approach to the theme of man's inhumanity. Produced with a combination of etching and aquatint, Figure 220 is not a conversation piece but an evocation of the artist's deep sense of identification with the print's content.

In the twentieth century American art has found a preeminent place in the mainstream of modern art, and the point at which it took its strongest thrust from European innovations was the great Armory Show of 1913, where for the first time the American public in general became aware of avant-garde experiments made by both European and American artists. Among the Americans selected on this signal occasion for exhibition in the 69th Regiment Armory building in New York City were John Marin (1870–1953), Edward Hopper (1882–1967), and John Sloan (1871–1951).

Throughout his long career, John Marin produced work with a strong personal style, one notable for flashing transparency of color and for the individual use it made of the abstraction and distortion characteristic of international modernism. Marin's lifelong residence in or near New York City and his early studies in architecture resulted in numerous cityscapes, and his many sojourns in Maine produced a large body of works devoted to woods and seacoast. Jagged rhythms

left: 219. JOAN MIRÓ. *Young Girl Skipping Rope, Women, Birds.* 1947. Etching and engraving, 12 × 9″. Museum of Modern Art, New York (Purchase Fund). (Figure 184 shows a detail of this work printed as a reverse etching by the relief method.)

right: 220. PABLO PICASSO. *Dream and Lie of Franco.* 1937. Etching and aquatint, 12 × 21⅜″. California Palace of the Legion of Honor, San Francisco (Achenbach Foundation for Graphic Arts).

Intaglio: The Development of an Art Form 201

and circular gyrations are typical of Marin's compositions (Fig. 221). Beginning in 1905, Marin etched for forty years, developing a clean-bitten line whose nervous strokes create more a dancing movement than continuous delineation. In 1928 Marin stated his theory of composition in this way: "Basic—the great horizontal—the culmination of rest. The great upright—the culmination of activity—for all things sway away from or towards these two."

Night Shadows (Fig. 222) embodies many of the memorable qualities that make Hopper the solitary giant of modern American art. This print displays a rather mystical yet matter-of-fact view pervaded with the

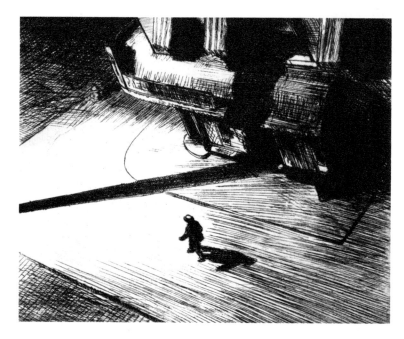

above left: 221. JOHN MARIN. *Woolworth Building, New York, No. 30.* 1913. Etching, $12\frac{7}{8} \times 10\frac{1}{2}''$. Brooklyn Museum (Dick S. Ramsay Fund).

above right: 222. EDWARD HOPPER. *Night Shadows.* 1921. Etching, $6\frac{7}{8} \times 8''$. Library of Congress, Washington, D.C. (Pennell Fund).

right: 223. JOHN SLOAN. *Night Windows.* 1910. Etching, $5\frac{1}{8} \times 7''$. Library of Congress, Washington, D.C. (Pennell Fund).

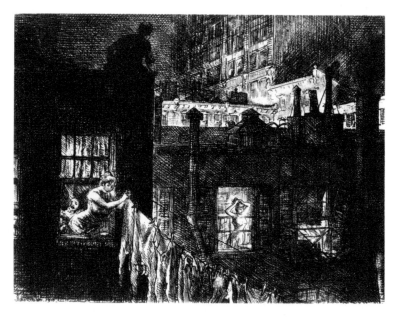

ineffable loneliness of the great city and of the psychologically remote or physically oblique perspective. Like most American artists of his generation, Hopper first earned his living in commercial art and illustration, but temperamentally he was an independent who produced entirely modern work that seems all the more successful for its freedom from the stylistic succession of Cubism, Expressionism, and after. In etching he taught himself by asking friends for advice on techniques and materials. Hopper said that etching "can and should be a means of self-expression." He worked patiently on his plates, sometimes through eight states, to eliminate inessential detail and to arrive at the generic sense of the idea. To attain maximum brilliance and contrast he printed his fifty or more etchings and drypoints on very white paper from Umbria, Italy, with an intense black ink from England.

John Sloan studied under Robert Henri, as did Hopper and many others of this generation, and with Henri was an original member of The Eight, a rebellious group of "realist" painters who in 1908 challenged the academic establishment in American art. A native Pennsylvanian, Sloan became as fascinated by New York as the subject of art as were Marin and Hopper. However, he concentrated on the city's teeming humanity, rather than on its forms and isolation, and did scenes ranging from genre to social criticism. Sloan made 125 etchings and sold few of them until years after they were printed. *Night Windows* (Fig. 223) is a tightly knit composition of sharply contrasted dark and light depicting crowded tenements on a hot summer night.

Counterbalancing the group of American urbanites was a generation of regionalist artists from the West and South who worked in intaglio but produced more telling graphics in lithography.

Philip Evergood (b. 1901) was a friend of Sloan's who combined fantasy and humor with a concern for social ills to express a sense of man's plight in a world gone awry. He received sound preparation in engraving from Stanley William Hayer (Pl. 36, p. 240) in Paris and in etching under Harry Sternberg in New York. *Aftermath* (Fig. 224) is

224. Philip Evergood. *Aftermath*. 1940s.
Etching, $6\frac{7}{8} \times 8\frac{7}{8}''$.
Library of Congress, Washington, D.C.
(Pennell Fund).

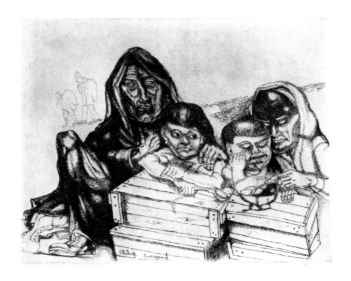

characteristic of one aspect of Evergood's wide-ranging artistic personality. The dark, brooding quality of the foreground figures, evoked in dense webs of line, contrasts with the pure outline used for the burdened men of the Great Depression in the background.

A painter and graphic artist of stature, Harry Sternberg (b. 1904) also served as mentor to many of today's practitioners of the print media. In his own work he has shown concern for human insecurity in various aspects as well as for the industrial milieu that creates the psychological malaise of our time. Figure 225 demonstrates the effects of aquatint with etching, and in his own book on printmaking (1949) Sternberg called attention to the detail from the lower right to show the smooth tonal blending in the aquatint.

The vast amount of experimental work in the field of intaglio tends to influence every practitioner as he, in turn, influences the field and the people who make up his audience. The question of size (unusually large plates are produced today) is no longer a factor. A strong minority group remains faithful to black and white, in opposition to the many proponents of color. Some court serendipity, eagerly searching "accident" with which to texture plates and invent new visual surfaces to titillate the eyes. Others, more concerned with their pictorial ideas, allow the image to dictate the way in which a particular plate is worked, whether the evolving method is traditional or otherwise. New techniques and new methods grow out of the struggle of the artist with what he has to say. Thus the way in which it is said becomes meaningful, not for itself alone, but as visual proof of the constant necessity for departing from tradition.

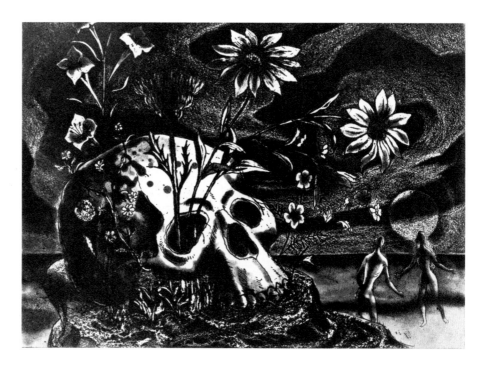

225. HARRY STERNBERG. *Tomorrow.* 1949. Etching and aquatint, $10\frac{7}{8} \times 14\frac{15}{16}''$. Collection Ione and Hudson D. Walker, on extended loan to the University Gallery, University of Minnesota, Minneapolis.

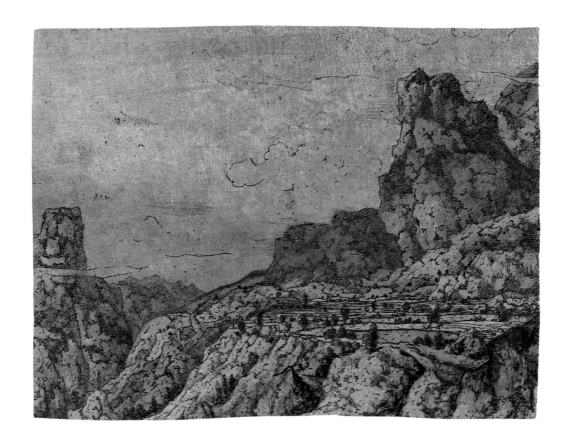

above: Plate 30. HERCULES SEGHERS.
Rocky Landscape with a Plateau. c. 1635.
Etching, 4¼ x 5½".
Metropolitan Museum of Art,
New York (Dick Fund, 1923).

right: Plate 31. THOMAS ROWLANDSON.
The Successful Fortune Hunter. 1802.
Intaglio, hand-colored; 12 x 9".
Metropolitan Museum of Art, New York
(Elisha Whittelsey Fund, 1956).

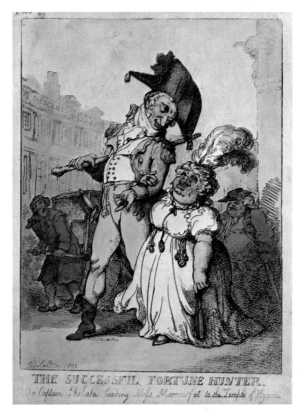

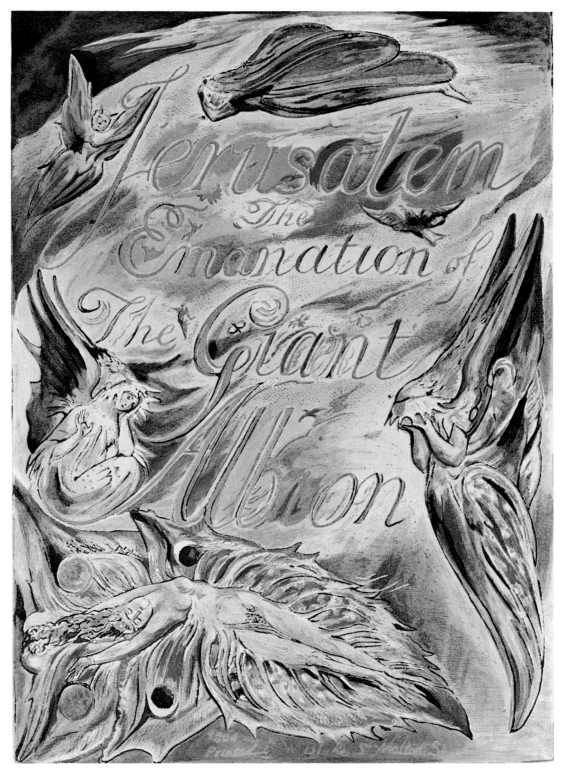

Plate 32. WILLIAM BLAKE. Title page from *Jerusalem: The Emanation of the Great Albion.* 1804–20.
Relief etching, hand-colored; 8¾ x 6¼". 19th-century facsimile
in the collection of the Beinecke Rare Book Library, Yale University, New Haven, Conn.

Making an Etching

Intaglio, which includes etching, engraving, and the other processes that will be described in this and the following chapters, defines an image engraved *below* the surface of the material—unlike woodcut, in which the image is left *on* the surface, and unlike lithography, in which both image and surface are in one flat plane. The image on a plate from which a print can be taken is incised by hand with burins or etched by acids. The image is filled with ink, and the surface of the plate wiped clean. Dampened paper is placed on top of the plate and both are run through a wringer-type press which forces the paper into the channels or grooves to pick up the ink. In a sense, the paper molds itself to the irregularities cut or etched within the plate. The word *intaglio* is used both for the process and for a print made by the process, and specific names are given to various types of intaglio.

In the printmaking field the intaglio has long held a position of prestige as the inheritor of the great Renaissance tradition of fine printmaking, and some artists consider it the most versatile of all graphic media. An overall view of printmaking, however, will tend to affirm what most artists feel instinctively—that no medium is per se better than another and that each artist will search for the one that satisfies his own purposes.

This chapter will introduce the basic etching techniques by which the great intaglio prints of the past three centuries were in large part

produced; the beginner is urged, as he follows the process through, to refer again to the works illustrated in the latter half of Chapter 13. By mid-twentieth century these well-developed techniques, along with various new and experimental ones, had been put into the service of a completely different kind of art. Two examples by established modern artists are included at this point to demonstrate that a fresh aesthetic approach, not necessarily involving new procedures, could change the character of the intaglio print. The first is by Henri-Georges Adam (1904–67), who worked in Paris, primarily as a printmaker; in addition to the various technical innovations he contributed, Adam imparted an original look to the simple etched line (Fig. 226). The other intaglio print (Fig. 227) is a late work by the American painter Barnett Newman (1905–70), who brought to etching the same concise control of design and space that, in his painting, proved to be a major influence in the developing trends of Abstract Expressionism and color-field painting.

While there are some technical problems involved in making an intaglio print, the procedures are like those in all the graphic arts—relatively simple to "learn," but difficult to master and worthy of arduous study. The persuasiveness of the content and the artist's unity with his visual idea may enable him to cut through technical problems and, without a great deal of experience, produce a work of art.

Every etcher, no matter how long he has worked in the medium, cannot but be excited anew at the first proof from a plate—though rarely does the initial proof live up to the artist's expectations. Many artists would agree that more is put into the image than ever appears on the working proof, and this may, in some measure, explain the

226. Henri-Georges Adam.
Sand and Water. 1957.
Etching, $36\frac{3}{16} \times 23\frac{5}{8}''$.
Brooklyn Museum.

craftsman's ardent interest in the medium. There are variables in etching that few artists can control consistently, but fortunately the process allows and, in fact, encourages reworking to the ultimate satisfaction of the printmaker.

PREPARING THE PLATE

The basic requirement for etching is a plate that will carry the etched lines, which are called the *intagliate*. A 16- or 18-gauge copper or zinc (micrometal) plate is generally used. Copper is the preferred plate for etching because it allows for finer work, can also be engraved upon, and may be used for drypoint. Zinc has certain limitations. Its molecular structure, for example, is such that engraving and drypoint should not *normally* be attempted in this material. On the other hand, the cost of zinc is usually about half that of copper; zinc plates impart a not unpleasant tone to the final print; and for those who require or prefer a "fast" medium, zinc reacts quickly in the acid bath. Zinc is highly regarded by many etchers who work in color.

While copper is the traditional surface for intaglio prints, early engravers sometimes used other metals. Today newer materials have been adopted, though not necessarily for work in the traditional manner; aluminum, triple metals, Lucite, and Masonite are but a few of them. For the purposes of this chapter, however, it will be assumed that you are using either a copper or a zinc standard-gauge plate. You may need to cut your plate to a desired size; this can be done in a nearby metal shop if you lack the equipment for doing it yourself.

227. BARNETT NEWMAN. *Untitled Etching #1.* 1969. Etching and aquatint, $14\frac{5}{8} \times 23\frac{1}{2}''$. Metropolitan Museum of Art, New York (Stewart S. MacDermott Fund, 1969).

CLEANING THE PLATE

To lay an acid-resistant ground that will adhere strongly, the plate must first be cleaned and freed from grease. Omission of this step may cause the ground to break away during the *biting*, that is, during the action of the acid as it attacks the metal plate. Therefore, with a cotton swab and a mixture of powdered whiting and water, rub the plate thoroughly. (Household ammonia can be substituted for water; any detergent can be substituted for whiting.)

To test the cleanliness of the plate, hold it under a water faucet and observe the action of the water on the surface of the metal. If it is still not free from grease, the water will form in globules, whereas a clean plate allows the water to form in an unbroken film over the entire surface. When the plate is thoroughly clean, dry it by heat on a hot plate or stove.

If you wish to remove tarnish from a plate, use plate polish or a thin solution of lye; or you can try rubbing magnesium carbonate on the plate with a piece of soft leather.

LAYING THE GROUND

The primary problem in etching is to provide the plate with an acid-resistant ground, which will allow the acid to bite into the design scribed by the etching needle without affecting the unneedled ground. There are numerous tools equal to this particular need. For the etching ground, the primary requirements are that it should not flake or chip when drawn through with a needle; it should allow being spread to a paper-thin consistency on the plate; it should not soften unduly through indirect heat; and it should be dark enough to provide a sharp contrast to the needled lines so that you can see your drawing clearly.

The Traditional Hard Ground

Laying a ground is not as difficult or unwieldy a process as words sometimes make it seem. Nor is it always as simple as one would desire. There is no magic formula for success—save practice. First, warm the plate on a hot plate and then rub several strokes of *hard ground* (the traditional ground) about on the plate. Hard ground, the main ingredient of which is wax, is normally supplied in a ball-like shape, about the size of a golf ball. The heat of the plate melts the ground as you rub it on. Using a leather-covered roller (which you should keep for this purpose only), pass it over the plate until you obtain an even, thin, protective cover (Fig. 228); go over the plate with the roller in several directions, if necessary, to achieve the proper result. If the ground is too thin, or too thick, it will not be acid-resistant, or will crack or flake. The ground can also be applied with a dabber, as shown in Figure 229.

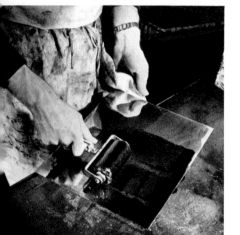

228. Rolling on hard ground.

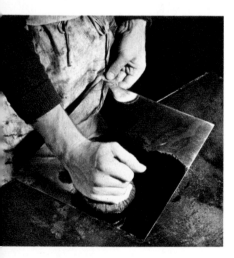

229. Dabbing on hard ground.

Smoking the Traditional Ground. In order to obtain greater contrast between the needled copper line and the blackened ground, and to observe flaws more easily, the traditional etcher smoked his ground. The smoking, neither difficult nor time-consuming, is accomplished as follows: Twist several wax tapers together, and line the jaws of a hand vise with felt. Hold the grounded plate face down with the hand vise in your upraised left hand, or otherwise support it so that you can get at the underside (Fig. 230). Pass the flame of the tapers across the grounded plate back and forth to allow the carbon to blacken the ground. Do not burn the ground by keeping the flame in one spot too long. When the plate is cool, the surface will be a sooty black.

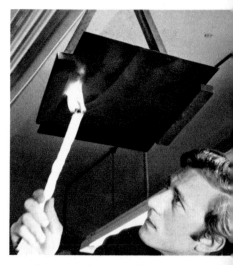

230. Smoking the ground.

Rembrandt's Ground

Printmakers interested in making their own grounds might try a formula that Rembrandt is supposed to have employed: $\frac{1}{2}$ ounce of asphaltum or amber, 1 ounce of virgin wax, and $\frac{1}{2}$ ounce of mastic. These ingredients should be melted together in the given order and allowed to boil up several times in a double boiler. Pour the mass into warm water and work it up into convenient-size balls. Cover each ball (after it is sufficiently hard) with a piece of silk so tied as to make a little sack. This will keep dust away from the ground until you are ready to use it and will thus prevent unintended pitting during biting. This ground is applied in the same way as the traditional ground.

Transparent Ground

By the simple process of weighing out and melting together 2 parts of wax to 1 part of gum mastic, a transparent ground can easily be made. Follow the same procedure in applying it as for the above grounds.

Liquid Ground

There are some etchers who prefer liquid grounds to all others. Liquid ground is hard ground dissolved in ether or chloroform, dependent upon the particular manufacturer's formula. To apply it, place a glass rod or wooden dowel under an etching tray so that the tray can be tilted easily—like a children's seesaw. Pour the ground into the low end of the tray. Place your cleaned plate face up at the other end of the tray and then tilt the tray so that the liquid ground covers the plate evenly. If it does not cover, repeat this procedure. Pour the residue of the liquid ground back into the bottle through a filter, and cap it quickly. This will keep dust out and stay evaporation of the ground.

The traditional method for applying liquid ground is to pour it quickly and evenly down a plate held just off the vertical, catching the excess in the tray in which the plate normally stands.

Asphaltum Hard Ground

Add equal parts of liquid asphaltum and lithotine, and stir well. Stand the plate against a vertical surface and brush on the ground as you would lay a wash. Use a soft-haired brush and place your strokes horizontally, one below the other, covering the plate evenly. The plate should then be heated on a hot plate or stove to allow the solvent to evaporate and ensure a smooth, hard, even coat.

Senefelder's Hard Etching Ground

Alois Senefelder, the "father of lithography," also developed various formulas for use in the intaglio field. Materials for his hard etching ground are: wax, 12 parts; mastic, 6 parts; asphalt, 4 parts; resin, 2 parts; tallow, 1 part. Melt all the ingredients in an iron pan until the asphalt is assimilated. Allow the mass to fire until about $\frac{1}{3}$ of the mixture has been consumed. Cool and shape the ground as desired. Keep it dust free.

A White Ground

A white ground, which may prove useful on occasion, can be made by painting the plate with white Carbona shoe polish (or its equivalent), or by mixing together 9 parts of gum arabic, 1 part tincture of green soap, and a few drops of morpholine.

Formula for a Seventeenth-Century Ground

In a clean pot, on a gentle fire, melt together 5 ounces of Greek or Burgundy pitch and 5 ounces of "Rozin of Tyre" or "colophonium" (that is, resin). Add 4 ounces of the best "Nut Oyl" and mix for at least a half hour. Allow the whole to boil well. Let it cool on a softer fire. Touch the end of your finger to the mixture; when it ropes like "glewy" syrup, strain through fine linen or taffeta into a well-stoppered jar. "Varnish thus made will last twenty years and will be the better the longer it is kept," according to the seventeenth-century makers.

MAKING THE DRAWING

Transferring a Sketch to the Plate

Few etching instructors encourage tracing a sketch onto the grounded plate, since it is generally conceded that tracing destroys the freshness of the original drawing. Many, however, acknowledge the fact that this will be done wholly or in part by many individuals, according to their particular needs. For those who need a method of transfer, the following devices may prove useful:

1. Using a cotton ball, rub powdered Conté or other dry color onto the back of your sketch. Place the drawing *face up* on the grounded plate and trace the image with a pencil, using very little pressure.
2. Place a sheet of colored carbon paper *shiny side down* under your sketch, and trace in the usual manner.
3. Having made a sketch on paper *with soft leads*, transfer it by damping the sketch lightly with a moist sponge, placing it *face down* on the grounded plate, and *slowly* running sketch and plate through the press with less than normal pressure. Use one blanket (that is, one of the felts you will use when printing) and a piece of cardboard for this transfer. Place the plate on the bed of the press several inches away from the roller, and see to it that the press roller grips the blanket and the cardboard before it engages the plate (Fig. 231). This third method will reverse your sketch on the plate, whereas the first two will not. (This technique can be used for images drawn with some ballpoint pens.)

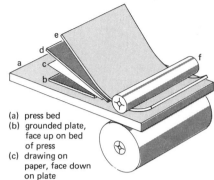

(a) press bed
(b) grounded plate, face up on bed of press
(c) drawing on paper, face down on plate
(d) cardboard (e) etching blanket (f) press roller

231. Transfer of sketch to grounded plate.

Needling the Ground

Draw your design on and through the ground with an *etching needle*, a particular steel tool used for scribing a design on a grounded plate (Fig. 232), or with any one of a score of substitutes, such as a darning needle, a dulled dentist's tool, or a phonograph needle secured in a pin vise or pen holder. Find and use any tool that will do the work and feel comfortable in your hand. You do not need to scratch more deeply where dark lines are intended, since that will be accomplished by the acid, but you must penetrate the ground and expose the plate.

M. F. A. Lalanne, writing in the nineteenth century, made the following recommendation in regard to drawing: "Lines which are to be deeply bitten ought to be kept apart from each other; those which are to be of medium depth ought to be nearer; and very shallow lines ought to be quite close to each other."

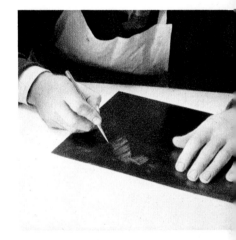

232. Drawing design with etcher's needle.

ETCHING THE PLATE

Preparing the Plate for the Acid Bath

Since the acid must penetrate *only* the needled sections of the ground, the back and the sides of the plate have to be protected with an acid-resist to prevent their being attacked in the bath. An acid-resist known as *stop-out varnish* is usually employed for this purpose. It is made by adding resin to denatured alcohol until you have a saturated solution (until a sediment begins to form at the bottom of the vessel). Stop-out can be thinned, for easier brushing on the plate, by adding denatured alcohol to obtain the desired consistency. Paint the back and the sides of the plate with a soft brush loaded with stop-out (Fig. 233).

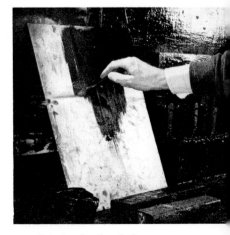

233. Painting back of plate with stop-out.

Some etchers use strawhat polish, stove polish, asphaltum hard ground, and other substitutes.

It is recommended that you bathe the needled plate in acetic acid prior to the actual biting; this removes all traces of grease from the lines to be bitten and tends to equalize the biting all over the plate. You need not wash the plate after using acetic acid; merely slip it into the acid bath.

Acids for Etching

The acid substances used for biting into the plate are generally called *mordants.* The most common are nitric acid, hydrochloric acid, potassium chlorate, and iron perchloride. The table of acids on the facing page may help you select the proper mordant for a particular job. In practice, you may find that one type of acid will serve most of your needs; do not feel obliged to use all these formulas.

A quantity of acid used for one metal should not be indiscriminately employed for another. It is useful to label and date acid mixtures to prevent improper usage and to determine whether the age of the mixture, aside from temperature and other variables, affects differences in performance. *Always add acid to water; never the reverse.*

The acids as diluted for etching are not as strong as they sound, and some printers work with bare hands. However, reasonable precautions should be taken against prolonged exposure, by wearing rubber gloves, especially in the case of persons subject to skin allergies. Pure acid can damage both skin and eyes, so care should be taken during the mixing of the etch. If pure acid should come in contact with the skin, immediately flush the acid-exposed area with water or a weak solution of ammonia. Apply bicarbonate of soda (baking soda) to neutralize the acid; if serious, call a physician.

For those interested in pursuing the subject further, some additional mordants are offered below for particular metals. In each case, add the acids to the water in the order named.

For Aluminum Plates
Water (warm): 10 parts by weight
Potassium dichromate: 1 part by weight
Sulphuric acid: 1 part by weight
Hydrochloric acid: $1\frac{1}{2}$ parts by weight
Grain alcohol (70%): 1 part by weight

For Soft Steel Plates
Water: 35 parts by weight
Hydrochloric acid: 1 part by weight
Nitric acid (chem. pure): 10 parts by weight
Methylated alcohol (70%): 5 parts by weight

For Copper Plates
Water (warm): 10 parts by weight
Potassium dichromate: 1 part by weight
Sulphuric acid: 1 part by weight
Hydrochloric acid: 1 part by weight

Table of Acids for Etching

Acid	Plate Zinc	Plate Copper	Formula	Gas Generated	Effect
Nitric	×		1 part nitric acid 6 parts water*	Hydrogen	Bubbles—bites horizontally as well as vertically; broad, irregular lines; bites *much-needled* effects faster than single lines; tendency to undercut
Nitric		×	1 part nitric acid 3 parts water*	Nitric oxide	
Dutch mordant		×	$\frac{1}{5}$ oz. potassium chlorate in 5 oz. *hot* water. Add 1 oz. hydrochloric acid	Chlorine gas given off when *mixing* the solution. Do not breathe the fumes	Bites straight and deep lines; no bubbles; lines darken during biting
Iron perchloride		×	To a saturated solution of iron perchloride, add an equivalent quantity of water	None	Bites clean, even lines. Sediment of iron oxide forms in lines, slowing down biting. Plate should be bitten upside down—an obvious disadvantage
Acetic	×	×	Use 30% solution	None	Merely employed to remove grease from needled lines prior to biting

Acid Combinations to Offset Disadvantages

	Copper			Effect
Iron perchloride *plus* 10% hydrochloric acid	×			Dissolves iron oxide sediment in lines
Nitric *plus* iron perchloride (noncritical in amount)	×			Stays tendency to widen lines
Dutch mordant *plus* nitric (enough to create bubbles)	×			Allows you to "see" foul biting immediately, due to bubbling action

*More or less water can be used, dependent upon the strength of the bite desired. For a slower etch use more water; use less water for a faster one. Always mix acid *to* water; not vice versa.

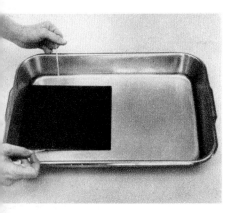

234. Lowering plate into acid bath.

Aqua Fortis. The following is a seventeenth-century formula for making *aqua fortis,* a term derived from the Latin name for nitric acid, which, in diluted form, was the earliest mordant used. Though the chemical terms are obsolete, William Faithorne's recipe provides more than academic curiosity:

Vinegar: 3 pints
Salt ammoniac: 6 ounces
Bay salt: 6 ounces
Vert de griz: 4 ounces

Put all of the ingredients into a large pot. Stir with a wooden stick. Bring to a boil several times. Cover the pot; remove it from the stove and allow it to cool. Pour the acid into glass bottles. Before using it, allow the mixture to stand for several days. If the acid is too strong, add a glass or two of vinegar.

Methods of Biting the Plate

Pour the acid bath (the mordant) into an etching tray; for this purpose a photographer's tray or any glass tray will serve. Lower the plate into the bath. (Some etchers wear rubber gloves; others run a string under the plate to aid in lowering it.)

Through the years etchers have developed three major approaches to biting plates, plus a host of variations. In actual practice methods 1 and 2 are often used in combination on the same plate.

Method 1. In method 1 the plate is fully *needled* (that is, the drawing is completed) and then immersed in the acid bath (Fig. 234). After a minute or so the *lightest* passages in the needled plate are prevented from further attack by being coated with an acid-resist or stop-out. (The stop-out is the same solution that was used in preparing the plate, that is, a saturated solution of resin in denatured alcohol.) When brushing stop-out on lines already bitten, be certain that the entire channel is filled with the stop-out and that the edges of the line are also protected. The plate is then returned to the acid bath and this procedure is

left: 235. Effect of nitric acid on immersing plate.

right: 236. Effect of nitric acid— soon after.

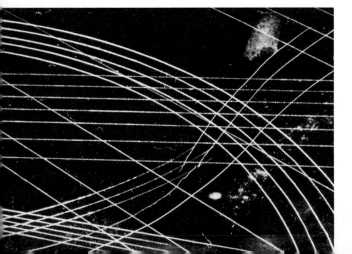

repeated until the darkest darks have been achieved. *You should wash the plate well with water and dry it thoroughly before applying stop-out between different bitings.*

Method 2. Needle the dark lines first. Then submerge the plate in the acid bath so that biting begins. The lighter and progressively lighter lines are needled as one proceeds. If you wish to cross heavily bitten areas with light lines, employ this method.

The English etcher Haden carried this approach to its limits. He submerged the grounded plate in acid and then, while it was under the acid, needled his dark lines, working the entire plate without removal from the acid. This method had a certain spontaneity which was greatly appreciated in his time.

237. Removing bubbles with feather.

Method 3. Use a feather or brush to carry the acid over areas of a needled design. This method sometimes incorporates what has been called *spit biting*, the practice of brushing saliva on a grounded plate in order to confine the acid to the particular area brushed. Spit biting is normally employed to obtain washlike effects.

Biting without an Acid Tray. Finally, here is an old method for biting a plate without a tray. A wall of wax is built up from under the plate to make a shallow vessel. A lip may be fashioned at one corner to allow for ease and safety in returning the acid to its container. Acid is then poured onto the surface of the plate and held within the walls of wax.

Controlling the Bite

If a bath of nitric acid is employed, you will notice bubbles of nitric oxide or hydrogen gas forming in the lines (Figs. 235, 236)—the former if your plate is copper, the latter if it is zinc. These gas bubbles appear almost immediately. If not removed from time to time, the bubbles will prevent the acid from further attacking the plate. The traditional way of getting rid of the bubbles is by employing a feather for the chore (Fig. 237); a pipe cleaner or a Chinese brush can also be used. Recent experts suggest merely tilting the bath tray sufficiently to expose the plate to the air, a procedure which has the advantage of keeping foreign objects out of the acid bath.

When biting a copper plate in a nitric bath that seems sluggish, especially if it is freshly mixed, add either some old mix (blue from the copper sulphate in solution) or drop a penny into the bath.

Do not intermix nitric solutions for zinc and copper, unless you are prepared for or desire uncontrolled and unpredictable effects. For example, if you were to place a needled zinc plate in a bath of nitric acid that had formerly been used for biting copper plates, you would achieve nothing more than copper-coated zinc lines and a poor bite.

If you are using a bath of iron perchloride, it may be helpful to bite the plate *face down* in the bath, supporting the plate on small pieces of glass rod. This procedure will allow the black copper oxide to fall to the bottom of the acid tray, keeping the lines clean. If the plate is bitten face up, you have to stop and remove the deposit from time to time to achieve a uniform bite.

Acids are quite temperamental; their behavior varies from place to place, subject to variables over which artists have little or no control. The confirmed etcher regards this as part of the excitement of the total process, considering it a compensation rather than a disadvantage.

How long should a plate be bitten? "Longer than you think" is the answer of experience. Most beginning etchers fail to allow the acid to penetrate deeply enough into the plate, and they are usually dissatisfied with the first bite. This may be avoided (1) by making a test plate; (2) by setting up a calculated geometric progression for line depth in minutes of biting time; or (3) by observation of the process in the hands of a seasoned craftsman. The most satisfying solution to the above problem is that which derives from experience with the materials. The inconstancy of acids reacting to age, temperature, the particular hardness or softness of the plate, and other factors challenge the printmaker to exert his utmost in controlling this medium.

Removal of the Plate from the Bath

When you are ready to take the plate from the acid bath, tilt the acid tray so that the mordant runs down to the bottom. Pick up the plate by two corners and wash it immediately with water. Dry the plate with paper towels or between blotters before examining it.

Remove the ground and stop-out with their respective solvents (turpentine and alcohol) and clean the plate thoroughly. Some etchers prefer to scrub their solvent-soaked plates with sawdust in a large metal, spring-lidded box set aside for this purpose. (The spring lid is a precaution against fire.)

Beveling the Plate

To prevent the sharp edges of the plate from cutting the blankets or the paper used when printing, it is important that you bevel the edges with a fine-toothed file. Round the corners and polish and remove any scratches on the edges.

PRINTING THE INTAGLIO PLATE

The printing stage is as creative a part of the total process as is any other step. If a group of first-rate photographers were given the same negative and each were asked to make a print from it, the resultant

prints would show a general resemblance—yet each one would reflect individual differences. Similarly, if a number of printmakers were requested to pull a print from the same plate, each printmaker would inevitably leave the stamp of his own personality upon it.

You now have a plate that has been needled and bitten with acids, and perhaps also textured by scoring, roughening, scraping, burnishing, and other techniques. To obtain a print from this plate, you will fill all the pits and depressions with ink, wiping the surface of the plate clean, then place a sheet of soft, dampened paper on top of the inked plate and run it through the press. This action forces the paper down into the lines, pits, and depressions, causing the ink to appear in relief above the paper surface when it is pulled from the plate. You will have "taken a cast" of the lines and other hollows in ink on paper. Looking at the back of the print, you can see the depression in the paper; turning the paper over, you can see the lines standing up in relief.

If you wish at this point to obtain a quick working proof without an etching press, rub lampblack into the intagliate (into *all* the lines of the plate), place a sheet of waxed paper over the plate, and burnish the back of the paper thoroughly. The intaglio printing process will now be examined in greater detail.

The Press

The action of the etching press resembles that of the old-fashioned clothes wringer, save that it has a heavy bed that rides through its two rollers under great pressure, and it has two pressure screws that can be turned to increase or decrease the pressure for optimum results (see Figs. 338–341). Many variants of this type of press have been manufactured throughout the years. Some have a half-round top roller (the D-roller press); many are geared for easier manipulation, whereas others are ungeared. For driving the bed through the rollers, the handles vary from a simple rod to the star wheel and to the large wheel seen on geared presses. Some presses are tabletop, portable models; others are floor models that may weigh over a ton. Despite these and other differences (price, size of rollers, width of bed, and so forth), all are similar in principle. Portable models and presses having a top roller under 6 inches in diameter are regarded by many experts as "mere toys." The larger the diameter of the top roller the finer the quality of the print should be. However, this does not mean that good proofs cannot be pulled from the smaller presses; many printmakers do remarkably well on equipment that seems something less than desirable.

The Blankets

The blankets used between the paper and the top roller of the press in the printing of an intaglio plate are expensive, resilient rectangles

of piano felt. Since the finest grade of felt is used for good printing, these blankets should receive excellent care; this care will be reflected in the quality of the prints.

Three blankets are used in etching, as shown in Figure 249. The texture and quality of the blanket nearest the plate directly affects the "look" of the print; this white-faced blanket (the *starch catcher*, or *fronting*) should be thin ($\frac{1}{16}$ inch), close-woven, malleable, and possessed of a degree of elasticity. The next felt (the *pusher*) and the thickest felt (the *cushion*) should be $\frac{1}{8}$ inch and $\frac{1}{4}$ inch thick respectively, and should possess the same attributes.

Blankets should be washed in soap and warm water when they show the slightest tendency to harden. Blanket rigidity, caused by absorption of the size in the paper, is often the cause for poor printing, as is the printing of small plates under large blankets. To keep blankets clean, lift them with small cardboard clips. Every workshop should have two or more sets of blankets, so that, through alternation and repeated washing, the difficulties arising from stiff or dirty blankets can be eased.

When printing collage-intaglio plates, use sheets of 1-inch foam rubber as substitutes for felts. In the printing of deeply bitten plates, it is recommended that you use dampened blotters between the starch catcher and the paper, for good embossment.

Adjusting the Press Pressure

Though few printmakers are called upon to put together a press, many find it necessary to set or reset the press pressure in order to pull a proper print. If you are confronted with this problem, refer to the presses shown in Figures 338–341 and proceed as follows:

First, pull or roll out the press bed. Place the starch catcher (the thinnest felt) on the press bed so that it is flat and evenly lined up with the bed edges. Place the other blankets down upon the first one, stepping them back so that they will pass under the top roller easily. Tighten the pressure screws by hand and turn the press handle to allow the blankets to travel under the roller. You may have to push the bed with one hand as you turn the handle with the other. Make certain, as soon as the blankets are gripped firmly, that they have not twisted or wrinkled. When the blankets are under the roller an inch or so, stop turning and throw the blankets up and over the roller.

Now to test the plate pressure: Take an already worked but uninked plate and place it face up inside a clean, folded blotter. Pull back the felts one at a time, straightening and smoothing each of them in turn. Then, pass the bed through the press by turning the handle. When you feel that the roller is off the plate, and before it overrides the blankets at the end of the bed, stop the press, throw the blankets back over the top roller and examine the raised white-on-white impression made by the plate upon the blotter. Tighten or loosen one or the other

238. Poor print.

239. Makeready.

of the pressure screws until the impression appears perfectly even; check the plate marks around the sides as well as the impress of the image itself.

If you have your own press, the chances are that you will adjust it once and rarely disturb the pressure thereafter, except for the hairline changes sometimes needed for particular prints. When working a press used by a group, adjustments may be needed, but they should be made only after consultation with the individual in charge of the press.

Makeready. If a particular area consistently prints poorly in successive proofs from an otherwise perfect plate, makeready may be needed (Figs. 238, 239). *Makeready* defines the process of building up parts of the plate so that an even impression will be obtained. (The term also applies to the material used.) This procedure can be accomplished in a simple way by cutting out from a proof the area that fails to "come up" in the print and then pasting this part of the proof in its corresponding position on the back of the plate. Make another proof, and if the defect reappears, again cut out the area involved and paste it down over the preceding cutout. Continue making proofs and pasting down the necessary areas until the image prints evenly.

Inking the Plate

Some printmakers prefer to use the commercially prepared etching inks that are available from suppliers, or to use oil paints. Other artists like to mix and grind their own ink from powdered pigments and appropriate plate oils.

Grinding Your Own Ink. To make a relatively inexpensive yet fine quality of black etching ink, follow these steps:

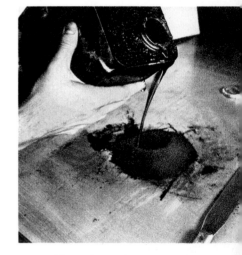

240. Adding plate oil to pigment.

1. Measure out on an ink slab (or on a piece of plate glass, marble, or other surface) the following powdered pigments: $2\frac{1}{2}$ or 3 parts of Frankfort black to 1 part of one or more colored pigments such as cobalt (or Thalo Blue), burnt sienna, Venetian red, or another of your own choice. The selection of a cool or warm color will impart a cool or warm tone to the black ink, and a combination of colors will vary the black accordingly. Mix the powdered pigments with an ink knife.
2. Push the pigments into a volcano-like mound. Slowly add to the "crater" small amounts of heavy plate oil (burnt linseed oil) as you work the mixture with a spatula or push knife. Now, add a sparing amount of light plate oil and mix (Fig. 240). The ingredients will feel gritty and coarse, if rubbed between your thumb and forefinger.
3. Using a glass, stone, or steel muller, grind and regrind the mixture until a buttery, fine texture obtains (Fig. 241). Test the body of the

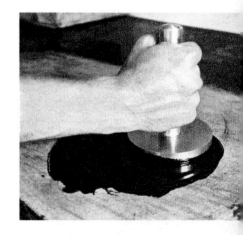

241. Grinding etching ink with muller.

242. Applying the ink
with soft plastic spatula.

243. Wiping the plate (1).

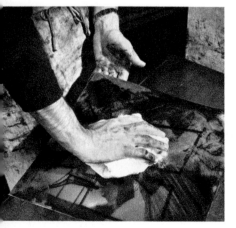

244. Wiping the plate (2).
Plate becomes light.

ink for the desired consistency and, if necessary, add more pigment or oil and regrind. There is no one ink body that suits all intaglio plates. The printmaker must make adjustments to fit the work in hand.

4. Store the excess ink in tubes or in plastic airtight containers. For additional protection, place wax paper and a quantity of water on top; or, preferably, put Ink-o-seal on top of the ink before sealing the containers. This will prevent skinning. Repeat the mulling when the stored ink is to be used again.

Applying the Ink to the Plate. Unless you prefer to work the plate cold, which can be done with a product known as *Easy-wipe,* you will first warm the plate upon a stove or hot plate and then put a small quantity of ink on the surface. Using matboard (cut into 3- or 4-inch squares), a plastic palette knife, a hard roller kept only for this purpose, or a tightly rolled piece of felt (called an *ink rubber* or a *dabber*), roll or spread the ink firmly over the plate so as to force the ink down into the lines, pits, or depressions (Fig. 242). As long as you can still see shiny gleams of copper, you have not inked the plate thoroughly. Apply ink until the intaglio work is completely filled in.

Wiping the Plate. Well-laundered tarlatan pads are recommended for the wiping procedure. These pads are made up by folding and refolding a yard or so of tarlatan until you have a circular wad that is flat on the bottom. Keep wiping pads in three separate containers: one batch that is heavily coated with ink, another that is less so, and a third consisting of clean pads suitable for the final wiping. On plates other than drypoints and mezzotints, squeegees made of matboard discards can be used to remove excess ink before wiping with a pad.

With firm pressure, start wiping the plate briskly with the oiliest of your tarlatan pads (Fig. 243), using circular or arclike strokes. Make certain the bottom of the pad is *flat,* so that the ink will not be removed from the etched lines. As the plate lightens, switch to a less oily pad. Continue to wipe, using less pressure and cleaner pads as you proceed (Figs. 244–246). Be sure to clean the edges of the plate before printing.

The amount of pressure to be used, how clean to wipe a plate, whether to use *retroussage* (an enriching effect obtained by flicking a piece of cheesecloth over a clean-wiped plate to cause the ink to "spill" slightly over the lines—all are important decisions that must be made by the individual printmaker for the specific print on which he is working.

Hand-wiping can be employed as follows to obtain a silvery, brilliantly clean print: After the ink has been wiped off, rub the heel of your palm on a chunk of whiting; brush off the excess whiting and wipe the plate with the heel of your palm; or you may apply the whiting with pieces of newsprint, tissue, or paper towel (Fig. 247).

Damping the Paper

There are many schools of thought related to the damping of paper, and it is difficult, if not impossible, to offer any foolproof advice. In general, you will submerge each sheet of paper in a trough or tray of water for a period of time that may vary from a few minutes (for very absorbent papers) to many hours for others. Each kind of paper will be found to have an optimum damping time. Since there are hundreds of varieties of paper in use by printmakers, you will find that you must build up your own experience by working with various papers. When ready for use, the paper is taken out of the tray one sheet at a time and the surface moisture is carefully removed by blotting: Place the sheet between a sandwich of two blotters; and rub or pat carefully, or go over it with a rolling pin, until the visible moisture is gone. You may prefer to "air dry" the paper by walking through the shop, sheet in hand. Check to see that no wet spots remain to repel the ink from the paper.

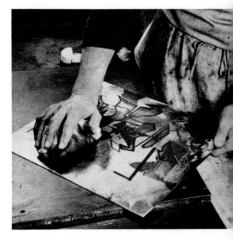

245. Wiping the plate (3). Plate becomes lighter.

Pulling the Proof

Warm the clean-wiped plate on the stove. Check and, if necessary, clean the bed of the press in order to keep the margins of the print free from stains. Some printmakers place a thin sheet of zinc on the bed as a protective covering; others use a fresh sheet of newsprint for each print, or a blotter; some wipe the bed clean after each successive pull, with solvent and a soft rag. On a clean bed, then, place the warmed plate *face up*. Take a sheet of dampened printing paper and, holding it at the top corners (Fig. 248), lay it over the plate with one decisive movement (that is, with no shifting or hesitation that might cause you to smear the ink and spoil the proof).

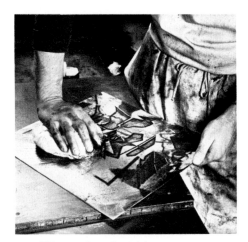

246. Wiping the plate (4). Plate becomes lightest.

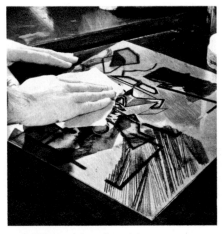

247. Wiping the plate (5). Applying whiting.

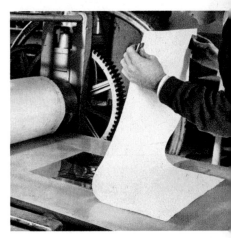

248. Sheet of dampened paper.

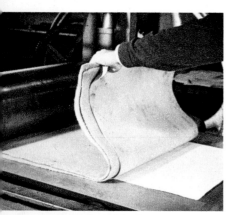

249. Pulling blankets over paper and plate.

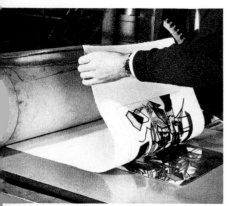

250. Pulling proof (1).

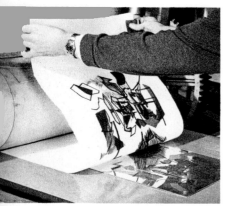

251. Pulling proof (2).

Some printmakers advise placing a sheet of tissue paper over the printing paper before pulling down the blankets, because the tissue acts as a size catcher and prolongs the life of the blanket. Others use a dampened blotter between the paper and the felts, on the theory that the blotter pushes the paper farther into the lines than does the felt. This author prefers the "look" of the print when the felt itself is placed next to the printing paper.

Up to now the blankets have remained gripped under and thrown back over the roller. Pull and smooth the blankets over the plate and paper, making certain that *each* felt is tight and unwrinkled (Fig. 249); smooth out each blanket *in turn* if there is any wrinkling. Roll the bed through the press very slowly and evenly without stopping. Lift and throw back the blankets. Carefully "pull" the paper from the plate by slowly peeling it off (Figs. 250, 251). Stretch and examine the proof before pulling another one.

Stretching and Drying Prints

On a plywood or Masonite panel, tape the damp print with gummed tape exactly as you would were you stretching a sheet of watercolor paper. Overlap the *top* edge of the proof by at least ½ inch with tape; then attach the *bottom* edge and the two sides to the board. The prints will dry flat, and can be removed by cutting through to the board with a single-edge razor blade.

Some printmakers dry their prints by stacking them between damp blotters, slip-sheeting each print with tissue to prevent offsetting of ink. The stack of drying prints should be weighted, and blotters must be replaced continually during drying. By this method the prints should be flat in a day or two. Stapling prints to a board is a dubious procedure that recently has been adopted.

Reworking the Plate

An examination of your first proof while it is stretching flat on a board or on the wall may reveal the need for further work upon the plate. If the conception seems to need enrichment or clarification by the addition of values and textures, or if the linear pattern requires correction, it is possible to make improvements, and much more, by reworking. As a means of deciding what to do, a method to follow is to work into a proof with charcoal, pencil, or white chalk and make on the proof additions and corrections that can provide a guide for working on the copper plate.

Methods of Regrounding. For prints contained within the traditional boundaries of etching, the problem of correction will center on ways of regrounding the plate so that you can rebite certain lines and etch

new ones. First clean the surface of the plate thoroughly. Regrounding can then be attempted in one of the following ways:

1. Heat the plate in the normal manner and roll on hard ground with a very stiff roller. This may not fill in the lines you desire to rebite.
2. Ground an unworked plate, warm it, and transfer the ground to your warmed plate by offsetting one upon the other.
3. Pack all the bitten lines with a substance such as casein paint that will "lift" from them when the plate is regrounded in the normal manner and submerged in the acid.
4. Reground the plate with transparent ground and reneedle each line to be rebitten.

The Scraper. The tool known as the *scraper* is valuable for reworking passages in a plate. It can be used for cutting deeper lines, removing lines, shaving away whole areas of the copper plate, and in other ways, some probably still to be explored. It is a three-sided, hollow-ground steel knife set in a wooden handle and kept razor sharp for use. Keep it sharp by working all its facets with the finest of emery paper. It is recommended that you tape the upper end of the instrument to protect your fingers when using it.

While the scraper should not be thought of solely as an "eraser," which lends to the tool a certain negative quality, this particular function cannot be overlooked. When you want to remove a given area from the plate, hold the scraper as close as possible to the plate surface, and actually shave away the unwanted copper (Fig. 252).

When work with the scraper is extensive, the resulting depression in the plate may be so great as to warrant hammering or building up the back of the plate to effect a level surface once more. This can be accomplished in one of two ways:

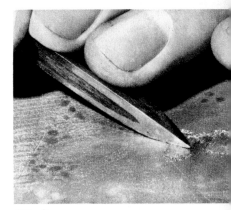

252. Scraper.

1. Using calipers, outline accurately on the back of the plate the particular area that needs attention, and hammer it on an anvil or other heavy, level surface.
2. Take several proofs and cut out the area involved from the proofs. Paste these cutouts onto the back of the plate in their exact relationship to the particular area. Run the plate through the press, and the thicknesses of paper will force the plate level again.

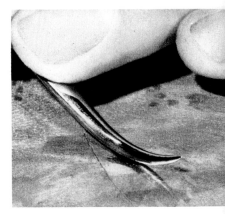

253. Burnisher.

The Burnisher. Another useful tool with which to smooth over minor lines, lighten areas, diminish textures, and accomplish other effects is the *burnisher* (Fig. 253). It is a highly polished, smooth steel instrument that should be used with a little machine oil for best results and should not be allowed to rust or become pitted. As with all engraving tools, it should be kept in excellent condition. It is good to grease tools with a little petroleum jelly, especially when not used regularly.

Making an Aquatint and Other Tonal Grounds

When you begin to visualize intaglio prints that call for tones applied to broad areas, you will probably want to do aquatints. How it is possible, by an intaglio process, to obtain variations in value that range subtly from white to black and that may require hard or soft edges at their respective perimeters can be discerned in a cross section of an aquatint plate (Fig. 254). Powdered resin particles are dusted onto the surface of the plate. When the plate is heated, the resin particles melt and each of them becomes an acid-resistant dot or blob. The acid pits the area surrounding *each particle* of melted resin and creates a cavity that will hold more or less ink dependent upon the length of the bite. Multiply this individual phenomenon thousands of times on one plate surface, and it is evident that by varying the biting time different values are obtained. In addition, the quantity and the coarseness or fineness of the resin laid on the plate determine the quality of the "grain" on the surface. Whites are obtained by applying stop-out varnish to the desired areas before any biting is done at all.

Figure 225, *Por qué fue sensible?*, plate 32 of Goya's *Los Caprichos*, demonstrates how a master of the medium could infuse an aquatint with the tonal quality of a wash drawing, in which no line whatever is used. It is regrettable that this technique has not been extensively followed, and one usually sees a bitten line in combination with an

aquatint tone. (The Picasso shown in Figure 220 is a particularly clear example of the combination.) *Complete all linear etching desired* (as described in the preceding chapter) *before applying the aquatint ground.*

254. Cross section of aquatint plate.

APPLYING THE RESIN GRAIN (The Aquatint Ground)

There are a number of ways of applying resin to the plate surface. Any one method or a combination can be employed.

Resin Dust Grounds

Place about 5 tablespoons of powdered resin in a fragment of a nylon stocking, tying the ends to make a small bag. The resin can be bought in lump form and either pounded or crushed through a household meat grinder to the consistency desired. The advantage of crushing resin lumps yourself is that you can make the particles coarse or fine or varied, as you please. Substitutes for powdered resin include gilsonite powder (powdered asphaltum), gum mastic, and gum dammar.

Move to an area of your work place where there are no drafts. Hold the bag of resin about 6 inches above a well-cleaned plate and shake or tap the bag gently with a pencil or your fingers. The resin will fall to the plate and cover the surface evenly if the bag is moved about slowly

255. Francisco Goya. *Por qué fue sensible?*, from *Los Caprichos.* 1797. Aquatint, $7 \times 4\frac{5}{8}''$. Metropolitan Museum of Art, New York (gift of M. Knoedler and Co., 1918). (See also detail, Fig. 12.)

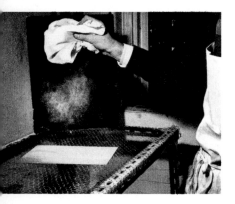

256. Using a resin bag to apply a resin dust ground.

257. Resined plate on the stove.

258. Resin beginning to melt.

above the plate (Fig. 256). *Too much or too little resin on the surface will result in a coarse grain;* when about 40 percent of the surface is evenly covered, a fine grain can be achieved.

Being careful not to jar the plate or to disturb in any way the resin particles on the surface, place the plate on the heater or stove. The resin will slowly become colorless as the plate heats up; you will soon see the plate color clearly, and, when the resin is melted, the surface of the plate will look as though it holds thousands of tiny droplets (Figs. 257–259). Move the plate to the bed of your press and allow it to cool. When it is cold, it will resemble a sea of frozen beads of perspiration.

Be wary of underheating or overheating the plate. Overheating will, as you can see by watching it carefully, produce smoke, turn the resin black, and smell burnt. To test for underheating, rub the palm of your hand firmly over the resined plate after it cools. None of the resin should powder off in your hand.

For a more even and mechanically perfect grain, you will need to construct a dusting box, which can be as simple or as complex and elaborate as you care to make it. In principle, finely powdered resin is placed in an airtight, lightweight box, and the resin is set in violent motion, either by shaking the box or by forcing a stream of air through a small opening at the bottom of the box. (The latter method can be accomplished by using either a hand bellows or a small powered fan.) After a moment or two, to allow the heaviest particles to settle, a clean plate is inserted in the bottom of the box (Fig. 260) and left there until the dust settles sufficiently to coat it. The plate is then removed carefully, heated, and allowed to cool.

Liquid Resin Grounds

Mix a saturated solution of resin (or gum dammar) in denatured alcohol. This base solution can be used with varying amounts of denatured alcohol added to produce varying tonal grounds. To apply the liquid resin ground, place the plate in the bottom of a tray that is tipped up at one end, and pour in the resin-alcohol solution (Fig. 261). Then tip the tray in the opposite direction so that the solution passes over the plate (Fig. 262). As the alcohol evaporates, the resin particles will be affixed to the plate. Continue tipping the tray in alternate directions until a satisfactory ground is obtained. A particular texture results if the plate is heated before evaporation takes place.

BITING THE AQUATINT

With the aquatint ground, since more of the plate is exposed to acid than is covered by the melted resin, it follows that you should use a milder etch than is normally used for solid etching grounds. Dutch mordant

and iron perchloride, being mild in action, are preferable acids for this purpose. If nitric acid is used, it should be diluted with water to slow down its usual boiling action.

With a stop-out varnish that does not contain alcohol (since alcohol is the solvent for the ground), carefully paint out those areas that are to remain white. Stop out the sides and the back of the plate and immerse the plate in the acid bath. Remove it after a minute or two (or less, dependent upon the strength of the acid and the depth you want for your *lightest* tone). Wash the plate thoroughly with water, then dry it. Paint out those areas you wish to remain light gray. Rebite, paint out again for the next lightest gray, and continue this process until you obtain as many tones as you wish, approaching a solid black.

Three questions come to mind at this time. How can you get a soft edge—that is, how can you make an aquatinted area merge imperceptibly with an adjacent area? How long should the plate be bitten to get a variety of values? And, if you underbite certain areas, is your work ruined?

Making a Soft Edge

Several ways to soften edges so as to obtain a gradated effect are:

1. Using litho crayon, work up to the edge of a stopped-out area. If the black crayon is gently gradated from dark at the edge of the brush stroke to white at the opposite point, you will have achieved a soft edge.
2. Gently blow on the acid bath in a tilted tray to avoid a hard edge.
3. Place the plate in a tray of water that barely covers the surface of the plate. Drop, or swab, or brush full-strength acid in local areas. The edges will become quite soft as the acid radiates outwards.

Length of Bite

The length of the bite required for specific values in an aquatint can vary disturbingly according to conditions affecting the materials or prevailing in the workshop, as well as according to the coarseness or fineness of the grain. Some sample plates worked up in this author's print laboratory have required from a few seconds for a very light gray to an hour for a dark tone. The next week, with the same bath, it took $2\frac{1}{2}$ minutes and 3 hours respectively to obtain the same values. You are advised to keep a record of the solutions used and the biting time for tones in your various prints so that you can systematically build up experience within your own working situation. Professional artists concerned with achieving exact results may make a test plate on which several strips are etched, from light to dark, with the length of bite timed for each.

259. Detail of cooled resin ground.

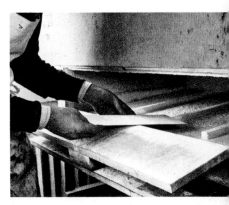

260. Inserting plate in bottom of dusting box.

261. Liquid resin ground at one end of tray.

262. Tipped tray.

Making an Aquatint and Other Tonal Grounds 229

Remedies for Underbiting

If a plate is underbitten, there are some remedies that can be tried.

1. Reground the plate with a finer resin ground than was used the first time.
2. Ground the plate with bitumen powder instead of resin.
3. Roll hard ground with a firm roller over the surface of the heated plate; when it cools, place it in the acid bath after the necessary steps are taken as for any plate.

Lightening Tones

The scraper and burnisher can be used to great advantage upon an aquatinted plate. Very little force is required to lighten passages in aquatint (since it is a tonal medium) as compared with linear work in etching or engraving. Some artists bite a plate to extreme blackness (imitating the mezzotint) and then burnish and scrape out the middle and light areas as they proceed.

OTHER TONAL GROUNDS

Sandpaper Aquatint

After having grounded a plate as for etching, it is possible to achieve a surface resembling aquatint in this manner: Place a sheet of sandpaper face down upon the grounded plate, which lies on the bed of your printing press. Using less than normal pressure, run the plate with the sandpaper through the press. Removal of the sandpaper will reveal many tiny holes in the ground, which will hold ink and thus provide a tone. Turn the sandpaper and repeat the process a number of times. Too much pressure will force the sand grains into the plate and damage any white areas intended thereon. Too little pressure will leave the ground unpenetrated.

Salt Aquatint

Before removing a grounded plate from the heat (when using hard ground or soft ground), sprinkle the surface evenly with ordinary table salt. The salt will penetrate the hot ground and affix itself to the plate. After cooling, the plate can be placed in water so that the salt dissolves, leaving the metal exposed.

Spray Techniques

A diluted solution of stop-out (resin in denatured alcohol) can be sprayed on the surface of the plate with any of the ordinary house and

garden spray appliances. For this technique there are, in fact, a variety of methods and materials at your disposal—from spattering with the common toothbrush to using the spray possibilities of the vacuum cleaner. Black lacquer in spray cans can also be used.

Manière Noire

The term *manière noire* describes a technique for creating an image out of a black background. To make the black background, start with a hard-grounded plate. Using a dulled needle and a straightedge, rule parallel lines as close together as is possible without breaking down or chipping the ground. Crisscross the lines in four directions. When the plate is bitten in the acid and printed, the result, provided none of the ground breaks away, will be a midnight-black surface. Work on the plate with burnisher and scraper to bring your image out of the black.

A less mechanical variation of the dark background can be created by passing a wire brush or a fine-toothed comb over a hard-grounded surface in any pattern desired. If not overdone, this can be an effective technique.

Offset Grounding

Heat a cleaned plate on the stove. Selecting any coarse fabric or flat, textured object that will provide a pattern, thoroughly coat it with hard ground, and pat it down on the heated surface of the plate. The ground will, of course, offset onto the warmed metal. Stop out those portions of the plate not to be bitten in the acid, and proceed to work in the usual manner.

Sulphur Tints

To obtain washlike tonal values on a plate, spread oil on the area to be bitten, and dust it with flowers of sulphur (powdered sulphur). Though the plate will not be deeply bitten, the area will print.

Angerer's Ground

According to Carl Angerer of Vienna, who perfected this process, he "black-leaded the plates and coated them with thin, white gum arabic. The design was scratched in through the greasy ink and benzene was poured over the plates. They were treated with water, dusted in with asphaltum [gilsonite?], which was melted, and then the design was etched on them." Plates made by this process have been called *zincographs*, though the term would not seem to be very accurately applied in this case.

Soft-Ground
and Lift-Ground Etching

MAKING A SOFT-GROUND ETCHING

This particular variation of etching employs a ground that does not harden. The technique offers possibilities for myriad textural effects, and it is often used in combination with aquatint and other processes. Applied traditionally, it provides a grainy line quite different from that obtained in hard-ground etching, and close examination reveals an image made of irregular dots and blobs—one similar in many ways to soft-pencil line made on rough paper (Fig. 263).

Laying a Soft Ground

Melt a ball of hard ground, and add to it half again as much automobile cup grease, Vaseline, tallow or mutton fat, lamb fat, or similar material. The acid-resistant substance thus obtained will remain soft when applied to the plate. *Almost anything deliberately pressed into this ground will remove the ground it touches and thus expose the metal.* The plate can then be bitten in acid by the same technique used for an ordinary etching.

Heat the plate, as is normally done for etching. Rub on a good quantity of the soft ground, and roll it out with a leather or hard-rubber roller used solely for this purpose. Remove the plate from the heat before it burns, and continue to roll as the plate cools. The finished ground has a definite brown color, and generally it need not be smoked.

263. Pierre-Auguste Renoir. *Seated Nude.* 1906.
Soft-ground etching, $7\frac{1}{2} \times 5\frac{7}{8}''$.
Grunwald Graphic Arts Foundation,
University of California, Los Angeles.
(See also detail, Fig. 10.)

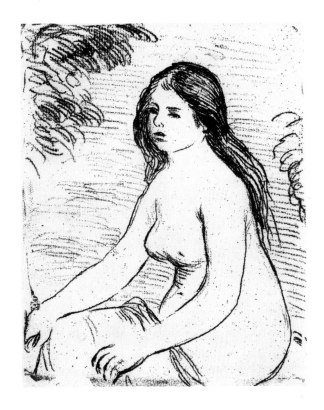

Making the Drawing

The traditional approach to drawing is made, not by needling directly into the ground, as in regular etching, but by drawing on a piece of paper laid over the ground. Damp thoroughly a sheet of paper that is somewhat larger than your plate and on which (if that is your preference) you may have made a preliminary sketch. Stretch the paper over the plate just as you would stretch a piece of watercolor paper, and fasten it with tape on the back of the plate. When dry, the paper will be wrinkle-free and ready to receive the weight of a pencil or stylus.

Draw rather firmly. By picking up a corner of the paper from time to time, you will observe how much pressure your pencil must exert on the paper in order to penetrate the ground and expose the metal. You will also see that the ground is being picked up on the back of the paper wherever you have made a mark (Fig. 264). The granular or lithographic "look" of the traditional soft-ground etching is effected by the texture and weight of the paper and the specific pressure employed by the artist upon his pencil or stylus.

Recent usage of soft-ground etching indicates that *contemporary printmakers are now interested in this medium primarily as a means of creating texture.* Evidence indicates that it is possible to make impressions upon the soft ground with string, lace, net, fingerprints, and a host of other materials.

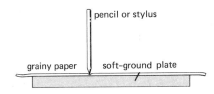

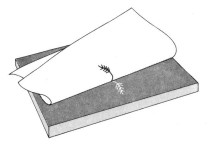

264. Making the drawing.

Soft-Ground and Lift-Ground Etching 233

Etching the Soft-Ground Plate

Using the mordant of your choice, you can proceed to bite the plate by any of the three major methods used for etching:

(1) You can complete the drawing, etch, stop out the lightest parts, and etch again; (2) you can draw only the lightest lines, etch, and draw succeedingly darker lines; (3) you can use a feather or brush to carry the acid to particular areas. You will find, however, that the variations made by the pressure of the pencil when drawing will be reflected in the bitten lines and that the desired effect can be achieved by a single biting of the whole plate.

Reworking the Plate

After examining your first proof, you will probably make changes. You may want to build up the texture of areas that look dull and uninteresting. Certain sections of the plate may have been overbitten; others may seem weak. Work on the proof with chalk, lithographic crayon, or other materials, and boldly set about altering the composition with scraper and burnisher. Keep copies of the various states of the work as you proceed; they will be invaluable as reference material for future work, especially if you make notes of particular problems and solutions.

RELATED TECHNIQUES

Tischbein's Ground

The German etcher Johann Heinrich Tischbein the Younger (1742–1808) devised a technique that yields an effect not unlike that of soft ground, though, as you will see, it is something else again.

Crush tartaric-acid crystals, and dust the powder over a grounded plate while it is heating on the hot plate and before the ground begins to harden. The dusted plate will resemble an aquatint ground at this stage in the process.

Using some pressure and a dulled etching point, draw your design. Immerse the plate in the mordant. After biting, clean the ground from the plate and print in the normal manner. The line quality will have an irregular, grainy look.

The Crayon or Chalk Manner

This technique employs a *hard ground*, but it is included here because the effect is comparable to that of soft-ground etching, that is, the resulting lines tend to resemble those of a crayon or lithographic drawing rather than the bitten lines characteristic of the hard-ground etching.

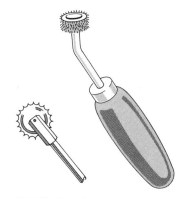

265. Perforating tools.

Work up the image with various roulettes or other perforating tools (Fig. 265) that enable you to roll (or punch) a series of small holes or dots in and through the ground. The drawing can then be reinforced, if you wish, by needling or using other etching tools. Etch and print.

MAKING A LIFT-GROUND ETCHING

The *traditional* use of a soft ground, as you have seen, enables the artist to achieve effects similar to pencil and crayon drawing within the intaglio process. The *lift ground* further expands the artist's vocabulary and encourages experiment with brush stroke or pen line made on the plate. Figure 266 shows how Picasso employed a lift ground to create a freely brushed drawing.

There is an important difference between lift-ground etching and aquatint. In aquatint the brush strokes painted in stop-out on the grained surface print as a light figure against a dark ground. In lift-ground etching the brush strokes painted in a darkened sugar solution remain as dark or positive strokes.

Procedure

Much experimentation has made most printmakers satisfied with a lift ground developed by S. W. Hayter at Atelier 17: To a saturated solution of sugar, add India ink for color. Add a small quantity of liquid soap to relieve the textured quality of the brush stroke. Paint with this solution on a cleaned plate and allow it to dry.

266. Pablo Picasso. *Ostrich.* 1941–42.
Lift-ground etching, $14\frac{2}{5} \times 11\frac{1}{5}''$.
Grunwald Graphic Arts Foundation,
University of California, Los Angeles.
(See also detail, Fig. 14.)

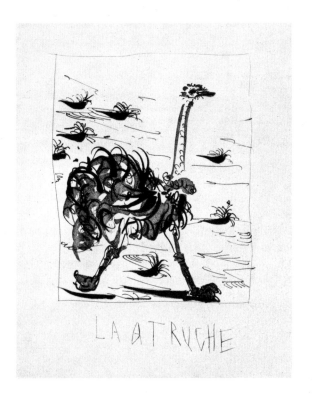

Ground the plate with a liquid ground. As soon as it is dry, immerse the plate in warm water *immediately*. Since the sugar solution will not have dried out, the ground above it remains porous. Water seeps in, swells the sugar solution, and forces it to *lift* from the copper plate.

If the ground is laid too thick, you may have difficulties. Should it fail to lift, try adding acetic acid to the warm water bath, or with a soft brush gently rub the areas to be lifted; if this fails, repeat the treatment.

In the lifted areas you can now lay an aquatint ground or a soft ground. Before biting, parts of the forms can be stopped out. The biting action may be strong, weak, or in between, dependent upon the effect desired. Stop-out and additional biting of specific areas can be used, as in the aquatint, to provide a range of gray tones.

Sugar-Lift Collage Intaglio

Misch Kohn devised a method for making prints on a laminated color collage, using the lift-ground technique. A general procedure for making such a print can be outlined as follows:

1. Complete a black line etching. Clean the plate.
2. Draw with a sugar lift composed of: 50 parts Karo syrup, 40 parts India ink, 7 parts of a granulated detergent, such as Tide, 3 parts gum-arabic solution. Allow to dry.
3. Flow a thin asphaltum ground on the plate. Allow to dry.
4. Soak the plate in lukewarm water. The sugar drawing will swell, lift, and expose the copper plate.
5. Rinse in clean water and a weak solution of acetic acid.
6. Dust with powdered resin. Heat.
7. Bite in a 45-percent solution of iron perchloride for about 45 minutes. Repeat, if desired.
8. Score and tear bits of Japan or China paper (for the color collage).
9. Cut a sheet of fine white China paper to the size of the plate, then trim about $\frac{1}{4}$ inch to allow for stretching.
10. Damp a sheet of backing paper (for example, 240-pound Whatman's watercolor paper or 160-pound hot-pressed Milbourne).
11. Place all papers in a damp press.
12. Ink the plate. Clean the surface thoroughly.
13. Paint the *back* surfaces of the color papers and the China paper with a very small amount of potato starch paste (watery solution).
14. Place the plate *face up* on the press bed. Place the color papers *paste-side up* in the desired arrangement.
15. Place the China paper *paste-side up* and lay the large backing sheet over all.
16. Pull the blankets down and over.
17. Run through the press at normal pressure.

Many variations are possible when collage is combined with the printing processes. In the illustration shown of Kohn's work (Fig. 267), for example, the color pieces were laminated on an oatmeal-colored paper, on which orange and white had been printed by silk screen. The artist has been kind enough to supply his own description of how this print was made.

First a sugar-syrup drawing was made on a clean copper plate, and, when dry, a thinned coating of Korn's Asphaltum-Etchground (thinned 50 percent with turpentine) was flowed onto the plate and allowed to drain off one corner by holding the plate nearly vertical. When the acid-resistant asphaltum was dry, the plate was soaked in a vat of water, and the sugar drawing dissolved in the water, exposing the plate where the drawing had been. The plate was put in the acid bath and etched in the usual manner for a rather deep etched line.

The color pieces were prepared from gold paper, silver-leaf paper, and red, green, and blue Japanese papers; these were scored with an etching point through stencils so that the color pieces for each impression would be exactly the same. I prepared two silk screens, one for an orange background and one for a white area, and proceeded to print the edition of 50 impressions with the orange, then the white, on an oatmeal-colored Japanese paper. I trimmed the prints, when dry, to slightly smaller size than my etching plate, allowing for stretching when the paper is wet. The prints and the color pieces to be used for the day's printing were dampened between blotters. The etching plate was inked and the surface wiped clean. All the color pieces were laid upside down on a damp blotter and brushed with a thinned library paste wash, using a 1½-inch brush. The color pieces were laid paste side up on the inked plate, and the printed sheet of oatmeal paper was placed over them. A previously dampened sheet of Rives paper larger than the plate (leaving an ample border) was laid on top, with a blanket over it, and then run through the press under the usual pressure. When the print was removed from the plate, it was placed between dry blotters under pressure to dry.

267. MISCH KOHN. *End Game.* 1968.
Etching and collage, 24 × 18″.
Brooklyn Museum (Bristol Myers Fund).

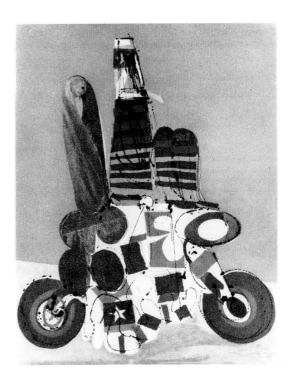

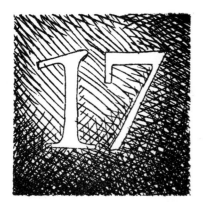

Drypoint,
Line Engraving, Mezzotint

In this chapter three types of intaglio prints will be taken up that differ in an important way from etching and the other intaglio processes already described. In etching, a ground was laid on the plate and then needled so that the plate was *exposed* to biting by acids. In drypoint, line engraving, and mezzotint, no ground is laid and no acid is used. The image is *incised into the plate* directly by the tool manipulated in the artist's hand. The plate is then simply inked, wiped, and printed.

MAKING A DRYPOINT

Drypoint is perhaps the least complicated but one of the most tenuous mediums within the graphic arts. It may seem difficult to understand why mere lines scratched into a copper surface with a sharp needle should present great difficulties. Perhaps the answer lies in the fact that there are no visual pyrotechnics between the image and the spectator; there is only the artist's drawing clothed in the rich, velvet line provided by the drypoint tool.

The drypoint needle, in the hands of the artist, plows furrows in the copper plate much in the same way that a plow, in the hands of the farmer, tills the soil (Fig. 268). The ridge of metal thrown up on each side of the cut, called the *burr*, is the distinguishing characteristic of the medium. This ridge catches and holds ink when the plate is wiped for printing and thus produces the seemingly soft lines. The

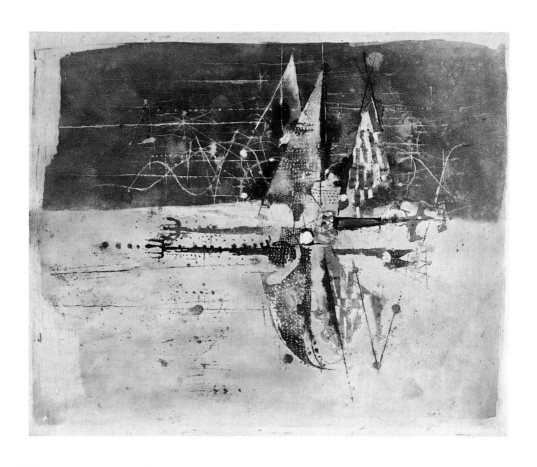

above: Plate 33. JOHNNY FRIEDLAENDER.
Vol d'Oiseaux. 1964.
Color etching and aquatint, 19⅛ x 23¼".
Associated American Artists,
New York.

left: Plate 34. MASUO IKEDA.
Fashion. 1969.
Color etching, mezzotint, and drypoint;
21 x 16". Graphics Gallery,
San Francisco and Los Angeles.

above: Plate 35. LEONARD EDMONDSON.
Made in U.S.A. 1967.
Color etching (black printed intaglio,
color printed relief); 11½ x 34½".
Serisawa Gallery, Los Angeles.

left: Plate 36. STANLEY WILLIAM HAYTER.
Vortex. 1968.
Color intaglio, 19 x 15⅞".
Collection Eugene Tellez, Toronto.

individual lines are shallower than those obtained in etching and line engraving, and they would possess but little character should the burr be removed by the action of the scraper or broken down in attempts to print a large edition.

Among younger artists nowadays it is perhaps unusual to find one who specializes in drypoint, but an exception is Mordecai Moreh (b. 1937; Fig. 269), an Iraqi-born artist who immigrated to Israel and has worked also in London and Paris. The subtle simplicity of the medium seems particularly suited to his subject matter, much of which is taken from the animal fables that he learned in childhood, and in which he finds "something primary, an innocence that has been lost in men" in a world of ever-changing technical innovations.

Procedure

The needle or point can be purchased or can be made by the print-maker. Best results are obtainable with a diamond point mounted in steel and set in a holder. Ruby, sapphire, carbide, or steel points are equally popular. Reground dental tools, engineers' scribes, pin vises with steel points, and so on will serve the purpose.

Copper is preferred over other plates both for the number of prints obtainable and for its working properties. Brass, zinc, aluminum, steel, and various plastics also can be used. Celluloid drypoints are not recommended even for practice, because they in no way reflect the possibilities inherent in the medium.

The main outlines of your drawing can be suggested on the plate with lithographic crayon, if the surface is shiny, or with ordinary lead pencil if you have deliberately dulled the surface. You can transfer a sketch to the plate (provided it is made in pencil or ballpoint pen) by damping it and running it through the press *face down* on the plate. (It is not advisable to follow slavishly the outline or tracing on the plate.)

In cutting with the point or needle, you will find that it takes rather strong pressure to obtain a forceful line. Much has been written on

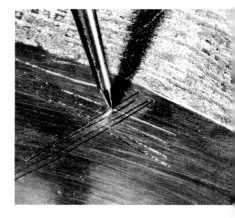

268. Detail of drypoint needle on a worked plate.

269. Mordecai Moreh. *Procession.* 1966. Drypoint, $7\frac{1}{2} \times 19\frac{1}{4}''$. Courtesy the artist.

particular ways of holding the tool in order to achieve a particular quality of line; the beginner will probably work best by doing what seems "natural," observing, as he works, the functioning of his own hand and the effect of the cut on the plate. There will be no difficulty whatever, at first, in accumulating many minor and unwanted scratches. When reworking a drypoint, you will use the burnisher and scraper—most probably, the burnisher.

MAKING A LINE ENGRAVING

Engraving is a term not limited to the print field; it may be defined as the act of cutting or incising grooves or channels into a plate, block of wood, or *any other material* that will "hold" the trace. The technique is common to many branches of art, from the "rock engravings" made by prehistoric and primitive peoples to the incised designs made on armor, gold and silver vessels, coins, jewels, and many other objects. As a technique in printmaking, engraving accounts for two major forms, which are generally referred to by their specific names: the *wood engraving* (which was taken up in Chapter 9), printed by the relief process from an engraved block of wood; and the *line engraving,* printed by the intaglio process from engraved metal.

Line engraving is the oldest form of intaglio printing, and examples of its crisp linear quality, harder than the line obtained in either etching or drypoint, can be studied in the earlier illustrations in Chapter 13 (Figs. 193–204). In modern prints it is perhaps more likely to be seen in combination with other techniques, as it is, for example, in Figures 219 and 284.

Sixteen-gauge copper is recommended for most line engraving, though you can engrave on other materials or on other thicknesses of copper; Lucite, steel, 18-gauge copper, and other surfaces have been used successfully. While hammered copper is preferable to all others, it is difficult to procure. (When copper is hammered—and this is a hand process—the molecular structure of the metal is altered in such a way as to harden the plate and make it highly desirable for line engraving.) Most practitioners, therefore, will probably use rolled-rod engravers' copper, which is readily available. The surface of this plate, and of all copper plates, is so mirrorlike and brilliant as to tire the eyes and, in addition, to discourage tracing or transfer. To offset this disadvantage, the surface should be deliberately dulled. Dip the plate in a mild acid bath, or scour it with fine pumice and water.

A sketch can be made with pencil directly upon the dulled plate. Tracing can be accomplished with black or colored carbon paper from an already completed drawing. Complex drawings which require accuracy can be transferred in the following manner: Coat the plate with a mixture of gum arabic and water. Allow it to dry. Trace the drawing or the structural lines upon the gummed plate through carbon paper.

With an etching needle, scratch lightly through the gum and into the plate. Do not use too much pressure. Remove the gum with water and proceed to engrave.

The tools required are one or more burins, an India oil stone for keeping the burins sharp, and a scraper and burnisher for reworking.

270. Burin and end-sections.

The Burin

An innocent-looking tool—or deadly weapon, if carelessly handled—the *burin* is the nucleus of the engraving. It appears in a variety of guises. As the end-section drawings in Figure 270 show, some are lozenge-shaped, excellent for fine line work. Others are square-ended, the best all-around tools for contemporary use. Still others are rectangular save for the rounding of the cutting edge; these are the *scorpers*, used for hollowing out deep trenches in the copper.

Sharpening. The act of engraving leads from exasperation to frustration for the worker who uses blunt tools, grinds them haphazardly, or allows them to become covered with rust. It is no less trying to attempt a particular line on the plate, only to find that you have cut in the wrong place because the tool slipped or the point broke. Sharpening the burin, once you have acquired experience, is a simple act.

First, check the two *undersurfaces* of the tool to make certain that they are knife-edged at their juncture, are parallel to the axis of the steel rod, and reveal two unmarred facets or planes all along the length of the instrument. If this test is not met, the undersurfaces of the burin should be sharpened in the following manner:

On a sharpening stone such as carborundum, place the burin flat on one of its undersurfaces. Holding it firmly in place, draw it up and down the stone sufficiently to "true up" the surface. Repeat for the other undersurface. Finish the grinding on an Arkansas stone or the equivalent. (This aspect of sharpening may not be required at all or possibly only once, dependent upon the particular tool you have purchased.)

The *cutting facet* normally needs constant sharpening as you proceed in engraving. For this, use an India oil stone #1B64 Norton list, or some other circular stone. Hold the tool as close to the cutting point as you comfortably can, making certain that it is perfectly flat on the stone. Keeping your wrist rigid, in order to maintain a flat edge, rotate the tool on the stone. (Flexibility in the wrist during sharpening would create an ovoid or spherical facet.) Again, finish by honing the burin on the fine side of the India oil stone, Arkansas stone, or equivalent. In testing the sharpness of the burin, hold the tool in your right hand, and place the point of the cutting facet on the thumbnail of your left hand. If the tool sticks as you push it, it is sharp. If it slides and scratches your nail, it is dull.

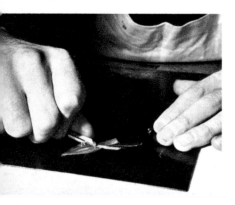

271. The act of engraving.

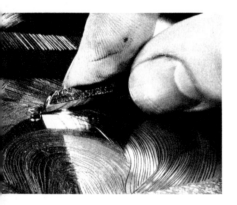

272. Variations in the act of engraving.

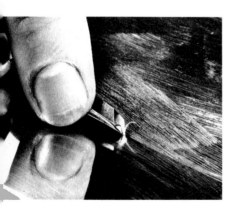

273. Variations in the act of engraving.

The Act of Engraving

Engraving is not a medium for the "quick sketch," and because it is a prolonged process, you should consider your physical surroundings, to discover whether light reflected on the plate makes a glare in the eyes, whether the plate can be turned easily on the work table, whether you tire quickly.

Though many contemporary engravers frown upon working by filtered light, you may find it useful to stretch a large sheet of tracing paper on a wooden frame to mount on the window. Study your light source, and provide yourself with optimum working conditions.

An engraver's pad may facilitate rotation of the plate. However, any smooth work surface will allow your left hand to turn the plate easily when engraving curved lines or circles (Figs. 271).

If you tire rapidly, analyze your engraving posture. Most craftsmen are satisfied to sit sideways or parallel to the work table, with the engraving arm flat on the table. Your hold on the burin should be as relaxed as possible. Pressure can then come from the shoulder and the palm of the hand, or from the plate pushed by the noncutting hand.

To hold the burin "properly" place it on a flat surface; compose the hand over the tool to grasp it with the thumb and middle finger; let the half-round wooden handle nest in the heel of the palm; arrange the other fingers naturally; lower the hand; and lift the tool.

Physical force can do little to advance the burin in the metal if the tool's angle of attack upon the copper plate is too great. To make the point enter the metal easily and smoothly, lower the angle of attack, by holding the tool as close as possible to the plate's surface. Once the burin is traveling easily and is removing metal from the trench, the slightest variation in the hand's position will affect the trace (Figs. 272, 273). The line can swell, go wisp thin, or become a veritable ravine—all such effects dependent on the printmaker's sensitivity to the material.

MAKING A MEZZOTINT

Since its inception in the seventeenth century, the mezzotint has been used mainly as a means of translating oils into cheaper, more easily distributed multiples. The medium seemed appropriate for the reproductive craftsman only, not for original creation. Despite the tradition, this laborious and demanding medium can produce stunning artistic results.

Like drypoint, mezzotint takes its principal effect from a burr that catches and holds ink when the plate has been wiped for printing. In drypoint the burr is a continuous ridge along the edges of plowed lines; in mezzotint thousands of burrs cover the entire plate surface. As Cyril Davenport said in *Mezzotints* (New York, 1903), the surface of a mezzo-

tint plate, seen through a microscope, "resembles a choppy sea suddenly solidified."

This "sea" of burrs is created with an instrument known as a *rocker* (Fig. 274). Its action is literally to rock from side to side, digging sharp teeth into the copper to throw up a surface of burr as it creeps forward. To realize Davenport's description, the plate should be rocked, and rocked, and rocked. If you moved the plate through an arc of about 5 degrees for each successive rocking, after you had rocked the plate parallel to its edges, you would have gone through this boring but absolutely necessary preparatory grounding stage no less than 76 times. Serious practitioners recommend even more use of the rocker. To attain the full range of values possible in this medium, from white through rich, velvety black, you should probably apply a rocker with no less than a hundred lines to the inch. (Rockers are numbered on this basis.) The completely rocked plate would print solid black.

Now for the scraper and the burnisher. The first removes the burr; the second flattens it. They bring the design out of the blackness of the ground. In process, parts of the plate may require regrounding, rescraping, and reburnishing, which can be done by roulettes and a variety of scrapers (Fig. 274). A rocker with fewer teeth to the inch can make a black area seem even more black. The plate should be handled carefully and printed with slightly more than normal pressure.

Mario Avati has been using this rare medium for twenty years. In Figure 275 Avati has realized "the special quality of blacks and grays" that mezzotint can provide. He has spread the still life out "as in a panoply, with each item independent of the others, but assigned its own place in relation to the other objects and to the surrounding space." Here, a separate copper plate was used for each color.

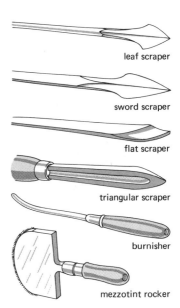

274. Mezzotint tools.

leaf scraper
sword scraper
flat scraper
triangular scraper
burnisher
mezzotint rocker

275. Mario Avati.
Il est 3 heures, Madame. 1969.
Color mezzotint, $9\frac{1}{2} \times 12''$.
Associated American Artists, Inc.,
New York.
(See also Fig. 13.)

Relief and Color Printing from Intaglio Plates

As is perhaps obvious, *any* intaglio plate can be printed as a relief plate. The procedure is very simple: Instead of inking the plate in the normal manner (whereby incised lines are filled with ink and the surface is wiped clean), ink the *surface* of the plate, leaving the incised lines clean. The plate is then said to be *surface-inked* or *surface-rolled.*

With this possibility in mind, take a look at some of your old plates, and try printing one of them by the relief method with surface inking. First, of course, you will see that the image is reversed: The lines that were black on white are now white on black. You can further vary the effect by printing on different colors of paper or with different colors of ink. You will also perhaps note that, even though you made the print by the relief method used in woodcut, it does not look like a woodcut. It still manifests the qualities of an intaglio print.

Many artists have made relief prints, or *reverse etchings,* as they are sometimes called, from their intaglio plates. Picasso, Braque, and Miró were among those who did so, and the work of Miró illustrated in Figures 184 and 219 is an example. The intaglio-relief, however, is not simply a technique for seeing your print in a new way or for getting, you might say, "two prints for the work of one." Used in combination with intaglio printing, it is a major aspect of color work; it provides, to name only one advantage, the possibility of large color areas that would otherwise have to be worked into the plate. It is also essential to some unorthodox procedures, where plates built up at different levels

can be inked for intaglio in their depressions and for relief on the upper surfaces.

This technique is a very old one, and it may be of interest to review some of the earlier experiments.

Older Methods of Relief Printing

It is reported that the pioneer Italian engraver Finiguerra (Fig. 197), when working as a metalsmith, used to test his designs before filling them with *niello* by making a sulphur cast from the engraved plate and printing from it onto paper, using oil soot. If history is accurate, he was probably making a very early relief print from an engraved metal surface. In any case the method can be tried by heating sulphur until it melts, mixing fine sand with it, and pouring the mixture onto the plate's surface contained within a mold. When cool, it is plastic and simple to remove, and, when allowed to harden inked, it should produce a relief print.

Senefelder, during the experiments he made when he was attempting to print musical notation, devised the use of a sealing-wax cast for relief printing. On a polished, dark gray stone he laid a ground equal to "two or three card-thicknesses" composed of burned, finely powdered gypsum, butter, and alum mixed with a certain amount of water. The ground was allowed to dry. He drew the music characters through the white ground with various steel needles to expose the dark stone underneath. He smeared a layer of warm sealing wax onto a block of wood, quickly laid it on the grounded surface of the stone, and applied pressure with a hand press. When cool, the ground was stuck to the sealing wax, but not affixed to the stone. He used a brush and water to remove the white ground from the wax; he then had a relief block from which to print a musical score. Variations on this method included the substitution of lead for sealing wax and the use of a thicker ground with which to obtain impressions for printing on calico.

William Blake, usually thought of as a unique artist and a great mystic, was at the same time greatly interested in technical experimentation. He developed a transfer method for relief printing which can be tried out as follows: With a half-and-half mixture of gum arabic and white castile soap, coat a sheet of paper. Draw upon the paper with a brush filled with a mixture of asphaltum and resin in benzine. Heat a clean metal plate, and place the drawing *face down* upon it. Pass through the etching press a number of times. Soak the back of the paper with water and peel the paper from the plate. Add work on the plate, if desired, with a brush and the asphaltum solution. Bite the plate in a mordant made of 2 parts of water to 1 part of nitric acid for at least nine hours. Print as a relief etching.

Closer in time to the present is the Hungarian artist Bertalan Bodnar, who, in 1940, began making relief plates from cast lead. He worked

his design in sculptor's clay, keeping level the parts that were to print in black and building up in relief those intended to be white. Molten lead was poured over the clay to produce a low-relief plate, which was then inked and printed as a relief block.

With these few examples it is perhaps evident that the innovations of the past two decades have not burst upon the printmaking world with startling suddenness, but have behind them a long history of technical inventiveness.

INTAGLIO PRINTING IN COLOR

The procedures for making an intaglio print in color are identical to those for a black-and-white print. The plates can be etched or engraved, subjected to the various grounds, and run through the press in exactly the same way. The differences stem primarily from the properties of color inks, used singly and in combination. These must be studied, and the possible methods available for applying the inks to the plate need to be explored. The color print in intaglio presents a challenge even to the accomplished printmaker, and no one has yet exhausted the range of possibilities.

As a point of departure for a first experiment in color printing, it is suggested that you select a plate you have already worked for black and white, preferably one upon which you have imposed a variety of technical approaches: etching, drypoint, aquatint, engraving, soft ground, and so forth. The greater the mosaic of techniques upon the plate, the more readily will you see how the color "works" in each.

Selecting an etching ink of the desired color or using oil paint, ink, wipe, and print the plate. To explore further, place the print in your damp box or in a water-filled tray. Remove the color from your plate with a soft, clean cloth. Then, using a hard roller and a different color, ink the *surface* of your plate, just as you would ink a relief block for a woodcut.

Remove your one-color print from the damp box or water tray, place it between two clean, dry blotters to take off surface moisture, and lay it face up on a clean surface. Then place your relief-inked plate face down, slightly off-register, over the image on your one-color print. (The problem of accurate registration will be taken up later.) Holding the plate and paper firmly, turn them over and place them on the press bed with the plate underneath and the paper on top. Run the bed through the press slowly and evenly, and then study your print.

Color Printing from Two or More Plates

The classical method for making a color print is to print each color successively from a separate plate. The plates can be worked by any or all of the intaglio processes and can be inked variously for relief

or intaglio printing. This is the general method followed by Johnny Friedlaender (b. 1912), a printmaker who has directed an atelier in Paris for the last twenty years. The rich pictorial effects in Friedlaender's print (Pl. 33, p. 239) derive from his use of this procedure.

Fashion (Pl. 34, p. 239), a work by Masuo Ikeda (b. 1934), a Manchurian artist living in Japan, was printed from two copper plates that were worked with etching, drypoint, and mezzotint. The artist describes his image as "somewhat realistic, perhaps even classic, but with a little difference—so as to make a little surprise, a little wonder, and a very strange feeling." With drypoint he achieved a strong, expressive line, and with mezzotint, using the roulette, he was able to create a more delicate image, almost a photographic one. Ikeda says of color intaglio, "Surely I know that the copper plate is not suitable for expressing pure color, but this is precisely the challenge."

Registration. When working from two or more plates you will encounter the usual registration problems. The most direct solution is obtained by working with plates of equal dimensions. After printing one color from the first plate, ink the second plate with its color. Place the print with the first color *face up* on a flat, smooth surface. Take the second inked-up plate and place it squarely *face down* upon the print. With some practice, you can acquire the knack of holding plate and paper firmly in place as you turn them upside down to place them on the press bed. The third plate is registered by eye in the same manner.

Another method of registration commonly used consists in drilling two tiny holes in the master plate at opposite ends from each other, then offsetting a print of the master plate, and the holes, onto each of the other color plates to be used. This is like the method used in woodcut, which is explained more fully in Chapter 10 (pp. 164–166).

Color Printing from a Single Plate

The old French method of color printing known as *á la poupée* consists of inking many colors in separate areas with small pieces of felt (or with the fingers or other devices) and then printing in a single run through the press. This method, which has been in use for a century, particularly for the production of inexpensive commercial prints, has accounted for a great many visual atrocities, but it is effective nonetheless, particularly for prints having separated color areas.

It is also possible to cut the plate apart, ink the pieces separately, reassemble them, and print in one run. This method was used by Mauricio Lasansky (b. 1914) for *Woman with Lute* (Fig. 276)—partly because this large print would have been difficult to handle on one piece of copper. However the artist recognized also the advantage of printing the colors on the five different pieces, two of which were made

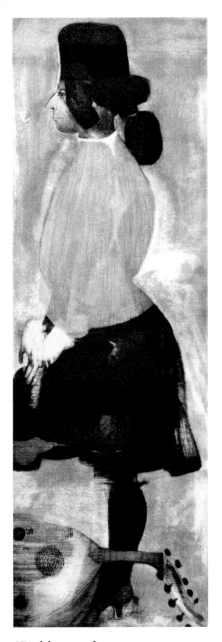

276. MAURICIO LASANSKY. *Woman with a Lute.* 1966. Intaglio print, 75 × 24".

of steel. Lasansky prefers transparency in his color work, believing that color printmaking is similar to fresco—the white of the paper, like the white of the wall in fresco, adds luminosity to the color.

As in the first experiment suggested at the beginning of this section, two colors can be obtained from one plate by inking the *intagliate* (the engraved or etched lines) for one color, wiping the plate clean, and then inking the *surface* of the plate for a second color. A further variation may be obtained by printing the intagliate in one color or black, and then re-inking it with a different color and printing it slightly off register. (Off register is sometimes deliberately sought in color printing to avoid "squashing" the lines.)

A masking technique can be employed to isolate the area or areas of color you wish to print in one run while blocking out the remainder of the plate. A separate stencil is cut, from stencil paper or other material, for each color to be used. The stencil, when laid over the plate for rolling the ink, will provide precise edges for the color shape that are not obtained by some of the other methods.

Combinations of any of these methods of single-plate printing may be used at the discretion of the printmaker, and it is sometimes feasible to combine them in a single run. A print (Pl. 35, p. 240) by Leonard Edmondson (b. 1916) shows an interesting use of various possibilities. The plate is in two parts, both cut to leave an irregular edge; they are printed side by side, but with a gap that is bridged by the colors and shapes in the image. The execution began with a deeply bitten line, continued with extensive use of soft-ground etching (incorporating such found shapes and textures as lace, coins, and arm patches), and concluded with aquatints ranging from light gray to dark gray. The plates were inked in black by the intaglio method, and the color was applied by the relief method, with the aid of stencils and rollers. For greater transparency, oil paint was used for the color work. Edmondson considers that his work has a close association with some aspects of Surrealism, with its invented images, its apparently random association of colors and shapes, some geometric and others irregular, and its evocative relationships.

Simultaneous Intaglio and Relief Printing

Various methods have been devised for printing the intagliate and the surface *at the same time,* as well as for imparting special color qualities to each. After inking the intaglio design in the normal manner with black (or with a colored) ink, and after wiping the surface of the plate *especially clean,* additional color can be applied on the surface of the plate before printing by using the following methods:

1. One or more stencils can be cut, and color litho ink can be rolled on the plate through the cut stencil with a gelatin brayer. If the

color film is kept thin enough, it is possible to lay on more than one color side by side and *in overlays.*

2. Oil paint can be brushed thinly in particular textured areas or sections of the surface.

3. On an aquatint or textured plate that is bitten very deeply, it is possible to scrub *oil-based crayon* of various colors into the deeply bitten areas; then roll with a hard roller, perhaps adding a colored surface ink. Heat the plate just to the point where the wax of the crayon melts, and print on dry, soft paper. This technique was developed by Milton Goldstein, a student of Harry Sternberg.

4. After the intaglio design has been inked, a colored ink can be rolled into the deeply etched portions of the plate with a *soft* roller. Clean the surface again. Then roll the surface with another colored ink, using a *hard* roller.

5. A technique can be borrowed from the principle of an offset lithographic press, in which the design is transferred from the plate first to the roller of the press and then transferred again to the paper. Work up the shape of your color area in colored ink on a flat surface. Roll over it with a clean composition roller or half-drum, thus picking up the ink of the design onto the roller. Then transfer the design to the copper plate by rolling across the desired area on the surface. Great brilliancy of color can be obtained by this method.

Some of these techniques or variations thereof are among the many that have been explored or evolved by Stanley William Hayter (b. 1901) and his colleagues. Hayter, a fine British printmaker who founded and directed the Atelier 17, has, with his experiments and innovations, his publications, and his constant encouragement of other artists, been an outstanding factor in the mid-twentieth-century renaissance of printmaking. An example of his work in color is reproduced as Plate 36 on page 240.

Some Innovative Intaglio Techniques

Innovations in the arts are as varied, and as individual and personal, as the artists themselves. In this discussion it is only possible to point out a few of the general directions in which a number of people seem to have moved. Students confronted with mastering a medium, however, do not find their problems solved by generalities, so specific examples will be given, some of which are technically unique. It would be a mistake to copy these or any other artists' methods; rather, the point under scrutiny is how and why new methods evolve.

PHOTO-INTAGLIO

The application of the photographic process to printmaking has already been discussed in connection with lithography (pp. 100–104) as a major innovation in the modern print. Similar applications have been made in the intaglio field. A copper plate can be coated so as to become light-sensitive, exposed to an image made on film or acetate, and then etched by the normal procedures. A simple procedure for making a photo-intaglio will be described at this point.

As a coating for the copper plate, you may choose to use a commercial preparation, in which case you should follow the manufacturer's directions exactly; do not improvise. If you prefer to make your own light-sensitive surface, you can proceed as follows:

1. Measure out 2½ ounces of albumin taken from fresh eggs, add 1 ounce of water, and beat thoroughly.
2. Add 2 ounces of water to 2 ounces of LePage's photoengraving glue (or the equivalent), and stir well.
3. Add the albumin mixture *to the glue,* and set the mixture aside.
4. Dissolve 70 grams of bichromate of ammonia in 1 ounce of water. Add this to the mixture.
5. Add 5 drops of concentrated ammonia.
6. Filter the mixture several times, and pour it into a dark bottle.

Coat the copper plate *in a darkroom.* See that the plate is thoroughly cleaned of grease, wet it with water, and flow the solution on as you would pour a liquid ground. The coating must be thin and even. Allow it to flow evenly and completely over the surface two or three times. If you have access to a plate whirler or can improvise one, simply pour a circle of the sensitizing solution on the plate and whirl moderately; the coating should be dry and hard within a few minutes. *The plate is now extremely sensitive to light and must be protected.*

A drawing can be made with ink, paint, or any opaque drawing medium on a .005 sheet of frosted acetate; you can also use photographic positives or negatives, or drawings and photographic film in combination. The print can then be made as follows:

1. Place or arrange the image on the sensitized plate, either in a vacuum frame or under a piece of glass that will bring the two surfaces into close contact.
2. Expose the plate with the image to direct sunlight for about four minutes. The time will depend somewhat on the density of the image and the brightness of the sunlight, but you will soon learn to vary it at need.
3. Immediately remove the plate and hold it under cold running water for about two minutes. The image areas exposed to sunlight will have become insoluble. The darkest darks or black areas in the drawing should begin to show bare copper.
4. Fan the plate dry, and place it on a hot plate to harden the coating. The plate coating will slowly turn light brown, then reddish in color, and finally it will tend toward black.
5. Remove the plate *before* it turns black, and allow it to cool gradually.
6. Etch the plate in a bath of iron perchloride; print in the normal way.

From this simple beginning many possibilities will open up, both for varying the technique and for using it in combination with the various intaglio processes. David Finkbeiner (b. 1936), for example, achieved the effects in *Garrison II* (Fig. 277) by printing an acetate overlay from an etched plate and placing underneath it a sheet of paper which completes the print with a photoengraved image.

277. David Finkbeiner. *Garrison II.* 1969. Photo engraving, 19⅞ × 15⅞". Brooklyn Museum (Charles Stewart Smith Memorial Fund).

Some Innovative Intaglio Techniques 253

One of the advantages of making use of the photographic technique in printmaking is that it facilitates the incorporation in the image of actual photographic and printed material—an element of content that has particularly interested the Pop artists and is now used in various art media in many ways. Among the artists specifically working in this direction, James L. Steg (b. 1922) has evolved interesting methods utilizing a photo-resist. Prior to his use of the photographic technique, he had been working with a decalcomania process for transferring magazine reproductions to various surfaces by using a polymer medium. He found that this transferred photographic material could be applied to a sheet of acetate and then used as a photographic negative. The image could be readily changed by washing out parts of it with alcohol, various images could be superimposed, and drawn elements could be added with grease pencil, India ink, or other drawing materials.

James Steg executed the print in Figure 278 by this general method. Using polymer paint as adhesive, he decaled several magazine reproductions onto a sheet of acetate. With an arc lamp he burned the image into a plate coated with photo-resist. This exposed the metal bearing the image and hardened the resist elsewhere. After coating the plate with an aquatint ground, the artist etched it, using weak nitric acid. He added textures by conventional line etching and aquatint. Steg says the photo-resist technique "gives an immediacy to the act of plate-making," and since he does most of the creative work on the acetate, the plate-making time is relatively minimal. Steg has commented that *Image #1* "deals primarily with a collage of photographic subjects, seemingly unrelated, yet fixed in a formal, central-axis relationship. The small photographic likeness of Berthold Brecht in the center is a modest homage to his concept of personal (alienated) relationships. The print is meant to convey a feeling of ambiguity, alienation, and sentimental nostalgia."

For *Mirror, Mirror on the Wall* (Fig. 279), John Ihle (b. 1925) utilized two copper plates—an outer square plate done in the traditional deep-etch and lift-ground techniques, and an inner circular plate derived from a 35-millimeter transparency. He has explained his process in detail as follows:

The first step in making a halftone image is to expose a continuous-tone positive in a process camera, using a 150-line screen which under a magnifying glass appears as a dot pattern reflecting the image exposed. In my case similar results were achieved by using a 4 × 5 inch photoenlarger and a 150-line halftone screen. Because I was dealing with an exploration of photoengraving, numerous halftone transparencies were executed, some positive and some negative. The final result was a positive and negative transparency taped together (slightly offset) to create an intentional moiré pattern and an interesting linear effect.

The next step was to photosensitize a 15 × 20 inch sheet of photoengraver's copper using a gelatin type photo-resist. The photoengraving platemaker uses a much more complicated piece of equipment, but I had a hand plate-whirler that

278. JAMES L. STEG. *Image #1.*
1966. Intaglio, 26½ × 17⅝".
Associated American Artists,
Inc., New York.

I set into a light-proof drum. I used several heat lamps to achieve the required temperature for flowing on the resist.

The final step in transferring the photo-image onto the plate was to place the positive-negative transparencies on the photosensitized copper plate and expose it in a photoengraver s platemaker. This machine is simply a vacuum table and light source, usually consisting of carbon arc, xenon, or mercury. After developing the plate it was burned-in with a hand torch at approximately 400° F. This set the resist to prevent it from filting in the acid.

The plate was then etched, face down, in a single bath of perchloride of iron 42° baumé. After etching, it was cut into the circular form to fit into the square plate for a single run through the etching press.

In this print, Ihle sought to "become familiar with more contemporary means of expression" and to employ the technology of the commercial printing industry in a more creative vein: "The methods I have employed in this particular print reflect only a few ideas for the use of photographic techniques in the printmaking field. They have a tremendous potential in opening up a more spontaneous medium."

left: 279. JOHN IHLE.
Mirror, Mirror on the Wall. 1970.
Deep etch and sugar lift,
with photogravure; $17\frac{3}{4}''$ square.
Collection Holt, Rinehart
and Winston, New York.

right: 280. PIERRE COURTIN.
Deuxième Jour. 1965.
Engraving, $11\frac{3}{4} \times 11\frac{3}{4}''$.
Courtesy the artist.

RAISED IMAGES

A centuries-old technique significant for decorative metal work is *embossing*—the creation of a raised design in the surface. Because it can be molded, dampened paper makes possible the application of techniques of embossment to the print.

The French printmaker Pierre Courtin (b. 1921) evolved a "sculptural technique" while working with zinc and other soft-metal plates (Fig. 280). As if preparing a bas-relief he carved his design directly into

metal. Into the metal "matrix" thus created he molded dampened paper, producing a three-dimensional effect in the print (despite carving less than $\frac{1}{8}$ inch deep) that is further increased by ink accumulations around the depressions. This seems to shade and thus project the forms. Paper is special in embossed work, and Courtin has worked with several sheets laminated together, the top sheet sometimes selected to give the desired textural effect.

Omar Rayo (b. 1928) produces a type of embossed print sometimes called *inkless intaglio,* works whose design derives solely from embossing (Fig. 281). "The medium permits the representation of many levels through the shadows made by superimposed plates. No color is necessary, and the whiteness purifies the object, taking it out of its ordinary context and making it symbolic as well as abstract." A can of sardines provided the theme for the print shown. Two keys open a cavity in the first level to reveal a second plane, suggesting infinite depth. The can exemplifies the contemporary trend "to explore the object"; it also comments on American life styles, while exploring form and geometry. Rayo bites the plate at different levels, the deepest level penetrating the plate itself. So as not to flatten the relief or break the paper, he prefers to print by hand, pressing the paper with his fingers or with smooth, rounded tools. The paper (here a 300-pound d'Arches) remains on the plate for 24 to 48 hours.

The technique can serve a variety of styles, from the cool perfection of Rayo's work to prints in which holes, breaks, or wrinkles, function aesthetically. Embossment can also be obtained from wood blocks, and it is possible to add raised effects to lithographs by running them through the press with a carved, uninked matrix.

281. OMAR RAYO.
Dos Llaves ("Two Keys"). 1965.
Embossed inkless print,
22 × 30".

Plate 37. ROLF NESCH. *The Pharaoh's Baker*. 1956.
Color metal print, 32 x 17½". National Gallery of Art, Washington, D.C. (Rosenwald Collection).

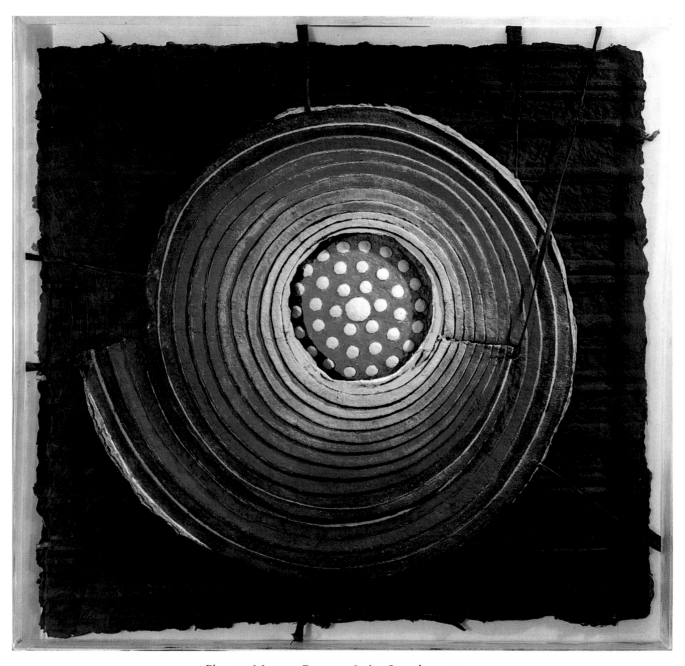

Plate 38. Michael Ponce de León. *Succubus*. 1966.
Collage intaglio, 26″ square. Courtesy the artist.

Boris Margo's Cellocut Technique

In 1932 Boris Margo (b. 1902), a Russian-American, began experimenting with a raised image and developed the *cellocut* (Fig. 282). Using celluloid dissolved in acetone, he created a design on a rigid surface (such as an etching plate or Masonite) which he inked (or left uninked), covered with damp paper or linen, and ran through an etching press. The celluloid substance could create all manner of forms—hills or depressions, delicate lines, and jagged or smooth shapes. Thicker solution can produce raised areas, and the dried image can be worked over with printmaker's tools. The medium's flexibility permits it to be mixed with conventional processes, and the print can be made by intaglio or relief or both. The example reproduced here was left uninked, its two white images mounted on shaped canvas stretched over a wood armature, dusted with ground marble, and embedded in acrylic. Acrylic varnish coats the entire surface.

Formerly identified with Surrealism, Margo says of this print that "for some time now my work has been moving in the direction of greater serenity. To express this there must be simplicity and the calmness of symmetry." Here he has counterpoised his two basic shaped-canvas forms—the rectangle and the egg (the latter a "gently symmetrical form of latent life")—which together suggest the facing pages of an open book. Of the design's hieroglyphic appearance Margo declares: "I borrow from the world's alphabets and combine words and phrases in many languages." This artist has been a consistent and conspicuous technical innovator who has never lost sight of the purposes of art.

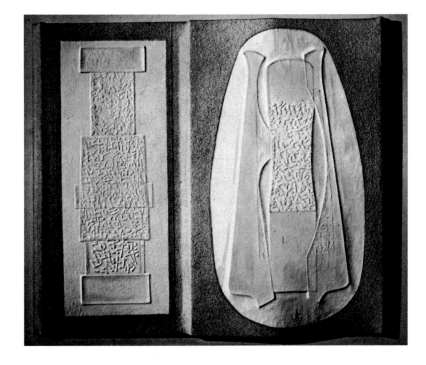

282. BORIS MARGO. *The Book.* 1968.
Cellocut on shaped canvas, 3'8" × 4'4".
Brooklyn Museum
(Carll M. De Silver Fund).

COLLAGE TECHNIQUES

In Figure 283 the aquatint made from a cover torn from a pack of cigarettes comes very close to the original "pasted paper" meaning of the term *collage* (see pp. 177, 178). This simple but strikingly effective work is by Robert Motherwell (b. 1915), a prominent American modernist with a strong affinity for the collage medium. In a statement made in 1946, in connection with an exhibition at the Museum of Modern Art in New York, Motherwell commented on the collage in this way:

> The sensation of physically operating on the world is very strong in the medium of the *papiers collés* or collage, in which various kinds of paper are pasted to the canvas. One cuts and chooses and shifts and pastes, and sometimes tears off and begins again. In any case, shaping and arranging such a relational structure obliterates the need, and often the awareness, of representation. Without reference to likenesses, it possesses feeling because all the decisions in regard to it are ultimately made on the grounds of feeling.

The great European printmaker Rolf Nesch (b. 1893) was one of the first to introduce collage techniques into the intaglio process. *The Pharaoh's Baker* (Pl. 37, p. 257) comes from experiments the artist began as early as 1925. A color print was made in a single operation from variously colored pieces of wire gauze and cut-out copper placed over the etched plate. At first Nesch soldered the collage elements of these *metal prints* to their plate. Later he laid them loose on the plate and changed them about so that often each is a unique example. An innovating technician, Nesch may have been the first deliberately to make holes in his plates, which, when printed, provided areas that stand out in striking contrast.

Red and Blue Eclipse (Fig. 284) was made by Gabor Peterdi (b. 1915) from two copper plates overprinted in intaglio with the addition of three smaller, movable, cut-out plates superimposed on the larger ones and printed at the same time. The plates were worked with a combination of hard-ground and soft-ground etching, aquatint, and line engraving; they were inked for intaglio color and were also, in the case of the superimposed plates, partly surface-rolled. Peterdi's work, which has some relation to Surrealism, is highly symbolic in vein, with a sense of timelessness that is implicit in what appear to be geological and cosmic references in this and other prints. His attempt, as he expresses it, is "to evoke a poetic image related to a natural phenomenon in nondescriptive terms, using abstract elements." He found that the richness of the overprinted intaglio plates helped to achieve depth and that the cut-out plates and the variety of surface tensions provided the ambiguity he wanted in this image.

Though their sophistication would seem to defy classification, Michael Ponce de León (b. 1922) catalogues his works as *collage intaglio* (Pl. 38, p. 258). He acknowledges them to be imprints from three-

dimensional objects. Still, they are made by a print process and printed on a press designed by the artist himself. The concentric pattern in *Succubus* was first carved from a plank of wood; from it a negative wax mold was made. In the mold was cast an aluminum shape 19 inches in diameter and $\frac{3}{4}$ inch thick, which the artist aquatinted and printed in 28 colors. Etching and various materials welded onto a zinc plate made the relief background. The work printed in three operations on two sheets of specially made paper; the overlapping spiral sheet, formed from a spiral mold, was 1 inch thick. The artist sees his purpose as discovering "a new meaning of art through graphics," as "expanding the meaning of the print by giving it the dimensions and insights of sculpture."

My plates are multidimensional constructions. Some units are welded to the main plate, others are interchangeables that adjust freely like a jigsaw puzzle. Since my work is not based on drawing but on composition, I start not with a sketch but with a miniature, three-dimensional cardboard construction. By working small I manage to eliminate nonessentials and arrive at a larger concept in my final work. I use copper, zinc, aluminum, brass, steel, etc., for each metal responds uniquely to hammers, saws, needles, acids, papers, and inks. For hammering surfaces copper is best; however, in order to retain convexities under the printing pressure, the reverse concavities have to be filled in with aluminum solder.

Some shapes and objects to be made printable have to be modeled in clay or wax or carved out of wood before being cast in metal. I do most of my casting, and I always rework the surface of my molds with vibrators, acids, sanders, etc., to enable them to retain the ink. Since most metal impressions are usually from 1 to 2 inches thick, the other shapes to be printed have to be built up and adjusted to the right height by means of plastic materials or other metals. The next step

left: 283. ROBERT MOTHERWELL. *Gauloises Bleues.* 1967. Aquatint and collage, $22\frac{1}{8} \times 14\frac{5}{16}''$. Marlborough Gallery, New York.

right: 284. GABOR PETERDI. *Red and Blue Eclipse.* 1967. Color intaglio print. Combined technique in six colors, $23\frac{1}{2} \times 17\frac{1}{2}''$. Courtesy the artist.

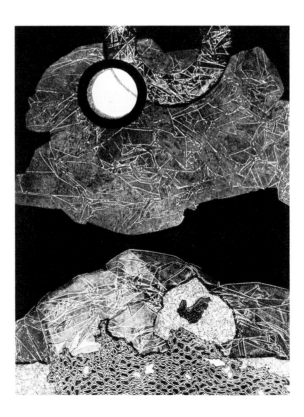

consists of beveling every shape to a 45-degree angle in order to make good contact with the paper and pick up every particle of ink in the printing. Some of my finished constructions weigh as much as 60 pounds.

I make my own inks and use a variety of oils and other media to attain transparencies and densities. The inking is done unit by unit in as many colors as necessary, since each shape is attached on different levels or fitted freely. For wiping I use my fingers or the palm of my hand, tarlatan being out of the question for this type of surface.

My paper, one of the most important factors in my work, is made specially for me by Douglass Howell. This handmade paper, 1 inch thick, is prepared out of pure linen in long fibers to be able to stretch to the limit of its flexibility. The dampening of this type of paper is done with sponges; a 2-foot sheet ($24 \times 24 \times 1''$) absorbs 2 quarts of water mixed with a tablespoonful of plaster of paris and a teaspoonful of pure gelatine. This solution hardens the paper when dry and retains its sculptural form. After printing, and with the paper still attached to the mold, I go over the back of it with a burnisher and force the paper into the extreme depressions not reached by the press.

MIXED MEDIA

Intaglio has long lent itself to mixing with other media, if only in the form of the various intaglio techniques worked on a single plate. Aquatint tone was normally combined with the etched line, and line engraving often was made to strengthen or accent an etched plate. In the seventeenth century artists began to do additional work in engraving, etching, drypoint, or aquatint to produce the *mixed mezzotint.* Once he controls a number of techniques the creative artist finds it difficult to restrict himself to a single process.

Mixing media in intaglio is even more common today. For *Homage to Vesalius* (Fig. 285) Rudy Pozzatti (b. 1925) pulled a two-color print from one zinc plate, worked as follows: The large central panel was

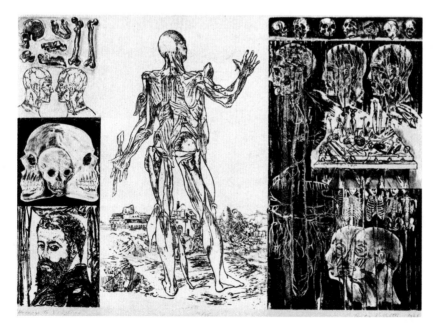

285. Rudy Pozzatti.
Homage to Vesalius. 1968.
Etching, $25\frac{1}{2} \times 35\frac{7}{8}''$.
Weyhe Gallery, New York.

done with a lift ground, then etched and heightened by engraving, drypoint, and roulette. On the right panel, to create the heavy vertical lines punctuating the background, the artist used a plaster dropper to run streams of highly concentrated solution of nitric acid down the plate. He realized the two heads in the upper left corner by lift ground and straight line etch, adding sandpaper texture for tone. In areas he made an aquatint ground and produced some of the heads and skulls as transfer images from old, type-high metal plates.

For his tribute to the great sixteenth-century pioneer in anatomical studies and drawing, Pozzatti placed in the central panel a page from *De humani corporis fabrica* (1544). He took the portrait in the lower left from the frontispiece of an old book on Vesalius. Otherwise conceptualizing, Pozatti sought to give "a visual display of physiological explorations with some of the same detachment that a surgeon or pathologist has in performing his professional function." A free combination of bones, skulls, elements of the nervous system, even anatomical tools—in near and far perspective—gives fresh significance to an impetus from the past.

Yonkers II (Fig. 286) by Romas Viesulas (b. 1918) is a work made by one aspect or another of all the basic processes described in this book. The second work in a triptych series called *Yonkers,* it was printed in three consecutive stages. The first stage was a lithograph on stone printed on dry, beige-gray paper. Its image was a detail from *Yonkers I,* printed and reworked for transfer to a new stone. Partial alterations were made on the transfer print while it was still fresh, by cutting out or effacing part of the image. Once the image was transferred, the artist made further alterations on the new stone, using a single-edge razor blade, pumice, and strong nitric acid and gum.

286. ROMAS VIESULAS. *Yonkers II.* 1967. Color lithograph and intaglio, 26 × 39¼". Brooklyn Museum (Bristol Myers Fund).

Since he worked in a direct manner, without preparatory sketches, Viesulas used proofs of state 1 for planning state 2. With burins, points, and blades he cut and slashed the proof so as to scar the image (the effacement meant to project a sense of "emotional injury," the theme of the series). After destroying many proofs, the artist finally took one version for use in tracing first on an acetate sheet and from there to a vinyl plate.

Inkless intaglio and surface-rolled dark gray ink were combined in one printing from the vinyl plate to make state 2. The artist produced embossment by engraving and sculpturing out in reverse of the image traced on the plate. The surface-rolling was done on parts of the plate with brayers from $\frac{1}{4}$ inch to 3 inches in size. Once state 2 dried state 3 was obtained by stenciling blue onto the print. Viesulas, a Lithuanian-born artist who arrived in the United States in 1951 and has since become one of America's distinguished printmakers, says of his work: "I do not start with a new medium in mind—I end up with it, as the only way to implement my aims."

Recently there has been a general tendency to break down the barriers between the various art forms. Some of the prints illustrated may seem to belong as much to sculpture as they do to printmaking. That connection may be carried one step further by describing the technique for making a *plaster print.* By this method you can obtain a print that is not made on paper at all but cast in plaster—in effect a sculptural bas-relief, but one made from an intaglio plate. The procedure is as follows:

1. Ink an etched or engraved plate in black ink or color as for normal press printing, save that the ink should be somewhat thinned. Lay the plate *face up* on a clean glass slab.

2. Make a wooden frame (or use clay or cardboard) at least $\frac{3}{4}$ inch high, with inside dimensions equal to the mat size you expect to employ for displaying the print. Secure the frame to the glass by weights, tape, or clay.

3. Mix plaster of paris, fine dental plaster, Hydrocal, cement, magnesia, or a convenient substitute to a creamy consistency, and just before the mixture starts to set, pour and spread it evenly into the frame or mold. A few sharp blows from your hand on the work surface should break any stubborn bubbles in the plaster. The plaster print can be reinforced with burlap, which should be spread and gently buried in the plaster. A twisted wire hook can be pushed into the plaster before it finally sets, or screw eyes can be twisted into the wooden frame to allow for hanging.

4. When the plaster has set, turn the frame over. Remove the plate carefully by inserting a knife blade at a likely point—and there you have a plaster print. Many printmakers further work into this framed plaster print with additional carving, engraving, or paint.

Workshop Solutions to Intaglio Printing Problems

The printing blankets are stiff
Cause: Sizing from the printing paper has permeated the felt and dried hard.
Solution: Wash the blankets with soap and lukewarm water, and hang to dry; avoid stretching.

The print wrinkles when pulled through the press
Cause: Blankets may be wet, stiff, wrinkled, or stretched; printing paper may be unevenly damped; the paper may be wrong for this use.
Solution: Change the blankets; check the printing paper to make certain the edges are not dry; try other papers.

Lines on the print have smeared or spread
Cause: Pressure of the press is too great; ink contains too much plate oil.
Solution: Reduce press pressure; add pigment to your ink, and regrind it thoroughly.

The print surface is shiny
Cause: Press pressure is too great; plate may be too hot; blankets may be wet or stiff with size.
Solution: Reduce press pressure; cool the plate; change the blankets.

Some of the lines do not print, or do not print well
Cause: Ink may be too dry, gritty, or too stiff; press may have too little pressure; plate may not be level and may need a makeready; paper may be too wet or too dry; foreign substances (for example, whiting, stop-out) may reside in the intagliate; inking of the plate was careless.
Solution: Mix a fresh batch of ink adding more plate oil than before; check press pressure; test level of plate and correct, if necessary, with a makeready; correct the condition of the paper; clean the intagliate thoroughly, using the proper solvent; improve your wiping procedure.

One part of a large plate (usually the center) refuses to print

Cause: The plate is not level.

Solution: Glue a makeready (enough thicknesses of paper to correct the deficiency) to the back of the plate, under the troublesome area.

In printing from a drypoint plate, the ink quality seems poor

Cause: The ink is too thin.

Solution: Add more pigment to the ink and/or a heavier varnish.

In printing from a plate worked with the burin, the ink quality seems poor

Cause: The ink is too stiff.

Solution: Use an ink which contains some raw linseed oil and/or add more plate oil to your ink.

Areas intended as relief whites are printing as darks, or carry dark edges

Cause: Assuming the fault is not in the bitten work or burin line in the plate, ink was wiped unintentionally into these areas.

Solution: Use a cotton swab or a Q-tip to clean the line or area thoroughly before placing the inked plate on the press bed.

A dense film covers the print; it lacks sharp definition

Cause: This is primarily a matter of wiping. Sometimes it reflects a rag wipe—if too oily a rag was employed.

Solution: Try a final hand wipe or wipe with small pieces of newsprint before printing from your plate. Also, if you desire little or no film in background areas, you can rub whiting on the heel of your palm before wiping. Be sure to remove excess whiting from your hand before wiping.

The print lacks a film of ink, the ink quality is poor

Cause: Probably too much whiting was used on the hand during the final wipe; ink was too stiff; too many wiping strokes were employed.

Solution: Use less whiting; add light plate oil to your ink; wipe when the plate still seems hot to your hands, and employ a minimum number of strokes in making the final hand wipe.

One side of your print shows a double impression

Cause: This is sometimes a problem for printmakers who prefer to run all plates under the roller twice. A slight inequality in press pressure is enough to make a plate twist and double-print on one side only.

Solution: Check roller pressure on both sides and adjust accordingly; perhaps the plate itself is buckled.

The print tears or sticks to plate after printing

Cause: Removal is too rapid or abrupt; ink is too tacky.

Solution: Peel the print from one corner of the plate slowly; reheat the plate, or add more plate oil to the ink.

The prints do not dry flat

Cause: Damp paper is stretched considerably in the printing of an intaglio plate. If you have not taken the necessary steps to ensure flattening of your prints after they are printed, you can be certain they will buckle as they dry.

Solution: Rewet the prints in a tray full of clean water, and then with butcher tape secure them by their outer edges to a large piece of $\frac{3}{4}$-inch plywood. When dry, they will have stretched flat.

The plate curls when pulled through the press

Cause: This is inevitable when the plate is placed improperly on the bed of the press.

Solution: Place the plate squarely in the middle of the press bed, making certain that its longest side is parallel with the axis of the press roller.

The Stencil Process

SCREEN PRINTING
PHOTOGRAPHIC
SCREEN PRINTING

*The true discoverer is not the man
who first chances to stumble upon anything,
but the man who finds what he has sought.*

Jacob Burkhardt

Screen Printing and Serigraphic Stencil Methods: The Development of an Art Form

Stenciling is a technique for pressing color through a flat, thin, precut guide or pattern. To understand the simplest forms of this technique, cut out a hole in a sheet of paper or cardboard, lay the sheet over a piece of paper, and draw or paint through the hole so that its shape is duplicated on the paper underneath. Or place the cut-out shape on a piece of paper and draw around it, so that the shape appears white in an otherwise drawn or colored area. The latter device was used in the earliest known art: Prehistoric men, for reasons no longer apparent, sometimes placed a hand against the cave wall and colored around it. The negative imprint of a hand with outstretched fingers can be seen in caves in various parts of the world today.

Stenciling has always been extensively used in the *decorative arts.* The Chinese knew the technique centuries ago, and the Japanese developed it to a high degree in the decoration of fabrics in the seventeenth and eighteenth centuries. Anyone interested in early periods of interior design will have seen, among other things, walls and chairs decorated by this process.

The use of the stencil in *printmaking* occurred very early and has been used intermittently over the years. Some of the fifteenth-century playing cards were colored by this process, as were portions of the

nineteenth-century lithographs of Currier & Ives. This, however, was simply coloring added by hand, and not the stencil printing process, as we know it today. The *screen print* was an invention that did not evolve until the twentieth century.

One of the difficulties in creating a complex stencil is that of holding in place the "islands" and "peninsulas" that are created within the design. If you want to stencil the letter *O* on a surface, for example, you are immediately confronted with the problem of how to cut an *O* in a sheet of paper and yet hold the inner circle or "island" in its correct position. Sooner or later, you would no doubt think of leaving a bridge or bar to connect the island to the rest of the paper. Such connections are called *ties,* and they can be seen any day, in rather crude form, in the stenciled lettering often used for the labels stamped on packing crates.

Although the tie also serves to strengthen the stencil so that it will last longer, the main disadvantage is that the tie can often intrude upon the proposed design. Centuries ago, the Japanese found a simple and ingenious solution for this problem. They created two-ply stencils by cutting two pieces of thin paper in duplicate and pasting them together with a paste that contained strands of human hair. These strands held

287. Guy Maccoy.
Melon and Apples. c. 1954.
Serigraph, 18 × 22".
Courtesy the artist.

the islands and other floating forms in their proper place. Though they are visible in the stenciled work, the effect of the hairs could be minimized, during the process of adhering the two plies of the stencil together, by placing additional hair about the surface at random or in an arrangement not unlike the effect of woven cloth. The wispy patterns that result do not intrude upon the design, and forms previously impossible to achieve grew out of this technique.

The *silk*-screen print originated in the idea of using silk and similar textiles, instead of paper, as a base for the stencil. Such a process was known in England in 1907, and patents for another were granted in San Francisco about 1915. The French developed an intricate stencil process known as *pochoir* for making art reproductions which, if used for works suited to being copied by the process, look remarkably like originals. The evolution of the stencil process into a unique fine-arts medium was, however, a development that took place mainly in the United States and primarily in the 1930s, when it came to the fore with astonishing rapidity. In a sense it was a product of the economic crisis, for it grew out of the great stimulus of the WPA Federal Arts Project. About two years after the Project was initiated, a separate screen printing unit of the New York City WPA Art Project was set up with Anthony Velonis as its head, and much was owed to his pioneering technical and aesthetic achievements. Less than two years after that, Guy Maccoy (Fig. 287) held the first one-man show of screen prints at the Contemporary Arts Gallery in the same city. Elizabeth McCausland, in reviewing several group shows of screen prints for *Parnassus* (March, 1940), caught the fervor of the times with these words:

> There is an exciting historical portent in the speed with which the silk-screen color print has captured the fancy of contemporary graphic artists. It is as if in 1800, two years after Alois Senefelder had discovered lithography, the French Academy—amid the throes of Napoleonic politics—had held a large group exhibition of lithographs. Or as if in 1842, two years after Daguerre's invention had been introduced into the United States, a large exhibition of daguerreotypes had been held at the non-existent Metropolitan Museum of Art.

Many men working individually and in concert throughout the United States were responsible for the burgeoning of the *silk-screen* print—christened *serigraphy* by Carl Zigrosser, now Curator Emeritus of Prints at the Philadelphia Museum of Art. Anthony Velonis, Guy Maccoy, Hyman Warsager, Edward Landon, Elizabeth Olds, Harry Gottlieb, Mervin Jules, Ruth Gikow, and Harry Sternberg are but a few of the early leaders in the medium.

This versatile process offers challenging color possibilities, adaptability to new materials and still newer aesthetic considerations, and richly satisfying optical effects. (My use of the terms *silk screen*, *serigraph*, and *screen print* has perhaps been more loose than purists would prefer. But then, the terms *do* mean, more or less, the same thing. *Screen print*, at the moment, enjoys a certain popularity.)

Making
a Screen Print

The most basic procedure by which a screen print can be made is as follows: A stencil is affixed to a piece of silk, or other fabric, stretched tightly across a wooden frame. The physical structure of silk is such that it allows paint to be forced with a squeegee through its warp and woof. Areas not to be printed are *blocked out* on the screen itself—that is, the pores of the "silk" are closed wherever desired, thus preventing paint from penetrating at those points. When a sheet of paper is placed underneath such a prepared screen and paint is forced through the mesh, the color will be deposited upon the surface of the sheet. For each color to be employed in the final print, a separate stencil is required, except where forms are so separated one from the other as to permit the screening of more than one color at one time.

The proper combination of ink or paint with the material used to make the stencil (which blocks out ink or paint where it is not wanted) permits the printmaker to use various color media—from inks, dyes, and oil colors to lacquers, enamels, poster paints, and other synthetic products. Serigraphs may be printed not only on paper but on almost any surface—canvas, cardboard, wood, cork, linoleum, leather, ceramics, foil papers, paper, glass, plastic, textiles, metals, and so on—provided that an appropriate ink or paint and stencil are employed.

PLANNING A SCREEN PRINT

The technical considerations in screen printing may be mastered in short order; consequently, the printmaker is free, almost from the beginning, to concentrate upon his drawing, his pictorial ideas. At this point you will want to take into consideration your own natural way of working. Will you prefer to let your print evolve screen by screen without exercising too much control from a preplanned idea? Or do you feel more at home when working from a carefully rendered color drawing? Either approach can be followed. You will also need to consider whether you want your color to be transparent, opaque, or semi-opaque; overall or in certain areas. You will make your sketches in pigments (gouache, oil, watercolor, pastel, and so on) that will preview in the preliminary sketch the effects desired in the final print. You will then plan which colors you want printed over or under others in order to determine the printing order of your stencils.

Some printmakers prefer to let the image develop during the process of making a screen print; that is, without a well-defined visual idea in mind, they proceed to invent and superimpose one screen upon another with seeming disregard for the final effect. At some point, control is exercised and a whole is welded together from these once unrelated parts. This approach, to be successful, must be in accord with the experience of the artist. It cannot be imposed upon a particular individual whose work habits are counter to an unstructured system.

Following the more usual method, you will work out a color sketch prior to making a screen print, and enlarge the sketch to the maximum printing format of your screens. This master sketch can be placed beneath the screen for tracing. Now, what is the best way of "atomizing" your sketch into many parts so that you can put it together in a different medium (the serigraph) to form a new whole, somewhat similar to the sketch, but "different"?

The obvious answer, though not necessarily the best, is to have a plan so complete in color that you merely trace area for area, line for line, texture for texture, from the sketch to the screen on successive stencils. On the other hand, you may find it more helpful to use a method that permits variations upon each part before the whole is crystallized in an edition. This can be done by painting each color from the master sketch on a separate sheet of cellulose acetate, or its equivalent, with transparent color inks, dyes, or paints. By so doing, you can examine the individual parts in their approximate colors. With all these color separations superimposed and held up to the light together, or viewed on a glass-topped, illuminated table, you can view the total effect of the color ensemble *before* the actual printing is begun. Changes may suggest themselves for one or more of the individual parts, or you may decide that the total image will be improved by the subtraction or addition of one or more colors.

MAKING A SILK SCREEN

Ready-made silk screens are available in a variety of sizes, but those who like to engage in a little elementary carpentry can easily make their own to any size they choose.

Making a Frame

wrapping tape covered with clear, synthetic enamel

wooden frame: 2 X 2″ lumber

20

40

picture rectangle

30

30

288. Diagram of frame for screen printing.

Figure 288 shows a frame that will allow for printing a picture 20 × 30 inches. The outside dimensions of the wooden printing frame measure 30 × 40 inches, and a yard of 40-inch-wide, 12xx silk will be adequate to cover it. While smaller work can be done on a large screen, the reverse is, of course, impossible.

The screen frame should be made of knot-free, kiln-dried wood (generally $1\frac{3}{8}$ × $2\frac{3}{4}$ inches) and should be hinged to a baseboard larger in area than itself. This baseboard may be a drawing table, a board, a piece of marine plywood, or any surface that is level and smooth. To attach the frame to the board, it is recommended that you use what are called *loose-pin hinges,* which contain a pin that can be easily withdrawn when you are removing one screen and replacing it with another. (Figure 293 shows a screen that is being slipped into place just before printing.) Since you will no doubt be using more than one frame as time goes on, set all your hinges so that they will fit on the same baseboard; this will save time later on.

Stretching the Silk

start tacking the silk here, continue on alternate sides of the starting point

pull taut, then tack; repeat on alternate sides of this point; finish third and fourth sides similarly

at this stage, the stretched frame should look like this

289. Stretching the silk.

Although there are many materials that can be substituted for silk (Swiss bolting cloth, organdy, bronze wire cloth, Dacron, monofilament nylon, nylon, taffeta, and so on), most printmakers prefer the original material. Silk is sold in standard widths ranging from 40 to 80 inches; there is a standard weight (x) and a double, extra heavy weight (xx). It is available in coarse (6x or 6xx) to very fine weaves (17x or 17xx to 20x or 20xx). The number specified for a particular lot of silk or bolting cloth refers to the number of threads per square inch. For nonphotographic, average use, 12xx is highly recommended, though artists commonly employ 10xx through 16xx in much work. The finer meshes are necessary for use with light-sensitive films. In purchasing silk, buy enough to cover the *outside* dimensions of your printing frame.

Cut the silk slightly larger than the frame to allow for ease in tacking it down. Line up the warp and woof of the fabric so that they run parallel to the frame and will thus ensure proper stretching. Your objective now is to stretch the silk as tightly as possible without doing injury to it.

The silk should be stretched on the frame in exactly the same way that a painter stretches his canvas (Fig. 289). Tack it in the middle of

Plate 39. ERNEST TROVA. *Untitled,* from the series *Index.* 1969.
Serigraph, sheet 15 x 12½". Pace Editions, Inc., New York.

Plate 40. Jack Youngerman. *Untitled,* from the suite *Changes.* 1970.
Serigraph, 43 x 33". Collection Welty K. Withers, New York.

above: Plate 41. Rita Letendre.
Twilight Phase 1. 1971.
Color serigraph, 27 x 35".
Courtesy the artist.

right: Plate 42. Victor Vasarely.
Orion MC. 1963.
Color serigraph, 24½ x 23½".
Courtesy the artist.

Plate 43. ROBERT INDIANA. *Numbers.* 1968.
Ten color serigraphs, each 9⅞ x 8¼".
Published by Editions Domberger, Stuttgart;
courtesy Pace Editions, Inc., New York.
(See also detail, Fig. 15.)

one of the longer sides, and, keeping the fabric parallel to the frame, continue to tack it down alternately on both sides of the starting point. Before you reach the corners, pull the fabric tight and straight, and attach it in the center of the opposite long side. Stretch and tack on alternate sides of this second starting point in the same way, and then do the same for the shorter sides of the frame. Finally, tack down the corners. The silk can be attached with either staples or tacks. Do not hammer tacks all the way in until the silk has been firmly secured.

The following are also workable methods of stretching silk across the frame:

1. Make your frame of grooved lengths of wood and assemble as before. Cut the piece of silk large enough to cover the grooves, and, with a piece of fiber rope, push it into the grooves on all four sides. The silk may then be made tight by tapping a wooden wedge into the grooves with a hammer.
2. Various commercial devices are available. One of the easiest to use is a mechanical stretching device that allows precise tensioning of any type of fabric on any size of frame. A frame adhesive with its appropriate catalyst is mixed and painted on a clean, dry, wooden frame or on a metal frame degreased with acetone. The frame is pressed against a stretched piece of fabric. A second coat of adhesive and catalyst is applied through the fabric. The frame and fabric will air-dry within minutes, but it is safer to allow twenty-four hours to pass before further processing.

Sizing can be removed from the silk by careful washing with a detergent after the material has been stretched upon the frame.

Sealing the Frame

After the silk is attached, trim the excess about $\frac{1}{4}$ inch from the edge of the frame. Apply butcher's tape over the staples, tacks, or rope that hold the silk in place. Turn the frame over. Cut four pieces of butcher's tape equivalent to the four inside dimensions of the frame. Fold each piece in half along its length, gummed side out. Apply these strips to the inside of the frame so that half of each strip is attached to the wood while the other half covers the silk. Brush a coating of shellac or acetate dope over the tape to further seal the inner sides of the frame (Fig. 290) at the juncture between the wood, the silk, and the tape. The protective seal not only covers the brown wrapping tape, but overlaps onto the silk itself. This should prevent paint from seeping through the frame to spoil the print. Further, it will keep paint from gathering and hardening under the frame and eventually cutting the silk. Be wary of allowing droplets of shellac or dope to spatter on the screen itself; if this happens, apply solvent to the area immediately.

290. Sealing paper tape on the frame.

291. Applying water-soluble resist to the screen.

METHODS OF MAKING THE STENCIL

Whether you plan to work spontaneously or from a drawing, it is recommended that you first make the following experiment. Using a commercial water-soluble substance called *WaterSol,* brush, spatter, dab, and dot the silk with a stick, brush, syringe, hypodermic needle, or other tool (Fig. 291). Instead of WaterSol, you can use a mixture of equal parts of LePage's Original Glue and water; do not use LePage's White Glue for this purpose. In a few minutes the WaterSol becomes a dry, tough, elastic, nonshrinking block-out that allows working the screen; it is easily removed in cold water, whereas hot water makes it insoluble. At this point, do not exercise control of any sort over the design; seek happy chance discovery. After this and one or two other spontaneously made screens have been printed in succession, in different hues upon trial printing paper, you will have created a variety of textures and shapes that can assist you in planning a serigraph.

There are various methods for executing the stencils that permit a serigraph to be printed, and a number of products are supplied under different trade names. When using products other than those noted in the following directions, similar general procedures may be followed.

Paper Stencils

Without resorting to complex procedures, you can simply affix torn or cut paper to the *underside* of the silk screen, apply paint, and run off all the prints you desire. The stencil can be adhered to the screen by the silk-screen paint after you have placed the torn or cut paper in position.

The Chinese have a method of obtaining a stencil by drawing on paper with an ink containing acid, which eats through the paper, leaving a ready-to-use stencil that is then affixed to the silk. As a substitute for the Chinese acidulated ink, try using a thin solution of gum arabic to which should be added ordinary red drawing ink (for color) and a sufficient amount of nitric acid to penetrate the paper within a reasonable amount of time. Use a pen, stick, or glass fiber brush to draw the design on the paper.

Tusche-Resist Method

The most autographic of all the approaches to the silk screen, the tusche-resist method allows you to paint or draw in a normal manner and retains the freshness of your original strokes. It is not an involved process; it can be learned in an afternoon; yet, it can produce as complex a color image as one would desire.

The principle involved in the tusche method is similar in many ways to that of the lift ground in the intaglio process. The image is painted

on the screen with lithographic tusche (grease suspended in a liquid) and a brush, and is allowed to dry. You can also use lithographer's crayons, liquid wax, asphaltum, and other grease-containing substances as materials for drawing upon the stencil, to obtain textural areas, or to soften edges within the design. If crayon or tusche is employed, be sure that the pores of the silk are filled in. A half-glue and half-water mixture of WaterSol is then coated over the entire screen, covering the drawing. When this glue mixture is dry, it is washed with a solvent (mineral spirits, Varnol, lithotine, and so on), which washes out only the tusche or grease drawing and not the glue. This leaves the silk *open* wherever you have drawn with tusche; the glue, resting on the undrawn areas, acts as a stencil or resist.

Art Maskoid Resist

Another approach, similar to the tusche-resist method, utilizes Art Maskoid, a commercially sold, mutated, water-soluble, synthetic latex that is impervious to water and alcohol when dry. This drawing material is easily removed by *erasing* with a piece of natural rubber. (Note again the resemblance to the lift ground; this, too, is a positive drawing material.)

Treat the stencil precisely as you would with tusche; that is, draw with a pen, brush, cardboard, sponge, stick, or other tool filled or loaded with Art Maskoid. Then squeegee glue or WaterSol across the Maskoid, and allow it to dry. Erase and remove the Art Maskoid. Check the stencil for pinholes that you may wish to eliminate.

Stop-out or Block-out Stencils

A stop-out or block-out, such as glue and water, can be painted directly upon the silk screen in all areas *not to be printed.* This method thus works by a principle opposite to that of the tusche-resist, but printmakers experienced in using stop-out for intaglio will find it familiar. Hold the screen to the light and check for pinholes (dots of light) in the stopped-out areas, and correct if necessary. Then let the stop-out dry.

Glue-Shellac Method

Mix equal parts of glue and water to which a few drops of glycerine are added. Prop up the screen so that the silk is raised above the working surface and does not contact any other surface. Paint the glue solution *in all the areas to be printed,* and allow it to dry. Check for pinholes, and correct, if necessary.

Using a rectangle of matboard 3 × 5 inches as a squeegee, brush lacquer or shellac (thinned, but not too thin) *over the entire screen* to act as the resist. Check for pinholes in the resist, and correct.

Place the screen once more in the original position, slightly raised off the table. Using a soft, clean rag and a pan of water gently work over the *underside* of the screen. Do not allow the water to saturate the screen, but slowly—by wiping and picking up excess water with the rag—soften, rub, and remove the glue from the open areas. Repeat until the open glue areas are dissolved, and until all that remains is a lacquer or shellac resist. Finish wiping the screen with a dry rag.

Using Lacquer Stencil Film

For meticulously precise edges and other geometric approaches, it is recommended that you become familiar with the lacquer stencil film. This film, known in the trade by various names, such as Nufilm, Ulano, and Craftint, is a laminated stencil composed of a colored lacquer film and a sheet of glassine paper. The stencil (the lacquer film) must be cut without penetrating the glassine paper (the backing), because the backing holds the islands or isolated areas (for example, the center of the letter *O*) in place until the film is attached to the silk screen. Be certain the cutting knife used is especially sharp; a short practice period will allow you to "feel" the proper cutting depth, and keep the knife from penetrating the glassine backing.

When the stencil is cut, place it under the screen so that the two are in *firm contact*. Using film-adhering liquid on a small, clean rag, rub the silk firmly, no more than 4 square inches at a time, and dry it immediately with a dry rag held in the other hand. Repeat this wet-and-dry rubbing procedure until the stencil is firmly adhered to the screen. Allow the stencil to dry, and then carefully peel off the backing sheet from the underside. A small electric fan will hasten the drying. If, on removing the backing, the stencil seems to be lifting, you should stop and repeat the adhering procedure. Block out the open silk between the edges of the stencil and the frame by taping the areas, applying paper, or then stopping out with lacquer screen filler, Water-Sol, or glue.

Imitation Shellac Method

In using imitation shellac, the image is first drawn on the silk with glue; that is, the *positive* is brushed on the clean, bare silk, as in the tusche-resist method. It may be helpful to add a coloring agent to the glue so that you can see the image more clearly. Allow the glue to dry.

Prop up the screen, and squeegee the imitation shellac over the screen in two or more directions. When this is dry and free from pinholes, apply water to both sides of the screen and rub thoroughly with a soft rag. The water-soluble glue will begin to swell underneath the imitation shellac, and will soon give way, leaving the silk open in the desired areas.

This method is useful for opaque watercolor (tempera), but cannot be used with normal screen process paints, which, because of the varnishes within them, would "melt" the imitation shellac stencil.

The following table of solvents will be of use in handling the various stencils and media. You may wish to enlarge it and place it in a prominent position in your studio until there is no longer any need for it.

Table of Stencils, Media, and Their Solvents

Stencil or Medium	Solvent
Acetate dope	Acetone
Enamels	Turpentine, benzine, kerosene
Glue (LePage's)	Water
Lacquer	Lacquer thinner
Litho crayon	Water—in drawing stage; mineral spirits, Varnolene, turps, or kerosene for wash-out
Maskoid	Mineral spirits, eraser
Nufilm, Blufilm, Profilm, etc.	Adhering solvent, acetone, lacquer thinner
Oils	Turpentine, benzine, kerosene
Photographic film stencils	Hot water
Shellac	Alcohol (denatured)
Tusche	Same as for litho crayon
WaterSol	Cold water
Wax crayon	Turps, kerosene, mineral spirits

PRINTING PROCEDURE

Having completed a stencil, you are now ready to lay a sheet of paper on the baseboard or tabletop, position the screen over it, and proceed to make a print.

Registration

The paper must be laid down so that the screen will be centered accurately over it and so that, when you are printing more than one color, the second screen and all the others that follow will fall accurately in place on the print. This is the problem of registration—one that has many solutions. Figure 292 demonstrates one method. Plastic registration guides with tabs have been affixed with tape to the tabletop seen in the photograph to make certain the printing paper will be lined up accurately. These inexpensive, plastic tabs are more accurate than pieces of paper or tape, which can also be used. The printing paper slides home against two tabs on a long side of the paper, then against a tab on one of the short sides, which process ensures proper registration.

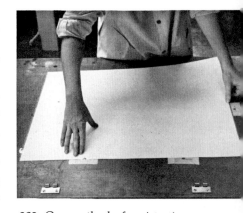

292. One method of registration.

294. Locking the frame
into the baseboard.

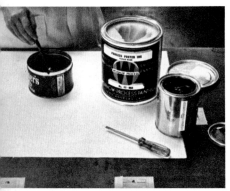

294. Preparing the paint.

Locking the Frame

The frame is secured to the baseboard or tabletop by means of a removable pin hinge. In Figure 293 the hinges on the frame are being locked to their already secured mates on the tabletop. The pins are inserted when both parts of each hinge mesh.

Mixing the Ink

Manufacturers supply many kinds of ink for screen printing, all calculated to print well on one surface or another and to provide various mat, satin, or gloss effects. It is not necessary, however, to use only the products manufactured especially for the purpose. If cost is not a factor, artist's oil colors are wonderfully adaptable, especially for transparent effects, and various water-based and synthetic pigments are often used.

There is one factor to be kept in mind when you choose your paint or ink, and that is the method by which you have made your stencil. You cannot, for example, use a water-based ink if you have made your stencil with water-soluble glue, for the stencil might then dissolve in the printing. The following chart suggests some suitable types of paint or ink for the different types of stencils.

Suggested Paints or Inks for Various Stencils

Resist or Stencil	Paint or Ink
Glue	Oil base, lacquers, plastic inks
WaterSol	Oil base, lacquers, plastic inks
Lacquer filler	Oil base, water base, enamels, dyes
Lacquer film stencil	Oil base or water base
Paper stencil	Oil base
Plastic-backed water-soluble film	Synthetic lacquers, vinyl lacquer
Photographic stencil	Lacquer, oils, any water-free paint
Shellac	Water base, lacquer
Art Maskoid	Oil base, lacquers, plastic inks

Figure 294 demonstrates mixing an ink to the consistency of heavy cream. The ink, in this instance, is a combination of transparent base with a commercial product called Wornowink. The amount of transparent base used with the color is not critical; you can add as much base as desired, up to 50 percent, according to the degree of transparency you wish in the color. (The manufacturer suggests 4 parts of clear base to 1 part of color plus the necessary mineral spirits, but the proportion in this case was deliberately varied.)

In order to determine the amount of paint or ink you should mix for an edition of prints, you can obtain from screen-ink manufacturers

their information on *opacity coverage;* this is usually quoted in gallons per square feet when printed through a particular mesh.

Applying the Ink with the Squeegee

The importance of the roller in lithography is paralleled by the function of the squeegee in serigraphy. It is a simple tool, consisting only of a rubber or plastic blade inserted in a wooden handle, but it is the instrument by which ink or paint is spread and forced through the screen to make contact with the paper, and it must be kept in good order if it is to function effectively. It must have no nicks, it must be level and sharp when running editions, and it must be cleaned thoroughly after each printing. The blade can be sharpened on fine sandpaper or emery cloth from time to time. Examine it carefully before each color run.

Purchase a squeegee of a size that can be manipulated within the *inside* dimensions of the printing frame. For different effects, use soft, medium, or hard rubber blades, over a range of from 20 to 70 durometers (the number assigned to the degree of softness or hardness through objective measurement). It is advised that you purchase a medium rubber blade at first. Plastic squeegee blades seem to be preferred by most professional serigraphers, but their cost is approximately twice that of a rubber squeegee.

With a batch of ink mixed, and the screen dry, add a generous line of ink at one end of the frame and squeegee it across to the other end while holding the squeegee at an angle of about 60 degrees (Fig. 295). Pull the ink across the screen smoothly in a sustained, continuous motion.

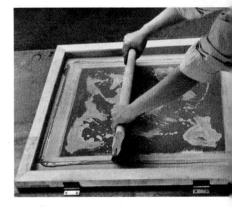

295. Squeegeeing paint across the screen.

Pulling and Drying the Prints

Raise the screen (Fig. 296) and remove the print. Before you proceed to pull the rest of the edition, you must answer this question: How and where do you find enough space in which to dry fifty or sixty wet prints? One answer to the problem lies in stringing lines with wooden clothespins across your workroom at a convenient height. Hanging two wet prints back-to-back from one clothespin allows you to dry numbers of them in a comparatively small space. *For those who have access to the drying racks used commercially,* this simple expedient may seem too primitive, but each printmaker, in the privacy of his studio, seems to arrive at his own solutions that are altogether workable for these mechanical problems.

When this color dries, the print is ready for the next screen, and the next. (With some commercial inks your prints are air-dry in under 30 minutes.) The same procedure is carried out for each additional screen until the serigraph is complete.

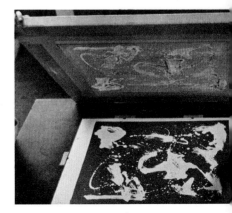

296. The print at its first stage of development.

Cleaning the Screen

When the last print in a run has been squeegeed, use cardboard rectangles (2 × 4 inches) to remove most of the paint from the frame.

Place a thick layer of newspapers on a work surface and lay your screen on top of them. Using a large rag saturated with mineral spirits or the equivalent, wash out the screen thoroughly on both sides. Keep removing the saturated newspapers under the screen from time to time to allow for a more efficient cleanup. When the paint appears to have been removed, wipe the screen dry on both sides with a clean, dry, lint-free rag. The screen can be stored away if you wish to save the stencil for future runs.

If you own but one silk-screen frame, and have to use the same frame again and again for each separate run, the removal of a water-soluble stencil is accomplished as follows: Soak your screen in a tray of *cold* water, or run water from a hose upon it as your hands gently massage the silk. Water-soluble stencils can be removed from silk easily and quickly.

SOME EXAMPLES OF SCREEN PRINTING

Screen printing offers distinct advantages to its many adherents: It does not require a press; its techniques can be simple; and it permits relatively easy execution of oversize prints. Furthermore, it encourages variety in artistic expression.

Ben Shahn (1898–1969) exploited the print medium for the dissemination of ideas, and his may be the most significant work of its kind by a twentieth-century American. A painter and muralist famed for his graphic art, Shahn was profoundly concerned for the social problems of his time (Fig. 297). His vision was clear and realistic, and he had a monumental sense of form, as well as a gift for caricature. Personal symbolism, mystery, and imagination brought his art close to Surrealism. Born in Russia, Shahn grew up in Brooklyn slums and began working as a commercial lithographer early in his student days.

The screen prints of Corita Kent (b. 1918) are notable for their verbal content as well as for the freshness and spontaneity of their design (Fig. 298). Silk screen has served her intentions unusually well. Words have been included in prints since the early religious woodcuts (Figs. 128, 129), but Kent uses words with remarkable freedom, in the manner of letters to friends. She believes that we should accept billboards and advertisements just as we have fairy tales and parables. Often her works are executed only with brush and glue.

Ernest Trova (b. 1927) proclaims that he remains "in the figurative camp," however much his "falling man" may be abstracted into a total composition (Pl. 39, p. 275). Trova views silk screen as a "change of pace" from painting and sculpture.

left: 297. BEN SHAHN. *Sacco and Vanzetti.* 1958.
Serigraph, $25\frac{1}{2} \times 17\frac{1}{4}''$.
Library of Congress (Pennell Fund), Washington, D.C.

above: 298. CORITA KENT. *One Day.* 1970.
Serigraph, $22\frac{1}{2}''$ square.
Mayfair Art Gallery, New York.

The hard-edge, curvilinear forms of Jack Youngerman (b. 1926) have their perfect realization in screen printing (Pl. 40, p. 276). Singly cut silhouettes for each of the flat colors can be easily executed by stencil, but the success of this print derives from the Youngerman's elegant and ingenious design.

A master of light and color, creator of an almost 900-square-foot mural for Long Beach State College in California, the Canadian Rita Letendre (b. 1929) can also work at the scale of the screen print reproduced as Plate 41 (p. 277), whose diagonal fields of force are brilliant, lush, sensitive, and intense with cool fire. She said recently, "I look for dynamism—actions which continue in the mind of the spectator."

The knife-cut lacquer film makes possible a crispness of form and edge that brush-applied stencils could not obtain. Nicholas Krushenick

(b. 1929) uses it to eliminate all traces of texture (Fig. 299). "Silk-screen paints or inks," he explains, "can be made very flat looking, which is similar to the Liquitex paint I use in my paintings." He adds, however, that "art is made with love, not paint."

Also made from cut stencil film, combined with water-base Ulano No. 60 screen filler, is *Self-Portrait with Sneakers* (Fig. 300) by Clayton Pond (b. 1941). It was printed from a monofilament polyester screen with petroleum-base paint. The artist says the serigraph process allows him "the rich opaque color deposits" that his work requires; it has also freed Pond to be concerned more with the nature of the image itself. A limited view of the artist's own legs and feet while sitting in a dentist's chair inspired the essentially abstract image in this print.

below: 299. Nicholas Krushenik. *Print #10,* from *Iron Butterfly.* 1968. Serigraph, $35\frac{1}{2} \times 27\frac{1}{2}''$. Pace Editions, Inc., New York.

right: 300. Clayton Pond. *Self-Portrait with Sneakers.* 1971. Serigraph, $22\frac{1}{2} \times 27\frac{1}{2}''$. Martha Jackson Graphics, New York.

below right: 301. Norio Azuma. *Morning Impression.* 1964. Serigraph on canvas, $20\frac{1}{4} \times 24\frac{1}{4}''$. Collection IBM Corporation, New York.

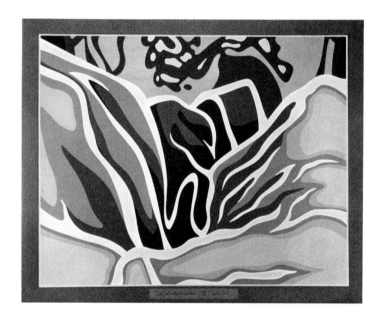

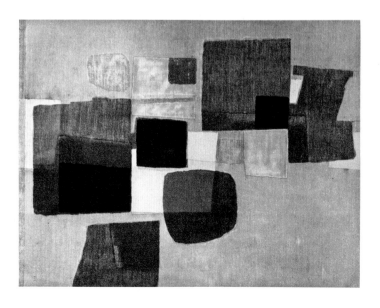

Norio Azuma, born in Japan (1928) but resident in the United States since 1955, uses silk screen to achieve subtlety of textural effect, along with balance in color, proportions, and shape, in his relatively flat forms (Fig. 301). The screen itself, variety in the materials applied, and the canvas support all contribute to the ultimate impact.

Op Art, with its fine chromatic variations and precise forms, has received especially successful expression in the screen process. Victor Vasarely (b. 1908) is a pioneer in perceptual abstraction whose prints have maintained a high level of technical achievement (Pl. 42, p. 277).

Robert Indiana's *Numbers* (Pl. 43, p. 278) is of particular interest in serigraphy because, not only is the work executed as a silk screen, but it is, in a sense, psychologically derived from the stencil technique at the basis of the medium. The so-called sign painters early in the Pop Art movement, in their search for everyday material, became interested in the numbers stenciled on signs and boxes. These artists incorporated the numerals into their works, adding to their timeliness not only an artistic organization but also some sense of mystery and allusion. Thus the print, in this case, seems to have returned full cycle to a homely stencil origin. It also demonstrates one of the advantages of silk-screen printing—the ease with which large editions can be issued. *Numbers* was published in book form as a collaboration between Indiana and Robert Creeley, who contributed ten number poems; there were two editions, one of 250 books in larger size ($25\frac{1}{2} \times 19\frac{1}{2}$ inches) and the other of 2,500 books in smaller size ($9\frac{7}{8} \times 8\frac{1}{4}$ inches).

Screen prints can be produced on almost any surface, and Roy Lichtenstein (b. 1923) used Rowlux, a metallicized plastic, for *Moonscape* (Fig. 302). In the imaginative work reproduced here the only survival of the artist's famed "comic strip" style seems to be the dots borrowed from the screen of commercial printing. *Moonscape* has been printed in blue, red, and white.

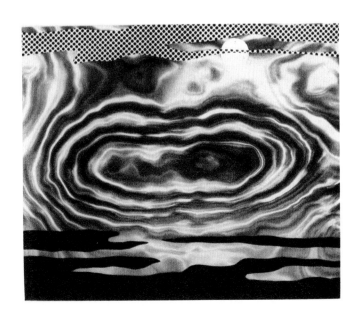

302. ROY LICHTENSTEIN. *Moonscape.* 1965.
Serigraph on metallic plastic, 20 × 24".
Collection Philip Morris, Inc., New York.

Because it can be applied to virtually any surface, screen printing is eminently subject to combination with other media, as in Figure 303, for which Dean Meeker (b. 1920) employed silk screen and intaglio. A notable technician, Meeker has developed the *polymer print*, by which process he builds up areas on an aluminum or plastic plate with polymer modeling and then creates white lines with lacquer and dark ones with a burin or a drill, as in intaglio. In serigraphy he has also combined thin and heavy inks or paints to produce relief effects and has screened acrylic paint onto glass to simulate stained glass.

The painter Larry Rivers (b. 1923) has done his most original work in collage, the example in Figure 304 combined with a screen printed on Plexiglas. It exhibits the unusual juxtaposition of themes and the highly personal style characteristic of Rivers' art.

Claes Oldenburg (b. 1929), one of the leading exponents of Pop, began to execute prints in 1961; by 1965 he was making multiples which were not prints in the strict sense of the word. By virtue of their three-dimensional quality and the incorporation of real objects, they are better termed *object-prints*. His first multiple, *Baked Potato* (1965) made of fiber glass and epoxy, was essentially a sculpture, intended to be viewed in the round. His second multiple, however, the now-familiar *Tea Bag* (Fig. 305), was intended to be hung on the wall and viewed from the front, and it made use of the silk-screen process. In brief, the work was created as follows: The bag was vacuum-formed in plastic from a plaster model. A felt bag was then sewn, silk-screened, stuffed with Kapok, and assembled with it. Behind the bag is a shape of opaque plastic, and attached to it by a nylon cord is a "label." These objects were loosely assembled between two sheets of clear plastic, the other color spots having been silk-screened onto the rear sheet, which serves as the transparent "back" of the work. The artist has been kind enough to provide for this book an account of his approach to the remarkable work that *Tea Bag* is:

> In general I have an anti-print attitude, which is an anti-flat attitude. Most of my activity in prints has been with reliefs or very sensuous surfaces, and I was one of the first to substitute an object in an edition of prints, because of my desire to create a tangible work rather than (or as well as) a purely visual one—a work requiring the contact of parts of the body as well as the intellectual response of the eye.
>
> The way the tea bag is executed deliberately separates the sensations coming via the eye from those coming via the fingers. The visual element is untouchable and does not correspond, except in a comically inadequate way, to what may be felt with the eyes shut (and imagined). The vacuum-formed plastic is like a formed "glass" over the "picture."
>
> I use recognizable objects for several reasons. One is for ease of communication, because an audience can share their physical knowledge of a familiar subject. My work begins with a sensation or an idea—usually both. Then I find an object which is both one that I enjoy and am familiar with and one that contains or can project the sensations and thought I have in mind. Often this is an object with an outside and an inside of equal interest, an object with "skin."

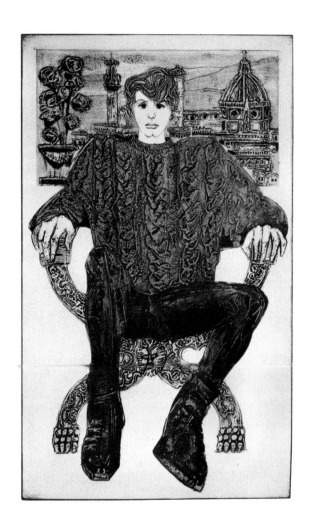

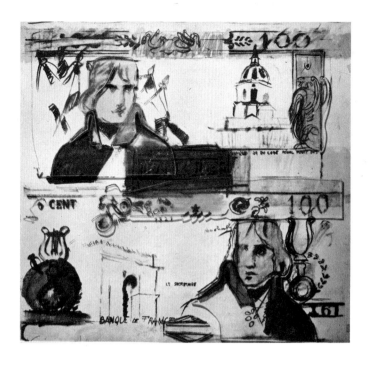

above left: 303. DEAN MEEKER. *Gregory as Lorenzo de Medici.* 1968. Silk screen and intaglio, $33\frac{1}{2} \times 20''$. Courtesy the artist.

above right: 304. LARRY RIVERS. *French Money.* 1965. Serigraph on Plexiglas, $32 \times 30''$. Multiples, Inc., New York.

right: 305. CLAES OLDENBURG. *Teabag.* 1966. Serigraph printed on felt, Plexiglas, and plastic, with felt bag and rayon cord attached; $39\frac{5}{16} \times 28\frac{1}{16}''$. Museum of Modern Art, New York (gift of Lester Avnet).

One reason for choosing the tea bag as a subject was that I often drop the bags I use when drinking tea, and the effect is that of a "print"—an unpredictable splash of color and an unpredictable form in the dropped bag. I was immediately influenced by an advertisement for tea bags, showing a dropped bag. I always try to establish a corresponding effect outside of art for what I do in art.

My work, because it uses familiar images simplified in a personal way, acquires a lot of interpretations, most of which come later when I am thinking of the work, and many of which come from others. I try for a form simple and of maximum suggestiveness. *Tea Bag* is only the starting point, and the title plays a part in the transformations.

Born in Russia (1920), a rugged cosmopolite who has lived, worked, and exhibited in Israel, Europe, the United States, Canada, and Japan—Kosso Eloul, professionally known as Kosso, is a superb maker of sculpture and prints. This writer first saw his graphics in the outer gallery of the Gemini G.E.L. workshop a number of years ago. They were sculptured lithographs (lithographic sculptures?), in which the artist had sensitively related a delicately powerful lithographic line to cut parts of the paper's surface that were folded out slightly towards the viewer. The back side of these folded sections was printed in rich, solid color, which showed only as a wash-colored fog reflected from a silvered backing. Unfortunately, this effect of the print would be difficult, if not impossible, to reproduce. Kosso's *Eluding* (Fig. 306) equally baffles the eye, at first glance. It is aptly titled, for the sculptor's three-dimensional, stainless steel, monumental works defy gravity, create unbelievable tensions and paradoxes, and seem to be frozen in time just short of splitting asunder. Kosso admits to being engaged in "a search for the capture of the illusions, for the implied motion, for potential movement in shape or in line."

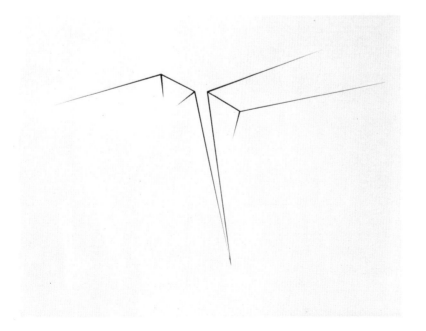

306. Kosso Eloul. *Eluding.* 1971.
Serigraph, 20 × 26". Courtesy the artist.

Photographic
Screen Printing:
Photo Stencil Methods

There is little doubt, in the minds of those who have seen recent exhibitions, that the photographic stencil has provided the new "look" in serigraphy. The technique can be employed alone or in combination with any of the approaches that were described in Chapter 22.

The painter-printmaker has two options: He can purchase the professional services of a local screen printer and thereby obtain one or more photographic stencils of certain dimensions and a particular halftone screen, or he can attempt to make the stencils himself.

Photographic stencils can be made in many ways, and manufacturers of the necessary materials supply detailed directions for the use of their products. Choices include direct photo stencils, the indirect or transfer photo stencil, the carbon tissue method, and others. All, however, function on the principle of light-hardened gelatin. This can be explained, in a limited way, through the *indirect* method.

INDIRECT PHOTO STENCIL

Assume that you have a source of light, a photographic positive or a drawing (Fig. 307), and a light-sensitive gelatin film. Further assume that the photographic positive (on an 85-line halftone screen) and the light-sensitive gelatin film (temporarily supported on a transparent backing such as Mylar) are locked together, emulsion sides facing each other, in a photographic vacuum printing frame (Fig. 308). Exposure to light will *harden* all the gelatin under the *transparent* areas of the

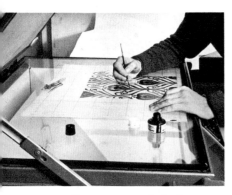

307. Drawing on a light box with opaque photographic ink.

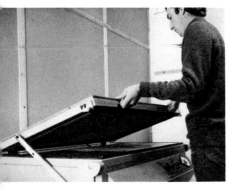

308. Placing the drawing in a Grapho-screen light box, lowering the vacuum frame lid, and exposing the film to mercury vapor lamps.

photographic positive, and leave undisturbed (or *soft*) the gelatin under the *opaque* areas.

Consequently, when the gelatin film is removed from the vacuum frame and *developed* or *etched* in hot water or the appropriate developing solution, the unhardened areas of the film wash-out (Figs. 309, 310). This leaves the light-hardened sections of the film as a resist, which provides a photographic stencil easily transferred to a 16xx silk screen (Figs. 311, 312). Blot the stencil dry (Fig. 313). The backing is removed, and printing proceeds in the usual manner (Figs. 314–320).

DIRECT PHOTO STENCIL

Reduced to outline form, here is the *direct* approach to photographic stencils for serigraphy:

Color Separation

1. Secure the drawing to a board.
2. Place a sheet of .005 frosted acetate over it, dull side up.
3. With photo-film retouching medium, or other *opaque* ink, paint the *positive* areas (the areas to be printed).
4. Draw register crosses or T-bars.
5. Repeat for each color to be screened.
6. On a light box, superimpose all the film positives. Align them according to the register marks. Correct faulty registration and other errors with a damp cloth. Retouch suspicious-looking translucent lines or areas to make them opaque.

Registering the Film Positives and Screens

1. Prepare screens with 10xx silk; wash them to remove lint and dust.
2. Align each film positive and each screen with care, placing the film positive *under* the screen.
3. On the *inside* of each screen trace the register marks with a pencil.

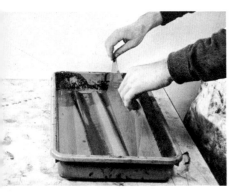

309. Fixing the exposed film in a solution of hydrogen peroxide.

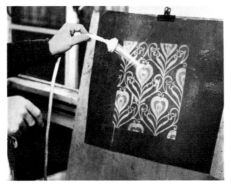

310. Wash-out of the film. First a hot-water spray should be used, then a cold one.

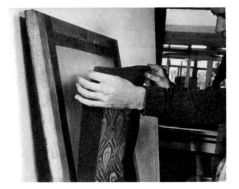

311. Affixing the washed-out film to the screen.

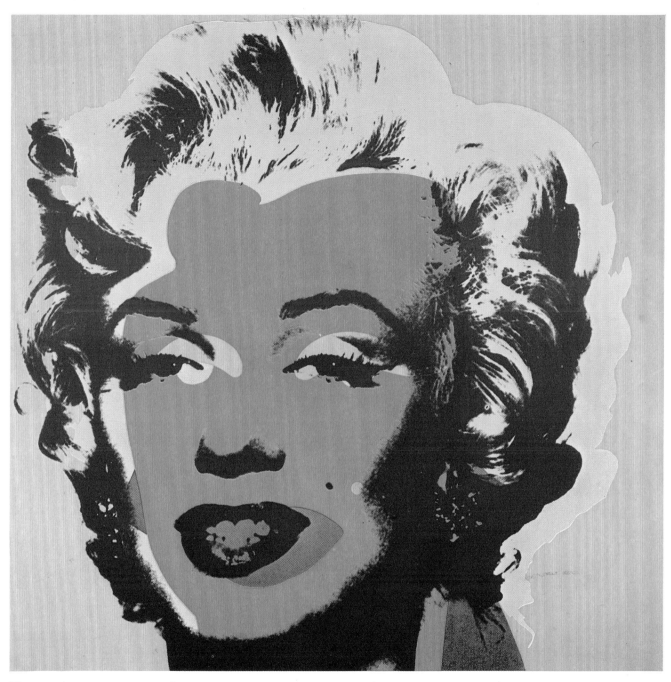

Plate 44. ANDY WARHOL. *Marilyn Monroe.* 1968.
Color serigraph, 36″ square. Leo Castelli Gallery, New York.

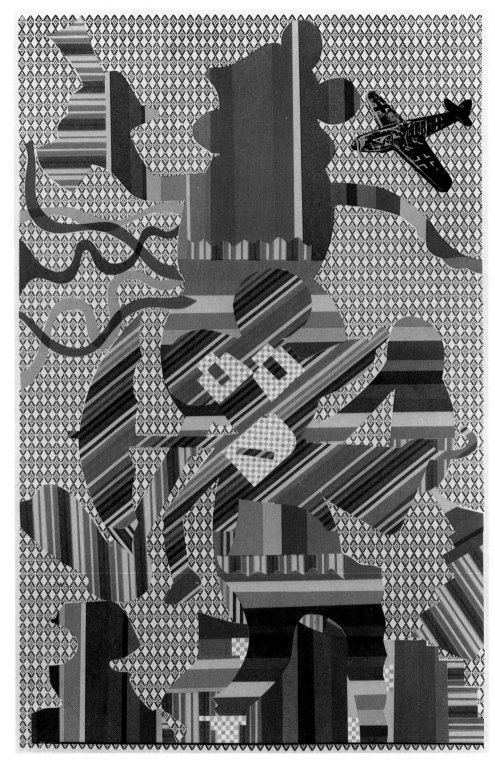

Plate 45. EDUARDO PAOLOZZI. *Exhausted*. 1965.
Color serigraph, 37½ x 25½". Collection York University, Downsview, Ontario.

312. The film on the screen.

313. Blotting the film.

314. Squeegeeing paint. Note the paper block-out beneath the screen between the edge of the photo stencil and the outer edge of the frame. Any appropriate material can be used.

315. Screen fully covered with paint.

316. The printed image appearing through the screen.

317. Flood coating the screen. With very little pressure, move the color across the screen but *not through* the mesh in preparation for the next print which will push the color through. Screen is raised slightly with left hand.

318. Raising the screen from the print.

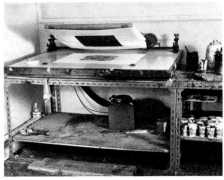

319. Portrait of the printing area.

320. Cleaning the screen with an appropriate solvent.

Coating the Screen

1. In a semidark room, prepare a mixture of 5 parts of a proprietary prepared emulsion and 1 part ammonium bichromate.
2. Place the screen as for printing. Pour the mixture on a long edge between the tape and the silk.
3. With a *metal*-edge scraper or squeegee, draw the emulsion across the silk without hesitation. Wipe the scraper clean. Squeegee the silk area again to thin the coating. Fan dry.

Exposing Procedure

1. On a light table, secure the film positive to the glass, *frosted side up.*
2. With the screen in printing position, you should then align the registration marks.
3. Bring the screen and the film positive together by weighting the inside of the screen. Place a $\frac{1}{4}$-inch etching blanket inside the screen, and weight it with heavy plywood and a lithographic stone.
4. Expose from two to five minutes.
5. Remove the weights and examine the screen. A pale, latent image should be visible.

Developing Procedure

1. Using hot, warm, or cool water (dependent upon the manufacturer's instructions), hose down and wash out the image.
2. Fan dry.
3. The undrawn areas (now the resist) will have hardened. Check for pinholes, and correct them.
4. Print in the normal fashion.

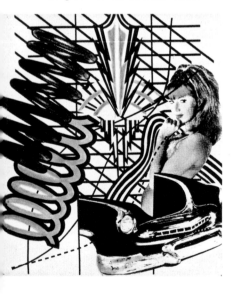

321. Peter Phillips. *Custom Print I.* 1965. Serigraph on aluminum foil, 24 × 19$\frac{7}{8}$". Rosa Esman, Original Editions, New York.

SOME EXAMPLES OF PHOTOGRAPHIC SCREEN PRINTS

Any sort of material can be photographed to produce the film from which a photographic stencil is made. For this reason the technique has had a particularly strong appeal for artists who are or have been oriented to the Pop movement; it facilitates the use of images directly derived from the mass-communications media—the sort of material that these artists often incorporate into their works.

Andy Warhol (b. 1930)—painter, sculptor, film-maker, and master of the Pop image—has made more than a hundred silk-screen prints, which he does not think of as prints, since he views all media as mixed. For the most part, Warhol's prints derive from photography, especially from candid shots of public personalities (Pl. 44, p. 295). Though the screens are commercially made, the artist usually prints them in his own studio.

In Figure 321 British artist Peter Phillips (b. 1931) printed the girl, the automobile, and the coil by photo screen, using high-varnish inks on shiny, silver foil to attain an aggressive Pop effect.

Robert Rauschenberg (b. 1925), whose combination of silk screen with lithography appears in Figure 107, has executed in Figure 322 a photographic silk screen that provides the dramatic journalistic impact of photomontage. This artist also uses silk screen to print on linen and to transfer images to the canvas support of his oil paintings.

In Figure 323 James Rosenquist (b. 1933) has assembled fragments of photographs whose only apparent relationship is shape. Like all Pop artists, he takes his subject matter from mass culture, letting irony reveal the content for what it is, or is not.

Tom Wesselman (b. 1931) encountered a technical problem of achieving in silk screen the necessary fine shading for the smooth, unblemished surfaces of his well-known Pop nudes (Fig. 324). His solution was to have the shading airbrushed by an expert under his supervision. The art was then photographed through a random-texture screen, which broke it down into an irregular dotted pattern. In order

below left: 322. ROBERT RAUSCHENBERG. *Signs.* 1970.
Silk screen, 43 × 34″.
Leo Castelli Gallery, New York.

right: 323. JAMES ROSENQUIST. *Whipped Butter for Eugen Ruchin.*
1965. Serigraph, 19⅞ × 24″.
Rosa Esman, Original Editions, New York.

below right: 324. TOM WESSELMAN. *Nude.* 1969.
Serigraph from 23 screens, 23 × 29″. Courtesy the artist.

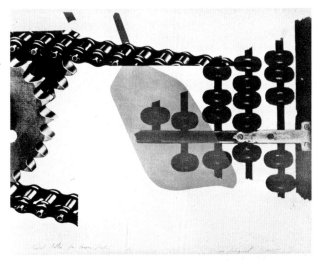

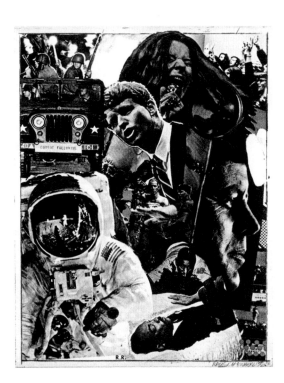

to let the ink through the tiniest dots, a fine nylon screen was substituted for the usual silk. The printing required 23 screens.

Ronald B. Kitaj (b. 1932) is a British-trained American artist who played a significant role in the development of Pop Art at its origins in England. He uses the photo screen to combine and associate his seemingly random elements into a controlled design. In the collage manner he includes textured papers and pastes on three-dimensional objects. The rectangular card in Figure 325 was collaged onto each printed sheet. His purpose was to create "an allusive conjunction of images—insinuating signs for a vital disorder." Even in his painting Kitaj finds that screen printing collects and composes images with a great economy of time and effort. The artist's passionate literary interests perhaps account for the remarkably wide range and eclectic character of his pictorial imagery.

In Plate 45 (p. 296) Eduardo Paolozzi (b. 1924) has placed a small photographic image of an airplane in the upper right-hand corner of a complicated arrangement of flat and strongly patterned shapes. Like Kitaj, Paolozzi was a founder of British Pop in the mid-1950s. To the two-dimensional print form he has translated the monstrous semi-human, compellingly real shapes of his sculptures, which are assemblages of machine elements. An experimenter in style, content, and media, Paolozzi has done films, books, and etchings as well as sculpture and serigraphs.

Joe Tilson (b. 1928), another pioneer of British Pop, sought in Figure 326 to create an "archetypal and mystic" presentation of one of the five senses. The edges of a film strip exaggerate the photographic character of the image, and, at the same time, isolate and dramatize the startling eye. The print was pulled on paper and transparent plastic.

left: 325. RONALD B. KITAJ.
The Defects of Its Qualities. 1967.
Screen print and collage,
$35\frac{1}{2} \times 24''$.
Marlborough Graphics Ltd.,
London.

right: 326. JOE TILSON.
Transparency Clip-O-Matic Eye.
1969. Screen print
on acetate film
with metallized acetate film;
$28 \times 20''$.
Marlborough Graphics Ltd.,
London.

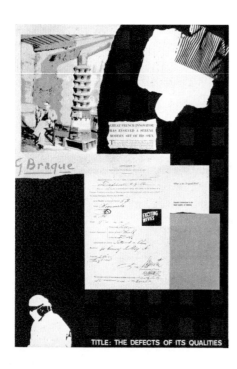

Workshop Solutions to Screen Printing Problems

The tusche drawing is difficult to remove from the screen
Cause: The tusche applied was too thin, or the glue mixture was too thick.
Solution: Instead of rags, try using a nail brush or toothbrush. Do not scrub in a rough manner, or you will damage the screen.

The screen clogs while printing
Cause: The paint dried too rapidly, closing the pores of the fabric.
Solution: Remove the screen, and wash with a rag and solvent. Add mixing varnish or transparent base to your paint plus a few drops of Varnolene, mineral spirits, or retarder solution.

Cause: Lint from printing paper or rags or tissues is responsible.
Solution: Run a still moist print under the screen. The lint will be picked off in that manner.

Registration of the print becomes faulty
Cause: Registration guides or tabs have gotten out of alignment.
Solution: Realign and test.

Cause: The hinges holding the printing frame to the baseboard may be loose.
Solution: Tighten, and try again.

Cause: The silk may not be taut enough over the printing frame.
Solution: Restretch the silk.

You desire unusual textures and special effects

Cause: To find materials and techniques to satisfy your needs.

Solution: Try makereadies on top of your baseboard and under the printing paper. These may be low relief collages of string, wire screen, leather, and so on, pasted on cardboard. Experiment with other materials. Then pull a print.

Using a syringe filled with china clay and glue, try making linear patterns on the screen. When dry, print in the usual fashion.

Brush, drip, or pour kerosene in areas on your silk screen. (These kerosene-soaked areas or linear patterns are the "positive" aspects of your screen. That is, they will pass color through to the printing paper.) Cover the screen with glue, as you would for the tusche-resist method. The glue will "creep" away from the kerosene areas. When the glue is dry, print in the normal way.

To obtain a "crackle" effect, mix and employ a glue stencil that is overly thick. For a "spatterlike" effect, deliberately use an overly thin glue stencil.

Tusche lines print with fuzzy edges

Solution: To make tusche lines print in a more precise fashion, make a size composed of 1 teaspoonful of cornstarch to 1 cup of water. Sponge this size on the bottom of your screen and allow it to dry. Then, apply your tusche in the usual manner.

You wish to "screen" some typewritten words or letters

Solution: Cut a mimeograph stencil on a typewriter. (It is also possible to draw on one with a stylus for certain results.) Affix the stencil with masking tape to the underside of the screen. Tape or block out the silk from the borders of the mimeograph stencil to the edges of your silk screen. Thin your ink or paint at the time when you are ready to print.

Print margins begin to show paint or ink stains

Cause: Paint or ink too thin.

Solution: With a rag kept handy for just this purpose, wipe the bottom side of the screen from time to time; change and/or alter the consistency of the paint.

Certain parts of the print do not screen well

Cause: The paint or ink consistency wrong.

Solution: Remove the paint from the screen with a piece of cardboard; alter by adding the proper reducer, thinner, varnish, or whatever is required for that particular paint to improve its working characteristics. Pour the paint back in the screen and continue printing.

Cause: The squeegee requires sharpening.

Solution: On the assumption that a makeready does not remedy the situation, check the rubber blade of your squeegee. It may be rounded or otherwise marred. Resharpen the blade on garnet paper or the abrasive provided by your local supplier for this purpose.

The image prints double or blurs during screening

Cause: The silk is not taut enough.

Solution: A makeready built up of tape applied close to the defective area on the underside of the screen may correct the difficulty. If not, the silk must be restretched.

Certain areas of the print develop unwanted specks or spots

Cause: There are pinholes in your stencil, or lint on or under it.

Solution: Hold the stencil up to the light to locate leaks in the stencil, and touch a brush filled with the proper block-out to each pinhole of light that is visible.

Workshops, Equipment, and Materials

Life without industry is guilt,
industry without art is brutality.

John Ruskin

Rags are brought unto my mill
Where much water turns the wheel,
They are cut and torn and shredded,
To the pulp is water added;
Then the sheets 'twixt felts must lie
While I wring them in my press.
Lastly, hang them up to dry
Snow-white in glossy loveliness.

Hans Sachs, 1568

25

The Print Workshop

Whether simple or elaborate in space and equipment, print workshops all have a certain atmosphere in common. Equipment and presses devour much of the existing space, the smells of inks, dyes, paints, solvents, acids, and fine papers combine to assault the nose, and raw sounds, not unlike electronic music, simultaneously strike the ear. Typically you will see two or more enthusiastic printmakers arguing a moot point, attempting to find equivalents for age-old formulas, discussing trichromatic halftone problems, or pondering a method for "unwrapping" a three-dimensional form or for printing the inside of a curved surface.

For some time to come, there will probably be three distinct varieties of this print workshop in existence or in the planning stage. The first would be the *conventional workshop* with facilities for planographic, relief, intaglio, and serigraphic printing with traditional and certain improved materials and supplies. Essentially, such a shop contains fine hand presses, stones, plates, and the necessary ingredients to teach printmaking. It also provides for limited editioning of the work of instructors, invited artists, and a certain number of graduate students. The second would be a *transitional workshop* capable of meeting the same needs but, in addition, providing one or more motorized or computerized industrial presses, platemaking facilities, including a plate whirler, vacuum frame, photocomposing machine, projection machine, arc lamp, and special developing sinks. The third variety is a *research workshop* that encompasses the facilities of the two previous types of shop and is available for use by *students* of printmaking and professional artists.

It will allow immediate application of research findings in inks, papers, platemaking, presses, and the chemistry and physics of printing *and* include a laboratory staffed by experts in chemistry, physics, mechanics, and aspects of engineering, as well as by artists, master-printers, and others who may contribute to the forward motion enjoyed by the print. It is clear that such a workshop would require the joint support of industry and university personnel, in addition to governmental and foundation assistance, if it is to be encouraged to develop, and is to survive the rigors of competitive societal needs.

The industrial and commercial worlds demand and receive from the printing industry new tools, new applications of old tools, new materials, new processes. The computer and automation are rapidly converting many hand skills to controlled machine processes. The laser will soon be used by artists and teams of advisers to create precise three-dimensional forms from two-dimensional autographic or photographic designs. Electronic devices already analyze color sketches or finished compositions and engrave the several color separations upon a number of single plates which, with autographic additions and deletions by the artist, may result in new possibilities for the printmaker. There are new plates (negative- or positive-working diazo-sensitized plates, negative-working polyvinyl alcohol-coated plates, light-sensitive deep-etch plates, bimetal and trimetal plates, in addition to greatly improved surface plates); new inks (heat-set, dry-offset, magnetic, moisture-set, and others); new papers and other supports for the print; almost unbelievable presses; and an entirely new chemistry to accompany the printing revolution. All of this, in one form or another, will provide a man-machine environment in which man, as a programmer and designer, will realize new work.

This does not eliminate the lone individual who feels more comfortable with the simple chemistry, mechanics, and autographic approaches possible in his own printmaking studio—the artist who neither has need for nor inclination toward technological sophistication.

left: 327. Collectors Press workshop, San Francisco.

right: 328. Pratt Graphics Center workshop, New York.

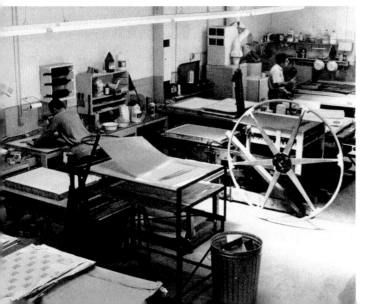

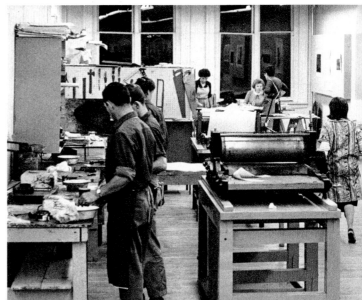

Even for workshops of a particular type with definite objectives, there is no ideal "workshop design" that will meet the requirements in every case. In theory, there should be separate areas for each of the printing processes, but even in this respect most situations are far from utopian. Each shop has its own problems in terms of space, equipment, and the volume and type of work carried out. Figures 327 through 330 show views of several well-known workshops whose operation could help printmakers to analyze their own organizational problems.

left: 329. Tamarind Lithography Workshop, Inc., Los Angeles, California.

right: 330. Wimbledon School of Art workshop, England.

THE PROFESSIONAL PRINT WORKSHOP

A question that arises for the artist who wishes to make prints today is whether he can best depend upon his own skills to produce effective prints within the limitations of his own studio or whether he wishes to take advantage of the technological know-how and the installations available in a professional workshop. In writing this book, the author has assumed that the serious printmaker will wish to pull some, if not all, of his own prints, or that he will at least wish to understand the basic processes well enough to collaborate effectively with a professional printer—a collaboration that is considered a requisite for the production of an edition of original prints.

As the illustrations in this book show, there are many fine printmakers who achieve their results by relatively simple techniques. There are also many who happen to be technologically inventive and who have produced work by highly innovative processes in their own studios. In both categories, there are artists who execute every step of the process and take pride in pulling every print by hand. At the same time there are some who can execute their ideas only (or better) with technological assistance. In particular, the workshops have made possible the production of multiples by many well-known painters and sculptors who might otherwise have felt that they could not take the time to acquire the necessary skills or to execute the actual works.

There is no doubt that such enterprises as Tamarind, Gemini G.E.L., Collectors Workshop, and the Bank Street Atelier—to name a few—have not only attracted artists to the print medium but have also brought a high standard of quality, superb craftsmanship, and technological advance to the art of the fine print. This complete professionalism stimulates some artists to greater achievement; on the other hand it creates an environment that tends to inhibit others. The artist must determine for himself how he works best. In the meantime, underlying these highly professional activities are the small, medium, and large workshops in universities and art schools throughout the world, where, basically, the ideas of the next generation of printmakers are being formulated.

In the early days of printmaking separate métiers for designer and technician were taken for granted. It has been noted, for example, that Dürer, on occasion, made use of a technician whom he supervised in the execution of the blocks that were sold as his own woodcuts; that the workshop of Finiguerra launched a manner of craftsmanship in Florence; that Raimondi executed multiples for Raphael; and that the Japanese by the seventeenth century had organized a clear-cut division of labor in the production of their woodcuts. When lithography was a new invention, the shop set up by Philipp André in London, with the aid of the inventor Senefelder, influenced some of the most famous artists of the time to turn their efforts toward production in the new medium. Few artists would have expended the time and cost of setting up such equipment and learning its use without the backing of an establishment, but, given the opportunity, almost anyone within reach would try his hand at so promising a technique. Similarly, more than a century later, many of the French Impressionists were taking their designs to the atelier of Auguste Clot for execution in color lithography. Bonnard, Vuillard, Toulouse-Lautrec, and such occasional printmakers as Cézanne and Renoir, all used the services of professional technicians. Works by Whistler and other famous etchers were executed at the atelier of Auguste and Eugène Delâtre. (For those who wish to pursue more extensively the historical relationship of the graphic artist to the technician, the works of Arthur M. Hind on woodcut and on engraving and etching are recommended.)

In the first half of the twentieth century, workshops seemed to thrive more successfully in Europe than they did in America, where many artists were printing their own works or, in some cases, having them printed abroad. A highly important figure in twentieth-century developments is the British artist Stanley William Hayter, who established the Atelier 17, first in Paris, and, for a period after 1940, in the United States. This, along with other contemporary groups, contributed much to what today is called the *revolution in printmaking*.

During the past decade or so a radical change has occurred in the situation in America. Spurred by a greatly increased demand for mul-

tiples and an expanding interest in technology as related to art, as well as by the requirements of the new art styles, a number of independent workshops have been founded, and many universities have greatly expanded the technological facilities of their graphic departments. These developments have been brought to public attention by a trend toward organizing exhibitions around the output of particular shops. For example, the Cincinnati Art Museum focused an exhibit upon nine graphic workshops in America (catalogue by Mary W. Baskett, *American Graphic Workshops,* 1968). Two shows at the Museum of Modern Art in New York have served to highlight the character of the work being done at the Tamarind Lithographic Workshop and by Gemini G.E.L. (1969 and 1971, respectively).

The commercial exigencies and the financial expenditure necessary to support a well-equipped and staffed workshop are a considerable hazard to individual enterprises. Without foundation money, university funding, commercial sidelines, or the reputation of a long-time or multigeneration firm, many worthy workshops are likely to founder; and anyone who wishes to keep abreast of current developments would do well to follow announcements made in the art periodicals. A particularly good coverage in this regard is given by the annual *Artist's Proof* (published by the Pratt Graphics Center and Barre Publishers), which reports regularly on the workshop situation both in the United States and in other countries.

DOCUMENTATION OF PRINT OUTPUT

The introduction to this book referred to the important contribution made by the professional workshops that maintain records of their activities and of the multiples they produce. If accessible, such records, which include technical processes, printing history, edition data, and disposition of plates, not only protect the value of the print on the market but also serve as a running history of the technological advances and the experimental work now so prominent in the print field. Two examples of record sheets, which were supplied by the workshops for two of the prints reproduced in this book, are shown in Figures 331 and 332.

Record-keeping is especially important for the beginning print-maker, and it is urged that you keep a log from the day you pull your first print. A student's log may be somewhat different from a professional workshop record; it might well be more detailed, especially in regard to the drawing techniques used for specific areas of the print, and it should record the failures as well as the successes on which you will base your further efforts. Figure 333 is a sample sheet from a log kept in 1957 by one of the author's students. The student, Raydelle Josephson, was at the time studying commercial offset printing practices in order to better understand and produce original lithographs.

TAMARIND LITHOGRAPHY WORKSHOP, INC. Francis (10)

Artist: Sam Francis

Title: Untitled Tamarind No. 2588
 Printed between March 26 and April 7, 1969.

A seven-color lithograph printed in three runs as follows:

 Note: Each of the seven colors was applied individually to the
 plates.

1. Zinc: red (90% Hanco Fire Red, 5% Hanco Standard Orange, 5% Hanco
 Tint Base); blue (88% Sinclair & Valentine Royal Blue, 2% Sinclair
 & Valentine Purple, 10% Hanco Tint Base); green (85% Hanco Thalo
 Blue (Green)). Execution: La Favorite stick tusche mixed with
 water applied with brush.

2. Zinc: orange (80% Hanco Standard Orange, 20% Sinclair & Valentine
 Special Chrome Yellow); yellow (100% Sinclair & Valentine #404
 Yellow). Execution: see run #1 above.

3. Stone: purple (60% Hanco Tint Base, 20% Sinclair & Valentine Purple,
 20% Sinclair & Valentine Permanent Rose Red); green (60% Hanco
 Yellow Shade Green Toner, 10% Sinclair & Valentine Special
 Chrome Yellow, 30% Hanco Tint Base). Execution: see run #1
 above.

Paper size 26" x 38½", torn and deckle edges; bleed image.

Record of printing:

 1 Bon a Tirer on uncalendered Rives BFK
 7 color trial proofs (numbered) on calendered Rives BFK as follows:

 I with run #1 and run #2 only, like the edition
 II with run #2 and run #3 only, like the edition
 III with runs #1, #2 and #3 in Charbonnel Noir a Monter
 IV with run #1 only, like the edition
 V with runs #1, #2 and #3, darker than the edition
 VI with runs #1, #2 and #3 like the edition; paper measuring 28½" x 40½"
 VII with runs #1, #2 and #3 like the edition; paper measuring 25" x 36"

 3 artist's proofs on uncalendered Rives BFK
 9 Tamarind Impressions on uncalendered Rives BFK
 20 artist's edition (numbered) on calendered Rives BFK
 1 cancellation proof on calendered Rives BFK

All other proofs and impressions have been destroyed.
The zinc plates have been effaced.
The stone has been effaced.

This lithograph bears the chop of candidate-printer Charles Ringness.

331. Worksheet of Tamarind Lithography Workshop, Inc., for Plate 8 (p. 61).

ARTIST: David Hockney

TITLE: Picture of a Portrait in a Silver Frame

GEMINI LTD. No. 118
 "Right to Pull" print made on October 14, 1965
 "Cancellation" print pulled on November 13, 1965
 Printed between September 20 – November 13, 1965

DESCRIPTION

Execution: The drawing of the man was made with crayon and
 brush using tusche diluted with water on stone.
 The solid gray and blue were made using Korn's
 autographic applied by brush to aluminum plates.
 The pink was drawn on the plate with crayon and
 Korn's autographic was sprayed on with an atom-
 izer for the splatter technique. The final color
 of dark gray was drawn on an aluminum plate using
 crayon.

Colors: First: Cobalt blue made from Sinclair and
 Valentine Thalo blue (red shade),
 Vermilion and opaque white. (Back-
 ground)

 Second: Bright pink made from Sinclair and
 Valentine Vermilion Red, opaque white,
 Thalo blue (red shade), and transparent
 base. (Skin and Splatter)

 Third: Black - G.P.I. black and transparent
 base. (Wash on face and crayon drawing
 of torso)

 Fourth: Transparent gray - G.P.I. Black, trans-
 parent base, Thalo blue and opaque white.
 (Frame color)

 Fifth: Dark gray was made from G.P.I. Black and
 opaque white. (Design on frame).

Paper and Size: Rives BFK, cut by hand to a hard edge of 22¾" x
 30¾".

This lithograph bears the stamp of Gemini Ltd. and Editions Alecto No. 13.
Collaboration was between Artist and Master Printer Kenneth Tyler with
assistance of Master printer, Bernard Bleha and printers Herb Fox and
George Page.

332. Worksheet of Gemini G.E.L. for Figure 79.

Name	Material and Size	Preparation	Printing	Stock	Notes
Prayer (3-color)	Stone, 16 X 20	1) Spattered with tusche diluted with distilled water; 2) Brush wash with same; 3) Same with incised lines. Etch:3; 75 drops HNO₃: 1 oz. H₂O.	1) Cerulean Blue; 2) Bronze blue; 3) Flesh tint. Normal procedure, using punched cross register. Paper stretche 1/8 in.	Fiesta cover, white.	1) Margins blacked up after 15th print; cleaned. 2) Not as transparent to cerulean as expected; 3) Cut edition to 10, saving 10 for substitution of woodcut for 3rd stone.
Santa Anita	Stone, 10 X 12	Transfer to stone from Strathmore charcoal paper. All work in no. 3 crayon. Etch: 20. Special care in grinding stone for flatness. Paper dampened. Pressure about same to print.	Normal.	Arches lightweight, white.	Satisfactory transfer.
Tidepool	Stone, 10 X 12	Engraving and scratching thru areas blacked with crayons no. 2-4 and brushed tusche. Same areas blacked over incising. Etch: 40.	Normal.	Same.	Enjoyed working stone in this method and find results predictable.
Christmas card	Zinc plate, 15½ X 20½, for Little Chief press; Grain 50 (coarsest): Cost $1.38. .50 to regrain. Max. sheet size: 14 X 20 Source: Lithoplate Co. 5601 Valley, L.A.	Harris-Seybold Counter Etch applied with sponge and rinsed with tap water. (Active agent is chromic acid.) Used no. 2 crayon only. Gummed with prepared gum, 14 degree Baume, applied and rubbed with sponge, dried with kleenex to polish.	Auto-litho by Welsh Printing co., Pasadena. Allowed no clean-up. No problems reported. Cost: $9/1000 plus stock.	Oatmeal (natural screenings).	Successful reproduction.
Pont Neuf	Zinc plate, 10 X 15½, for Multilith press; Grain 180 (fine): Cost: $.44. .25 to regrain. Sheet size: 7½ X 9½ (Max. sheet size: 10 X 14	Tusche with pen and brush; crayons 2 and 3, toning only by hatching broadly.	Auto-litho by Pasadena Lithographers, Pasadena. No clean-up allowed, but some done in error. No problems reported, except technique not clean enough to suit printers.	Linweave text, dark blue laid. Ant. Fin. D.E.-P.O. 25 X 38, 140M, Basis 70 Grain long. Linweave Paper Ass'n.	Some details of crayon work lost; printer attributes to stock, as borne out by trials on other stocks. Cost: $2.20/1000 plus stock.
Fallen Giant	Multilith Sheet size: 9 X 12	Same as Christmas card, except right arm of standing sahuaro drawn with pen and scraped with razor after gum; line replaced with crayon, then re-gummed.	Printed on litho hand-press, placed on top of 16 X 20 stone; newsprint between plate and stone.	Linweave Ivory Wove, D.E. Plate finish, 60 basis.	Plate reproduced well, but drawn with too many strike-overs. Experiment to remove line failed. Plate did not slip on stone appreciably.
Sandwich	Multilith Sheet size: 9 3/8 X 12½	Same as Christmas card.	Printed on etching press, using rubber offset blankets. About same pressure as for etching.	Suede Book, 60 sub. Mead Paper Co. (obsolete stock)	No difficulties with press; gave especially celan prints, with all details.
Jungle (2-color)	Multilith Sheet size: 8½ X 11 (oversize for register)	Tusche with pen, crayons on key plate; tusche with brush on tint plate.	Auto-litho by Pasadena Lithographers. No clean-up. Red tint ink ordered transparent. Cost: $4.40/1000 plus stock.	260M Tweedweave. Felt finish, forest green. Curtis Paper Co.	Good register and reproduction, except for loss of detail in tint plate. Paper too textured, colors ugly, mood wrong.

333. A student worksheet maintained by Raydelle Josephson.

26

Presses

Although both woodcut and screen prints can be executed without the benefit of a press, this piece of equipment is basic for the production of lithographs and intaglio prints. It constitutes, therefore, a major investment for any print workshop. The following information is intended only as a basic description of the types of equipment that are available and the purposes they serve. The printmaker confronted with the problem of selecting and purchasing a press will, of course, survey the catalogues of the various suppliers (see pp. 330–331) and determine what will best suit his own needs.

LITHOGRAPHIC PRESSES

Although it may be apocryphal, there is a story still extant that Senefelder's original scraper press derived through accident rather than by design. It is reported that the wooden top cylinder of a sort of etching press he invented developed a 2-inch crack along its longitudinal axis. For reasons unknown, he continued to print. The resultant drag or scraping action across the stone, caused by the damage, provided the inventor of lithography with better lithographic proofs than were previously obtained and established the principle upon which all scraper presses are based.

Whatever the truth, there are but two major types of scraper presses manufactured for *direct printing:* the relatively inexpensive side-lever scraper press and the top-lever press (usually employed for collotype printing, but well suited for printmakers).

Side-Lever Transfer Press

In geared form, the side-lever transfer press (Fig. 334) is the most popular and serviceable press for lithography. It minimizes the physical exertion required when pulling large editions of prints. A press bed large enough to accommodate a stone about 30 × 40 inches should satisfy most printmakers.

The well-constructed, sturdy frame supports a movable wooden bed and a steel cylinder. Steel runners are fixed to the underside of the bed to allow the cylinder proper contact. The bed rides on friction rollers or slides, dependent upon the manufacturer's design. All of the force is brought to bear upon the scraper, which is covered with a 2-inch-wide strip of leather stretched tautly from end to end of the hardwood. The scraper is housed in a scraper box and held in place by a retaining screw.

When a proof is to be pulled, printing pressure is brought about through a cam, and the bed is propelled through the press by a friction cylinder. The mechanics are as follows: Pressure is exerted by pulling down the pressure lever. This action revolves the cam 90 degrees, which pushes up the cylinder bearing, the cylinder, and the bed tightly against the scraper. Thus is printing pressure obtained, as well as the necessary friction between bed and cylinder. Hand or motor power, through a crank shaft coupled with a gear, is required to move the bed through the press.

Through trial and error, the optimum pressure for each stone can be found: Adjust the pressure until the pressure lever, which is tested from time to time, "feels" heavy at about the ten o'clock position. (Adjustment of the pressure screw transfers pressure to the scraper from the yoke or crosshead.) Note that the bottom of the pressure screw and the top of the scraper box are connected through a self-aligning joint. This aspect of design allows the scraper to compensate, to a degree, for unevenly grained stones.

334. Side-lever transfer press.

Top-Lever Press

The top-lever press (Fig. 335) is of German origin and operates on a principle different from that of the side-lever press. Pressure is applied by pulling down a lever hinged to the top of the yoke. This action forces the scraper *down* onto the stone or plate on the bed of the press, whereas the side-lever press pushes the bed *up* against the scraper.

Correct pressure for printing can be obtained in the following manner: Turn the hand wheel on the pressure screw above the scraper box to wind up the scraper. Pull down the pressure lever and wind down the scraper until it "kisses" the tympan. Release the pressure lever. Increase or decrease the pressure for optimum results when proofing a print.

Offset Lithographic Presses

The direct, hand-operated, lithographic-stone transfer press was followed by the invention of a machine-operated direct lithographic transfer press. This, in turn, led to hand offset lithographic printing presses, which were followed by flatbed offset presses and, finally, by the huge rotary offset widely used in commercial printing. The primary difference between direct lithographic printing and all offset lithographic printing lies in the fact that the printed sheet of paper comes in direct contact with the stone or plate in the *former* process, whereas it receives its printed image from a rubber blanket in all of the *latter* processes (Figs. 336, 337).

Readers interested in detailed information about offset lithographic presses are referred to manuals published by the graphic arts industry,

335. Top-lever press.

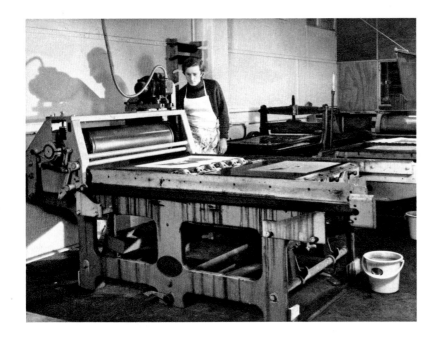

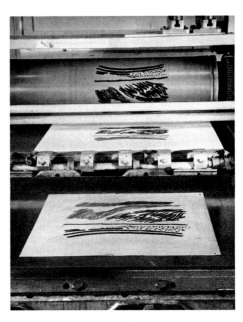

left: 336. Offset press.

above: 337. Offset press,
showing principle of operation.

their research foundations, and the many schools operated by the
lithographic unions—or to a friendly local printer, who probably will
be glad to supply a bit of advice.

INTAGLIO PRESSES

An etching press is composed of a rigid bed that passes between two
rollers. This over-simplified description of the most salient piece of
equipment in the intaglio workshop applies to all etching presses—from
an inexpensive, hand-operated, table-model press to a large, floor-
model, geared and motorized, professional piece of equipment.

Since it would be unwise to print a small plate on a large press
and it is difficult or impossible to print a large plate on a small press,
you must either select from what is available on the market or consult
with your local machinist to build or modify an old press that meets
the requirements of your largest work.

The combined experience of many printmakers suggests that the
press selected should have a *bed* machined of solid steel no less than
$\frac{3}{4}$ inch in thickness and measuring more than 2 feet in width and up
to 4 feet in length. The *top roller* should be at least 7 inches in diameter,
and the *drum*, which should be manufactured of 1-inch steel, should
measure no less than a foot in diameter. It should be geared and

motorized for ease of operation. There are many variations available, of which two are shown in Figures 338 and 339.

A press that has found considerable use in workshops and art schools is the Dickerson Combination Press, which can be converted within a few minutes from an etching press to a conventional lithographic press. Figures 340 and 341 show two renderings of this press, one with the roller installed for intaglio work and the other with a scraper, for lithography. Invented about a decade ago, this piece of equipment is available either with a motor or for hand operation.

Whatever press you choose, it must be leveled, and the bearings must be well greased. Without printing pressure, make certain that the bed of the press does not ride on the drum. Since the drum may be leveled independently of the top roller through the employment of metal shims placed under the axle bushings, adjust and readjust the number of metal shims until newsprint strips can be pulled through the space between drum and bed. Test for uniformity of pressure by inking the *drum* and running a sheet of paper between the drum and the bed. Readjust the shims, and repeat, if necessary.

RELIEF PRINTING PRESSES

The invention of movable type, generally credited to Johann Gutenberg of Mainz, an adaptation of the papermaker's or bookbinder's press, and the manufacture of paper coincided in the fifteenth century to create a printing explosion and a cultural revolution. Impressions from inked relief surfaces were known prior to this radical development, as

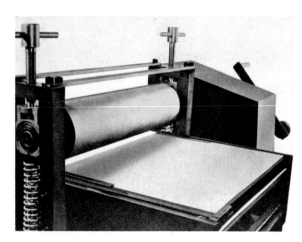

above: 338. Intaglio press.
Charles Brand Machinery, Inc.

right: 339. Intaglio press.
Graphic Chemical and Ink Co.

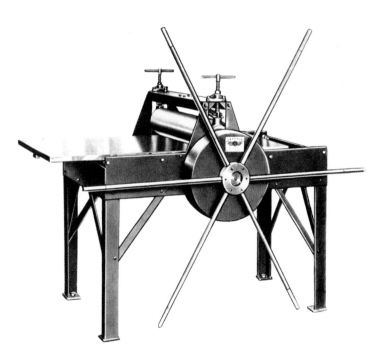

316

the history of the woodcut reveals, and many woodcuts are printed by rubbing rather than on a press. However, the development of these early types of presses is of great interest.

The early relief printing presses were solid, cumbersome wooden contrivances that reflected the skills, or lack of them, of the joiners engaged for their manufacture. Various improvements upon the wooden press were effected for more than three hundred years.

About 1813, a Philadelphian named George Clymer invented the ornate Columbian Press (Fig. 342). The cast-iron American eagle, which dominated the press and acted as a counterweight, appeared to alienate European printers and press manufacturers. Until the conclusion of the nineteenth century, mutations of this press appeared with appropriate national insignia, or other symbols, which were substituted for the eagle. Press pressure was generated by a series of levers connected with the counterweight.

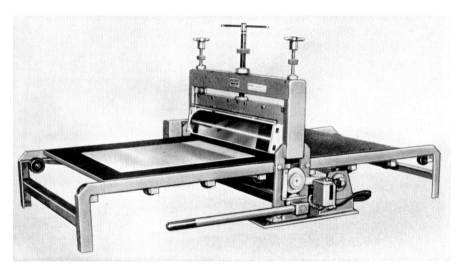

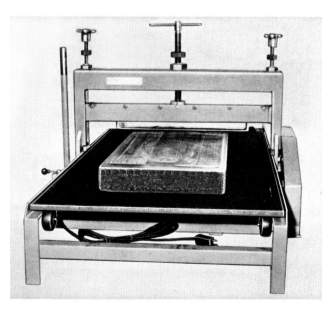

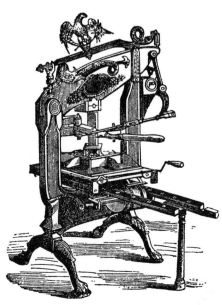

above left: 340. Dickerson Combination Press, with plate.

below left: 341. Dickerson Combination Press, with stone.

below right: 342. Columbian Press.

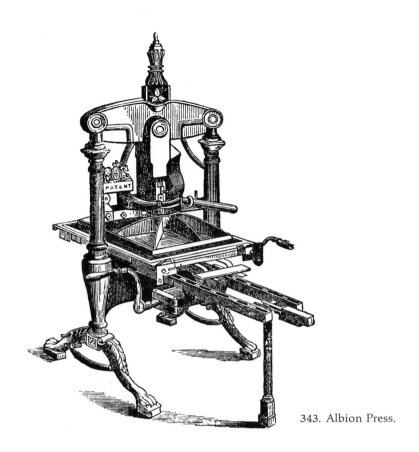

343. Albion Press.

The Albion Press (Fig. 343), an English invention (c. 1820) by R. W. Cope, obtains press pressure from a knuckle joint operating within a hollow piston from which the platen is suspended. The Washington Press (Fig. 344), developed in the United States, works on the same principle. It was manufactured by R. Hoe and Company of New York beginning about 1827.

PRESSES DESIGNED BY PRINTMAKERS

There are many experimental-minded practitioners in the graphic arts field, and some of them have turned their attention to designing presses that will satisfy particular requirements in printmaking. Two examples are shown here.

Figure 345 is a new type of hydraulic press designed by Michael Ponce de León in order to make possible the printing of his three-dimensional constructions, of which an example is shown in Plate 38 (p. 258). The press embodies the principles of die-casting and is operated by hydraulic pumps that exert an overall 10,000 pounds of pressure. A plate of any height can be printed; free pieces can be stamped without danger of shifting, and reprintings over specific areas can be pinpointed without destroying previous embossments. Plate and paper

can be left under compression for any length of time for a deeper and more permanent relief. The adjustment of the counter-molds (blankets for the average print) is done with wet pulp, a form of papier-maché; to equalize the multiple levels of the matrix, damp blotters and blankets are placed over this mass of pulp.

The Meeker-McFee Press (Fig. 346) was designed to meet special problems of color and deep-cut techniques. It is motor-driven and exerts 11,000 pounds of pressure. The upper roller has a $1\frac{1}{2}$-inch travel, which allows for a great variety of plate thicknesses and also for woodblock and type-high printing. The micrometer settings for the rollers, with divisions to $\frac{1}{1000}$ of an inch, allow accurate and sensitive adjustments for plates varying in character and thickness. (One of Dean Meeker's prints is shown in Figure 303.)

above right: 344. Washington Press.

below left: 345. Michael Ponce de León with his hydraulic press.

below right: 346. Meeker-McFee Press.

27

Ink, Paper, Rollers, and Brayers

Aside from the press, which is essential for printing some, though not all, works in the graphic arts media, the essential material requirements for making any print are the paper (or other substance) on which it is printed, the ink or pigment that carries the design to the paper, and the tool required to bring the two together. Study and experimentation in regard to papers and inks and pigments will continue throughout an artist's career; a little background information is provided here.

NOTES ON INK

Colin Bloy, writing on "The Use of Bread in Early Ink-Making" (*The Black Art*, Vol. 3, No. 1, 1964, p. 21) has preserved this view of what it was like to make ink in the early days of printing:

> Those were the days of ink-making when it was made on a still, sunny day before the city gate, far from the damp air of the printing house, when the fire crackled under the pot, which stood on the trivet in a hole in the ground, and threw fantastic lights on the old city wall, a pleasant interlude in the monotonous profession of the printer—and the festive mood was heightened by the oil-scented warm rolls which had been fried in the varnish, with which that ever-thirsty race of men who wield the balls, downed a heart-warming shot of schnapps—which they did, naturally, only to ameliorate the effects of the fatty oil on the stomach—and then the stirring in of the black provided the prose on a day of festive poetry.

Those who would like to test old recipes might try the following early-nineteenth-century formula for printing ink: Mix together 3

ounces of lampblack, $1\frac{1}{4}$ ounces of equal proportions of indigo and Prussian blue, and $\frac{3}{4}$ ounce of Indian red. Mull with 9 ounces of Balsam of Capive. Add 3 ounces of dry turpentine soap. Mull thoroughly and store until use. Most of us, however, will continue to scrape ink from the commercially canned product—except for some intaglio printers, who still tend to mix their own inks by adding plate oil to their personal selection of powdered pigments.

Although the romance of yesterday's ink manufacture may be gone, the need for high-quality inks, without benefit of rolls fried in linseed oil, continues unabated. Most of the printing problems in the workshop are attributed, in one way or another, to ink problems. Most artists, taking a casual attitude to the chemistry and physics of ink, approach these problems on the simple basis of trial and error, and this is the way they will probably continue unless a new set of conditions forces the fruits of research into all workshops, large and small.

Ink is composed of *pigment* (powdered color), diffused or dispersed in a *vehicle* (usually liquid varnish) containing a little or no *drier*. This semi-fluid or plastic substance must possess the somewhat magical property of becoming a solid after it has been rolled up on the stone or plate and transferred to the paper.

The physical properties of the ink must be adjusted to each other and to the materials and conditions of the workshop for each stone or plate to be printed. They are referred to as the *working properties* of the ink, and they determine the printing quality obtained. The following are requirements that lithographic ink must meet:

Tack: The pulling power of ink against another surface. It must be sufficiently "sticky," and have the quality of *tackiness.*

Length: The degree of flow or viscosity of ink. A *short* ink cannot be drawn between the fingers into a string or filament; it breaks.

Thixotropy: The tendency of an ink toward fluidity when worked and toward a solid when left standing. The solid mass in a freshly opened can of ink, when worked on a slab, becomes plastic.

Color intensity: The concentration of pigment in the ink. The ideal ink should lose neither brilliance nor grayed subtlety when made transparent or printed in a delicate film.

Moisture resistance: The ink should not be readily wet by water. It should be hydrophobic (water hating) rather than hydrophilic (water loving). Pigments and vehicles should neither be soluble in nor emulsify in water or weak acids.

Drying propensity: Suitable driers are present in the usual vehicles contained in commercial inks. Under unusual circumstances, an appropriate drier may be added in miniscule amounts.

Lightfastness: The printmaker, like the painter, may test colors for resistance to change by exposing samples of ink in direct sunlight for periods of time and comparing them with samples not so exposed. (*No print* should ever be exposed to direct ultraviolet rays.)

Finish: Ink can be treated or manufactured so as to reveal a mat, semigloss, or high sheen, within limits imposed by the paper used.
Grease content: Though it seems self-evident, ink should possess a grease content sufficient to allow it to cover the drawn areas of the plate or stone.

Additives are sometimes required for particular prints or to eliminate such problems as bleeding, scumming, or poor body. Offset inks, particularly, if they are substituted for the crayon or stone inks made especially for lithography, are likely to need "doctoring." (Offset inks present problems because of their fast-drying properties and should be avoided, if possible, by the beginning printmaker.) In general, ink makers, proud of their products, provide inks that presumably require little or no alteration.

Any compound added to ink will, first, affect the strength of the ink color. If this does not act as a deterrent, you may find occasion to make use of some of the products listed below. *Do not use any compounds, driers, or additives indiscriminately, and use them only in minimal amounts.*

Cornstarch: Reduces ink set-off (imprinting on and possibly sticking to slip sheet between drying prints); too much retards drying; provides some body; makes color less transparent.
Flat transparent white or offset tint base: Provides transparent tints or high values of given colors; add heavy-bodied varnish (No. 3 or No. 4) plus a drop of linseed oil to ink. Note that varnishes range from *thin* (No. 00000 to No. 000), to *medium* (No. 00 to No. 2), to heavy-bodied (No. 3 to No. 8), to *body gums* or binding varnishes (No. 7 to No. 10).
Cobalt drier: Speeds drying; adds gloss; dried ink film will not *trap* (allow another ink to be overprinted); add miniscule amounts; certain amount of skinning.
Balanced or trimetal driers: Contain the metals cobalt, lead, and manganese—drying *catalysts;* no skinning; fast drying; add gloss; use sparingly.
Boiled linseed oil: Original vehicle for conventional inks in the past; varnish derived from it by "boiling" or heat bodying; reduces tack; softens ink. No. 0000 varnish also serves same purpose.
Kerosene: Reduces stiffness; slows drying; reduces set-off.
Wax compounds: Sold under various proprietary names; reduce tack; prevent ink set-off; may prevent trapping of subsequent ink; use very sparingly, or tinting and other problems may follow.
Shortening compounds: If solids are mottled when printed, use judicious amounts of one of the following: wax compound, cup grease, cornstarch, magnesium carbonate, calcium stearate, etc.
Body gum (No. 8, 9, or 10 linseed varnish): Stiffens soupy ink; stops scumming or tinting.
Lithotine, turpentine, mineral spirits: Reduces set-off; reduces gloss; softens ink.

Magnesium carbonate: Reduces gloss; lends body to ink; reduces set-off; adds opaque quality.

An ideal ink for all prints does not exist. One or more inks for one or more projects, through experience of handling, may come to seem "best" and will continue to be used without question, but experimentation with ink generally reveals the possibility of improvement.

An excellent handbook on printing ink which should be on the shelves of every print workshop is the *Printing Ink Handbook.* It can be obtained from the National Association of Printing Ink Manufacturers, 39 West 55 Street, New York, New York 10019.

The woodcut artist will be likely to prove his prints with materials probably already available in his studio, such as oil paints or watercolors, and he can also make use of artist's colors in printing. Otherwise he can purchase the letterpress ink recommended by his local supplier or turn to a variety of special inks, for which the manufacturer supplies information. For the serigrapher it is recommended that inks be purchased from a specialized manufacturer, who should know the answers to the various ink problems, when his materials are used. The intaglio printer may very well make his own ink, as has been described in Chapter 14. The lithographer should make every effort to procure the proper lithographic ink, which is generically called *chalk, crayon,* or *stone* ink, though it may be manufactured under various names. Since direct or stone lithographic inks are sometimes difficult to obtain, especially in nonurban areas, suggestions for an ink palette with names of manufacturers are shown in the table on page 324.

NOTES ON PAPER

Examining various sheets of paper with and without the aid of a microscope proves interesting: paper is a felted web of fibers; it appears to be porous to a greater or lesser degree; its nonfiber areas (voids or pores) may equal, in some sheets, one-half its substance. It has a particular color, texture, and quality of surface; it has a grain; presumably, it has a given thickness; it appears to have a top and a bottom, or a "right" and a "wrong" side; it is more or less hygroscopic; some papers seem to be stronger than others.

Because of its structure, manufacture, the acidity or alkalinity of the materials it is made of, temperature, humidity, and other factors, it would seem that this substance would be less than stable when employed in printmaking, especially for color registration. And so it is.

There are few hard and fast rules on selecting papers. The printmaker, young or old, might consider the following advice when choosing paper for *editions:*

1. *Avoid,* in lithography, those papers with pH factors below 4.5 for fear of scumming the plate or stone. (The pH scale of acidity ranges

A Suggested Ink Palette for Lithography

Ink Name and Code	Key	Ink Manufacturer
Stone Neutral Black LA-76823	(+)	S & V
Noir Velour #2255	(+ .)	Charbonnel (Flax)
Noir a Monter	(+ .)	Charbonnel (Flax)
Retransfer		Charbonnel (Flax)
Black 24-NI-57 (Offset)		Cal Ink
Opaque White LA-71460	(=)	S & V
Opaque White CS-850		Hanco
Opaque White W-220-X		Hanco
Opaque White 64-Wl-9		Cal Ink
Flat Transparent Base LA-68294		S & V
Offset Tint Base W-191-X		Hanco
Offset Tint Base 20-W3-3		Cal Ink
#404 Yellow LA-58013	(= ..)	S & V
Special Chrome Yellow LA-71986	(*)	S & V
Chrome Yellow Y-2716		Hanco
Primrose Yellow Y-2710		Hanco
Yellow 24-19-53		Cal Ink
Medium Yellow 24-7-100		Cal Ink
Policy Orange OR-1347	(*)	Hanco
Standard Orange CS-200		Hanco
Sun Orange OR-1349		Hanco
Persian Orange OR-1348		Hanco
Orange 24-11-46		Cal Ink
Vermillion Red La-60177		S & V
Permanent Rose Red LA-67477		S & V
Fire Red CS-360		Hanco
Valentine Red R-6710		Hanco
Sun Red R-6706		Hanco
Blue-Red 24-04-120		Cal Ink
Royal Blue LA-75390		S & V
#411 Blue LA-67792		S & V
Thalo Blue (Red) CS-420	(+ ..)	Hanco
Thalo Blue (Green) CS-400	(+ .. = ..)	Hanco
Marine Blue 24-76-87		Cal Ink
Purple LA-62537	(+ .. = ..)	S & V
Christmas Green G-4996		Hanco
Yellow Shade Green Toner G-8720		Hanco
Oriental Green LA-67473		S & V
Tamarind Green LA-69760		S & V
Autumn Brown LA-67474		S & V
Leaf Brown BN-3434	(*)	Hanco
Bismark Brown BN-3433		Hanco
Chocolate Brown BN-3429		Hanco
Trophies Brown BN-3428		Hanco
Rustic Brown 24-NY15-60		Cal Ink
Tamarind Silver LA-67796	(+ .. = ..)	S & V
Rich Gold DC-1267 (powder)	(*)	Hanco

KEY: (*) prints excellently;
(+) scums lightly; (+ .) scums moderately; (+ ..) scums severely;
(=) marks lightly; (= .) marks moderately; (= ..) marks severely.

from 0 (extreme acidity) through 7 (neutral) to 14 (extreme alkalinity). (See p. 81.)

2. *Avoid* using papers (especially buff and colored stocks) that are not lightfast.

3. *Avoid* papers that show tendencies to distort or to stretch significantly, especially for multicolor printing.

4. *Avoid* machine-made papers, except for proofs and nonedition printing.

5. *Prefer* handmade (vat) or moldmade papers. (Both are made in molds; the latter are manufactured on a cylinder-mold mechanism.)

6. *Prefer* papers made from unbleached white rag, except when a particular reason for selection outweighs this consideration.

7. Finally, ignore all these admonitions and select papers that attract you or "feel" right for a given stone or plate.

These tables supply data on a selected list of papers that the printmaker may wish to try and on a few prominent paper manufacturers.

Selected Papers for Printmaking

Name	Size in Inches	Number of Deckles	Process
Arches	22 × 30	4	Moldmade
Charing	18 × 22½	4	Handmade
Chatham	19½ × 24½	4	Handmade
Copperplate Deluxe	30 × 42	4	Moldmade
Crisbrook Waterleaf	22 × 31	4	Handmade
Crown & Sceptre	15 × 20	4	Handmade
Fabriano Book	19 × 26	4	Handmade
Fabriano Cover	20 × 26; 26 × 40	4	Moldmade
Frankfurt	25 × 38	4	Moldmade
German Etching	31¼ × 42½	4	Moldmade
Goyu	21 × 29	4	Handmade
Hammer & Anvil	17 × 23	4	Handmade
Hosho	19 × 24	4	Handmade
Inomachi (Nacre)	17½ × 22½	4	Handmade
Invicta	26 × 40	4	Moldmade
J. Barcham Green Waterleaf	23¼ × 31¼	4	Moldmade
Laga Velin	20 × 25	4	Handmade
Magnani Italia	20¼ × 28; 28 × 40	4	Moldmade
Maidstone	18 × 22½	4	Handmade
Mokuroku	18 × 23	4	Handmade
Okawara	12 × 16	4	Handmade
Rives BFK	22¼ × 30; 29.3 × 41½	4	Moldmade
Shogun Heavy	17½ × 22½	4	Handmade
Tuscany	16 × 20	4	Handmade
Umbria	20 × 26	4	Handmade
Weimar	25 × 38	4	Moldmade

Selected Paper Mills

Papeteries d'Arches,
30 rue Mazarine, Paris, France

Arnold & Foster, Ltd., c/o Spicers Ltd.,
19 New Bridge St., London

Papeteries Delcroix,
Nevelles, Belgium

Robert Fletcher & Son, Ltd.,
Stoneclough, Manchester, England

J. Barcham Green Ltd., Hayle Mill,
Maidstone, Kent, England

Papeteries Johannot,
Annonay, Ardèche, France

Moulins à Papier du Val de Laga,
Ambert, Puy de Dôme, France

Papeteries du Marais et de Ste. Marie,
3 rue du Pont-de-Lodi, Paris, France

Catiere Miliani-Fabriano,
Fabriano, Italy

Arthur Millbourn & Co.,
31 Watling St., London, England

Portals Ltd.,
Whitchurch, Hants, England

Papierfabrik Zerkall Renker & Sohne,
Zerkall über Duren, Germany

Papeteries de Rives, Rives,
Isère, France

ROLLERS AND BRAYERS

The several purposes of rollers and brayers for printmaking include laying down a thin film of ink on the surface of a stone, block, or plate; grounding plates; inking different levels of a plate with one or more such tools; transferring; and other techniques. It seems appropriate to begin with some notes on the traditional lithographic leather roller.

To condition a new roller, it first should be smeared with a soft lithographic varnish (No. 00 to No. 2) until it can absorb no more. At this point it will begin to drip varnish; set the roller handles on two short lengths of 2-×-4-inch lumber and catch the varnish drippings on waste paper placed beneath the roller.

Scrape the varnish off the roller with a spatula, first against the grain, then with the grain of the leather. (Engrave an arrow on one of the handles of the roller which points in the direction for scraping.) Here is a convenient method for scraping the roller:

Place one end of the roller securely against the frame of the press. Moving your body toward the press, allow the other end of the roller to come to rest against the line of your belt or waist. The roller should be supported at this point without the use of your hands. Grasp the spatula with both hands, as with a draw knife, and raise slightly the edge nearest yourself. Now, pull the spatula firmly across the length of the roller. Wipe the spatula clean, and proceed to scrape the rest of the varnish from the roller. You will observe that bits of nap from the roller come off during the scraping. Be careful not to scrape across the seam of the roller. Doing so will leave an ugly line when the stone is inked.

Add a harder varnish (No. 6 or No. 7) to the roller and work it into the leather with your hands. Then, pass the roller over the ink slab firmly for about 15 to 20 minutes. This will pull off the excess nap. Scrape the roller down and repeat this procedure until there is a minimum of nap appearing on the ink slab. Clean the ink slab thoroughly after each rolling period. At this point, you can add a line or two of ink across the ink slab, and roll the roller in ink for several sessions of about 15 to 20 minutes each. Scrape the roller well each time before proceeding to the next session. Your roller should soon be in good condition. Keep it this way by rolling it in fresh ink and scraping it down even on days when you do not intend to print. The roller should be wrapped in a plastic bag, wax paper, or aluminum foil when not in use. If you have to leave it idle for a week or so, it is recommended that you coat it with mutton tallow or Vaseline, or a convenient substitute.

If you have acquired an old or secondhand roller, the procedure for reconditioning it is essentially the same as for a new one. You might first, however, go over the roller with a wire suede brush and some white gasoline to pick up the nap of the leather and to remove the

old, dried ink. You can also use paint remover to get out old ink; or you can brush on a commercial leather-roller cleaner, scrape it, brush it on, and scrape it again. Then you can treat the roller with a commercial leather conditioner once or twice before rolling it in fresh ink. Turpentine, according to traditional lithographers, should never be used on a leather roller. They say it will harden the leather and make the roller unfit for use in a short period of time.

In addition to the traditional leather-covered rollers for lithographic proving, print workshops house composition rollers for work in color. Composition rollers for lithography are made of wooden or metal cores covered with a resilient material such as vulcanized oil, synthetic rubber, or synthetic plastic. There appears to be no standard size for these rollers: they range from 12 to 24 inches long, and from 4 to 10 inches in diameter. Vulcanized oil composition has excellent printing qualities; it is not oil-absorbent; it is cleaned without difficulty. Its chief drawbacks are that it devulcanizes after a few years, loses its flexibility, and is damaged easily. A good vulcanized oil roller measures about 20 durometers on the hardness scale for rubber.

Synthetic rubber rollers are widely used throughout the printing industry. They are much more sturdy and lasting than vulcanized oil rollers. Synthetic plastic rollers seem to offer no greater advantages or disadvantages than synthetic rubber ones.

All composition rollers must be kept clean. If traces of gum or ink are allowed to build up and form a glaze on the roller surface, certain unhappy procedures will be required to make them shopworthy again:

1. Rub some ground pumice powder and alcohol into the roller surface, then wash it off, dry, and powder with talc. The roller will go out of round, if this has to be repeated.
2. As a last resort, use a lathe to remove the glaze from the composition roller and true up its original form.

Rubber, leather, and all varieties of composition rollers are employed in relief and intaglio printing. Rubber brayers continue to do yeoman service in the cause of laying grounds; they run the gamut of the durometers on the scale of hardness (or softness, if you prefer). Do not allow grounds to cake on the roller. Clean regularly with kerosene. Hard gelatin and plastic brayers of all sizes are used for color roll-up on intaglio plates, with stencils, and for relief prints. Medium and soft brayers are employed to reach separate levels of the plate with different color inks. Use appropriate solvents to keep these tools in working order. Leather rollers are preferred by some etchers for laying hard and soft grounds. Synthetic plastic, synthetic rubber, and vulcanized oil brayers and rollers enjoy wide use among printmakers. Treat all these tools well.

Checklist of Equipment and Supplies

The following lists are limited to essential or commonly used materials required for the various printing processes. They have been prepared primarily for the beginning printmaker—to suggest what his minimum needs will be when he chooses to undertake one or another of the printing techniques, and to enable him, from this basis, to add to his equipment gradually as he goes along. These materials are described in the text, where a number of supplements and substitutes are also discussed. As he gains experience, the printmaker naturally studies the catalogs of his suppliers, which are constantly changing, and adds extensively to his resources. The first list includes general workshop items needed for all or most of the processes. The remainder are organized by chapters in the order of their citation in the text.

PRINTMAKING IN GENERAL

a press, or presses: required for lithography and intaglio; used but not essential for relief printing; not used for stencil printing (see Chap. 26)
press equipment: assorted scrapers, tympan, and blotters for lithographic press (pp. 64, 65); blankets for etching press (pp. 219, 220)
work surfaces, including a table sturdy enough for graining stones
water supply with sink and hose
ordinary tools, including hammer, screwdrivers, files, 48-inch ruler, steel square, straightedge, sandpaper, emery paper, steel wool, knives, razor blades, glue; also useful, if available, band saw, vise, staple gun, sprayer, paper and metal cutters, drill, calipers, pin vises for points and needles
printing paper (see Chap. 27)
facilities for dampening paper: blotters and damp press or a homemade damp book (page 58)
facilities for drying prints: blotters and tissue slip sheets, or lines and clips, or boards and mounting tape, or commercial drying racks
inks and/or paints, as suggested below for each process (see also Chap. 27)
ink slab, or a slab of plate glass, marble, or Plexiglas
ink knife or spatula
rollers and brayers, as suggested below (see also Chap. 27)
artists' materials, for making a preliminary or master sketch: pencil, pastel, watercolor, oil, or medium of choice
tracing materials: tracing paper or acetate, Conté crayon or powder, carbon paper
drawing board
clean newsprint (print size or larger)
trays: acid or etching trays, or hard rubber or enameled photographer's trays (to accommodate plates of the size used)

glass or plastic jars, graduate, 1-ounce measure, funnel, and stirring rods
sponges
cheesecloth, cotton wadding, rags, and paper wipes
brushes, including a 3-inch rubberset brush and other sizes, and small watercolor brushes
tapes: decorator's tape, kraft paper tape, pressure-sensitive tape
rubber gloves
solvents, as suggested below and on page 283 (for stencil); also commonly used, acetone, amyl acetate, amyl alcohol, benzol, butanol, butyl acetate, butyl lactate, carbon tetrachloride, diacetone, ether, ethyl acetate, ethyl alcohol (anhydrous), gasoline, gum turpentine, kerosene, lithotine, methanol (anhydrous), mineral spirits, naptha, toluol, wood turpentine, and oxylol

THE PLANOGRAPHIC PROCESS

Chapter 2: Making a Lithograph on Stone

a lithographic stone
a levigator, or a second stone, for graining
abrasives: carborundum Nos. 80, 150, 220, F–FFF, or equivalent
snake slip, or pumice, or Schumaker brick
a stone file, or rasp, or belt
lithographic crayons and pencils, Nos. 00–5
rubbing ink
tusche: liquid and/or stick tusche
a lithographic needle, or diamond point
razor blades
gum arabic: crystals, or powder but also prepared
nitric acid (70 percent USP)
talc (powdered French chalk)
powdered rosin
printing paper (pp. 57, 58)
black crayon ink (also called chalk or stone ink)
a leather hand roller
lithotine, or turpentine
glacial acetic acid
phosphoric acid

Chapter 3: Making a Lithograph on Plate

materials listed for Chap. 2, *excluding* stones, levigator, and abrasives
a zinc or aluminum plate
counteretch solution: commercially prepared (e.g., Prepasol) or homemade (p. 79)
etch solution: commercially prepared (e.g., Hanco Acidified Gum Etch No. 571) or homemade (pp. 80–83)
fountain solution: commercially prepared (e.g., Harris Non-Tox) or homemade (pp. 84, 85)

Chapter 4: Various Lithographic Techniques

materials listed for Chap. 2 (stone) or Chap. 3 (plate)
for transfers:
transfer paper: commercially prepared (e.g., Kesmoi, Charbonnel's à Report, German Everdamp) or homemade (p. 86)
transparent base (aluminum oxide)
for reverse image:
shellac
denatured alcohol
for metallic effects:
commercial metallic inks, or bronzing powders
for photolithography:
a wipe-on plate (e.g., ST plate) with the coating and developing materials supplied by manufacturer
a vacuum frame
photographic negatives, film positives, and/or drawings on sheet acetate
a light source (e.g., Pulse-Xenon arc, quartz iodine, white-flame carbon arc, or No. 2 photoflood lamp)

Chapter 5: Multimetal Lithography

materials listed for Chap. 3, *substituting:*
a bimetal or a trimetal plate
counteretch and etch solutions supplied by the plate manufacturer

Chapter 6: Color Lithography

materials listed for Chap. 2 (stone) or Chap. 3 (plate)
additional stones or plates
composition rollers, preferably several of different sizes
color lithographic inks (suggested list, p. 324)

THE RELIEF PROCESS

Chapter 9: Making a Relief Print

a block: plank-grain wood (for woodcut), end-grain wood (for wood engraving), or linoleum
India ink
flour paste
woodcutting tools: traditional knife, or a pocket knife, V-gouge, U-gouge, chisel
wood-engraving tools: assorted burins (gravers, p. 154)
sharpening stone and light oil
letterpress (printer's) ink, or block-printing ink
a gelatin brayer (roller), or a dabber
printing paper, preferably Japanese (rice) paper
a burnisher, or baren, or tablespoon
lithotine, or turpentine
talc
a bench hook (p. 154), or engraver's pad

Chapter 10: The Relief Print in Color

materials listed for Chap. 9
additional wood or linoleum blocks
additional brayers, small and large
stencil paper, or substitute
artist's oil paints, or block-printing color inks
rice paste (p. 163)
linseed oil
two long needles
right-angle register guide (pp. 165, 166)

Chapter 11: New Approaches to the Relief Print

materials listed for Chap. 10
substitutes for the wood block: found woods, lami-
 nated blocks, veneers, plywood, wallboards,
 cardboards, sheet plastic, etc.
found objects for textural and collage effects
for the collagraph:
support: any rigid material (e.g., plywood, Masonite,
 Formica)
plastic sealer (e.g., white brushing lacquer, polyester
 resin)
glue (e.g., Elmer's Glue-all, Liquitex, gesso, Wilhold)
cardboard shapes

THE INTAGLIO PROCESS

Chapter 14: Making an Etching

a copper or zinc plate, 16 or 18 gauge
a hot plate, or stove
powdered whiting, or detergent
hard ground, or liquid ground, or other ground
 (pp. 210–212)
a leather roller, or a felt dabber
wax tapers, for smoking the ground
an etcher's needle, or substitute (p. 213)
stop-out: resin and denatured alcohol (p. 213), or
 asphaltum
acetic acid
mordant (etching acid): nitric acid, or hydrochloric
 acid, or potassium chloride, or iron perchloride
 (pp. 214–216)
a feather, or pipe cleaner
turpentine
alcohol
handmade ink (pp. 221, 222), or commercial etching
 ink
a hard roller, or a dabber
tarlatan pads
printing paper
a steel scraper
a burnisher

Chapter 15: Making an Aquatint

materials listed for Chap. 14
resin, powdered or in lump form
denatured alcohol
stop-out varnish (containing no alcohol)
lithographic crayon
bitumen powder
for other tonal grounds:
sandpaper
salt
powdered sulphur

Chapter 16: Soft-ground and Lift-ground Etching

materials listed for Chap. 14
for soft-ground etching:
cup grease, or Vaseline, or tallow, or other fat
a pencil, or stylus
for related techniques:
tartaric-acid crystals
a roulette, or other perforating tools
for lift-ground etching:
saturated sugar solution
India ink
liquid soap

Chapter 17: Drypoint, Line Engraving, and
Mezzotint

a copper plate
lithographic crayon, pencil, or ballpoint pen
a diamond point, steel point, or substitute (for
 drypoint)
burins (for line engraving)
a rocker, roulettes, and scrapers (for mezzotint)
sharpening stones: carborundum, Arkansas stone,
 and India oil stone, or equivalents
a burnisher
a scraper
printing paper
ink
a hard roller, or dabber
tarlatan pads

Chapter 18: Relief and Color Printing from Intaglio
Plates

materials listed for Chaps. 14–17, selected according
 to the process or processes used
additional copper and/or zinc plates
color etching inks
small pieces of felt
stencil paper, or substitute
gelatin brayers, and hard and soft rollers

oil paints
oil-based crayons

Chapter 19: Some Innovative Intaglio Techniques

for photo-intaglio:
a copper plate
light-sensitive plate coating: commercially prepared
 or homemade (p. 253)
photographic positives and/or negatives and/or
 drawings on frosted acetate
a vacuum frame, or a sheet of glass
a hot plate, or stove
iron perchloride etch
printing paper
ink
rollers
note: This chapter is intended to suggest individual
 variations. Refer to the text for possibilities.

THE STENCIL PROCESS

Chapter 22: Making a Screen Print

one or more silk screens: commercially supplied,
 or homemade (pp. 274, 275)
table top or baseboard with loose-pin hinges fitted
 to accept each screen
WaterSol, or LePage's Original Glue, or some
 equivalent
stencil paper, or equivalent
lithographic tusche or crayon, or other greasy draw-
 ing material
solvent: mineral spirits, Varnol, or lithotine (chart,
 p. 283)
Art Maskoid, or equivalent commercial resist
shellac, or lacquer, and glycerine
lacquer stencil film (e.g., Nufilm, Ulano, Craftint)
 with appropriate film-adhering liquid
imitation shellac
printing paper, or substitute (e.g., canvas, cardboard,
 wood, cork, foil, glass, plastic, textile, metal)
plastic registration guides
screen printing inks, or artist's oil or water-based
 colors, or dyes, lacquers, enamels, and other
 synthetic products
transparent base
squeegees, with soft, medium, and hard blades
mineral spirits

Chapter 23: Photographic Screen Printing

note: It is suggested that the services of a professional
screen printer be utilized for first attempts; other
possibilities are discussed in the text.

Sources for Printmaking Supplies

Advance Machinery, Ltd.
25–29 Vale Royal, York Way
London N79AP, England
lithographic presses

Aiko's Art Materials Import
714 North Wabash Ave.
Chicago, Ill. 60611
Japanese paper and other artists' supplies

American Graphic Arts, Inc.
150 Broadway
Elizabeth, N.J. 07206
lithographic hand press

Ames Laboratories, Inc.
200 Rock Lane
Milford, Conn. 06460
Ink Sav, an antiskinning agent

Harry J. Anderson
5851 Leona St.
Oakland, Calif. 94605
lithographic stones

Andrews, Nelson, Whitehead
7 Laight St.
New York, N.Y. 10013
fine handmade printing papers

Ault & Wiborg, Ltd.
71 Standen Road, Southfields
London SW 18, England
printing inks and rollers

Berkey Photo, Inc.
25–15 50th St.
Woodside, N.Y. 11377
photographic printmaking equipment

Samuel Bingham Co.
201 North Wells St.
Chicago, Ill. 60606
rollers, chemicals, blankets, etc.

Bottega d'arte Grafica
Fredy Re'em
via S. Spirito 11
Florence, Italy
etching presses

V. Bouzard et ses fils
10 Boulevard de la Bastille
Paris XIIIe, France
photographic equipment, cameras, etc.

Charles Brand Machinery, Inc.
84 East 10th St.
New York, N.Y. 10003
custom-built etching and lithographic presses

Brodhead-Garrett Co.
4560 East 71st St.
Cleveland, Ohio 44105
broad range of technical educational supplies

Arthur Brown and Bros., Inc.
2 West 46th St.
New York, N.Y. 10036
artists' supplies

Cal/Ink Division of Tenneco Chemicals, Inc.
600 California St.

San Francisco, Calif. 94108
inks

Central Plastics Distributors
527 South Wells
Chicago, Ill. 60607
plastics

F. Charbonnel
13 Quai Montebello et rue de l'Hotel-Colbert
Paris Ve, France
transfer papers, inks, etc.

Christie Chemical Co.
7995 14th Ave., St. Michel
Montreal 455, Quebec, Canada
chemicals and sundries

Coates Bros. and Co., Ltd.
Easton St.
London WC1X0DP, England
printing inks

Colonial Printing Ink Co., Inc.
180 East Union Ave.
East Rutherford, N.J. 07073
screen printing equipment, supplies, papers and inks

Continental Felt Co.
22 West 15th St.
New York, N.Y. 10011
etching blankets

L. Cornelissen & Son
22 Great Queen St.
London WC 2, England
transfer papers

Craftool Co., Inc.
1 Industrial Road
Wood-Ridge, N.J. 07075
all printmaking equipment and supplies

Fezandie & Sperrle, Inc.
103 Lafayette St.
New York, N.Y. 10013
colors and pigments

Sam Flax, Inc.
25 East 28th St.
New York, N.Y. 10016
artists' supplies, printmakers' supplies

Forrest Printing Ink Co.
48 Gray's Inn Road
London WC1X8LX, England
lithographic and letterpress inks

G.A.C.E.P.
A. Paolini
via Sasso 51
61029 Urbino, Italy
presses

W. R. Grace & Co.
Ideal Roller Division
2512 West 24th St.
Chicago, Ill. 60608
printing rollers

Graphic Chemical and Ink Co.
728 North Yale Ave.

Villa Park, Ill. 60181
printmakers' equipment, materials, and supplies

J. Barcham Green, Ltd.
Hayle Mill
Maidstone, Kent, England
handmade and other printing papers

M. Grumbacher, Inc.
460 West 34th St.
New York, N.Y. 10001
artists' supplies

Handschy Chemical Co.
2525 N. Elston Ave.
Chicago, Ill. 60647
lithographic supplies and equipment

E. Harris Co.
1 Leslie St.
Toronto 8, Ontario, Canada
screen printing equipment, supplies, and materials

Frank Horsell and Col., Ltd.
Howley Park Estate
Morley
Leeds LS27 0QT, England
lithographic plates

Howson-Algraphy Ltd.
Ring Road
Seacroft
Leeds LS14 1ND, England
lithographic supplies, including rollers

Hunter-Penrose-Littlejohn, Ltd.
7 Spa Road
London SE 16, England
chemicals and general graphic arts supplies

Inmont Corp. Graphics Group
925 Allwood Road
Clifton, N.J. 07012
printing inks

Andrew Jeri Co., Inc.
190 Horseneck Road
Fairfield, N.J. 07006
Maskoid products for serigraphy

J. Johnson & Co.
33 Matinecock Ave.
Port Washington, N.Y. 11050
wood engraving and other tools

Heinz Jordan & Co., Ltd.
42 Gladstone Ave.
Toronto 3, Ontario, Canada
artists' supplies, fine papers, inks

W. C. Kimber, Ltd.
24 Kings Bench St.
London SE 1, England
etching, lithographic, and relief materials

Klimsch & Co.
Schmidtstrasse 12
6 Frankfurt (Main) 1, Germany
c/o Repro Graphic Machines, Inc.
180 Varick St.,
New York, N.Y. 10014
photographic printmaking supplies

William Korn, Inc.
260 West St.
New York, N.Y. 10013
lithographic crayons, pencils, tusches

T. N. Lawrence & Son
2–4 Bleeding Heart Yard
Greville St., Hatton Garden
London EC 1, England
wood blocks, relief and intaglio tools and materials

Ralph Leber Co., Inc.
P.O. Box 88700
17200 West Valley Highway
Tukwila, Wash., 98188
collagraphic and lithographic inks

Lefranc & Bourgeois
Zone Industrielle Nord
Route d'Alençon
72 Le Mans, France
c/o Art Center, Inc.
58 Main St.
Hackensack, N.J. 07601
artists' materials

Linhof Nikolaus Karpf K.G.
Rupert Mayer Strasse 45
8 Munchen 25, Germany
offset and screen printing cameras

Litho Chemical & Supply Co., Inc.
46 Harriet Place
Lynbrook, N.Y. 11563
lithographic chemicals, multimetal plates

Litho-Plate Co.
5082 Alhambra Ave.
Los Angeles, Calif. 90032
lithographic chemicals

Philip Lochman & Co.
2405 W. Oakton St.
Evanston, Ill. 60204
lithographic and photoengraving equipment and chemicals

Dean Meeker
309 Park Way
Madison, Wisc. 53705
the Meeker-McFee press

Frank Mittermeier, Inc.
3577 East Tremont Ave.
Bronx, N.Y. 10465
relief and intaglio tools

National Card, Mat and Board Co.
11422 South Broadway
Los Angeles, Calif. 90061
boards and papers

Naz-Dar Co.
1087 N. North Branch St.
Chicago, Ill. 60622
screen printing inks and supplies

Northwest Paper Co.
Cloquet, Minn. 55720
papers

Harold M. Pitman Co.
515 Secaucus Road
Secaucus, N.J. 07094
lithographic plates (ST products)

Printing Developments, Inc.
Time and Life Building
Rockefeller Center, New York, N.Y. 10020
products for intaglio and planographic printing (large-scale), miltimetal plates

Rembrandt Graphic Arts Co., Inc.
Stockton, N.J. 08559
presses, rollers, stones, etc., for all processes

Revere Copper and Brass, Inc.
Edes Manufacturing Division
Plymouth, Mass. 02360
plates and materials for intaglio, multimetal plates

Sericol Group, Ltd.
24 Parsons Green Lane
London SW 6 4HS, England
screen-process supplies and materials

H. Schmincke & Co.
4 Düsseldorf
Grafenberg, West Germany
artists' supplies

Screen Process Supplies Manufacturing Co.
1199 East 12th St.
Oakland, Calif. 94606
screen-process equipment, materials, and supplies

Sculpture Associates, Ltd.
114 East 25th St.
New York, N.Y. 10010
relief and intaglio tools

Sinclair and Valentine
Screen Printing Inks Division
201 East 16th Ave.
North Kansas City, Mo. 64116
screen printing inks and chemicals

Strathmore Paper Co.
West Springfield, Mass. 01089
artists' papers

3M Company
Printing Products Division
3M Center
St. Paul, Minn. 55101
plates, chemicals, and general supplies for lithography

Wholesale Supply Co.
1005 Lillian Way
Los Angeles, Calif. 90038
acids, solvents, and sundries

Winsor & Newton, Inc.
555 Winsor Drive
Secaucus, N.J. 07094
artists' supplies

Winstones Ltd.
Park Works
Park Land
Harefield, England
printing inks and rollers

X-Acto, Inc.
48–41 Van Dam St.
Long Island City, N.Y. 11101
knives and tools

Yamada Shokai Co., Ltd.
5–5 Yaesu, Chuo-ku
Tokyo, Japan 104
handmade papers for all media

Zimmcor Artmetwork, Inc.
6120 Metropolitan East
Montreal 451, Quebec, Canada
etching press

Films Related to Prints and Printmakers

Age of Rococo, Alemann, 17 min., col., 1961
Albrecht Dürer, BBC TV Enterprises, 10 min., 1961
Anthony Gross, BBC TV Enterprises, 15 min., 1960
Around Perception, Nat. Film Board of Canada, 16½ min., col., 1969
Art in Woodcut, Bailey, 20 min., col., 1966
Art of Etching, Argonaut, 49 min., col., 1957
Art of Etching, Part 1, Argonaut, 27 min., col., 1960
Art of Etching, Part 2, Argonaut, 22 min., col., 1960
Artist's Proof, Rembrandt, 25 min., col., 1957
Arts of Japan, Univ. Ed. & Vis. Arts, 29 min., 1954
Basic Reproduction Processes in the Graphic Arts, GATF, 25 min., col., 1963
Block Cutting and Printing, Stout Inst., 13 min., col., 1952
Block Printing, U. of Iowa, 14 min., 1958
Collage, ACI Prod., 15 min., col., 1966
Collagraph, The, Glen Alps, U. of Wash., Seattle, 20 min., col.
Color Lithography: An Art Medium, U. of Miss., 32 min., col., 1955
Color on a Stone, Bailey, 13 min., col., 1955
Currier and Ives, Radim Films Inc., 13 min., col., 1966
Daumier, Roger Leenhardt, 15 min., 1958
Drei Meister Schneiden in Holz, Kulturfilm Inst., 12 min., 1951
Drypoint, Harvard Films, 30 min., 1942
Edvard Munch, Part 1, Radim Films Inc., 30 min., col., 1968
1848, Radim Films Inc., 22 min., 1949
Ernst Barlach, Film Images, 2 reels, 20 min. ea., 1949
Etcher's Art, The, Harvard Films, 30 min., 1942
Exploring Relief Printmaking, Bailey, 12 min., col., 1967
Fantasticna Balada, Triglav Films, Yugoslavia, 10 min., 1957
Follies of the Town: Hogarth, McGraw-Hill Text Films, 26 min., n.d.
Georges Braque, Film Images, 17 min., 1954
Goya, Harris, 11 min., 1955
Goya: Disasters of War, Radim Films Inc., 20 min., 1952
Graphic Arts, The, U. of Ill., 22 programs, 30 min. ea., 1958
Graphisme, French Embassy, Cult. Div., 20 min., 1956
Great Passion, The, Film Images, 14 min., 1957
Hanga: Japanese Woodblock Prints, Japanese Embassy, 29 min., 1960
Heights and Depths, Jam Handy, 9 min., 1938
How a Color Wood Engraving Is Made, Harmon, 20 min., col., silent, 1946
How to Make a Linoleum Block Print, Bailey, 13 min., col., 1955
How to Make an Etching, Almanac Films, 20 min., 1951
How to Make a Silk Screen Print, Almanac Films, 21 min., 1952
How to Make a Stencil Print, Bailey, 12 min., col., 1961

Incised Image, The, Firebird Films, Australia, 23 min., 1966
Japanese Calligraphy, Brandon, 17 min., 1957
Japanese Printmaking, Ind. Film Prod. Co., 11 min., col., 1953
Jasper Johns, Ind. U., 30 min., 1965
Joan Miró Makes a Color Print, Bouchard, 20 min., col., 1951
John Piper, BBC TV Enterprises, 30 min., 1955
Kenojuak, NFB of Canada, 20 min., col., 1964
Last of the Wood Engravers, The, Wholesome Film Serv., 30 min., silent, 1935
Lines in Relief: Woodcut . . . , Encyc. Brit., 11 min., col., 1964
Litho, Elektra, 9 min., col., 1961
Lithography, Inter. Film Bureau, 14 min., 1952
Look of a Lithographer, The, Tamarind, 45 min., 1968
Lynd Ward at Work, Elias Katz, 15 min., silent, 1937
Maison aux Images, La, Les Films du Dauphin, France, 17 min., col., 1956
Make a Linoleum Block, Elias Katz, 15 min., silent, 1938
Make an Etching, Elias Katz, 25 min., 1941
Matthaus Merian, T. N. Blomberg, 16 min., 1956
Miserere, Pictura Film Corp., 14 min., 1953
Modern Lithographer, The, Encyc. Brit. 11 min., 1940
Moku Hanga: The Japanese Wood Block Print, Young America, 14 min., 1955
Monotype Prints (rev. ed.), Bailey Films, 5 min., col., 1967
Neighboring Shore, The, Brandon Films, 15 min., col., 1960
New Ways of Gravure, Film Images, 12 min., 1951
Paris Balzac, Jeune Cinéma, France, 10 min., 1964
Portrait of Misch Kohn, A, Weiner, 25 min., col., 1967
Posada, Film Images, 10 min., 1964
Poster Making: Printing by Silk Screen, Bailey, 15 min., col., 1953
Printing Through the Ages, EBF, 13 min., 1950
Print with a Brayer, Bailey, 8 min., col., 1959
Printmaking: Four Artists, Four Media, Film Assoc., 19 min., col., 1968
Silkscreen, ACI Prod., 15 min., col., 1967
Silkscreen Fundamentals, Bailey, 14 min., col., 1969
Silk Screen Printing, Av-Ed Films, 10 min., col., 1957
Silk Screen Process, Library Films, 20 min., 1945
Silk Screen Techniques, Bailey, 14 min., col., 1969
Silk Screen Textile Printing, Bailey, 11 min., col., 1952
Simple Block Printing, Brandon, 10 min., 1941
Story of Papermaking, Films of Fact, 16 min., 1948
Technique of Lithography, Ind. U., 32 min., n.d.
Technique of the Silk Screen Process, Contemp. Films, 15 min., 1941
This Is Ben Shahn, Film Assoc., 17 min., col., 1968
Toulouse-Lautrec, Brandon, 22 min., col., 1952
Ukiyo-E: Prints of Japan, Brandon, 27 min., col., 1960
Up North: Eskimo Art Colony, Cape Dorset, NFB, 11 min., 1962

With Wood Engraving, British Info. Serv., 3 min., 1950
Woodblock Printer, ACI Prod., 16 min., col., 1968

FILM DISTRIBUTORS

The best reference book on the educational film is the *NICEM* (National Information Center for Educational Media at the University of California in Los Angeles), published by R. R. Bowker Co. (1969). For those who do not have access to this published source, it is possible to write to or visit a local or regional film library or audiovisual center and arrange to view promising films. The following list cites certain major distributors of educational films and provides their addresses.

ACI Productions, 16 W. 46th St., New York, N.Y. 10036
Almanc Films, 29 E. 10th St., New York, N.Y. 10003
Argonaut Productions, Box 335, Altadena, Calif. 91001
Audiovisual centers of states, provinces, and universities
Av-Ed Films, 7934 Santa Monica Blvd., Los Angeles, Calif. 90046
Bailey-Film Associates, 11559 Santa Monica Blvd., Los Angeles, Calif. 90025
Brandon Films, 221 W. 57th St., New York, N.Y. 10019
Contemporary Films, Inc., 267 W. 25th St., New York, N.Y. 10001
Elias Katz, M.D., 808 Sir Francis Drake Blvd., Kentfield, Calif. 94904
Encyclopaedia Britannica Educational Corp., 425 N. Michigan Ave., Chicago, Ill. 60611
Film Associates of California, 11559 Santa Monica Blvd., Los Angeles, Calif. 90025
Harmon Foundation, Inc., 140 Nassau St., New York, N.Y. 10038
Harrison Pictures Corp., 1501 Broadway, New York, N.Y. 10036
Independent Film Production Co., Box 501, Pasadena, Calif. 91102
Janus Film Library (Canada) Ltd., 224 Davenport, Toronto, Ontario, Canada
McGraw-Hill Text Films, 330 W. 42nd St., New York, N.Y. 10018
National Film Board of Canada, P. O. Box 6100, Montreal 3, Canada; 680 Fifth Ave., New York, N.Y. 10019, U.S.A.
Radim Films, Inc., 220 W. 42nd St., New York, N.Y. 10036
Rembrandt Film Library, 267 W. 25th St., New York, N.Y. 10001
Universal Educational and Visual Arts, 221 Park Ave. So., New York, N.Y. 10003

Bibliography

GENERAL

Adhémar, Jean. *Graphic Art of the 18th Century.* New York: McGraw-Hill, 1964.

Andrews, Michael F. *Creative Printmaking.* Englewood Cliffs, N.J.: Prentice-Hall, 1964.

Arms, John Taylor. *Handbook of Print Making and Print Makers.* New York: Macmillan, 1934.

Bartsch, Adam von. *Le Peintre-graveur . . . ,* new ed., 21 vols. in 18. Wurzburg: Verlagsdruckerei Wurzburg, 1920.

Brunner, Felix. *A Handbook of Graphic Reproductive Processes.* London: Tiranti, 1962.

Buchheim, L.-G. *The Graphic Art of German Expressionism.* New York: Universe Books, 1960.

Camnitzer, Luis. "A Redefinition of the Print," *Artist's Proof,* Vol. 6, 1966, pp. 102–105.

Carrington, F. R., and C. Dodgson, eds. *The Print Collector's Quarterly,* 30 vols. New York and London, 1911–51.

Cleaver, James. *A History of Graphic Art.* New York: Philosophical Library, 1963.

Craven, Thomas, ed. *A Treasury of American Prints.* New York: Simon & Schuster, 1939.

Delteil, Loys. *Manuel de l'amateur d'estampes du XVIIIe siècle.* Paris: Dorbon-Aîné, 1910.

———. *Manuel de l'amateur d'estampes de XIXe et XXe siècles . . . ,* 4 vols. Paris: Dorbon-Aîné, c. 1925.

———. *Le Peintre-graveur illustré,* 32 vols. Paris: 1906–30; repr. New York: Da Capo, 1968.

Drepperd, Carl W. *Early American Prints.* New York: Century, 1930.

Eichenberg, Fritz, ed. *Artist's Proof Annual.* New York: Pratt Inst., Barre, N.Y. Graphic Soc., 1961—.

Fern, A. "A Half Century of American Printmaking: 1875–1925," *Artist's Proof,* Vol. 3, No. 6, 1963.

Fünf Jahrhunderte Europäische Graphik ("Five Hundred Years of European Graphics"), catalogue in German and French. Munich: Haus der Kunst, 1965.

Gerber, Jack. *A Selected Bibliography of the Graphic Arts.* Pittsburgh: Graphic Arts Technical Foundation, 1967.

Hayter, Stanley William. *About Prints.* London: Oxford, 1962.

Hirth, George, ed. *Kulturgeschichtliches Bilderbuch aus drei Jahrhunderten,* 6 vols. Leipzig: Hirth, 1881–90.

Holman, Louis A. *The Graphic Processes.* Boston: Goodspeed, 1929.

Holme, Geoffrey, ed. *Modern Woodcuts and Lithographs by British and French Artists.* New York: Studio, 1919.

Ivins, William M., Jr. *How Prints Look.* New York: Metropolitan Museum, 1943; Boston: Beacon Press, 1958.

———. *Prints and Visual Communication.* Cambridge: Harvard, 1953; repr. New York: Da Capo, 1969.

Johnson, Una E. *Ambroise Vollard, Éditeur.* New York: Wittenborn, 1944.

Kruiningen, H. van. *The Techniques of Graphic Art.* New York: Praeger, 1969.

Lehrs, Max. *Geschichte und Kritischer Katalog . . . ,* 9 vols. Vienna: Gesellschaft für vervielfältigende Kunst, 1908–34.

Leporini, Heinrich. *Der Kupferstichsammler* Berlin: Schmidt, 1924.

Lindemann, Gottfried. *Prints and Drawings, A Pictorial History,* tr. Gerald Onn. New York: Praeger, 1970.

Lippmann, Friedrich. *Engravings and Woodcuts by Old Masters . . . ,* 5 vols. London: Quaritch, 1889–1904.

Lucas, E. Louise. *Art Books: A Basic Bibliography . . . ,* pp. 91–100 (graphic arts). Greenwich, Conn.: N.Y. Graphic Soc., 1968.

Maberly, Joseph. *The Print Collector.* New York: Dodd, Mead, 1880.

Passavant, Johann D. *Le Peintre-graveur . . . ,* 6 vols. in 3. Leipzig: Weigel, 1860–64; repr. New York: Franklin, 1964.

Passeron, Roger. *French Prints of the Twentieth Century.* New York: Praeger, 1970.

Pennell, Joseph, *The Graphic Arts* Chicago: U. of Chicago Press, 1921.

Peterdi, Gabor. *Great Prints of the World.* New York: Macmillan, 1959.

———. *Printmaking.* New York: Macmillan, 1959.

Plowman, George T. *Etching and Other Graphic Arts.* New York: Lane, 1914.

Poortenaar, Jan. *The Technique of Prints* London: Lane, 1933.

Portalis, Roger, and Henri Beraldi. *Les Graveurs du dix-huitième siècle,* 3 vols. Paris: Morgand et Fatout, 1880–82.

Robertson, Ronald G. *Contemporary Printmaking in Japan.* New York: Crown, 1965.

Roger-Marx, Claude. *Graphic Art of the 19th Century.* New York: McGraw-Hill, 1962.

Rosenthal, Leon, and Jean Adhémar. *La Gravure . . . ,* 2d ed. Paris: Laurens, 1939.

Sachs, Paul J. *Modern Prints and Drawings* New York: Knopf, 1954.

Schreiber, Wilhelm L. *Manuel de l'amateur de la gravure . . . ,* 8 vols. Berlin: Cohn, 1891–1911.

Singer, Hans W., and William Strang. *Etching, Engraving and the Other Methods of Printing Pictures.* London: Paul, Trench, Trubner, 1897.

Sotriffer, Kristian. *Printmaking: History and Technique.* New York: McGraw-Hill, 1968.

Statler, Oliver. *Modern Japanese Prints* Rutland, Vt.: Tuttle, 1956.

Stubbe, Wolf. *Graphic Arts in the Twentieth Century.* New York: Praeger, 1963.

Weaver, Peter. *Printmaking, a Medium for Basic Design.* London: Studio Vista, 1968.

Wechsler, Herman J., *Great Prints and Printmakers.* New York: Abrams, 1967.

Wedmore, Frederick. *Fine Prints,* new ed. Edinburgh: Grant, 1905.

Weitenkampf, Frank. *Famous Prints.* New York: Scribner, 1926.

Whitman, Alfred. *Print Collector's Handbook,* new ed. London: Bell, 1921.

Willshire, William H. *An Introduction to the Study and Care of Ancient Prints,* 2d ed., 2 vols. London: Ellis and White, 1877.

Zigrosser, Carl. *The Artist in America.* New York: Knopf, 1942.

———. *The Book of Fine Prints,* rev. New York: Crown, 1956.

———. *Multum in Parvo* New York: Braziller, 1965.

———, ed. *Prints.* New York: Holt, Rinehart and Winston, 1962.

——— and Christa M. Gaehde. *A Guide to the Collecting and Care of Original Prints.* New York: Crown, 1965.

THE PLANOGRAPHIC PROCESS

A.B. "Lithography and Lithographer," *Burlington Magazine,* Vol. 30, 1917, pp. 115–117.

Antreasian, Garo Z., and Clinton Adams. *The Tamarind Book of Lithography: Art and Techniques.* New York: Abrams, 1970.

Arnold, Grant. *Creative Lithography and How to Do It.* New York: Harper, 1941.

Audsley, George A. *The Art of Chromolithography.* London: Low, Marston, Searle, and Rivington, 1883.

Barker, Albert W. "Lithographic Notes," *Prints,* Vol. 7, No. 3, Feb., 1937, pp. 139–142.

Beraldi, Henri. *Les Graveurs du XIXe siècle,* 12 vols. Paris: Librairie L. Conquet, 1885–92.

Berri, D. G. *The Art of Lithography.* London, 1872.

Bjorling, Frank. "Proving," *National Lithographer,* Oct. 1914, pp. 28–29; Nov., 1914, pp. 27–29.

Bouchot, Henri. *La Lithographie.* Paris: Librairies-Imprimeries Réunies, 1895.

Braquemond, Félix. *Étude sur la gravure sur bois et la lithographie.* Paris: H. Beraldi, 1897.

Brattinga, Pieter. "Eugene Feldman's Creative Experiments in Photo-Offset Lithography," *Artist's Proof,* Vol. 2, No. 2, 1962, p. 25.

Brown, Bolton. *Lithography.* New York: Carrington, 1923.

———. *Lithography for Artists.* Chicago: U. of Chicago Press, 1929.

Browne, Warren C. *Practical Text Book of Lithography* New York: National Lithographer, 1912.

Cliffe, Henry. *Lithography: A Complete Handbook* New York: Watson-Guptill, c. 1965.

Copley, John. "Some Thoughts on Lithography," *Artwork,* Vol. 1, 1925, pp. 247–252.

Cumming, David. *A Handbook of Lithography*, 3d ed. London: Black, 1948.

Curtis, Atherton. *Some Masters of Lithography*. New York: Appleton, 1897.

Dehn, Adolf A., and Lawrence Barrett. *How to Draw and Print Lithographs*. New York: American Artists Group, 1950.

Dussler, Luitpold. *Die Inkunabeln der deutschen Lithographie*. Berlin: Tiedmann, 1925.

Engelmann, G. *Das Gesammtgebiet der Lithographie*, 2d ed., tr. from *Traité théorique et pratique de lithographie*. Leipzig: Binder, 1843.

Farrar, Joan. "The Embossed Lithographs of Angelo Savelli," *Artist's Proof*, Vol. 5, No. 2, 1965, pp. 41–42.

Fisher, R. E. *Transferring and Proofing*. London: Pitman, 1961.

Fisher, T. "The Process of Polyautographic Printing," *The Gentleman's Magazine*, Vol. 78, Part I, 1808, pp. 193–196.

Ganso, Emil. "The Technique of Lithograph Printing," *Parnassus*, Nov., 1940, pp. 16–21.

Goulding, Frederick. "Lithographs and Their Printing," *Studio*, Vol. 6, 1895, pp. 86–101.

Gräff, Walter. *Die Einführung der Lithographie in Frankreich*. Heidelberg: Karl Rössler, 1906.

Griffits, Thomas E. "The Herkomer Technique and Applications," *The Penrose Annual*, XLV, 1951, pp. 77–78.

————. *The Rudiments of Lithography*. London: Faber, 1956.

————. *The Technique of Colour Printing by Lithography*. London: Faber, 1948.

Gutman, Walter. "American Lithography," *Creative Art*, Vol. 5, 1929, pp. 800–804.

Harrap, Charles. *Offset Printing from Stone and Plates*. Leicester: Raithby, Lawrence, 1927.

Hartrick, Archibald S. *Lithography as a Fine Art*. London: Oxford, 1932.

Hullmandel, Charles. *The Art of Drawing on Stone*. London, 1824.

Huntley, Victoria H. "On Making a Lithograph," *American Artist*, May, 1960, pp. 30–35.

Jackson, F. E. "Lithography," *The Imprint*, Vol. 1, 1913, pp. 18, 125, 171, 319.

Jones, Stanley. *Lithography for Artists*. London: Oxford, 1967.

Kistler, Aline. "Western Lithographers," *Prints*, May, 1935, pp. 16–25.

Kistler, Lynton R. *How to Make a Lithograph*. Los Angeles, 1950.

La Dell, Edwin. "Autolithography at the Royal College of Art," *The Penrose Annual*, Vol. 46, 1952, pp. 46–48.

Lemercier, Alfred. *La Lithographie française de 1796 à 1896* Paris: Lorilleux, c. 1896.

Lieure, J. *La Lithographie artistique et ses diverses techniques*. Paris: Papyrus, 1939.

Man, Felix. *150 Years of Artists' Lithographs*. New York: McGraw-Hill, 1966.

Marthold, Jules de. *Histoire de la lithographie*. Paris: Société française d'éditions d'art, n.d.

McCausland, Elizabeth. "Lithographs to the Fore," *Prints*, Oct., 1936, pp. 16–30.

Miller, George C. "Craft of Lithography," *American Artist*, Sept., 1943, pp. 21–23.

Mönch, Erich. "Techniques with Berlin Transfer Paper," *Artist's Proof*, Vol. 6, 1966, pp. 50–53.

Ozzola, Leandro. *Rassegna d'arte antica e moderna: La Litografia italiana*. Rome: Alfieri, 1923.

Pennell, Joseph. "Lithography," *The Print Collector's Quarterly*, Vol. 2, p. 459.

————. "The Truth about Lithography," *Studio*, Vol. 16, 1899, pp. 38–44.

———— and Elizabeth Robins. *Lithography and Lithographers*. New York: Macmillan, 1915.

Peters, Harry T. *Currier & Ives* New York: Doubleday, 1942.

Petheo, Bela. "Polymer-Coated Lithographic Transfer Paper," *Artist's Proof*, Vol. 8, 1968, p. 100.

Reed, Robert F. *Offset Lithographic Platemaking*. Pittsburgh: Graphic Arts Technical Foundation, 1967.

————. *What the Lithographer Should Know about Paper*. New York: Lithographic Technical Foundation, 1961.

————. *What the Lithographer Should Know about Ink*. Pittsburgh: Graphic Arts Technical Foundation, 1966.

Rhodes, Henry J. *The Art of Lithography*. London: Scott, Greenwood, 1924.

Richmond, W. D. *The Grammar of Lithography*. London: Wyman, 1886.

Rothenstein, Will. "Some Remarks on Artistic Lithography," *Studio*, Vol. 3, 1894, pp. 16–20.

Sansom, W. B. *Lithography: Principles and Practices*. London: Pitman, 1960.

Seddon, R. "Producing a Colour Lithograph," *Artist*, March, 1944, pp. 22–24.

Senefelder, Alois. *A Complete Course of Lithography*, tr. A.S. London: Ackerman, 1819; repr. New York: Da Capo, 1968.

————. *The Invention of Lithography*, tr. J. W. Muller. New York: Fuchs and Lang Mfg. Co., 1911.

Seymour, Alfred. *Practical Lithography*. London: Scott, 1903.

Sykes, Maltby. "The Multimetal Lithographic Process," *Artist's Proof*, Vol. VIII, 1968, pp. 97–99.

Tory, Bruce E. *Photolithography*. Sydney: Associated General Publications, 1953.

Toussaint, Manuel. *La Litografia en Mexico en el siglo XIX*. Mexico: Estudios Neolitho, 1934.

Trivick, Henry. *Autolithography*. London: Faber, 1960.

Weaver, Peter. *The Technique of Lithography*. New York: Reinhold, 1964.

Weber, Wilhelm. *A History of Lithography*. New York: McGraw-Hill, 1966.

Weddige, Emil. *Lithography*. Scranton: International Textbook, 1966.

Wehrlin, Robert. "Reflections on Original Lithography," *Graphis*, Vol. 4, No. 22, 1948, pp. 168–171, 192–193.

Weitenkampf, Frank. "Lithography for the Artist," *Scribner's Magazine*, Vol. 60, 1916, pp. 643–646.

————. "Lithography for the Artist," *American Magazine of Art*, July, 1918, pp. 352–355.

————. "The Making of a Lithograph," *New York Public Library Bulletin*, May, 1918, pp. 291–293.

Wengenroth, Stow. *Making a Lithograph*. New York: Studio, 1936.

Westhaver, Kenneth H. "Experiments in Autolithography with Paper Masters," *Artist's Proof*, Vol. 7, 1967, p. 84.

Woods, Gerald. *The Craft of Etching and Lithography*. London: Blandford, 1965.

THE RELIEF PROCESS

Anderson, William. *Japanese Wood Engraving*. London: Seeley, 1908.

Azechi, Umetaro. *Japanese Woodblock Prints: Their Techniques and Appreciation*. Tokyo: Toto Shuppan, 1963.

Balston, Thomas. *English Wood Engraving, 1900–1950*. London: Art and Technics, 1951.

Beedham, R. J. *Wood Engraving* London: Faber, 1938.

Biggs, John R. *Woodcuts*. London: Blandford, 1958.

Bing, S. *Artistic Japan*. London: Sampson, Low,

Marston, Searle and Rivington, 1946.

Binyon, Laurence. *Catalogue of Japanese and Chinese Woodcuts in the British Museum*. London: Clowes, 1916.

————. *Japanese Colour Prints*, 2d ed. New York: Scribner, 1960.

Bliss, D. P. *A History of Wood Engraving*. London: Spring Books, 1964.

Boller, W. *Masterpieces of the Japanese Color Woodcut*. Boston: Boston Book and Art Shop, n.d.

Brown, L. N. *Block Printing and Book Illustration in Japan*. New York: Dutton, 1924.

Chatto, W. A. *A Treatise on Wood-Engraving, Historical and Practical*. London: Knight, 1839.

————. *Chinese Flower and Fruit Prints from the Mustard Seed Garden and the Ten Bamboo Studies*. New York: Metropolitan Museum, c. 1946.

Day, Wörden. "Experiments in Woodcut," *Artist's Proof*, Vol. 1, No. 2, 1961, pp. 26–27.

Ficke, A. D. *Chats on Japanese Prints*. London: Ernest Benn, 1958.

Fletcher, F. Morley. *Wood-Block Printing Based on the Japanese Practice*. London: Hogg, 1916.

Furst, Herbert. *The Modern Woodcut*. London: 1924.

Glaser, Curt. *Gotische Holzschnitte*. Berlin: 1923.

Hind, A. M. *An Introduction to a History of the Woodcut*, 2 vols. New York: Dover, 1963.

Ishida, Mosaku. *Japanese Buddhist Prints*, tr. Charles S. Terry. New York: Abrams, 1964.

Kurth, Julius. *Geschichte des Japanischen Holzschnitts*. Leipzig: Ersterbrand, 1925.

Lankes, J. J. *A Woodcut Manual*. New York: Crown, 1932.

Ledoux, L. V. *Japanese Prints of the Ledoux Collection—The Primitives*. New York: Weyhe, 1942.

Leighton, Clare. *Wood-Engravings and Woodcuts*. London: Studio, 1932.

Linton, W. J. *Wood Engraving, A Manual of Instruction*. London: Bell, 1884.

Macnab, I. *Wood Engraving*. London: Pitman, 1947.

Michener, James A. *The Floating World*. New York: Random House, 1954.

Mueller, H. A. *Woodcuts and Wood Engravings and How I Make Them*. New York: Pynson Printers, 1939.

Musper, H. T. *Der Holzschnitt in Fünf Jahrhunderten*. Stuttgart: Kohlhammer, 1964.

Ono, Tadashige. *Gendai Hanga No Giho* ("The Art of Modern Woodblock Printing"). Tokyo: David-sha, 1956.

Platt, John E. *Colour Woodcuts*. New York: Pitman, 1917; repr. 1938.

Rothenstein, Michael. *Frontiers of Printmaking: New Aspects of Relief Printing*. New York: Reinhold, 1966.

————. *Linocuts and Woodcuts: A Complete Block Printing Handbook*. New York: Watson-Guptill, 1964.

Salaman, M. C. *The New Woodcut*. New York: Boni, 1930.

Smith, Charles. *Experiments in Relief Print Making*. Charlottesville: U. of Virginia, 1954.

Sonenberg, Jack. "The Cast-Paper Woodcut," *Artist's Proof*, Vol. 7, 1967, pp. 85–87.

Strange, Edward. *Japanese Colour Prints*. London: Victoria & Albert Museum, 1913.

Tanizaki, Jun'ichiro, and Shiko Munakata. *Kaka Hanga No Maki*. ("The Tanka and Wood Block"). Tokyo: Hobun-kan, 1957.

Ward, Lynd. *Vertigo*. New York: Random House, 1937.

Warner, L. W. *The Enduring Art of Japan*. Cambridge: Harvard, 1953.

Watson, Ernest W., and Norman Kent. *The Relief Print*. New York: Watson-Guptill, 1945.

Yoshida, Toshi. *Japanese Wood-Block Printing*. Tokyo: Sanseifo, 1939.

THE INTAGLIO PROCESS

Alken, Henry T. *The Art and Practice of Etching: with Directions for other Methods of Light and Entertaining Engraving.* London: Fuller, 1849.

Ashley, A. *The Art of Etching on Copper.* London: Darling, 1849.

Avati, Mario. "The Mezzotint Technique," *Artist's Proof,* Vol. 8, 1968, pp. 94–96.

Barry, John J. *How to Make Etchings.* New York: Bridgman, 1929.

Bernard, David. "The Collagraph Print," *Artist's Proof,* Vol. 2, 1962, p. 43.

Bishop, Thomas. *The Etcher's Guide.* Philadelphia: Janentzky, 1879.

Blaker, M. "The Craft of Etching," *Artist,* Sept., 1959, pp. 130–134.

Bosse, Abraham. *Traicté des manières de graver;* rev. C. N. Cochin II. Paris: 1745.

Brunsdon, John. *The Technique of Etching and Engraving.* New York: Reinhold, 1965.

Brussel-Smith, B. "Relief Etching . . . ," *American Artist,* Dec., 1959, pp. 22–27.

Buckland-Wright, John. *Etching and Engraving* London: Studio, 1953.

Cassara, Frank. "A Unique One-bite White Etching Ground," *Artist's Proof,* Vol. 3, No. 1, 1963, pp. 36–38.

Chattock, R. S. *Practical Notes on Etching.* London: Low, Marston, 1886.

Dodge, Ozias. *Experiments in Producing Printing Surfaces.* New York: De Vinna, 1908.

Evelyn, John. *Sculptura: or the History and Art of Chalcography & Engraving in Copper* London: G. Beedle, 1662.

Faithorne, William. *The Art of Graveing and Etching.* London: 1662; repr. New York: Da Capo, 1968.

Fielding, T. H. *The Art of Engraving* London: 1884.

Gariazzo, P. A. *La stampa incisa.* Turin: 1907.

Green, J. H. *Complete Aquatinter.* London: 1801.

Green, Virginia B. "The Magnesium Plate," *Artist's Proof,* Vol. 7, 1967, pp. 88–90.

Hamerton, Philip G., *The Etcher's Handbook.* London: Robertson, 1871.

———. *Etching and Etchers.* Boston: Roberts, 1878; Little, Brown, 1916.

Hammer, Sid. "The Thermo-Intaglio Print," *Artist's Proof,* Vol. 2, No. 2, 1962, pp. 43–44.

Hassell, John. *Graphic Delineation: A Practical Treatise on the Art of Etching* London: M. Hassell, the widow, 1829.

———. "Improvement in the Aquatinta Process, by which Pen, Pencil, and Chalk Drawings Can Be Imitated," *Nicholson's Journal,* No. 30, 1811, p. 220.

Hayter, Stanley William. *Atelier 17,* New York: Wittenborn, 1949.

———. *A New Way of Gravure.* New York: Pantheon, 1949.

Herkomer, Hubert von. *Etching and Mezzotint Engraving.* London: 1892.

Hind, Arthur M. *A History of Engraving and Etching,* repr. New York: Dover, 1963.

Hurwitz, S. "White-Ground Etching . . . ," *American Artist,* Jan., 1965, pp. 60–65.

Lalanne, Maxime. *A Treatise on Etching,* tr. from 2d French ed. S. R. Koehler. Boston: Estes and Lauriat, 1885.

Landseer, John. *Lectures on the Art of Engraving* London: Engraver to the King, 1807.

Lumsden, Ernest S. *The Art of Etching.* Philadelphia: Lippincott, 1925.

Morrow, B. F. *The Art of Aquatint.* New York: Putnam, 1935.

Ponce de León, Michael. "The Metal Collage Intaglio Print," *Artist's Proof,* Vol. 4, No. 1, 1964, pp. 52–54.

Prideaux, Sarah T. *Aquatint Engraving.* London: Duckworth, 1909.

Pyle, Clifford. *Etching Principles and Methods.* New York: Harper, 1941.

Reed, Earl H. *Etching, a Practical Treatise.* New York: Putnam, 1914.

Roger-Marx, Claude. *French Original Engravings from Manet to the Present Time.* New York: Hyperion, 1939.

Schöb, A. "Max Hunziker, Direct Relief Etchings," *Graphis,* Nov., 1959, pp. 478–485.

Short, Frank. *Etchings and Engravings.* London: 1911.

Silsby, Wilson. *Etching Methods and Materials.* New York: Dodd, Mead, 1943.

Steg, J. L. "The Photo-Resist Etching Ground," *Artist's Proof,* Vol. 8, 1968, pp. 93–94.

Sternberg, Harry. *Modern Methods and Materials of Etching.* New York: McGraw-Hill, 1949.

Strang, David. *The Printing of Etchings and Engravings.* London: Ernest Benn, 1930.

Taubes, F. "Lift-ground Etching," *American Artist,* May, 1956, pp. 40–43.

Torrey, Frederic C. *The Art of Etching.* Berkeley: U. of California, 1923.

Trevelyan, Julian. *Etching: Modern Methods of Intaglio Printmaking.* New York: Watson-Guptill, 1964.

West, Levon. *Making an Etching.* London: Studio, 1932.

SCREEN PRINTING

Arends, Jack, "Silk Screen Printing," *Design,* March, 1940, pp. 12–13, 23.

Auvil, Kenneth W. *Serigraphy: Silk Screen Techniques for the Artist.* Englewood Cliffs, N.J. Prentice-Hall, 1965.

Baker, F. A. *Silk Screen Practice.* London: Blandford, 1934.

Biegeleisen, J. I. "Silk Screen," *Design,* June, 1942, p. 9.

———. "Silk Screen Printing," *Design,* Jan., 1941, pp. 24–25.

———. "Silk Screen Printing Process," *Art Instruction,* July, 1938, pp. 27–30.

———, and E. J. Busenbark. *The Silk Screen Printing Process.* New York: McGraw-Hill, 1941.

———, and M. A. Cohen. *Silk Screen Stencilling as a Fine Art.* New York: McGraw-Hill, 1942.

Bornstein, E. "Serigraphy—Why a New University Course . . . ?" *Canadian Art,* Vol. 14, No. 3, 1957, pp. 98–100.

Carr, Francis. *A Guide to Screen Process Printing.* London: Studio Vista, 1961.

Chieffo, Clifford T. *Silk Screen as a Fine Art.* New York: Reinhold, 1967.

Cloonan, Jack. "The Direct Photographic Silk Screen," *Craft Horizons,* Nov., 1963, pp. 54–55.

Fossett, Robert O. *Techniques in Photography for the Silk Screen Printer.* Cincinnati: Signs, 1959.

Foster, Judith. "Mezzotint-Silkscreen Experiments," *Artist's Proof,* Vol. 8, 1968, p. 97.

Kinsey, Anthony. *Introducing Screen Printing.* New York: Watson-Guptill, 1968.

Kosloff, Albert. *Elementary Silk Screen Printing.* Chicago: Naz-dar, 1954.

———. *Mitography.* Milwaukee: Bruce, 1952.

———. *Photographic Screen Process Printing.* Cincinnati: Signs of the Times, 1968.

———. *Screen Process Printing.* Cincinnati: Signs of the Times, 1950.

———. *Silk Screen Printing with Mimeograph-type Stencils.* Chicago: 1946.

Leboit, Joe. "The Serigraph," *The New York Artist,* Vol. 1, No. 2, 1940, pp. 12–13.

Marsh, Roger. *Silk Screen Printing for the Artist.* London: Tiranti, 1968.

Mackenzie, F. W., ed. *Screen Process Printing.* Wealdstone, Middlesex: Skinner, 1951.

Middleton, H. K. *Silk Screen Process: A Volume of Technical References.* London: Blandford, 1949.

Musser, Alice. "Silk Screen. A Device for Printing Color in Quantity," *Design,* Nov., 1942, pp. 18–19.

Poleskie, Steve. "On Silkscreen Printing," *Artist's Proof,* Vol. 7, 1967, pp. 78–83.

Prater, Christopher. "Experiment in Screenprinting," *Studio,* Dec., 1967.

Reinke, William A. *Silk Screen Printing.* Chicago: Oil Color Litho Co., n.d.

Roberts, E. A. "Silk-Screen Printing with Anthrasol Indigosol Dyes," *Craft Horizons,* Sept., 1958, p. 40.

Russ, Stephen. *Practical Screen Printing.* London: Studio Vista, 1969.

Shokler, Harry. *Artist's Manual for Silk Screen Printing.* New York: Tudor, 1960.

Stephenson, Jessie B. *From Old Stencils to Silk Screening: A Practical Guide.* New York: Scribner, 1953.

Sternberg, Harry. *Silk Screen Color Printing.* New York: McGraw-Hill, 1942.

Strauss, Victor. *Modern Silk Screen Printing.* New York: Pied Piper, 1949.

Summer, Harry, and Ralph M. Audrieth. *Handbook of the Silk Screen Printing Process.* New York: Arthur Brown, 1941.

Taussig, W. *Screen Printing.* Manchester: Clayton Aniline Co., 1950.

Velonis, Anthony. *Technique of the Silk Screen Process.* New York: WPA Art Project, 1939.

Zahn, Bert. *Silk Screen Methods of Reproduction.* Chicago: Drake, 1930.

Zigrosser, Carl. "Serigraph—A New Medium," *Print Collector's Quarterly,* Dec., 1941, pp. 442–477.

Glossary

absorption. In lithography, the process by which a liquid is drawn into a porous surface.

acid-resist. See *stop-out.*

adsorption. In lithography, the process by which a plate or stone gathers and holds a liquid in one or more molecular layers.

à la poupée. (French, "with a dolly.") In intaglio, a technique for printing several colors at one time from a single plate by applying each color with a separate pad or rolled piece of felt.

aqua fortis. (Latin, "nitric acid.") In intaglio, the acid solution or *mordant* that etches the plate.

aquatint. An intaglio process in which a porous ground of resin or other substances is applied to a plate, heated, and etched; produces a range of tonal values.

artist's proof. A proof reserved by the artist for his own record or use, excluded from the numbering of an edition.

asphaltum. A bituminous substance used: (1) in lithography, instead of tusche, or in rolling up stones or plates; (2) in intaglio, as a stop-out varnish when long bites are required, usually mixed with turpentine or benzine; also an ingredient of hard ground. Called *bitumen* in older texts.

assemblage. A work of art made up of various objects and materials including found objects used either with or without standard art materials.

baren. A slightly convex, bamboo-covered tool of Japanese origin, about 5 inches in diameter, used for burnishing the back of the paper when printing from an inked relief block.

bath. In etching, the tray of mordant in which the plate is etched or bitten.

bench hook. A device used to keep a block from slipping during cutting, made by fastening two cleats at opposite ends and sides of a board.

bevel. (1) To file the edge of a stone or plate at an angle. (2) The sloping edge itself.

bimetal plate. A plate made with two layers of metal, usually copper over stainless steel or aluminum.

bite. In intaglio, the penetration of acid into a plate. The *biting time* is the length of time a plate has been or should be acted upon by acid in a bath.

bitumen. See *asphaltum.*

blankets. Rectangles of piano felt (or foam rubber) used between the paper and the roller on an etching press. Usually three blankets are used: the starch-catcher, next to the paper, the pusher, and the cushion.

bleeding. (1) In intaglio, exudation of oil around a printed line. (2) In lithography, tints of color on nondrawn areas of the print, caused by relatively soluble ink pigments that stain the damping water.

bleed prints. Prints in which the image extends to the edges of the paper.

blended roller technique. See *rainbow printing.*

blind embossing. See *embossing.*

blinding. Loss of receptivity to ink in an image area of a stone or plate.

body. The relative density or viscosity of a pigment.

bon à tirer. (French, "good to pull.") A proof so labeled by the artist to indicate that the quality of printing meets his requirements and that it may serve as the standard for printing the edition. Also called *printer's proof.*

bordering wax. Wax formed into an edge around a plate so that it may be bitten without immersion in a tray; used especially for extra-large plates.

brayer. A roller used for applying ink. In relief printing a *gelatin brayer* is commonly used.

bridge. A support for the hand that facilitates drawing without touching the surface of the work; may be made of a piece of wood with felt-covered cleats or a barrel stave.

burin. A tool used for engraving metal or end-grain wood blocks, usually having a steel shaft sharpened to a square or lozenge section and a half-round wooden handle. Also called *graver.*

burn. In lithography, to damage or destroy delicate drawing by using a gum etch containing too much nitric acid.

burnisher. (1) A highly polished, oval-sectioned hand tool of bone or metal, used to diminish intaglio lines. (2) Any tool, such as the baren, that burnishes or rubs.

burr. (1) In drypoint, the ridge of metal thrown up on each side of a line cut by a needle in the plate. (2) In mezzotint, the surface created by working over the plate with a rocker.

cancellation proof. A proof made from a defaced stone, plate, block, or screen, to show that no further prints can be made from the original art work.

cellocut. A print made from an image created with celluloid dissolved in acetone.

chalk manner. See *crayon manner.*

chalking. Pigment rub-off caused by too little binding vehicle.

charcoal block. Engraver's charcoal in block form, used for polishing plates.

charge. To cover or roll with printing ink.

chop. An identifying mark or symbol impressed upon the paper; used by workshops and printers and by some artists and collectors.

cliché verre. (French, "glass print.") A print made photographically from an image needled through a light-resistant coating applied to glass.

collage. Originally, a picture made of pasted papers (French, *papiers collés*); extended to include fabrics and other materials and objects. When heavily three-dimensional objects are included, so that the work loses its flatness, it is called an *assemblage.*

collage print. A print with collage elements incorporated by inking them or stamping them or transferring them photographically to the plate or print.

collagraph. A print pulled from a surface that has been built up in the collage manner.

color separations. A series of proofs of a multicolor print showing each color on a separate sheet. Contrast with *progressive proofs.*

counteretch. See *resensitize.*

counterproof. A proof obtained by offsetting a wet proof or print onto a clean, dampened sheet of paper.

crayon manner. A technique for creating an image on the plate with the use of roulettes and punches, providing an effect resembling crayon drawing.

crevé. (French, "broken away.") An area on the surface of a plate or ground that is damaged by overbiting of lines laid too close together. Some contemporary artists exploit this effect.

criblé. (French, "sieve.") See *manière criblée.*

dabber. A tool used for inking a plate or laying a ground; usually a cotton pad covered with silk or leather, sometimes a piece of rolled felt or other material.

damp press. A device for dampening paper; as a covered box lined with oilcloth, rubber, or zinc.

deckle edge. The irregular, untrimmed edge of paper, typical of handmade paper and sometimes produced artificially in commercial papers.

deep etch. A method that allows for relief and intaglio color printing simultaneously.

desensitize. In lithography, to treat a drawing on a stone or plate with acidified gum etch so that the undrawn areas become insensitive to grease and will not print. Also called *etching* the stone.

diamond point. A diamond-tipped needle set in a handle, used for needling a plate in *drypoint.*

direct transfer. In lithography, to transfer an image directly from a flat or a three-dimensional inked object onto the stone.

drying oil. An oil such as linseed or tung that changes to a solid as a result of the action of oxygen.

drypoint. An intaglio process in which the plate is needled with a steel or other point, inked, wiped, and printed. The burr created by the cut of the needle provides a warm, velvety line, but tends to break down in large editions.

durometer. (1) A device for computing the indentation hardness of rubber. (2) A unit of measure thereof.

Dutch mordant. A mixture of potassium chlorate with hydrochloric acid, used for fine biting.

échoppe. (French, "graver.") An etching needle ground to an oblique face, used originally by Callot to obtain swelling lines.

edition. The total number of prints pulled and authenticated by the artist for distribution. The eleventh print in an edition of fifty is numbered as follows: 11/50.

embossing. Creating a raised image or design element in the surface of a print. In *blind embossing* the raised element is printed without ink and thus appears in white (or in the color already given to the paper).

end-grain block. A block of wood cut across the grain, used for wood engraving; usually of boxwood, also maple.

engraver's pad. A circular, convex, sand-filled leather-covered pad, used to support the plate in line engraving so that it may be turned easily. Also called a *cushion.*

engraving. (1) In the intaglio and relief processes,

the act of incising lines with a *burin* or graver into a plate or end-grain block of wood. (2) The print obtained from an engraved plate or block of wood. (3) Loosely, all prints that utilize a press.

etch. (1) In lithography, see *desensitize.* (2) In intaglio, to apply acid to a grounded plate so that the image incised theron will be bitten into the metal plate.

etching. An intaglio process in which an acid-resistant ground is applied to a plate, an image is cut into the ground with a needle, and acid is applied to bite the image into the plate.

etching needle. A blunt, rounded steel point used to lay open the ground when making an image on an etching plate.

extender. (1) A mixing white, used in screen printing to add body to the ink and increase coverage. (2) A white or colorless pigment employed with black or color ink to improve its working condition or reduce its color strength.

fatty rag. An ink-charged rag that has been used repeatedly for wiping plates.

feathering. (1) In intaglio, a method of biting specific areas by controlling drops of acid with a feather. (2) In lithography, rolling ink on a plate or stone from the edges toward the center, gradually lifting the roller to avoid lines.

felt side. The top side of paper.

foul biting. Accidental dots or irregular areas bitten into a plate; caused by improper grounding.

found objects. Objects other than standard art materials that are incorporated into a work of art in any medium.

French chalk. Talc; used in powdered form in lithography.

frothing etch. In lithography, an etch so strong that it "boils" on the stone or plate (e.g., 50 drops of nitric acid to 1½ ounces of gum-arabic solution).

gauffrage. Blind embossing, done with a tool known as a *gauffer* or *goffer.*

ghost. In lithography, the remnant of a previous drawing on a stone that may reappear when the stone is wet.

gouges. Tools used for cutting wood and linoleum. The two basic types are the *V-gouge* and the *U-gouge.*

grain. In lithography, to prepare a stone for use by grinding with an abrasive. The resulting *grain* can be finer or coarser, according to choice.

graver. See *burin.*

grind. In lithography, to grain a stone.

ground. In etching, an acid-resistant coating of beeswax, resin, and asphaltum (or like substances) rolled or dabbed on a metal plate. The design or image is scratched through the ground.

gum. In lithography, a common contraction for gum-arabic solution. To gum a stone or plate means to apply a coating of pure gum-arabic solution.

gum etch. In lithography, a mixture of gum-arabic solution and nitric acid used for desensitizing or "etching" a stone or plate.

gypsographic prints. See *blind embossing.*

hammer up. To correct a nonlevel area in a plate by hammering it from the back, working on the surface with a scraper, and polishing with a burnisher.

hard ground. A ground composed of various substances used in etching, supplied in a ball shape, to be melted on a hot plate, or in liquid form.

hickey. An undesirable ink spot with a white halo, usually caused by dirt or skin in the ink.

impression. An imprint on paper resulting from contact with an inked image on stone, plate, or block.

India oil stone. A sharpening implement used for burins, knives, scrapers, and other tools.

ink-in-water emulsion. Fine droplets of ink surrounded by water.

ink slab. A fairly large piece of stone, plate glass, marble, etc., on which ink is prepared and rolled.

inkless intaglio. A print made by blind embossing, that is, by printing a raised image without ink.

intagliate. The cut or etched lines forming the design on an intaglio plate.

intaglio. One of the four major divisions of printmaking, in which an image is either cut or bitten by acid into a metal plate. Ink is forced into the lines of the image, the surface of the plate is wiped clean, and the print is made with the pressure of an etching press.

intaglio-relief. A print made by inking the surface rather than the etched or engraved lines of an intaglio plate.

island. In stencil printing, an area in the design, like the inner circle of the letter "O," that will be cut loose from the stencil unless it is attached in some way. (See *tie.*)

jigger. An inverted wooden box, equal in height to the hot plate or stove, which facilitates moving warmed plates from the hot plate.

kara-zuri. A Japanese term for blind embossing.

key block or *plate.* The block or plate that contains the master design, with which all other blocks and plates are registered in multicolor printing.

knock up. See *hammer up.*

letterpress printing. A commercial printing process that operates on the principle of relief printing; that is, the raised surface of the type or plate is inked and printed.

levigator. A cast-iron or aluminum circular tool, usually weighing 30 pounds and 3 to 4 inches thick, with a handle mounted eccentrically; used to grain lithographic stones.

lift. To print properly; said of ink when it transfers properly from the inked stone, plate, or block to the paper.

lift ground. A ground laid over an image painted with sugar solution. When soaked, the ground lifts off in the areas where the image was brushed on. The resulting print is a *lift-ground etching.*

lightfastness. Resistance to change caused by exposure to ultraviolet rays; colorfast, said of ink or paper.

light-sensitive plates. Plates used for photolithography or photointaglio, which are treated so that the image may be transferred photographically onto the plate. A *light-sensitive coating* may be applied to an ordinary plate.

line engraving. An intaglio process in which the plate is engraved with burins, inked, wiped, and printed.

linocut. See *linoleum cut.*

linoleum cut. A relief print made from an image cut on a piece of battleship linoleum.

lithographer's needle. A sharp steel point in a holder used to lighten accents or create white lines in crayon or tusche drawings.

lithographic crayons and pencils. Grease crayons and pencils made especially for lithography. (Other grease crayons are also sometimes used.)

lithographic stones. Bavarian limestone, cut in various sizes about 3 to 4 inches thick.

lithographic varnish. A varnish used (1) when preparing lithographic ink for printing; (2) when breaking in new leather rollers; (3) when surface-printing intaglio plates in color.

lithography. One of the four major divisions of printmaking, in which a drawing is made with a greasy substance on a stone or plate. The surface

is then treated so that the image accepts ink and the non-image areas repel ink, and the print is made with a lithographic press.

lithotine. A substitute for turpentine that is less irritating to the skin.

lithotint. In lithography, a print executed with wash techniques; a term no longer much used.

livering. Thickening of ink, on standing, to a spongy, rubberlike mass; caused in part by oxidation of the oil vehicle.

maculature. In intaglio, the pulling of a second proof without re-inking, to remove surplus ink.

makeready. Preparation of a plate so that it will print evenly; may be accomplished by pasting layers of paper on the back corresponding to the low areas in the plate that fail to print.

manière criblée. (French, "dotted manner.") An old technique for creating textures and background with the use of stamps or punches that pierce the block or plate with tiny holes.

manière noire. (1) A method of working from dark to light, as in mezzotint. (2) A tonal ground obtained by ruling a hard-grounded plate in at least four directions, and etching it.

metal print. (1) A technique invented by Rolf Nesch, in which metal objects or cutout shapes are soldered to prints made from plates. (2) Collage intaglio.

mezzotint. An intaglio process in which the surface of the plate is methodically roughened with a rocker to produce a dark background. With various scrapers the printmaker lightens certain passages, working from black to white to clarify his design.

mixed intaglio. A print made by combining two or more of the intaglio processes. See *etching, engraving, aquatint, drypoint, mezzotint.*

mixed media. In printmaking, prints made by combining two or more processes (e.g., lithograph and intaglio) or by combining a print process with a different art form (e.g., silk-screen printing and assemblage).

mixing white. A transparent or opaque white ink used for making high-valued colors.

monotype. A print made by transferring to paper a wet painting made on glass (or stone or metal). Only a single print can be made.

mordant. In intaglio, any one of the acid solutions that penetrate the plate.

muller. A stone, glass, or metal tool used for grinding inks and pigments.

multimetal plate. A plate made with two or more layers of metal. See *bimetal* and *trimetal.*

multiple. A work of art in any medium that exists in duplicated examples of which all are considered to be originals.

needle. See *etching needle; lithographer's needle.* In intaglio, to *needle* a plate is to incise the design with a needle.

offset printing. A method of commerical printing in which the image is transferred from the plate to the roller of the press and then to the paper, rather than, as in letterpress printing, directly from the plate to the paper.

opacity coverage. The area that can be covered by a specific quantity of ink or paint; usually quoted in gallons per square feet, specifying the surface on which printing is applied and/or the silk-screen mesh through which the ink is applied.

open. In silk-screen printing, a term describing the areas that will receive ink and create the image.

papiers collés. (French, "pasted papers.") See *collage.*

pH scale. A scale that measures the acidity or alkalinity of a solution or material.

photo-intaglio. A method in which an image is transferred by photomechanical means onto a

light-sensitive plate. The plate is then completed by normal etching procedures.

photolithography. A method of lithography in which the image is transferred photographically onto a light-sensitive plate.

piling. Build-up of ink on a stone or plate.

pitting. See *foul biting.*

plank-grain block. A block of wood cut parallel with the grain, used for woodcut.

planographic printing. Printing from a flat surface. See *lithography.*

plaster print. (1) A print cast in plaster (rather than printed on paper) from an intaglio plate. (2) A print made from carved plaster or a plaster mold instead of from a block or plate.

plate mark. The imprint of the edges of the plate on intaglio prints.

plug. A wedge of wood forced into a cut-out area of a wood block in order to provide a new surface for making corrections.

pochoir. A French stencil process, used for making art reproductions.

printer's proof. See *bon à tirer.*

progressive proofs. A set of color proofs showing first color A, then colors A and B, then colors A, B, and C, and so on, with the next color added on each successive proof.

proof. An impression made at any stage of the work from an inked stone, plate, block, or screen; not a part of an edition of prints. See *artist's proof; printer's proof; cancellation proof.*

pull. To make a print by transferring the ink to the paper.

pumice or *pumice stone.* An abrasive of volcanic origin used to polish the stone in lithography.

rainbow printing. The printing of several colors rolled simultaneously onto a stone or plate from a single roller, and blended together at the edges.

register marks. Hairline crosses or T marks placed in diagonally opposite margins of the paper as a guide to correct registration.

registration. Placement of the paper, when printing, so that each succeeding color impression is made in the correct relationship to the first one. A print is said to be "in registrar" when the colors overlap properly, and "out of registrar" or "off registrar," when they do not.

relief printing. One of the four major divisions of printmaking, in which the image is printed from the surface of a wood or linoleum block (or other material), the nonprinting areas having been cut away. (Intaglio plates can be used to make relief prints by applying the ink to the surface of the plate instead of to the incised lines.)

resensitize. In lithography, (1) to reopen a stone so as to add work; (2) to treat a metal plate so that it will receive the grease drawing.

resin ground. The ground used for aquatint, made by dusting resin particles onto a plate and heating.

retroussage. In intaglio, a technique for enriching the lines in a wiped plate, by flicking a piece of cheesecloth over the surface to cause the ink to "spill" over the lines.

reverse etching. Made from an intaglio plate surface-inked and printed by the woodcut technique.

reverse image. An image in which the lines and areas normally or previously printed in black become white and white becomes black.

rocker. A steel tool with a many-toothed, curved front edge, used for laying a mezzotint ground.

It is rocked across the plate many times in many different directions to produce an even-textured burr.

roller. The tool used for applying ink. In lithographic printing it is usually leather-covered and shaped like a rolling pin, with two handles. See also *brayer.*

roll up. To ink a stone or plate.

rotten lines. In etching, interrupted or fractured lines, caused by uneven needle pressures.

roulette. A tool with a revolving, toothed wheel, used to make dotted lines and areas in a metal plate or ground.

rubbing ink. A rectangular cake of ink used in lithography to obtain soft tones; applied with a finger stroked across the rubbing ink and then on the stone.

rub up. In lithography, to bring "up" the drawing on the stone by rubbing the stone with a sponge saturated with thinned lithographic ink and then with a sponge saturated with gum-arabic solution and water.

salt aquatint. An aquatint made with a porous ground obtained by sprinkling salt on a hot, thin-grounded plate. When the plate is cool, the salt is dissolved in water.

sandpaper aquatint. An aquatint made with a ground obtained by running a normally grounded plate through the press with fine sandpaper placed face down on it.

scraper. (1) In lithography, the element of a lithographic press (typically a leather-covered blade) that presses the paper onto the inked stone or plate. (2) In intaglio, a three-faced steel tool used for removing burrs and for other aspects of creating the image.

scum. In lithography, undesirable formation of grease on non-image areas of the stone or plate.

seal print. A blind-embossed print.

serigraphy. A term originated by Carl Zigrosser for screen printing as a fine-arts process.

short ink. Ink that cannot be drawn into a string between the fingers without breaking; ink that is too stiff.

silk screen. A wooden frame on which a piece of silk or other meshed material is stretched.

silk-screen printing. See *stencil printing.*

slip sheet. A sheet of paper placed between prints when they are pulled.

snake slip. An abrasive in stick form, used in lithography to clean the margins of the stone and in intaglio to polish off scraper marks.

soft ground. A ground to which grease is added so that it does not harden; resembling drawing.

squeegee. A tool consisting of a flat wooden bar with a rubber blade; used to apply the ink or paint in stencil printing.

state. A term describing a print or proof that shows a work in a particular stage of development.

stencil printing. One of the four major divisions of printmaking, in which paint or ink is forced with a squeegee through a silk screen onto the paper. The non-image areas of the print are blocked out by applying to the screen a paper stencil, glue, or other specially prepared products.

stop-out. (1) In intaglio, a substance that, when applied to a plate, prevents biting (or further biting) by the acid. (2) In screen printing, a substance that prevents ink or paint from penetrating the screen.

stopping out. Preventing lines and areas from biting or printing.

St Plate. A light-sensitive plate obtained through commercial sources; used in photolithography and in photo-intaglio.

struck off. Printed; pulled; said of prints or an edition.

sugar-lift intaglio. See *lift ground.*

suite. A group of original prints, usually related in theme; sometimes issued in a portfolio containing a title page and colophon.

surface-rolled. Inked on the surface, as for relief printing, and not in the grooves or cut-away areas of a block or plate.

tack. The pulling power of ink against a surface; stickiness.

tap-out. A test of ink color, made by dipping a finger in the ink and running it along a piece of paper so that it shows variations from full intensity to light tints.

thixotropy. The property of ink that makes it more fluid when worked and less fluid on standing.

tie. In stencil printing, a bridge or bar that holds an island to the remainder of the stencil.

tint tool. A graver that makes a series of delicate, parallel lines.

transfer paper. In lithography, a paper by means of which a drawing can be transferred from one stone or plate to another.

transparent base. Aluminum stearate or similar substances that reduce the opacity of color and improve screening in serigraphy, without changing the hue.

trial proof. An early proof of a block, plate, stone, or screen. In collaborative work, a stabilized impression pulled by an artisan-printer; often indicates the artist's revisions in color and in drawing.

trimetal plate. A plate made with three layers of metal, usually copper over chromium on a base sheet of stainless steel, mild steel, or aluminum.

tusche. Grease in liquid or stick form, used in making lithographic drawings; also used in serigraphy.

tympan. A tallow-covered sheet of red pressboard, zinc, glass epoxy, or other material placed between the scraper of the lithographic press and the printing paper to form a cushion.

type-high. Having the height of type used for letterpress printing (0.018 inches).

underbiting. In intaglio, leaving a plate in the acid for too short a time.

uninked intaglio. Blind embossing from an intaglio plate.

walling wax. See *bordering wax.*

wash out. In lithography, the act of washing the stone with a sponge and turpentine prior to rolling the stone with ink.

water-in-ink emulsion. Fine droplets of water surrounded by ink.

water-of-Ayr stone. Snake slip.

wipe-on-plate. A light-sensitive plate used in photolithography.

woodcut. A relief print made from a plank-grain wood block cut with knife, gouges, and chisels.

wood engraving. A relief print made from an end-grain wood block cut with burins and other tools.

working proof. A trial proof with additions and corrections indicated on it.

xylography. Wood engraving.

Index

Photographic Sources

References are to figure numbers, unless indicated Pl. (plate).

Art Gallery of Ontario, Toronto (Pl. 45); Baker, Oliver, New York (301); Baum, Hank, San Francisco (327, 335); Bristol, Bert, Verona, N.J. (178–179); Brooklyn Museum, New York (73–74, 188, 276, 281); Burckhardt, Rudolph, New York (100, 109, 322); Deutsche Fotothek, Dresden (194); Freeman, John R., & Co., London (153); Graphic Chemical & Ink Co., Villa Park, Ill. (339–341); Hemstedt, Otto, Seebüll, W. Germany (143); King, John, New Cannaan, Conn. (13, 65, 104–105, 155–157, 159–163, 189, 191–192, 238–241, 269, 275, 279, 285, 298, 324, 345, Pls. 10, 15, 24, 26, 28–29, 32–33, 38–40, 43–44); McMaster University, Hamilton, Ontario, Audio-Visual Dept. (142); Moulin Studios, San Francisco (147); Nelson, O.E., New York (283); Pennsylvania State University, University Park, Pa., Still Photography Studios, UDIS (1); Perrin, Brian, Kingston-upon-Thames, England (56, 60, 66, 68–69, 71, 83–89, 228–230, 232–233, 235–237, 242–253, 256–260, 268, 271–273, 307–320, 330, 336); Pollitzer, Eric, Garden City Park, N.Y. (111, Pl. 9); Riedl, Thom, Islington, Ontario (306, Pl. 41); Rosenblum, Walter, Long Island City, N.Y. (185, 284); Ruder & Finn, Inc., New York (302); Schiff, John D., New York (300); Steinkopf, Walter, Berlin (193, 195); Sunami, Soichi, New York (173, 186); Tamarind Institute, Albuquerque, N.M. (63, 67, 90, 93, 96–99, 116); Tamarind Lithography Workshop, Inc., Los Angeles (4, 92); Uht, Charles, New York, and Brooklyn Museum, New York (183); Witzel, Liselotte, Essen, W. Germany (141); Wyatt, Alfred J., Philadelphia (7, 21, 24, 36–37, 48, 133–134, 139, 146, 151, 205, Pls. 1–2) Works by Avati, Bonnard, Braque, Dubuffet, Kandinsky, Miró, Villon: Permission A.D.A.F.P. 1971 by French Reproduction Rights, Inc. Works by Carrière, Degas, Klee, Matisse, Picasso, Redon, Renoir, Rouault, Signac, Vuillard: Permission S.P.A.D.E.M. 1971 by French Reproduction Rights, Inc.